REMBRANDT

HIS LIFE AND WORKS IN 500 IMAGES

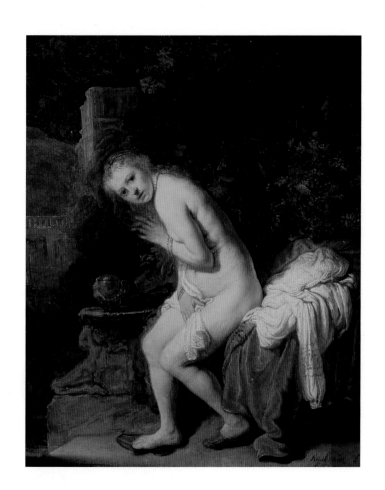

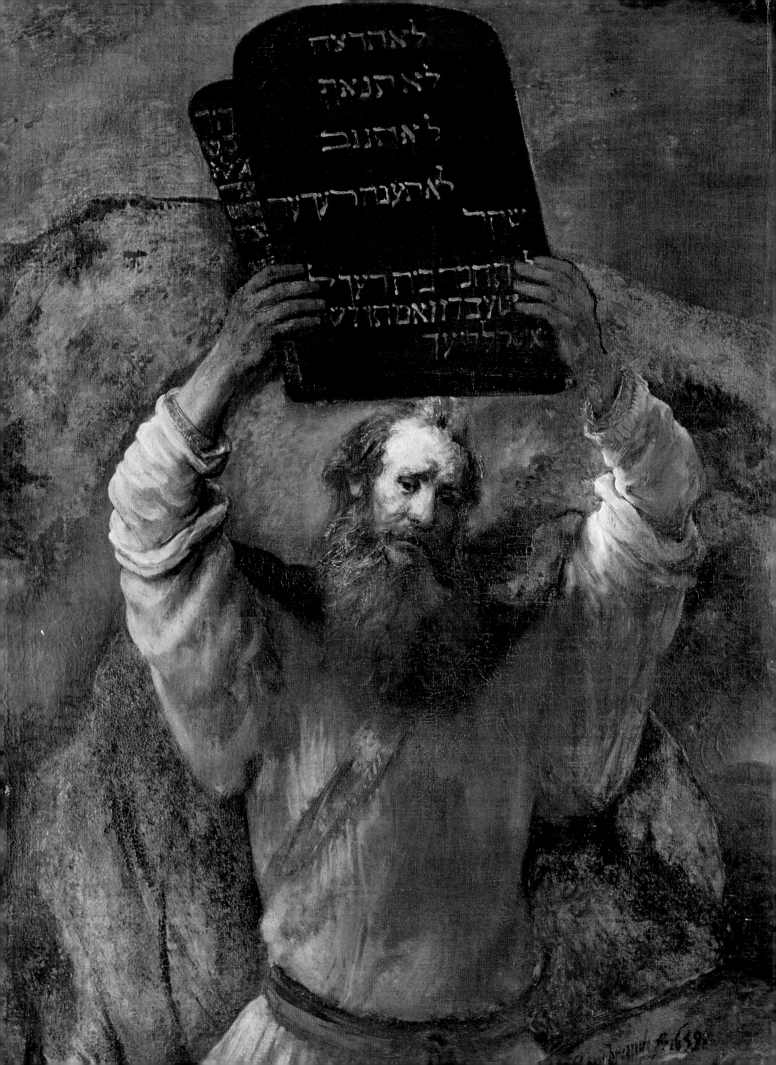

REMBRANDT

HIS LIFE AND WORKS IN 500 IMAGES

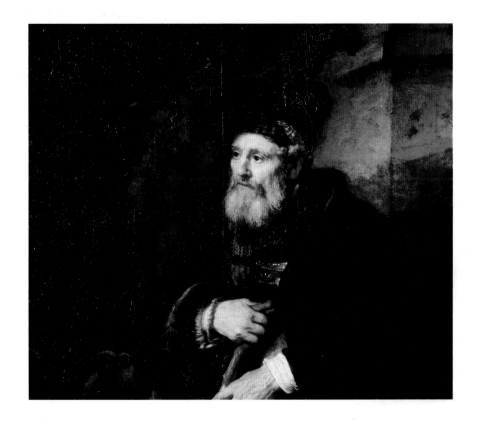

AN ILLUSTRATED EXPLORATION OF THE ARTIST, HIS LIFE
AND CONTEXT, WITH A GALLERY OF 300 OF HIS FINEST WORKS

ROSALIND ORMISTON

LORENZ BOOKS

This edition is published by Lorenz Books, an imprint of Anness Publishing Ltd, Blaby Road, Wigston, Leicestershire LE18 4SE

Email: info@anness.com

Web: www.lorenzbooks.com; www.annesspublishing.com

Anness Publishing has a new picture agency outlet for images for publishing, promotions or advertising. Please visit our website www.practicalpictures.com for more information.

ETHICAL TRADING POLICY
Because of our ongoing ecological investment programme, you, as our customer, can have the pleasure and reassurance of knowing that a tree is being cultivated on your behalf to naturally replace the materials used to make the book you are holding. For further information about this scheme, go to www.annesspublishing.com/trees

© Anness Publishing Ltd 2012

PUBLISHER'S NOTE
Although the information in this book is believed to be accurate and true at the time of going to press, neither the author nor the publisher can accept any legal responsibility or liability for any errors or omissions that may be made.

Publisher: Joanna Lorenz
Project Editor: Anne Hildyard
Designer: Sarah Rock
Production Controller: Mai-Ling Collyer

PICTURE ACKNOWLEDGEMENTS
AKG akg-images/:53b; 190b; De Agostini Pict. Lib: 137g; Graphische Sammlung Albertina, Vienna, Austria: 49; 126t; British Museum, London, UK: 103t, 244m; Erich Lessing: 59bl, Fitzwilliam Museum, Cambridge, UK: 186b, 192t; Fogg Art Museum, Harvard, USA: 186t; Gemaldegalerie Berlin, Germany: 70l; Musée Conde, Chantilly, France: 169b; National Gallery, London, UK: 210t; National Gallery of Scotland, Edinburgh, Scotland: 187b; National Gallery of Victoria, Melbourne, Australia: 115t; Staatliche Kunstsammlungen, Dresden, Germany: 188t; Kunsthistoriches Museum, Vienna, Austria: 173t; Nationalmuseum Stockholm, Sweden: 124t; Museum Het Rembrandthuis, Amsterdam: 216m; The NetherlandsRijksmuseum, Amsterdam, The Netherlands: 150t, 176t, 227b; The State Hermitage Museum, St Petersburg, Russia: 68tr; Staatliche Graphische Sammlung, Munich: 186m; Herzog Anton Ulrich Museum, Brunswick, Germany: 213b. Alamy Darmstadt Museum, Germany: 244t; Gemaldegalerie Alte Meister, Dresden, Germany: 124m; Metropolitan Museum of Art, New York, USA: 204t, 206t, 148t; Alberto Paredes: 45tr: The State Hermitage Museum, St Petersburg, Russia: 178t. Art Archive Ashmolean Museum, Oxford, UK: 43tl; Bibliotheque des Arts Decoratifs, Paris, France: 38tl; Frick Collection, New York, NY, USA: 206t; Gemaldegalerie Alte Meister, Dresden, Germany: 132t; Calouste Gulbenkian Foundation, Oeiras, Portugal: 158t; Hermitage Museum, St Petersburg, Russia: 125; National Gallery, London, UK: 40; Bridgeman Alte Pinakothek, Munich, Germany: 131b, 170t, 175b, 177m, 181t, 182m, 238b; Ashmolean Museum, Oxford, UK: 37tl, 242t; The Aurora Trust, New York, NY, USA: 172; The Barber Institute of Fine Arts, University of Birmingham, UK: 137, 245; Bibliotheque des Arts Decoratifs, Paris, France: 74r; 78b; Birmingham City Art Gallery, UK: 119t; British Library, London, UK: 13b; British Museum, London, UK: 69br, 204m, 237t; Duke of Buccleuch Collection, Drumlanrig, Scotland, UK: 218b; Burrell Collection, Glasgow, Scotland, UK: 118b; Chatsworth House, Derbyshire, UK: 129t, 216b; Cheltenham Art Gallery & Museums, Gloucestershire, UK: 12bl; City Art Gallery, Leeds, UK: 61bl, 89tr, 89b, 112b, 114 (both), 133 both, 142m, 159t, 167b, 179t, 196; Sterling & Francine Clark Art Institute, Williamstown, MA, USA: 222t, 230t; The Courtauld Gallery, London, UK: 36, 138t; Detroit Institute of Arts, USA: 81tl, 180b, 184b; Deutsches Historisches Museum, Berlin, Germany: 81b; Dulwich Picture Gallery, London, UK: 64, 142t, 217; Dutch National Museum of Prague: 5r; Eglise du Mas d'Agenais, France: 33t, 166 (both); Fitzwilliam Museum, University of Cambridge, UK: 17bl, 50t, 73b, 164b, 169t, 206b, 207t, 220b, 225 (both), 242b; Fogg Art Museum, Harvard, USA: 52, 69t; Frans Hal Museum, Haarlem, The Netherlands: 62, 63t, 63m, 63b, 74l; Galleria degli Uffizi, Florence, Italy: 20, 72t, 85br, 154b, 203t, 211m, 214t; Gemaldegalerie Berlin, Germany: 140b, 178m, 182t, 183b, 234t; Gemaldegalerie Alte Meister, Dresden, Germany: 98, 107b, 130b, 141t, 154t, 176b, 189t; Gemaldegalerie Alte Meister, Kassel, Germany: 2, 7b, 17tr, 22, 23b, 25bl, 25bm, 56, 65tl, 67bl, 67br, 73tl, 120t, 123t, 123b, 136t, 134 (both), 135 (all), 136t, 144t, 146t, 147, 148 (both), 182b, 183t, 200t, 235b, 235t, 248b; Gemeente-Archief, Amsterdam, The Netherlands: 44; Germanisches Nationalmuseum, Nuremberg, Germany: 105b; Graphische Sammlung Albertina, Vienna, Austria: 37b, 117, 126b, 188b; Guildhall Library, City of London, UK: 167t; Hamburger Kunsthalle, Germany: 43tr; 45b, 51b, 83bl, 113b, 145b, 159b, 233; Harris Museum and Art Gallery, Lancashire, UK: 81tr; Hunterian Art Gallery, University of Glasgow, Scotland, UK: 90; Indianapolis Museum of Art, USA: 102t; The Israel Museum, Jerusalem, Israel: 160b, 165b, 228t, 243b; Isabella Stewart Gardner Museum, Boston, MA, USA: 32, 105t; The Iveagh Bequest, Kenwood House, London, UK: 197, 211t; Jacob Valls, London, UK: 18l; Johnny van Haeften Gallery, London, UK: 5l, 6b; J Paul Getty Museum, LA, USA: 107t, 162t; Art Gallery and Museum, Kelvingrove, Glasgow, Scotland: 185t, 251m; Koninklijk Museum voor Schone Kunsten, Antwerp, Belgium: 145t; Kunsthaus, Zurich, Switzerland: 7t; Kunsthistorisches Museum, Vienna, Austria: 16, 75tr, 88t, 173t; Kunstmuseum, Basel, Switzerland: 112m; Kupferstichkabinett det Staatliche Museen, Berlin, Germany: 29b; Lobkowicz Collections, Nelahozeves Castle, Czech Republic: 93br; Mauritshuis , The Hague, The Netherlands: 127b; Metropolitan Museum of Art, New York, USA: 1, 8, 17tl, 31t, 39b, 53tr, 84, 103b, 106b, 151t, 153 (both), 152 (all), 210b, 214b, 215b, 216t, 251t; Metropolitan Museum of Art, New York, USA: 55br, 73t, 194b, 196b; Minneapolis Institute of Arts, MN, USA: 85bl, 222b; Municipal Hospital, Delft, The Netherlands: 39t; Museu de Arte, São Paulo, Brazil: 121b; Musée Condé, Chantilly, France: 77l, 77b; Musée de l'Hotel Sandelin, Saint Omer, France: 34bl; Musée de la Ville de Paris, Musée du Petit-Palais, France: 11, 43b, 47tl, 61br, 65b, 119b, 139b, 140t, 143 (both), 156b, 165t, 170b, 171t, 172b, 185m, 191t, 203b, 204b, 205t, 223 (both), 226b, 229 (both), 231 (both), 232b, 239t, 244b, 247 (both), 249t; Musée des Beaux-Arts, Lyon, France: 24, 110b; Musée des Beaux-Arts, Tours, France: 26; Musée des Beaux-Arts et d'Archeologie, Besançon, France: 93l, 94l, 160t; Musée Bonnat, Bayonne, France: 199b, 224t, 238t, 240t; Musée du Louvre, Paris, France: 6t, 18t, 21t, 31b, 49tl, 51m, 55bl, 58, 67t, 69bl, 71b, 75tl, 86r, 89tl, 120b, 121t, 148b, 169m, 177t, 178b, 187t, 191b, 194t, 199t, 201 (all), 202t, 205b, 206b, 209b, 221b, 232m, 246t; Musée Jacquemart-Andre, Paris: 33br; Museum Boymans-van Beuningen, Rotterdam, 72br; Museum Narodowe, Gdansk, Poland: 91tr; Museum of Fine Arts, Budapest, Hungary: 232t; Museum of Fine Arts, Houston, TX, USA: 138b, 149b; Museum of Fine Arts, MA, USA: 102b; National Gallery of Canada, Ontario, Canada: 113t; National Gallery, London, UK: 12br, 13t, 23tr, 42t, 48, 49tm, 80t, 87t, 115m, 131t, 132, 174t, 174b, 202b, 214m; National Gallery of Scotland, Edinburgh, Scotland: 12t; National Gallery of Victoria, Melbourne, Australia: 27ml, 82b; Nationalmuseum, Stockholm, Sweden: 10, 72bl, 82t, 87ml, 106t, 212b, 219t, 240b; Newport Museum and Art Gallery, S Wales, UK: 47b; Art Gallery of New South Wales, Sydney, Australia: 226t; Norton Simon Collection, Pasadena, CA, USA: 211b; Norwich Castle and Art Gallery, UK: 80b; Pallant House Gallery, Chichester, UK: 228b; Prado, Madrid, Spain: 190t; Collection of the Early of Pembroke, Wilton House, Wiltshire, UK: 109; Penrhyn Castle, Bangor, Wales, UK: 207m; Private Collection: 4, 14t, 14b, 15t, 15b, 19t, 19b, 21b, 27t, 27mr, 28 (both), 30t, 33bl, 37tr, 38tr, 38b, 41tl, 47tr, 49tr, 59, 66, 68br, 78t, 83br, 83t, 85t, 91b, 92, 94br, 95tl, 95m, 97t, 108t, 108m, 127t, 129b, 130t, 146m, 146b, 156t, 156m, 158b, 161b, 162b, 189m, 200b, 220t, 246b, 248t, 250b; Pushkin Museum, Moscow, Russia: 42b, 100, 110t, 196t, 215t, 237b; Rijksmuseum, Amsterdam, The Netherlands: 57, 75b, 88b, 101, 111t, 115b, 118t, 122b, 150b, 155 (both), 184t, 209t, 212t; Royal Academy of Arts, London, UK: 94mr; Royal Pavilion, Brighton, UK: 35b; Rubenshuis, Antwerp, Belgium: 30b; San Diego Museum of Art, USA: 59br; Santa Maria della Grazie, Milan: 54; Stadelsches Kunstinstitut, Frankfurt, Germany: 53tr; 163t; Staatliche Museen zu Berlin, Germany: 122t; Staatliche Museum, Brunswick, Germany: 87br; The State Hermitage Museum, St Petersburg, Russia: 41tr, 55t, 61t, 71, 175t, 79b, 104, 116, 136b, 139t, 144b, 173b, 177b, 179b, 180t, 192b, 193 (both), 218t, 219b, 224b, 237m, 241t, 243t, 250t; Temple Newsam House, Leeds, UK: 60; Timken Museum of Art, San Diego, CA, USA: 234b; Taft Museum of Art, Cincinnati, OH, USA: 149t; Tokyo Fuji Art Museum, Japan: 59bm; Towneley Hall Art Gallery and Museum, Burnley, Lancashire: 25t; UCL Art Collections, University College, London, UK: 50, 51t, 249b; Van Gogh Museum, Amsterdam, The Netherlands: 3, 95tr; Victoria and Albert Museum, London, UK: 77tr; 164t; Walker Art Gallery, Liverpool, UK: 108b; Wallace Collection, London, UK: 17br, 25br; 34br; 35t, 65tm, 65tr; 151b, 161t, 207b; Wallraf-Richartz Museum, Cologne, Germany: 86l, 221t; Collection of the Duke of Westminster, England, UK: 142b, 157; Worcester Art Museum, MA, USA: 21; Yale Centre for British Art, USA: 79t. Corbis © Francis G. Mayer: 33br, 223t; © Adam Woolfitt, 45tl; Philip de Bay: 76; Floris Leeuwenberg: 93; Gemaldegalerie, Berlin: 40; Isabella Stewart Gardner Museum, Boston, MA, USA: 128 (both); Metropolitan Museum of Art, New York, USA: 181m; Paul Getty Museum, LA, USA: 185b; Private collection: 46, 70; Rijksmuseum, Amsterdam: 41b, 227t; Sergio Pitamitz: 96b. Mary Evans 124b; Photo12 Brunswick, Staaliche Museen: 87dr; Gemäldegalerie, Berlin: 168; Calouste Gulbenkian Foundation, Portugal: 251b; Rembrandt House Museum, The Netherlands: 163b; Rijksmuseum, The Netherlands: 127b; Superstock © image broker.net 96tl; ©Age footstock: 97b; Rijksmuseum, The Netherlands: 111t; British Museum, London, UK: 195; Gemäldegalerie, Dahlem-Berlin, Germany: 236; Collection of the Duke of Berwick and Alba, Madrid, Spain: 189b; Gallery of Art, Washington DC, USA: 141b; Calouste Gulbenkian Foundation, Oeiras, Portugal: 251b; Robert Harding Picture Library: 91lt; Isabella Stewart Gardner Museum, Boston, MA, USA: 171b; Metropolitan Museum of Art, New York, USA: 239b; Rijksmuseum, Amsterdam: 206b, 227b, 241b; Staatsgalerie, Stuttgart, Germany: 112t; The State Hermitage Museum, St Petersburg, Russia: 181b, 213t.

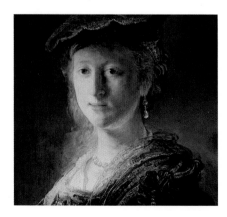

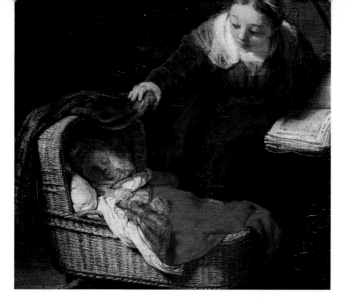
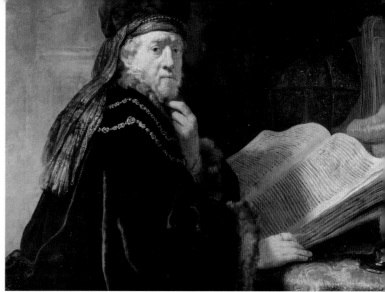

CONTENTS

INTRODUCTION

The remarkable artist Rembrandt van Rijn defines art of the Dutch Republic in the 17th century, not only through a vast catalogue of sought-after works, but as a major influence on the artists of Europe in the following centuries.

To consider the art of the Dutch painter Rembrandt van Rijn, one readily studies his vast output of drawings, etchings and paintings. To learn about his life is a little more complicated.

DOCUMENTS AND LETTERS

Rembrandt's personal correspondence remains at a scant nine letters, the majority addressed to one patron. Other personal documentation includes a few notes on works of art in progress. The lack of notes or letters is not that unusual for this period. The Dutch artists Jan Steen, Jacob van Ruisdael and Frans Hals did not leave correspondence. Notwithstanding the lack of written material by the hand of Rembrandt, there are about 500 legal documents, relating to baptisms, burials, house purchases, sales of goods, and insolvency. Dutch archives, galleries and museums hold useful primary resources, particularly the provenance of his artworks. For secondary sources, the research undertaken by Rembrandt scholars, in particular Christopher White, Seymour Slive, Svetlana Alpers, Gary Schwartz and Simon Schama, inform our view and open up the world of the 17th-century Dutch Republic to us, to explore Rembrandt van Rijn's life and work in depth.

AN INDEPENDENT COUNTRY

Shortly after Rembrandt's birth in 1606, the Netherlands achieved a 'Twelve Year Truce', 1609–21 – a period of

Above right: Allegory of the Truce of 1609 between the Netherlands and Spain, *1616, Adriaen Pietersz. van de Venne (1589–1662), oil on panel.*

Right: An Estuary Scene with Cattle Aboard a Ferry and a Windmill Beyond, *c.1645, Salomon van Ruysdael (c.1600–70), oil on panel.*

ceasefire while the Dutch united northern provinces were fighting for independence from the southern provinces controlled by the Spanish. The truce came in the midst of the 'Eighty Years' War' (1568–1648), the Dutch War of Independence from King Philip II (1527–98), which started as a revolt by all 17 provinces of the Netherlands against Spanish rule. Philip II regained control of the southern provinces but the bravery of the northern provinces, initially led by William I, Prince of Orange (1533–84), led to permanent independence in 1648. The removal of Spanish troops

resulted in seven provinces of the northern Netherlands free to create the United Provinces of the Dutch Republic.

DUTCH PROTESTANTS

The society of the north Netherlands that emerged from the truce of 1609 and the Peace Treaty of Münster in 1648 was essentially middle class and Protestant, in contrast to the Catholicism of the Spanish-ruled southern states. One hundred years earlier, the Protestant Reformation, initiated by the German priest Martin Luther (1483–1546) in 1517, and its counterpart, the Catholic Reformation -

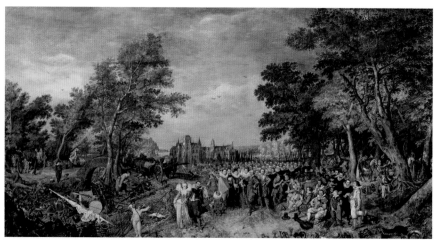

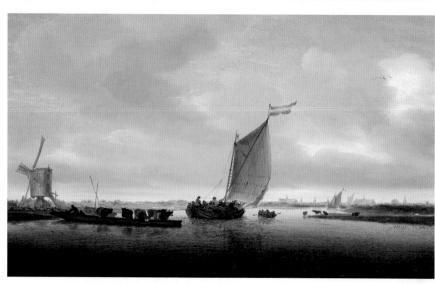

Right: Bleaching Ground in the Countryside near Haarlem, *1670, Jacob van Ruisdael, (1628/9–82), oil on canvas.*

instigated by the Roman Catholic church in 1545 – created factions of religious intolerance throughout Europe in the 16th and 17th centuries. In northern Europe, the Protestant Reformation was urged on by followers of Luther and John Calvin (1509–64). Calvinism led to the destruction of religious iconography in churches. By the time of Rembrandt's birth, the Dutch Reformed Church showed tolerance toward the Catholics; they could not hold public office but observed religious beliefs in their homes in hidden chapels. Rembrandt's parents were an example of this tolerance, his father was a Reformant and his mother remained a Catholic.

Below right: Portrait of Rembrandt with Overshadowed Eyes, *after 1628, Studio of Rembrandt Harmensz. van Rijn.*

THE GOLDEN AGE

The newly formed Republic enjoyed unprecedented economic growth, overseen by the Regents, who were the middle-class moneyed landowners and merchants. The period that spans the 17th century is referred to as 'The Golden Age'. The newly formed states traded as far afield as the Caribbean, Africa, Ceylon (Sri Lanka), and the Far East, resulting in great wealth and stability. Amsterdam became the banking capital of Europe, its cashless transfer system attracting overseas merchants, traders and investors. The Republic also received religious refugees, seeking security from persecution in their own countries, in the aftermath of the Reformation and Catholic Reformation. Scholars were drawn to the new university in Leiden. Writers enjoyed literary freedom. Mercantile prosperity enabled a flowering of art in the new Republic.

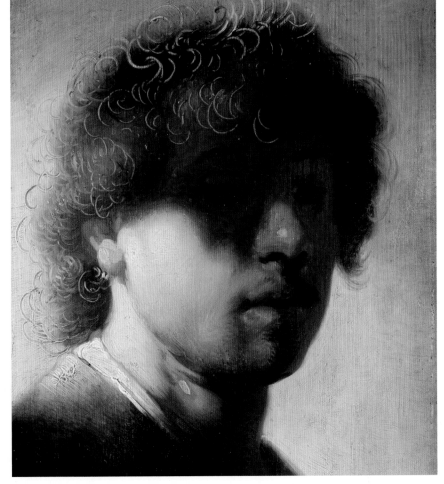

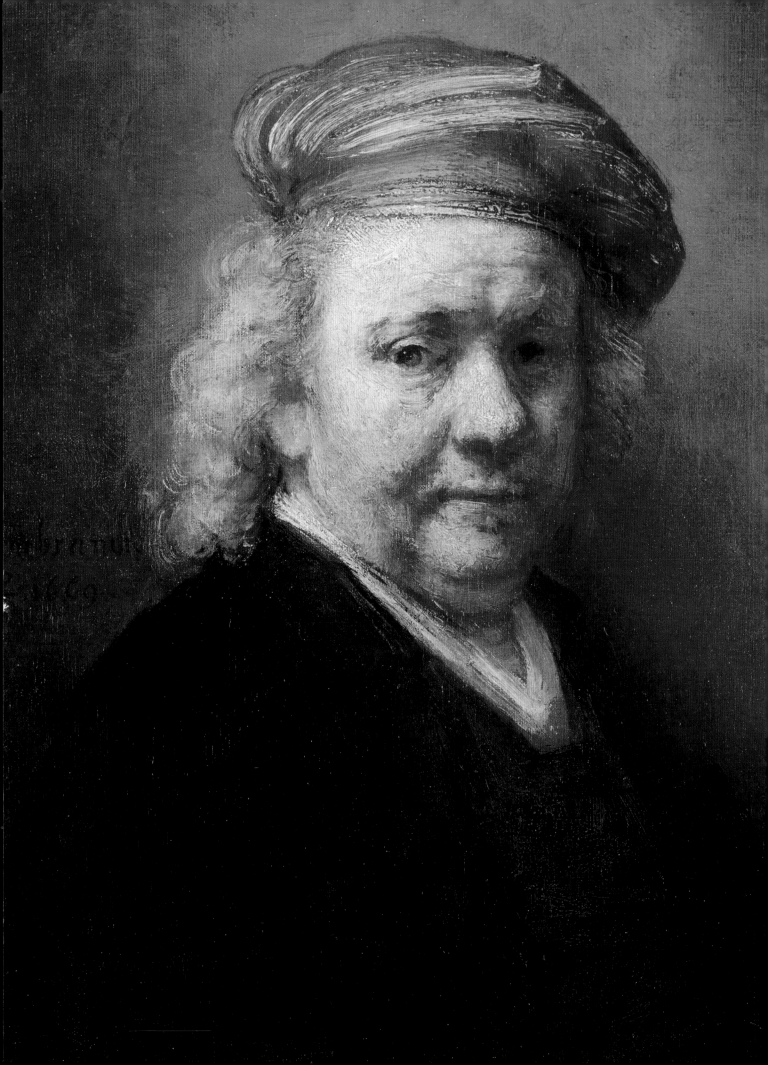

REMBRANDT: DRAUGHTSMAN, PAINTER, ETCHER

The eventful life of Rembrandt Harmenszoon van Rijn, a masterful painter, draughtsman and etcher, epitomizes the vibrancy and diversity of the Dutch art market in the 17th century. Rembrandt was born in the middle of the fledgling Dutch Republic's Eighty Years' War against Spain. He was in his 40s by the time a treaty and conclusion was reached at the Peace of Münster in 1648. None of it would seem to have affected his living as an artist. After a meteoric rise to fame and marriage in the 1630s, the following 20 years brought the patronage of royalty, plenty of rich clients, and a school and workshop full of pupils and apprentices. The death of his wife Saskia in the 1640s led to a lack of control on his expenditure, which left him near penury with his house and possessions sold. The support of his common-law wife Hendrickje, and his son Titus, helped him to re-establish his business, to start again.

Left: Self-portrait, *1669, oil on canvas, Mauritshuis, The Hague,*
The Netherlands.

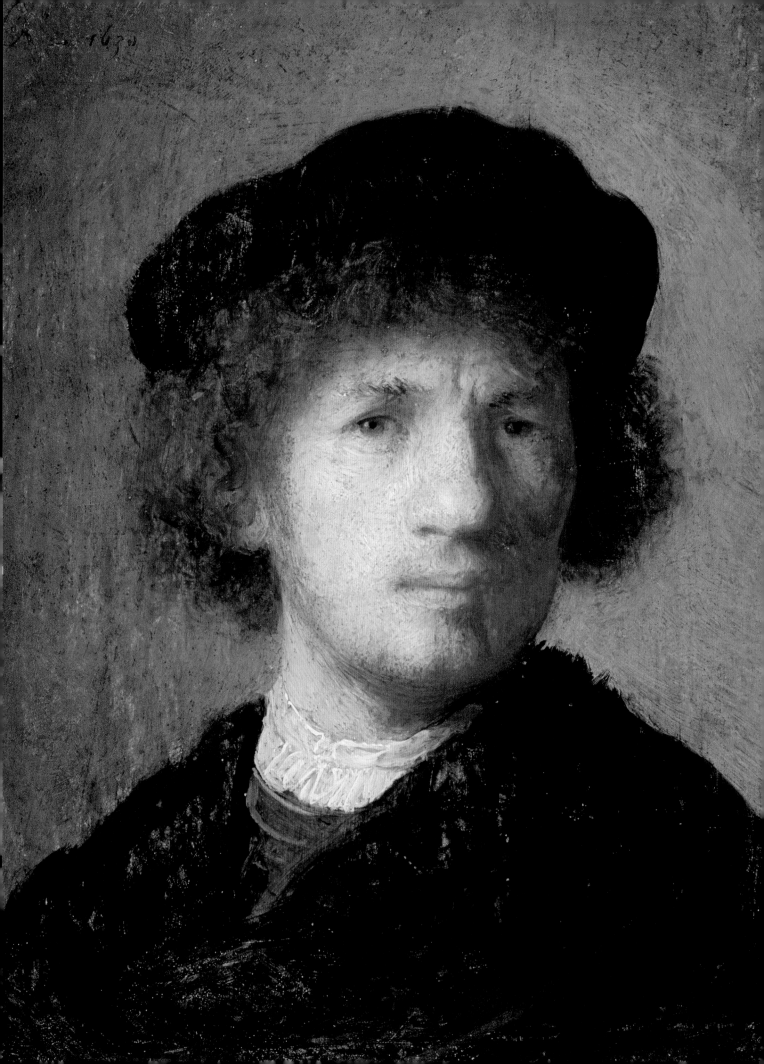

A PAINTER'S LIFE

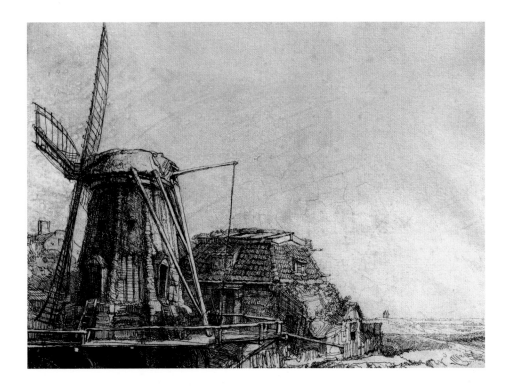

The birth of Rembrandt van Rijn in 1606 coincided with a flowering of artistic talent in the Netherlands, a key period, from 1600–1700 that is now referred to as the Golden Age of Dutch Art. In spite of a continuing war with Spain, the new Republic flourished and its artists too, who eagerly recorded life in the united provinces. The Dutch Republic's embrace of Protestantism meant there was no need for elaborate altar paintings and religious sculptures or frescoes, previously an artist's main staple of work and source of patronage. What emerged was the patronage of the Dutch art market, from the wealthy regents to the manual workers, keen to buy portraits, landscapes, genre and still life. The population visited the regular markets and annual art fairs searching for paintings, etchings and drawings, with money to invest in local artists.

Above: The Mill, *1641, engraving.*
Left: Self-portrait, *1630, (detail of face), oil on copper.*

REMBRANDT'S NETHERLANDS

Dutch paintings of the 17th century, particularly in the Protestant north, focused on everyday life in the towns, depicting townsfolk busy at the market, the beauty of the countryside, and the sea. Above all other genre, the portrait became the defining image of the era.

Paintings of 17th century Netherlandish life typically show gatherings of people at fairs, or walking or skating on frozen lakes in winter, or just going about their everyday business.

FACETS OF NETHERLANDISH LIFE

The English diarist John Evelyn (1620–1706) travelled through many Dutch towns, including Delft, The Hague, Leiden, Utrecht and Rotterdam, in 1641. His diary entries highlight diverse aspects of Dutch life. Evelyn writes that on 26 July, en route through Delft to The Hague, he passed by 'leprous poor creatures dwelling in solitary huts on the brink of the water…'; calling to passers-by, 'the lepers cast out a floating box…' to collect money. Children were taken from orphanages and poor houses in Germany and Flanders to work for the prosperous Dutch in their mills. Records show that a Liège businessman

Below: A Flemish Fair, Isaac Claesz Swanenburgh, (1537–1614), fl. 1602.

supplied approximately 4,000 children for the milling industry in Leiden; the rift between rich and poor was vast.

DUTCH ART MARKETS

The Dutch art markets offered visual images of a cross-section of life in the Netherlands, as artists sought to

portray people's lives in town and country. Morality tales were popular. Evelyn arrived in Rotterdam on 13 August 1641, coinciding with the annual

Below: A School for Boys and Girls (The Village School), Jan Havicksz Steen, (1625/6–79), c.1670, oil on canvas.

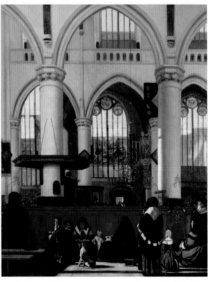

Above: The Interior of Oude Kerk, Amsterdam, c.1660, Emanuel de Witte (c.1617–92), oil on canvas.

Right: The Courtyard of a House in Delft, *Pieter de Hooch, 1658.*

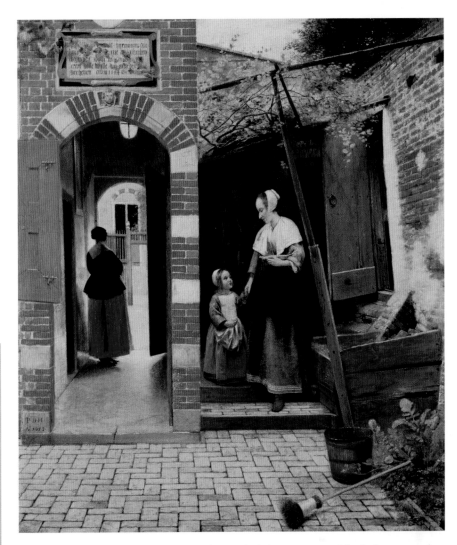

fair. He observed the market 'so furnished with pictures (especially landscapes and drolleries, as they call these clownish representations), that I was amazed. Some of these I bought and sent into England…' Current research lists around 650 to 700 known painters belonging to the artists' Guild of St Luke at that time in the Netherlands, which does not include the many unregistered artists working for art dealers, or assistants, not yet registered, many more artists than Italy supported. Many Dutch artworks from this era changed in style and composition, the result of a group

MICHELANGELO MERISI DA CARAVAGGIO

In Rembrandt's era of Dutch art, the Italian artist Michelangelo Merisi da Caravaggio (1571–1610) dominated the style of painting. From still life to history painting, the influence of his commanding use of *chiaroscuro* is present. Caravaggio was in Rome, from 1592 until 1606, when he departed after killing a man in an argument. The city has spectacular Caravaggio paintings in the church of the San Luigi dei Francesi in Rome, particularly *The Calling of St Matthew*, and in the Vatican Museum, and the Borghese Gallery. Other paintings by the artist crop up in the places he travelled to, such as the breathtaking vision of *The Beheading of St John the Baptist*, in the Oratory of the Co-Cathedral of St John, Valletta, Malta. Early 17th century Dutch admirers of Caravaggio's art, which can be defined by the intensity of his use of *chiaroscuro* and the harmony of his colour palette, visited Italy to study his works and to learn from his Italian followers, such as Orazio Gentileschi (1563–1639), and Carlo Saraceni (1579–1620). Caravaggio's adage, to 'follow nature', was central to the Dutch 'Caravaggisti'.

of artists in the 1620s travelling to Italy, influenced by paintings of Italian artist Michelangelo da Merisi Caravaggio (1571–1610).

COLLECTING ART FOR PROFIT

The direction of the Dutch art market changed dramatically during the 17th century. The established patrons of the church, royalty and wealthy aristocrats, were overtaken by the middle-class Dutch bourgeoisie. Evelyn, analyzing the popularity of the art market, suggested that, 'The reason for this store of pictures, and their cheapness, proceeds from their want of land, to empty their stock, so that it is an ordinary thing to find a common farmer lay out two or three thousand pounds in this commodity.' (In 1641, £3,000 was the equivalent to circa £363,000 today, so he may have been exaggerating slightly.) It was, stated Evelyn, the reason that

their houses were full of pictures, 'to vend them at their fairs, to very great gains'. Many wealthy patrons commisssioned Rembrandt to produce solo and group portraits, but he also portrayed poor characters, more often in the fine detail of his etchings and drawings.

Above: Map of the Province of United Netherlands, *17c., Pieter van den Keere (1571–c.1646), engraving.*

LEIDEN

Leiden (Leyden, in archaic Dutch), the birthplace of Rembrandt, is a town on the river Rhine, situated close to the sea, in the Dutch province of South Holland. In the 17th century, the population of Leiden was second in size only to Amsterdam.

In 1574, the year of the siege of Leiden by Spanish troops, the population was around 15,000. By 1606, the year of Rembrandt's birth, the medieval walled town held a prosperous community of around 17,000 inhabitants. The fast growth of the town, which was estimated at 45,000 by 1625, could not accommodate all comers, even though properties had been divided and divided again. Accommodation outside the medieval walls sprang up.

AN INDUSTRIOUS TOWN
Many Leiden citizens were employed in its textile industry, particularly in the production of Leiden broadcloth. The number of its workers increased after a migration of Flanders weavers to the town. By 1640 Leiden had around 20,000 textile workers, often living in cramped quarters or sparsely furnished huts on the outskirts of the town. For the richer merchants, Leiden prided itself on its many libraries, and its book trade, with a profusion of companies selling books, printing and publishing. John Evelyn, visiting Leiden at the end of August 1641, headed straight for the publishing houses, 'Heinsius [a publisher], whom I so longed to see… and Elzever's printing house and shop.'

THE SIEGE OF LEIDEN
In 1572 the townspeople of Leiden had sided with the Dutch revolt against Spanish rule. In 1574, the town of

Below: De Oude Rijn, Leiden, 1904, Nico Jungman. The title of the painting refers to a branch of the River Rhine.

Bottom: A View of Leiden from the North East, Jan Josephsz van Goyen, (1596–1656).

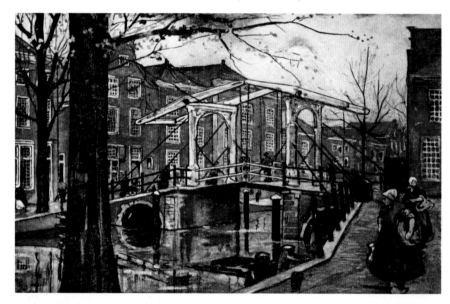

JAN JANSZOON ORLERS (1570–1646)

Much of what we know about life in Leiden in the early 17th century comes from the Leiden-born writer Jan Jansz. Orlers, a burgomaster of the town and the first chronicler of its history, in his work, *Beschrijvinge der stad Leyden* ('Description of the town of Leyden') (1641). His summation of Leiden-born Rembrandt gives relevant facts about Rembrandt's introduction to painting. It is from Orlers that we learn that after a three-year apprenticeship with Jacob van Swanenburgh in Leiden, Rembrandt moved to the studio of Pieter Lastman in Amsterdam 'for further and better instruction….[and] stayed with him for about six months but then decided to practise the art of painting entirely on his own'. He charts Rembrandt's life to 1641, the date of the book's publication.

Above: A View of Leiden with Figures Resting in the Foreground, *fl.1650, Anthony Jansz. van der Croos (c.1606–63).*

Leiden was subjected to a siege by Spanish troops. It lasted four and a half months, from May to October. During this period, the townspeople were cut off from food supplies. Up to one-third of the population died of starvation. At a low point some of the townspeople approached the mayor, to suggest surrendering, such was their hunger. He told the Leiden citizens that they would have to kill him and eat him before the city would give in. After the lengthy incarceration and upkeep of defences, a plan initiated by Prince William of Orange (1533–84) to knock down the dykes, flooding the farmland to the south of the town, to allow ships to bring supplies and the prince's troops to the town, led to a withdrawal of Philip II's Spanish army. The long battle ended on 3 October 1574. A breakfast meal of bread and herring eaten on that day by the surviving townspeople is commemorated in Leiden each year.

UNIVERSITY OF LEIDEN
Leiden university was founded in February 1575, a gift to the people from William of Orange, in recognition

Right: Rembrandt's Father's Mill, *1838, Edward William Cooke, oil on panel.*

of their fortitude during the siege in 1574. The university motto, *Praesidium Libertatis* (Bastion of Liberty), symbolized the promotion of freedom of speech and religious independence. The free-thinking spirit of its fraternity and the talented array of lecturers encouraged local families, including Rembrandt's, to seek a university education for their children. The presence of the university brought increased prosperity to the town of Leiden. One of its inaugural tutors was the French humanist Josephus Justus Scaliger (1540–1609). His presence attracted many students from across Europe. The town's population, which had been reduced by about a third during the siege, quickly recovered.

ARTISTIC COMMUNITY
Looking at portrayals of Dutch markets and domestic interiors, from grand houses to humble cottages, one can see framed paintings on the walls. The Reformation had swept away commissions for religious paintings, created to adorn church walls, altars and chapels. The focal point in the reformed churches was the pulpit. The newly rendered whitewashed walls were a reminder of the removal of biblical frescoes. Leiden supported an artists' community. They included Rembrandt's first master Jacob van Swanenburgh (1571–1638), Jan Lievens (1607–74), Jan van Goyen (1596–1656), Jan Davidsz. de Heem (1606–83/4), Harmen van Steenwijck (1612–c.1636), Gerard (Gerrit) Dou (1613–79), Rembrandt's first apprentice, Jan Steen (c.1626–79), and Frans van Meiris (1635–81).

PARENTS AND SIBLINGS

The parents of Rembrandt, his father Harmen Gerritszoon van Rijn (c.1568–1630), and mother, Cornelia Neeltgen Willems van Zuytbrouk (1568–1640), lived at 3 Weddesteeg, near the Wittepoort in Leiden, when Rembrandt was born.

Rembrandt's father, a miller, shared the ownership of a profitable family malt mill in Leiden, close to his home. On the death of Harmen's own father, when he and his sister were young, his mother had remarried. They were brought up in the house of their stepfather, a miller whose family had lived and worked in Leiden since the early 16th century.

A COMMERCIAL BUSINESS

At about the time of his marriage to Cornelia, Harmen bought a half-share of his stepfather's mill and the building that adjoined it. He and his wife lived in a new house which adjoined his stepfather's and mother's house in Weddesteeg, a small street, at the edge of the northern part of the town. The mill's location on the banks of the 'Oujd Rijn' (Old Rhine), had given Harmen's stepfather's family the origin of its surname 'van de Rijn'. The family homes near the medieval walls of the city looked on to the Rhine river and their mill. Cornelia's family were bakers, a fitting link to her in-laws' milling business, and she was related to a ruling regent family of Leiden. Her family were Roman Catholic, although she and Harmen attended the Protestant Reformed Church. On her death in 1640, the record of her estate showed that she owned many properties and land, and a share of the malt mill business.

BROTHERS AND SISTERS

The banns for the wedding of Harmen and Cornelia were published on 22 September 1589 and they were married in the Pieterskerk, Leiden, on 8 October the same year, when both were 21 years of age. Rembrandt was the couple's youngest son and the eighth of at least nine, possibly ten children. Cornelia was 38 when he was born. Three of the couple's children had died of plague in infancy. The surviving children, Rembrandt's siblings, were involved in business trades. We know that his brother

Below: A Woman with Infant and Serving Maid with Child, c.1663–65 Pieter de Hooch.

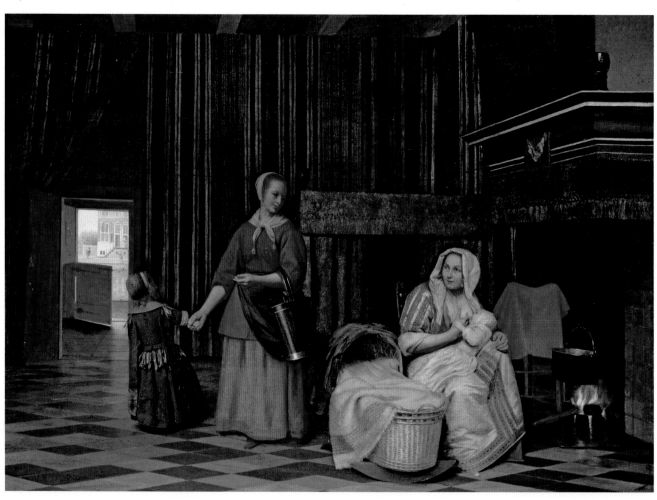

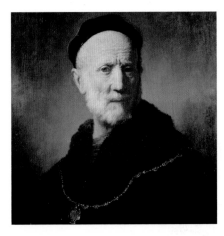

Above: Rembrandt's Father, *1631, (detail), oil on canvas.*

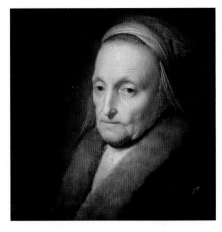

Above: Head of an Old Woman with a Fur Collar, *after 1630, Gerard Dou.*

Willem (1603–55) worked as a baker, and Adriaen (b.1593) as a shoemaker. Other children to survive infancy were Machtelt (c.1596–c.1625), Cornelis (b. c.1600) and Elisabeth (c.1609–55). By 1640 only three of Rembrandt's siblings, including his sister Elisabeth, were alive. Rembrandt must have been a bright, intelligent child. He attended the Latin

School in Leiden, then Leiden's university. Many children of Rembrandt's era received no formal education.

SCHOOL AND UNIVERSITY

According to Leiden's biographer, Jan Jansz. Orlers, Rembrandt attended the Latin School from the age of seven, for seven years.

At about the age of 14, Rembrandt was registered as a student to study literature at the University of Leiden. The date of admission, his name and status, is recorded in the registry: *'20 Mai 1620 Rembrandus Hermanni Leydensis Studios[us] Litterarium Annor[um] Apud Parentes'.* To date, this is the first reference we have to Rembrandt. Attendance at university gave exemption from guard duty and a tax-free allowance of beer and wine.

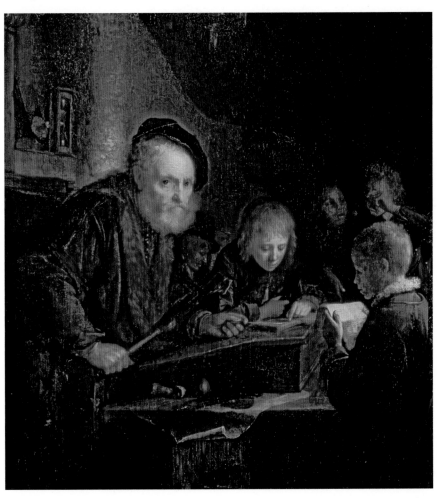

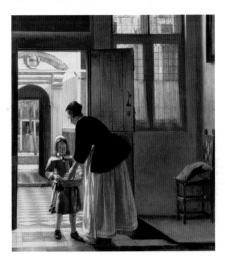

Above: A Boy Bringing Bread, *c.1663, Pieter de Hooch.*

Left: The Schoolmaster, *1645, oil on panel, Gerard Dou.*

AN APPRENTICESHIP

Following Rembrandt's seven-year period at the Latin School in Leiden, he transferred to Leiden University to read literature at about 14 years of age, registering on 20 May 1620. His tenure was short, for reasons unknown.

It is clear that Rembrandt was a single-minded and determined person, wanting to do things his way. His parents may have been disappointed that he did not want to complete a university degree, but recognizing his artistic talent, they allowed him to become apprenticed to one of Leiden's local artists, Jacob van Swanenburgh.

FIRST MASTER

Leiden's biographer, Jan Jansz. Orlers, noted that:

> by nature he [Rembrandt] moved toward the art of painting and drawing. Therefore his parents were compelled to take him out of school, and according to his wish they brought and apprenticed him to a painter from whom he would learn the basic and principal rules of art.

The purpose of Rembrandt's apprenticeship would be to teach him how to prepare canvases and panels, and the procedure and methods of preparing and grinding pigments, and drawing in chalk, charcoal, pencil and ink. The techniques of drawing or painting objects, from still life

Left: Fall of Satan and the Rebel Angels from Heaven, *17th c., Jacob Isaacsz. van Swanenburg, (1571–1638).*

Above: The Young Artist, *Jan Lievens, c.1630–5, oil on canvas.*

to the human form, usually studied from models, were part of an artist's apprenticeship as well as studying the works of established painters.

When an apprentice had reached a certain degree of ability in the application of paint, part of his workshop duties would be to paint sections of larger works contracted to the master.

As was usual at the time, while he was still an apprentice, Rembrandt was not allowed to sign or sell his own works. Professional status, nominally recognized by membership of the Guild of St Luke (closed down in Leiden in 1572, possibly due to the fairly small number of workshops in the town), was offered in Amsterdam once he had completed his three-year apprenticeship.

JAN LIEVENS (1607–74)

In contrast to Rembrandt's formal school education prior to apprenticeship, the painter Jan Lievens, with whom Rembrandt possibly shared a studio in Leiden, started his career by a different route. His birth date is recorded by Leiden burgomaster Jan Jansz. Orlers as 24 October 1607. Orlers stated that Lievens was the son of an embroiderer, and that he joined the Leiden workshop of the painter Joris van Schooten (c.1587–1652/3) at the age of eight, to study drawing and painting. Schooten was an acknowledged figure and landscape painter. After two years Lievens' parents sent their son to Amsterdam to study with Pieter Lastman for a further two years. On his return to Leiden, c.1619–20, the child prodigy set up an art studio in his parents' house. Orlers recalled that:

> *His consummate skill astounded numerous connoisseurs of art who found it hard to believe that a mere stripling of 12 or scarcely any older could produce such work, usually his own compositions and ideas to boot.*

Lievens emerged at an early age as an exceptional painter and etcher and a gifted creator of woodcuts.

JACOB VAN SWANENBURGH (1571–1638)

The Leiden-born artist Jacob van Swanenburgh may have been known to Rembrandt's mother through his Catholic family. Swanenburgh was from a family of successful artists. His father, Isaac Claesz. van Swanenburgh (1537–1614), was an important civic leader in Leiden.

Van Swanenburgh trained as an artist in Antwerp under the direction of Frans de Viendt (1517–70), also known as Frans Floris. Jacob's father had a distinguished career as a portrait painter in oils and on glass; Jacob's brother, Claes Isaacs. van

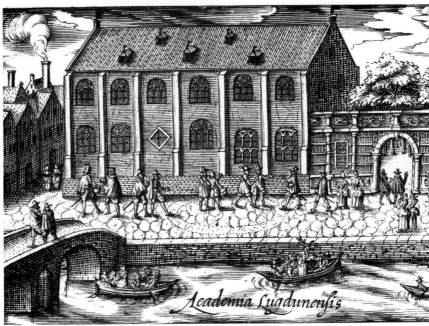

Top: The Temptation of Saint Anthony in a Landscape, *date unknown, Jacob Isaacsz. van Swanenburg (1571–1638).*

Above: 'University of Leiden', *from* A Dutch Athens *J. Meursius, published in 1625, engraving.*

Swanenburgh (1572–1652) was a painter, and William Isaacs. van Swanenburgh (1580–1612), another brother, was a noted engraver, whom Peter Paul Rubens (1577–1640) used for engravings of his works.

After serving an apprenticeship in his father's workshop, Swanenburgh had left Leiden to travel to Venice, Rome and Naples. In Naples he

married a local girl and lived in Italy for 25 years, before returning to Leiden in 1618, in order to set up his workshop. Due to the very few works that remain extant by his hand, it is difficult to know what influence, if any, he had on Rembrandt's style.

However, the Swanenburgh family connection with Rubens led Rembrandt to close study of Rubens' work.

LEIDEN TO AMSTERDAM

The distance between Leiden and Amsterdam is approximately 36 km (22 miles). Rembrandt came to Amsterdam, *c.*1622–4, to study with Pieter Lastman (*c.*1583–1633), one of Amsterdam's foremost painters. He stayed for only six months, then returned to Leiden.

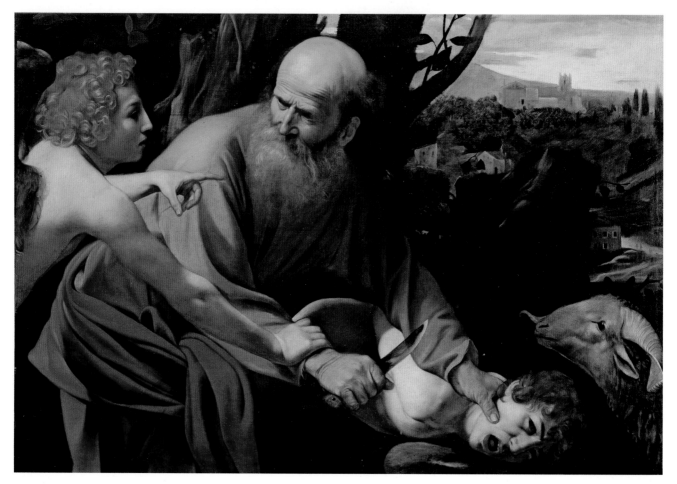

A receipt given to Rembrandt's father, Harmen van Rijn, by Pieter Lastman stated, 'Received from Harmen, son of Gerrit, of Leyden, the sum of two guilders fifty for having instructed Rembrandt, son of Harmen, in the art of painting for half a year.'

PIETER LASTMAN (c.1583–1633)

In a book of biographies of over 250 Netherlandish artists, *Het Schilderboek*, published in 1604, and written by the Flemish painter, poet and art historian Karel van Mander (1548–1606), he commented 'now in Italy there is a certain Pieter Lastman who shows great promise'. Pieter Lastman was born in Amsterdam and, according to van Mander, trained in the workshop of the

Mannerist painter Gerrit Pietersz Sweelink (1566–*c.*1608), who was influenced by his own teacher Cornelis van Haarlem (1562–1638). Lastman had spent time in Italy, between 1604 and 1607 travelling to Venice, Rome and Naples. His love of Italy led him to sign many of his works, 'Pietro Lastman'. His interest in the northern painters of Venice, and the sculptural elements and use of *chiaroscuro* in the paintings of the Naples-born Michelangelo Merisi da Caravaggio, on view in Rome, greatly influenced the character of his painting. Lastman was stimulated by the works of Annibale Carracci, and in Rome, he followed the German painter Adam Elsheimer's adoption of Caravaggesque technique.

Above: The Sacrifice of Isaac, *1603, Michelangelo Merisi da Caravaggio (1571–1610), oil on canvas.*

LIEVENS-REMBRANDT STUDIO

Leaving Amsterdam after six months, Rembrandt was able to forgo payment of guild fees. Another economical move was to live with his parents and share a studio. Orlers' 1641 biography records that Rembrandt and Lievens possibly set up a studio together. Such is the close resemblance in the two painters' styles that artworks from this period have been wrongly attributed as the work of the other artist, particularly as both had been taught by Lastman, and reflected his method of composition for several

Right: The Sacrifice of Isaac, *1616, Pieter Lastman, oil on panel.*

years. The rules of the Guild of St Luke forbade independent artists to share studios, possibly to avoid dominance by one studio, but the guild did not operate in Leiden.

Lievens' skill was to create dramatic large-scale narrative paintings, such as *The Feast of Esther, c.*1625, which is informed by Caravaggio's *Supper at Emmaus,* 1601. In response to commissions, Lievens produced many portraits, still life, landscapes, genre, as well as biblical and mythological narratives.

THE 'CARAVAGGISTI'

During Pieter Lastman's stay in Rome, a group of painters, dubbed the 'Caravaggisti', sought to emulate the sculptural quality of Caravaggio's compositions and his dramatic use of light and shade. They were inspired by the German artist Adam Elsheimer, living in the city, and included young Italians, such as the Venetian-born painter Carlo Saraceni (c.1580–1620), and the Flemish painter Paul Brill (1554–1626). Although there is no direct evidence that Lastman was part of this circle, his subsequent works show the influence of Elsheimer, who was able to transfer Caravaggio's large-scale set-pieces to miniature works and to landscape paintings. On leaving Italy, the 'Caravaggisti' took their new method of painting back to their own countries. In 1607, Lastman returned to Amsterdam, to forge a highly successful career. His reputation was subsequently made on his portrayal of religious and mythological subjects, which show the influence of Caravaggio and Elsheimer. Both Jan Lievens and Rembrandt were apprenticed to Lastman and were taught his Caravaggesque technique. Lievens stayed for two to three years, Rembrandt for six months.

Above: Paris and Oenone, *1619, oil on panel, Pieter Lastman, (1583–1633).*

Below: Map of Amsterdam, c.1572, from *'Civitates Orbis Terrarum'.*

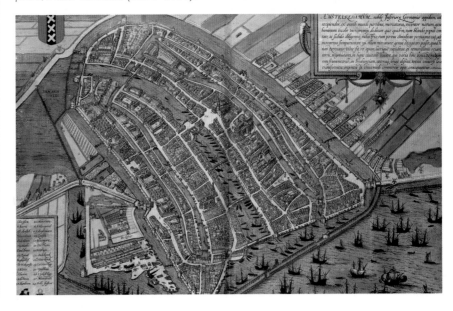

A PROFITABLE LIAISON

A semi-professional partnership with the gifted Jan Lievens launched Rembrandt into the arts community, bringing profit to both partners, and the lucrative challenge of a workshop studio for new apprentices, one of whom would prove to be very successful.

The Lievens-Rembrandt enterprise paid off in both commissions and sales. Like Rembrandt, Lievens could paint whatever a client ordered. Rembrandt's oil on panel painting *The Stoning of St Stephen* (1625) is his first dated work as a professional painter. By 1628 Rembrandt was ready to take on his first apprentice.

A PROFITABLE BUSINESS

At one time both Rembrandt and Lievens were producing paintings, drawings and etchings of the same subject matter. Rembrandt painted *The Raising of Lazarus* (1630–1) in oil on panel, plus an etching and a drawing; Lievens painted *The Raising of Lazarus* (1631) in oil on panel, plus an etching.

However, there are differences between the two works, primarily because each artist chose to depict a different moment from the biblical narrative, John II:38–44.

BACK TO AMSTERDAM

The partnership broke up when Rembrandt moved his studio to Amsterdam, in late 1631 or early 1632; and Lievens, following a lucrative contract with the court of King Charles I, travelled to England around 1632, staying for three years. Thereafter he moved to Antwerp, residing there until 1644.

FIRST APPRENTICE

The workshop of a successful artist was a busy place. Soon after Rembrandt set up his first studio in Leiden, he took on his first apprentice, Gerard (Gerrit) Dou (1613–75).

Dou, the son of a Leiden glass engraver, had been instructed by his father with further teaching in design and drawing by Bartholomew Dolendo, a glass engraver, and Peter Kouwhoorn, who was a glass painter.

Gerard Dou began his apprenticeship with Rembrandt on 14 February 1628, just before his 15th birthday. His ability to absorb Rembrandt's style and method of painting is visible in a comparison of two paintings, *Old Woman Reading the Bible* (c.1630), by the apprentice Dou, and *Old Woman Reading* (c.1631), by the master.

Art critics view the Rembrandt version as the superior work, particularly in his ability to capture emotion, but one can see through

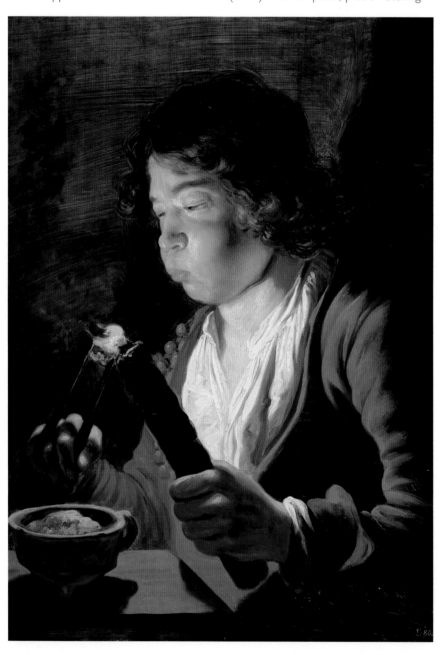

Left: Boy with Fire Tongs and Torch, 1623–25, Jan Lievens the Elder (1607–74), oil on panel.

Right: Self-portrait, Open-mouthed, *1628–9, pen and brown ink, brush and grey paint.*

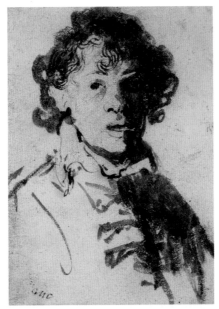

comparison how closely Dou followed Rembrandt's technique. On becoming an independent artist Dou would remain in Leiden all his life as a successful painter, particularly of miniature paintings, setting up a 'school' of Leiden painters skilled in this technique. Dou's work was consistently in demand, with first refusal going to Pieter Spiering, who was a Swedish diplomat in The Hague, on behalf of Queen Christina of Sweden. Spiering paid Dou an annual fee of 1,000 guilders for this service.

Above: Anna and the Blind Tobit, *Gerrit Dou, c.1630. This is one of the pictures that was believed to be a collaboration between Gerrit Dou, his first apprentice, and Rembrandt. When Rembrandt left Leiden, Dou remained.*

Left: Water and Old Age: Fishmonger with Bucket and Tub of Fish, *1623–5, Jan Lievens the Elder (1607–74), oil on panel. Lievens and Rembrandt were born in Leiden within a year of each other.*

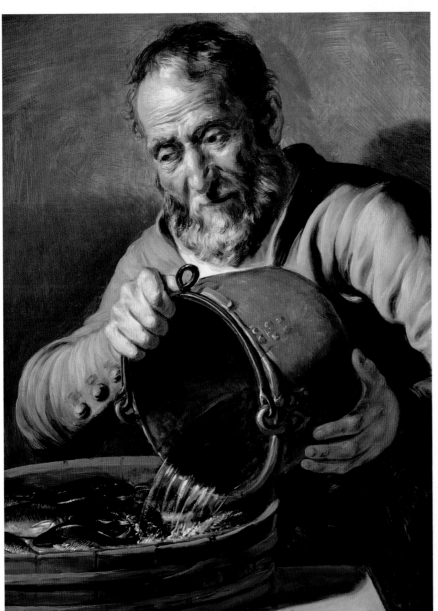

FIRST WRITTEN APPRAISAL

In 1628 Rembrandt took on his first apprentice, Gerard, (who was commonly called Gerrit) Dou, on 14 February, and the first sale of a Rembrandt work is documented on 15 June of that year. This was a painting of a *Head* sold to a lawyer from Utrecht, Joan Huydecoper of Amsterdam, for 29 guilders. The humanist and antiquarian scholar, Arnold van Buchel (1565–1641), visited Leiden. In his diary he recorded that an artist who was a miller's son (Rembrandt) was causing a sensation. Van Buchel considered it rather too early to heap praise on Rembrandt's ability as a painter: 'a lot is expected of a miller's son from Leiden but that is premature'.

THE ART OF BUSINESS

The praise of Rembrandt and Lievens by Constantijn Huygens led to both receiving royal patronage and noteworthy commissions. However, not only were their styles of painting alike but critics were beginning to compare their worth.

Constantijn Huygens (1596–1687), Secretary to the Stadholder Frederik Hendrik, Prince of Orange (1584–1647), the governor of five Dutch provinces, was looking for exceptionally talented artists to commission. He came across the work of Lievens and Rembrandt around 1627–9, through contact with his friend Caspar Barlaeus in Leiden.

A CITY OF VAST POTENTIAL
Rembrandt's former master, Jacob van Swanenburgh, was known to Huygens and had sent commissioned artwork to court. Huygens recalled 'a pair of young and noble painters of Leiden'. He admired both artists, who he thought resembled boys rather than men, and commented that Rembrandt was 'superior to Lievens in his sure touch and liveliness of emotions'. He turned his attention to Lievens, whom he considered to have 'the greater inventiveness…' Huygens remarked of Lievens: 'Rather than depicting his subject in its true size, he chooses a larger scale. Rembrandt by contrast, obsessed by the effort to translate into paint what he sees in his mind's eye, prefers smaller formats, achieving on that modest scale a result that one would seek in vain in the largest piece of others'. (This appraisal of Rembrandt was not published until 1891.)

PRAISE FOR REMBRANDT
Huygens singled out one of Rembrandt's works for close appreciation, *Judas Returning the Thirty Pieces of Silver* (1629), comparing him to the most famous artists of antiquity:'… I tell you that no one, not Protegenes, not Apelles and not Parrhasios, ever conceived, or for that matter could conceive if he came back to life, that which (and I say this in dumb amazement) a youth, a born and bred Dutchman, a miller, a smooth-faced boy, has done… Truly my friend Rembrandt, all honour to you…' In his appreciation of the painting, Huygens does not mention Rembrandt's changing palette of colours. *The Stoning of St Stephen* (1625), was a colourful depiction of a sordid scene. By contrast, *The Rich Man from Christ's Parable*

Below: The Stoning of St. Stephen, 1625, oil on panel.

(1627), *Two Old Men Disputing* (1628) and *Judas Returning the Thirty Pieces of Silver* (1629) illustrate Rembrandt's muted palette of neutral honeyed tones, using Caravaggio's *chiaroscuro* technique to draw in the viewer as a witness to an intimate scene.

THE STONING OF ST STEPHEN

Rembrandt's oil on panel painting *The Stoning of St Stephen* (1625) is his first dated work as a professional painter. He took inspiration from the

Above: Rembrandt in his Studio, *Sir John Gilbert (1817–97), oil on canvas.*

biblical narrative, Acts VII:54. The influence of Pieter Lastman and Adam Elsheimer is evident in the work. Rembrandt possibly saw both artists' earlier versions of the same subject. The Lastman painting is lost but Elsheimer's *The Stoning of St Stephen* (c.1602–5), a smaller oil on copper panel, carries an intensity of composition and dramatic use

HET SCHILDERBOEK

Karel van Mander's *Het Schilderboek* (Book on Painting), with various sections such as 'Grondt der Edel Vry Schilderconst' ('Foundations of the Noble, Free Art of Painting'), was published in 1604, with a special Amsterdam edition published in 1614. It was the first Dutch treatise on painting, a key source of recognition for new artists of the Dutch Republic. Biographies of Netherlandish artists included those that were newly established alongside deceased artists, such as Jan van Eyck and Jan van Leyden. Van Mander based his book on the Florentine Giorgio Vasari's *Lives of the Most Excellent Painters and Sculptors*, published in 1550 (enlarged and republished in 1568). Vasari primarily focused on the biographies of famous Italian artists who were dead, with the exception of Michelangelo Buonarroti (1475–1564).

of light, which shines as a heavenly beam on to the martyred saint, evident in both Rembrandt's and Elsheimer's versions.

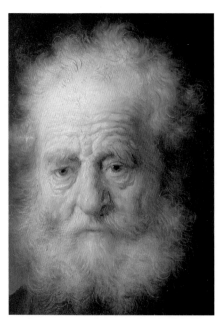

Above: Bust of an Old Man with a Gold Chain, *1632, (detail), oil on panel.*

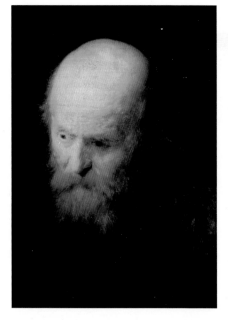

Above: Head of a Bald, Old Man, *1632, oil on panel, studio of Rembrandt van Rijn.*

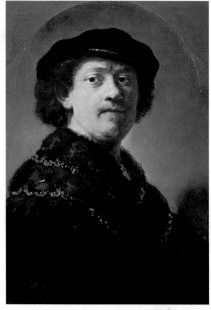

Above: Self Portrait in a Black Cap, *c.1637, oil on oak panel.*

AN INDEPENDENT ARTIST

Leaving Leiden and Lievens, Rembrandt moved to Amsterdam, to become an independent artist in the city which had more potential for him as a commercial painter of portraits than the moderate arts fraternity in his home town.

On arrival, in late 1631, or possibly early 1632, Rembrandt set up in business with Hendrick van Uylenburgh (c.1587–1661), a successful art dealer. It was through Hendrick that Rembrandt reached a broad art market, and wealthy patrons.

THE 'PRE-REMBRANDTISTS'
When Rembrandt moved permanently to Amsterdam, the inner circle of artists in the city were noted for history paintings. Pieter Lastman was one of this group. Others in this circle, labelled by 19th century scholars the 'pre-Rembrandtists', due to their possible influence on Rembrandt's style of painting, included the brothers Jan Pynas (c.1581/2–1631) and Jacob Pynas (1592/5–after 1656), followers of Adam Elsheimer, and noted for their mythological and religious paintings. The writer Houbraken related, in his history of Dutch and Flemish painters, *De Groute Schouburgh* (1718–21), that Rembrandt studied with Jacob Pynas for a short time, following the six months he had spent in Lastman's workshop in Amsterdam, and that some thought that Jacob also taught Rembrandt prior to Lastman. However, there is no proof to corroborate that either statement is correct. Jan Tengnagel (1584–1635), who also spent time in Italy, and painted in the style of Lastman and Elsheimer, and Claes Cornelisz Moeyaert (c.1590/1–1655) and François Venant (1590/1–1636), were included in this group. In Amsterdam, Tengnagel, the city's deputy-sheriff from 1625, Thomas de Keyser (c.1596–1667) and Nicolaes Eliasz. Pickenoy (c.1588–1655) were in demand as portrait painters. Rembrandt joined this established group as the youngest painter, ready to surpass his former tutors and their colleagues.

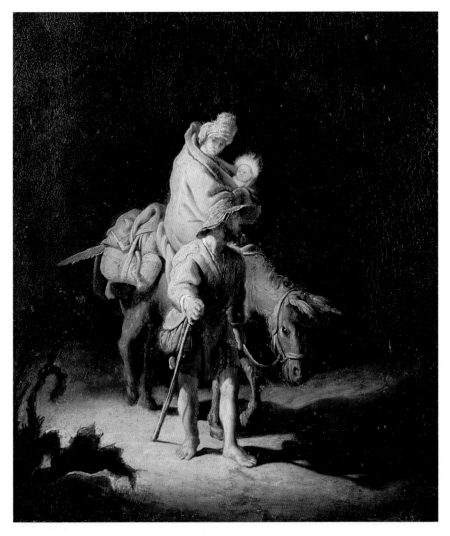

ARTIST AND ART DEALER

In Amsterdam, Rembrandt lived in Hendrick van Uylenburgh's house and had his studio there for four years, including the two years following his marriage to Hendrick's cousin, Saskia. Rembrandt and Van Uylenburgh treated all commissions as a commercial enterprise. Van Uylenburgh ran the business side, Rembrandt organized the painting programme, the studio and the assistants. It was a well-run enterprise, which benefited both partners, creating a lot of work and a lot of money. At times, demand by wealthy patrons for paintings dominated the studio work, increasing the size of the workshop and the number of assistants. Rembrandt still made time to run a school for pupils, usually the sons of wealthy clients.

Left: The Flight into Egypt, c.17th century, attributed to Gerard Dou (1613–75), oil on panel.

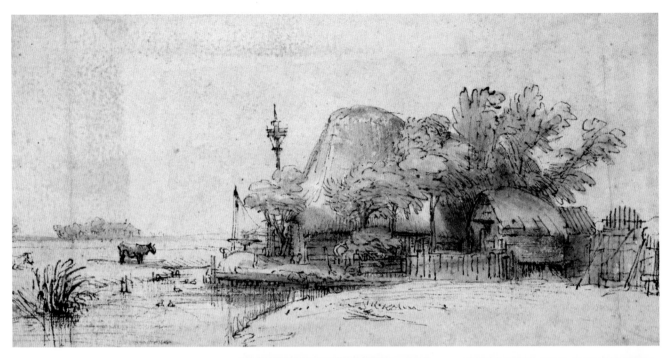

Above: A Farmstead by a Stream, *c.17th century, reed pen with brown ink.*

ANDROMEDA, A FEMALE NUDE

Rembrandt's first female nude was painted around 1630–1. The subject was mythological, another first for him, and he chose to portray *Andromeda*.

In the Greek myth, the boasting of Andromeda's mother's about her daughter's beauty led to a flood and a sea-monster being sent to destroy the land. Deliverance can only come by Andromeda being sacrificed to the monster. Perseus arrives on Pegasus, the winged horse, falls in love with Andromeda and kills the monster.

Rembrandt created a three-quarter-length near naked portrayal of Andromeda, abandoned in a rocky cove, close to the sea. Her arms are raised with hands tied and chained to a rock above her head. Her naked body falls forward as her arms try and fail to take the weight of it. The traditional depiction of the scene would have included Perseus and the monster in battle. Rembrandt chose to ignore tradition and focus instead on the writhing naked body and anguished face of the girl, dramatically lit in Caravaggio's *chiaroscuro* manner. The bright light, which highlights Andromeda's non-idealized body,

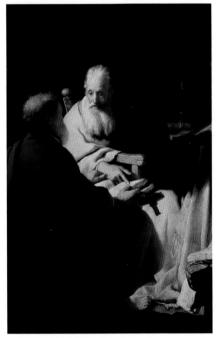

Above: Two Old Men Disputing, *1628, oil on panel.*

reveals her flaccid arms and stomach, adding a touch of natural realism to the mythical scene.

REMBRANDT'S NUDES

Writing at a much later date, the Dutch poet and art critic Andries Pels (1631–81) called Rembrandt a heretic in the art of painting. In 1681, Pels, rebuking Rembrandt's portrayal of female nudes, wrote the following:

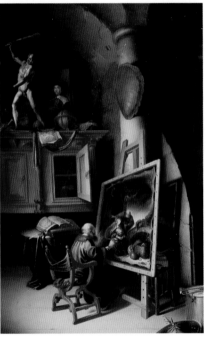

Above: An Artist in his Studio, *1635, Dutch School, oil on panel.*

When he would paint a naked woman, as sometimes happened, he chose no Greek Venus [sic] as his model, but a washerwoman or peat-trader from a barn, naming his error truth to Nature, and everything else idle decoration. Flabby breasts, distorted hands, yes, even the marks of corset-lacing on the stomach and of the stockings round the legs, must all be followed, or nature was not satisfied.

A MASTERFUL ETCHER

Approximately 285 etchings are acknowledged to be by the hand of Rembrandt, with the majority created in 1630, the year that his father died. His etchings concentrate on religious studies, portraits, landscapes, and the poor.

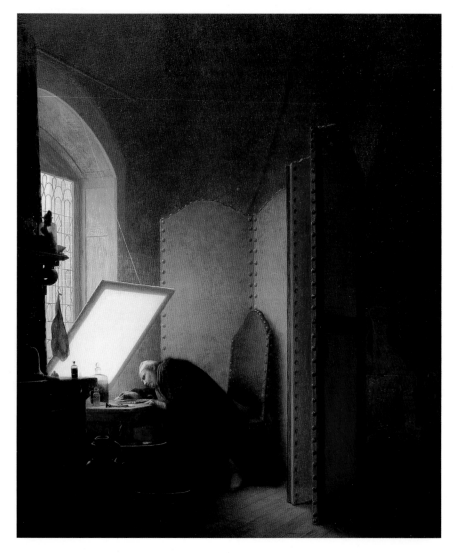

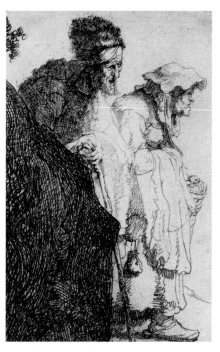

Above: Beggar Man and Woman Behind a Bank, *c.1630, etching.*

Left: Rembrandt Etching a Plate in his Atelier, *1861, Jean Leon Gerome, oil on panel.*

Fortunately for Rembrandt, Pieter Lastman, his master in Amsterdam, was an excellent etcher, having been taught by the talented Dutch artist Gerrit Pieterz. Sweelinck (1566–1612). Lastman passed the skill on to Rembrandt.

ETCHING METHOD

Rembrandt had his own method of etching plates. He used a soft wax in which to draw his lines on copper plate, further deepening the grooved lines with a drypoint needle. For printing, his preferred medium was vellum or

Japanese or Chinese paper; he looked for unusual papers. He experimented with different ways to etch his imagery, often discovering groundbreaking methods of creativity. Moreover, he would make several different versions of an etching, in order that collectors should buy more than one copy of a print. By slightly altering a depiction of a woman, with and without a cap, or a figure in shade in one version and standing in light in another, the etchings, in several different states, were sold as 'new', thus making more money for the etcher, Rembrandt.

A READY MARKET

The thriving Dutch art market gave opportunities for young artists to sell their works. Prints were a popular medium. Scenes of local life, from cottages and street scenes, to inns and markets and townspeople, were all saleable. For the farmers who filled their walls with artworks, the subject of the print or small painting would more often be a genre scene, a reflection of life in the Netherlands, or a scene from the Bible, subjects known to them, rather than an unfamiliar mythological or historical narrative. Rembrandt often focused on the humble and poor in his etchings, particularly the elderly and vulnerable, and the beggars that passed through towns and villages. *The Beggar with a Wooden Leg, c.1630,* highlights

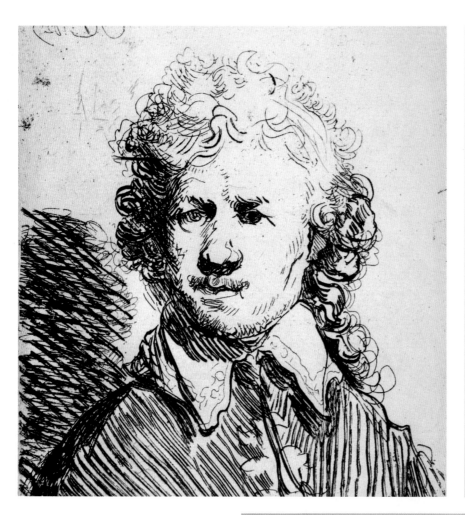

THE ETCHING PROCESS

To create an etching, the artist uses a metal stylus or needle to draw an image on to a sheet of copper, steel or zinc that has been covered with a thin film of acid-resistant wax. The plate is then immersed in an acid solution and wherever the plate has been scratched the acid will eat at the grooved lines. The length of time the plate is immersed determines the depth of the etched lines, which in turn determines the depth of light and shade in the print that will be made from the plate. When the plate is removed from the acid a greasy ink is pushed into the plate surface. The surface is then wiped clean, leaving the ink in the recesses of the eroded lines. The etched plate with ink is placed on the flat bed of a press with paper in place then a blanket on top of both. The flat bed with plate and paper is squeezed through rollers to create a print of the etched plate.

Above: Self-portrait, Bareheaded, *1629, etching.*

Right: Rembrandt's Mother Seated at a Table, *1631, etching.*

Rembrandt's freehand use of the etching needle, to produce an image closer to a drawing than an etching.

FIRST ETCHINGS

Two of Rembrandt's earliest etchings, *The Rest on the Flight into Egypt*, and *The Circumcision*, are generally dated to 1626. The subject of the Holy Family resting on their flight to Egypt is apocryphal; it is not mentioned in biblical narratives. It is a subject that Rembrandt returned to again and again, in etchings, drawings and paintings. The first etching, quite different to subsequent versions, has a raw impressionist quality, as though quickly drawn in freehand. *The Circumcision* has greater clarity of image. This work is known to have been printed by Johannes Pietersz. Berendrecht (1590–1645).

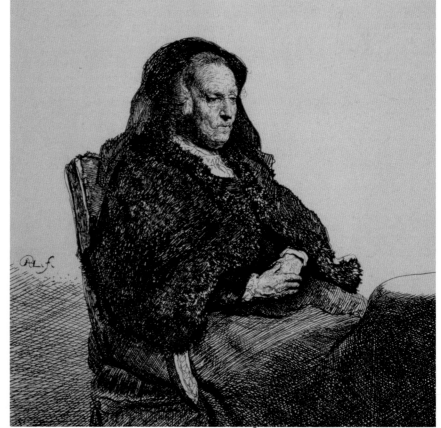

PATRONS AND PORTRAITS

The lifeblood of a professional artist was the patronage of wealthy patrons. Rembrandt was a commercially inspired artist, who used his gift for portraiture to capture the patron, his purse and further commissions for nearly 40 years.

It was a lucky moment when Constantijn Huygens, Secretary to the Stadholder, Frederik Hendrik, Prince of Orange, visited Leiden around 1627–8, and viewed the paintings of Jan Lievens and Rembrandt. The meeting resulted in both artists receiving commissions.

PROTESTANT AFFILIATION
Huygens was searching for an artist or artists from the Dutch Republic to compare in artistic stature to the revered Peter Paul Rubens (1577–1640) of Antwerp. Rubens, 30 years older than Rembrandt, was favoured in the European courts, a friend and confidant to princes and kings. However, Rubens was a Roman Catholic of the southern Netherlands, in the employ of the Spanish king, and suspicion arose that he was a spy for the Spanish court. From 1631, coinciding with Rembrandt's new position as a court painter, Rubens was not welcome in the northern Netherlands.

Huygens wanted to promote a Protestant artist of equivalent talent. What is significant is whether Huygens tried to model Rembrandt on Rubens, to make him presentable as a painter to the Stadholder family, or, in other words, to smarten him up to work for the royal court.

SMARTER STYLE
Eleven etchings created by Rembrandt around 1631, each with slight variations, do show a smart young man in fashionable clothing, in the style of Rubens, quite different to the earlier wide-eyed etching self-portraits. In *Self-Portrait with a Soft Hat*, 1631, and *Self-portrait with a Soft Hat and Embroidered Cloak*, 1631, and *Self-portrait in a Soft Hat and Embroidered Cloak*, 1631, he is

Right: The Gallery of Cornelis van der Geest, *1628, by Willem van Haecht (1593–1637).*

thought to have modelled the composition on a print *Self-portrait in a Slouch Hat*, 1630, by Paulus Pontus (1603–58), after a self-portrait by Rubens.

Below: Picture Gallery with a Man of Science Making Measurements on a Globe, *1612, by Frans Francken II (1581–1642), oil on panel.*

THE RISE OF THE PORTRAIT
In the 17th century, the capture of a likeness of a person at a specific moment in time was a recent innovation in the Netherlands. From the 14th to the 16th century, a growing interest in the definition of the individual saw an increase in personal portraits. Italian portraiture of the

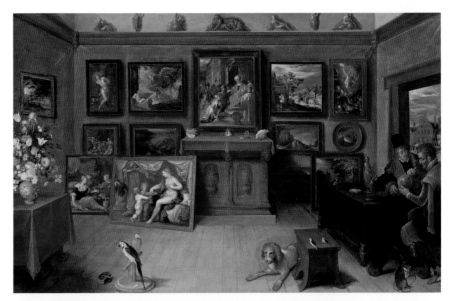

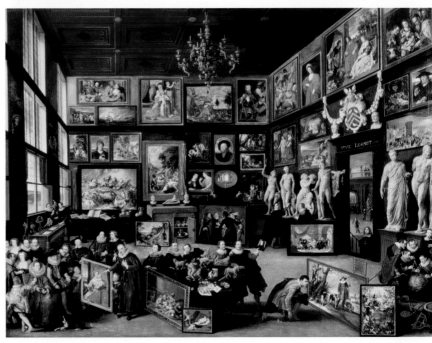

Right: The Burgomasters of Amsterdam learning of the Arrival of Marie de Medici, *1631, Thomas de Keyser, (1596/7–1667).*

16th century influenced Dutch artists. For example, the Leiden-born artist Lucas van Leyden (1494–1533) was influenced by the German artist Albrecht Dürer, who had first journeyed to Italy 1494–95, and was impressed with the art of Jacopo da Pontormo (1494–1557), Leonardo da Vinci (1452–1519) and Gentile Bellini (1429–1507). The popularity of portrait commissions rose swiftly and portraiture was in demand by wealthy Netherlandish patrons in the 17th century. Rembrandt, who respected the portraiture of Lucas van Leyden and the etchings of Albrecht Dürer, would make portraiture his niche marketing tool.

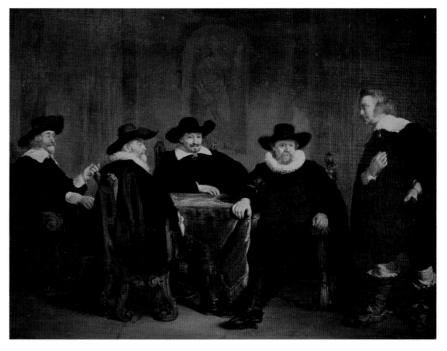

A PORTRAIT OF COURTLY FRIENDSHIP

The portrait of *Jacob de Gheyn,* 1632, was painted by Rembrandt and intended as a companion piece to his *Portrait of Maurits Huygens,* 1632.

Below: Interior of a Studio with a Painter Painting the Portrait of a Couple, *17th century, pen, ink, bistre & wash on paper.*

Maurits Huygens (1595–1642) and Jacob de Gheyn (1596–1641) were friends and each had made a will to leave the other their portrait, whoever died first. Jacob was a close friend of Constantijn Huygens, the cousin of Maurits. Remarkably, Constantijn rebuked Rembrandt for what was, in his opinion, an inferior portrait of Jacob. He wrote eight verses in Latin in February 1633, to emphatically make his point. The diatribe, which was titled 'Squibs on a Likeness of Jacob de Gheyn that Bears Absolutely No

Resemblance to Its Model' gave the gist of his argument against the work, which he said did not resemble Jacob. However, it did not deter Jacob de Gheyn from keeping the portrait, which Maurits received on the death of Jacob in 1641.

PORTRAYING THE MIDDLE CLASS

The contracts for Rembrandt portraits increased dramatically in the 1630s. Some of the sitters are not known to us today, which perhaps highlights Rembrandt's middle-class clientele. Many of his commissions were for members of his extended family too. *A Portrait of a Lady, Aged Sixty-two, Perhaps Aeltje Pietrersdr Uylenburgh* (c.1632) is thought to depict Aeltje Uylenburgh (c.1571–1644), a cousin of Saskia and Hendrick and married to Johannes Cornelis Sylvius (1564–1638). This is likely to have been a companion piece to a portrait of Cornelis, for both portraits were listed in the estate of their son, in a will dated 1681, as painted by Rembrandt. Aeltje was a witness at the baptism of Saskia and Rembrandt's first child, Rombertus.

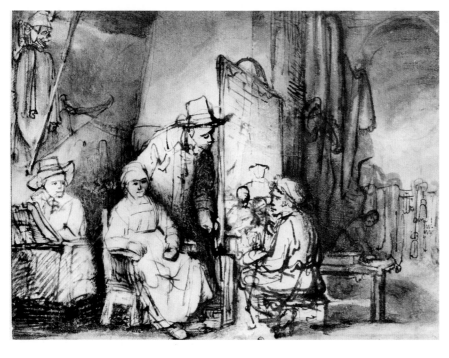

ROYAL PATRONAGE

Frederik Hendrik, Prince of Orange, commissioned Rembrandt for a series of five paintings depicting 'The Passion of Christ'. It was the artist's first major series commission and the first to elevate him to royal patronage. However, payment for the paintings was not immediately forthcoming.

Constantin Huygens, on behalf of Frederik Hendrik, ordered a series of paintings of 'The Passion of Christ' from Rembrandt. It is clear that it was to compare to Rubens' series of the same subject, created for Antwerp Cathedral, which were vast panels measuring 420 × 360cm (165.4 × 141.7in).

THE PASSION OF CHRIST

Rembrandt's 'Passion' series would be in a smaller format, for which Huygens had praised his ability, to measure approximately one-twenty-fifth the size of Rubens' versions. The preamble to this contract may have begun as early as 1628–9, when Rembrandt was still residing in Leiden, for drawings made by Rembrandt, relating to *The Raising of the Cross*, date from that period.

PAINTED TO ORDER

The request for a very precise size must relate to the room size of the intended location of the paintings. Rembrandt's *The Raising of the Cross* (c.1633), an unsigned and undated oil-on-canvas painting, compares in composition to Rubens' painting of the same subject c.1612. In addition, Rembrandt's *The Descent from the Cross* 1633, closely follows Rubens' earlier version c.1612. One difference was the insertion of a self-portrait of Rembrandt as a helper, easing Christ's body from the cross.

GETTING PAID

The commissions from the prince were prestigious assignments that would boost Rembrandt's career. However, he still wanted to be paid for his work. A letter dated February 1639, from Rembrandt to Huygens, explained his position:

Worthy Sir: I have full faith in you, particularly as regards the remuneration for the last two pieces. If things had gone according to your wishes and to propriety, no objection would have been raised to the asking price. As for the pieces delivered previously, no more than 600 guilders were paid for each of them, and if His Highness cannot be persuaded in the face of valid arguments to pay a higher price, even if they are obviously worth it, I shall be content with 600 guilders each, with the provision that reimbursement shall be authorized for my outlay of 44 guilders for the two ebony frames and the crate. Therefore, I ask you, Sir, kindly, that I might soon

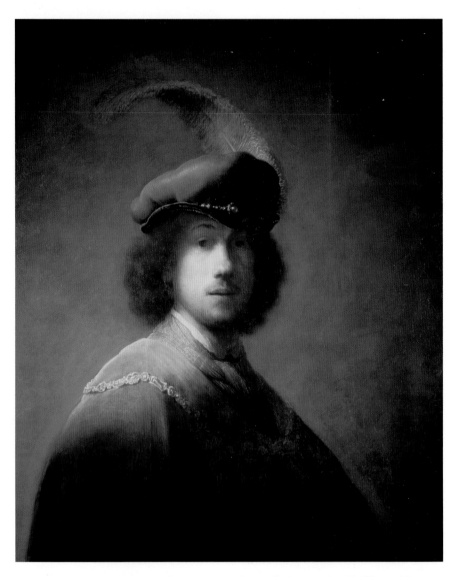

Above: Self-portrait with Plumed Beret, 1629, oil on panel.

as possible receive payments here in Amsterdam, and I trust with [your] kind help on my behalf I shall soon be able to enjoy my pennies, and I shall remain grateful for all your acts of friendship…

FURTHER COMMISSIONS

Following the delivery of these works, a commission for the three further paintings followed: *The Entombment, The Resurrection* and *The Ascension*.

Right: Christ on the Cross, *1631, oil on canvas.*

For the latter painting Rembrandt chose not to follow Rubens, and possibly encouraged by Huygens, who favoured the work of the Venetian artist, Titian, he looked to Titian's spectacular *The Assumption of the Virgin c.*1516, known to Huygens from his time in Venice as a diplomat.

Although still cordial, the Huygens-Rembrandt relationship cooled a little during 1633, owing possibly to Huygens' dislike of a portrait created by Rembrandt of his friend, Jacob de Gheyn (1596–1641). Copying the composition of the Titian work also may have been a mistake on Rembrandt's part for he was summoned to court in 1636, due to *The Ascension* not fitting with the first paintings in the series. Rembrandt wrote to Huygens, 'I agree that I should come soon to see how the picture matches with the rest.' *The Entombment* and *The Resurrection* were finally completed in early 1639. It was at this time that Rembrandt ceased to sign his works 'RHL', standing for Rembrandus Harmensz. of Leiden (*Rembrandus Hermanni Leidensis*), preferring to sign his work simply as 'Rembrandt'.

'THE PASSION OF CHRIST'

The last events in the earthly life of Jesus Christ are described in all four Gospels of the Bible; and according to Acts 1:3, Christ '...presented himself [to his apostles] alive after his passion [suffering]'. An outstanding 'Passion' series in fresco was created by the Italian early Renaissance painter Giotto di Bondone (c.1267–1337), in the Arena Chapel, Padua, Italy. It was a challenge for artists to depict the 'Passion' series, which were 'The Raising of the Cross', 'The Descent from the Cross', and 'The Entombment', 'The Resurrection' and 'The Ascension'.

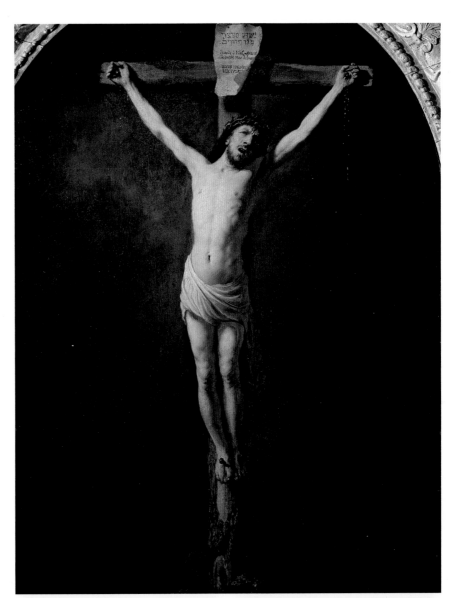

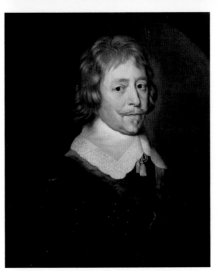

Above: Portrait of Frederick Hendrik (1544–1647), Prince of Orange, 1584–1647, *studio of Gerrit van Honthorst, oil on panel.*

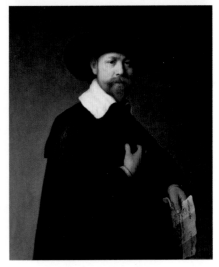

Above: Portrait of Martin Looten, *1632. In this portrait of the Amsterdam merchant, Rembrandt portrays him holding a letter, signed RHL.*

DUTCH CONTEMPORARIES

In the present day, Rembrandt is referred to as an 'Old Master', recognized and respected for his genius. However, in his own time he was seen more as one of the many talented artists in the Dutch Republic and in other parts of Europe.

Netherlandish artists associated with the 'Golden Age' of Dutch painting were contemporary to Rembrandt. A survey of names includes an astonishing array of talent, working separately but making Dutch art and artists the most desirable commodity in 17th-century Europe.

EUROPEAN ARTISTS

A brief survey of European artists, contemporary to Rembrandt, produces a substantial list, many working for the European courts. In Spain, in 1614, the death of El Greco (1541–1614) pushed forward new talents, such as Diego Velásquez (1599–1660), Francisco de Zurburan (1598–1664), Jusepe Ribera (1588–1652) and

Bartolomé-Esteban Murillo (1617–82). In France, Nicolas Poussin (1594–1665) and Claude Lorrain (1600–82) dominated the period. In Italy, the untimely death of Michelangelo Merisi da Caravaggio (1573–1610) curtailed an inspired painter whose works informed the art of many followers, not only Italians but the European artists who visited Italy to understand his *chiaroscuro* method and dramatic treatment of subject matter.

BAROQUE PAINTERS

Rembrandt did not travel to Italy but gained knowledge through his tutor Pieter Lastman and other artists who had travelled to Italy of the theatrical Baroque style that flourished there.

Caravaggio had his Dutch followers but other Baroque artists also held respected status. Between 1602 and 1619 three esteemed painter-members of the Carracci family died. The cousins Lodovico (1555–1619), Agostino (1557–1602) and Annibale Carracci (1560–1609) had helped to establish the Accademia degli Incamminati in Bologna – often referred to as the Accademia dei Carracci – in 1580. Their Baroque legacy was continued by the Bolognese artists Guido Reni (1575–1642), and Domenichino (1581–1641), both linked to the Carracci Accademia; plus 'Il Guercino' Giovanni Francesco Barbieri (1591–1666), deeply influenced by the Carracci and Caravaggio. In Rome, Gianlorenzo Bernini (1598–1680), noted primarily as a sculptor and architect of the Baroque, flourished at the Vatican court with his highly theatrical style. Also at work in Rome and influenced by the remarkable success of Bernini, Pietro da Cortona

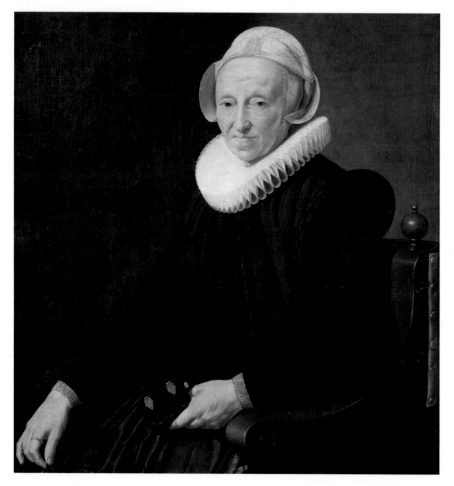

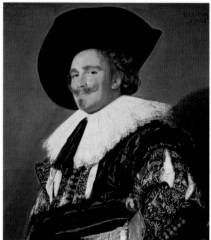

Above: The Laughing Cavalier, *1624, oil on canvas, Frans Hals (1582/3–1666).*

Left: Portrait of an Old Woman, *1624, oil on canvas, Nicolaes Eliasz (Pickenoy) (1590–1653).*

Right: The Good Samaritan *(after Rembrandt), 17th century, oil on oak panel, Govaert Flinck (1615–1660).*

(1596–1669) was commissioned by the Pope and his family, the Barberini. In England, Peter Lely (1618–80), was a favourite at court, where Jan Lievens became a popular alternative. In Germany, the death of the noted artist Adam Elsheimer (1578–1610), who influenced Rembrandt's tutor, Pieter Lastman, led the way for Joachim von Sandrart (1606–88); and Sandrart was known to Rembrandt.

ARTISTS OF THE DUTCH REPUBLIC

Local and European patrons came to the vibrant open arts market in the Netherlands. Many Dutch artists travelled to Italy, to study the art of Caravaggio. In Haarlem, a short distance from Amsterdam, Rembrandt's contemporaries included the slightly older Frans Hals (1582/3–1666), a fine portrait painter, and Salomon van Ruysdael (1600–70), possibly unsurpassed as a landscape painter, alongside Pieter Claesz (1597/8–1661) and Jan Molenaer (1600/10–68). In the town of Delft, south of Leiden, Michiel de Miereveldt (1567–1641), an artist older than Rembrandt, was joined by his contemporaries, Emanuel de Witte (1617–92), Carel Fabritius (1622–54), and two of the most documented Dutch artists, Pieter de Hooch (1629–c.1684), and Jan Vermeer (1632–75), both born at the time Rembrandt was establishing his career as an independent artist.

ALBERT CUYP IN DORDRECHT

Dordrecht, a town directly south of Amsterdam, was enriched by the work of Albert Cuyp (1620–91), a painter of sublime landscapes in and around his birthplace, and Samuel van Hoogstraten (1627–78), a former pupil of Rembrandt, who wrote a book on painting, published in 1678. Other painters, such as Govaert Flinck (1615–60) from Kleve, a former pupil of Rembrandt's, and Gerard Terborch (1617–81) added to the enriched source of art in this 'golden age' of painting.

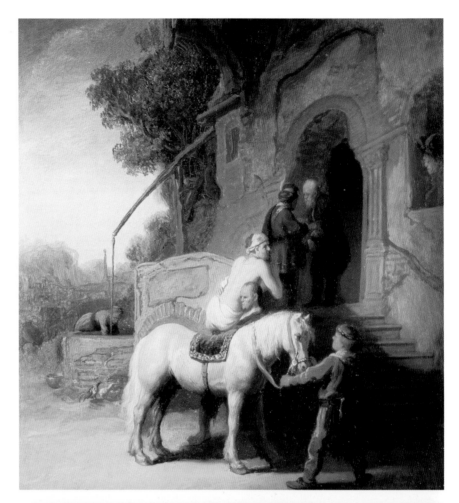

UTRECHT AND FLANDERS

In Utrecht, a town to the south of Amsterdam, the 'Utrecht School' of painters were inspired by Michelangelo Merisi da Caravaggio. Hendrick Terbrugghen (c.1588–1629), Gerrit van Honthorst (1590–1656) and Dirck

Above: The Raising of Lazarus, *1631, Jan Lievens, the Elder (1607–74).*

van Baburen (c.1590–1624) were together labelled the 'Caravaggisti' for their appropriation of the Italian artist's technique.

REMBRANDT'S DRAUGHTSMANSHIP

A six-volume catalogue, *The Drawings of Rembrandt: A Critical and Chronological Catalogue*, published 1954–7, by the Austrian art historian Otto Benesch (1896–1964), ascribed over 1,400 drawings to Rembrandt. Some of these have been reattributed to various students and followers of Rembrandt.

For drawing, Rembrandt preferred to use a reed pen with light and dark brown ink on paper, to produce simple outlines, often with brown wash. Other media included red or orange chalk, often wetted, and heightened with white.

PROBLEMS OF AUTHENTICITY
The vast number and style of drawings assigned to the artist drew criticism from other Rembrandt scholars;

Benesch had included many disputed and unauthenticated works. The catalogue was revised and enlarged by his widow Eva Benesch, and published in 1973. Subsequent research has lowered the figure to around 800 drawings but the problem of authenticity still remains for Rembrandt

Below: Saskia with her First Child Rumbartus, *1635–36, red chalk.*

scholars, cataloguers for museums and galleries, and the auction houses, to know how to distinguish an original drawing from the work of a student or a follower of the artist.

CLASSIFICATION OF DRAWINGS
Of the current corpus of circa 800 drawings and sketches attributed to Rembrandt, only 70 hold his signature or mark of identity. The remainder are

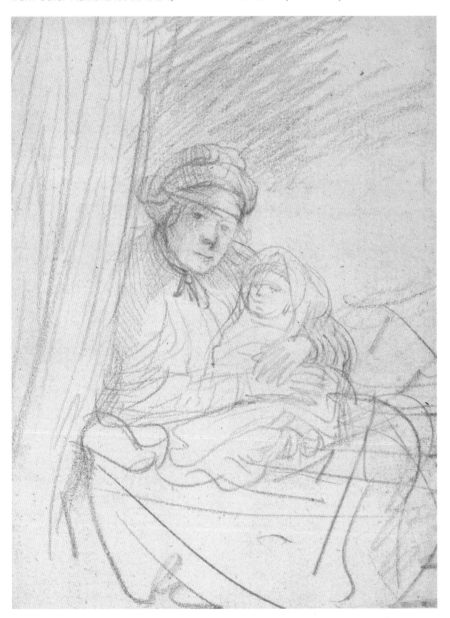

A QUESTION OF ATTRIBUTION

As soon as the Otto Benesch complete catalogue of Rembrandt drawings was published, in the mid-1950s, Rembrandt scholars queried certain attributions, leading to closer analysis by critics in the late 1950s and 1960s. Of the 1,450 works, on closer inspection many drawings and sketches were found to be created by Rembrandt's apprentices, assistants and pupils; works that Rembrandt had 'finished' or added to, or authenticated. Subsequently, the works had lost the name of the originator, submersed under Rembrandt's body of work. For example, the artist Willem Drost (1633–59), a pupil of Rembrandt in the 1650s, had very few drawings traditionally attributed to him. Today through subsequent analysis, many works have changed attribution from Rembrandt to Drost. Another follower, Johannes Raven (1634–62), is now recognized as the author of works that were formerly attributed to Rembrandt. Reattribution includes former students, such as Govert Flinck (1615–60) and Nicolaes Maes (1634–93).

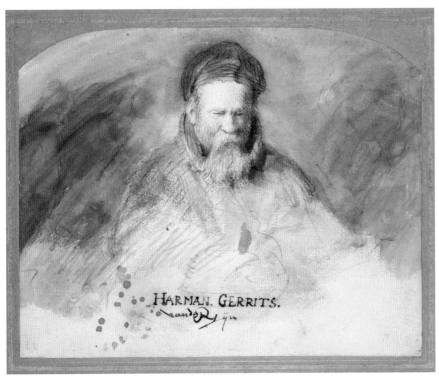

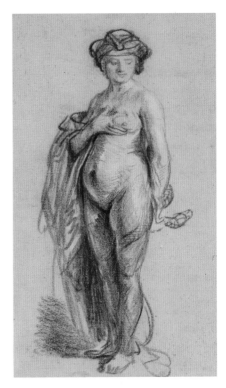

accepted as his work through other types of documentation, materials, and cross-referencing of artworks. The drawings can be classified into about 12 groups; figure drawings and nudes, portraits, family portraits and self-portraits, women and children, animals and genre, religious subjects, landscape and buildings, mythology, and copies of other artists' works. Rembrandt was in the habit of classifying his work, using separate portfolios, probably for ease of reference. In 1680, an inventory of the estate of Jan van de Capelle (1626–79), a painter, referred to a portfolio of drawings, that contained 135 drawings by Rembrandt of women and children. This was a portfolio possibly purchased at Rembrandt's 1656 insolvency sale, or after his death in 1669.

PREPARATORY DRAWINGS

In the 17th century, most artists appear not to have kept preparatory drawings. There is not one from Johannes Vermeer, or Frans Hals, or Pieter de Hooch, extant. It is fortunate for art historians that Rembrandt kept portfolios and albums of drawings. He catalogued them by different types, such as portraits, animals, landscapes, nudes

Right: An Elephant, 1637, black chalk on paper.

Above: Portrait of an Old Man, 17th century, chalk and bistre wash.

and sculpture. Some drawings are indented and relate to etchings that were subsequently produced. Only a few are linked to specific paintings as preparatory sketches. The historical importance of an accompanying sketch or drawing, to view the artist's original intention and any subsequent alterations, is evident in two examples. After painting *The Anatomy Lesson of Dr Joan Deyman* (1656), Rembrandt drew a sketch of how the painting should be

Above: Study of a Nude Woman as Cleopatra, 1637, drawing.

positioned. A fire later destroyed part of the painting; the sketch reveals to us how it originally looked.

Rembrandt's large historical painting *The Conspiracy of Claudius Civilis* (1661–2) was cut down from 580cm (228in) to a quarter of the original size, after the content had not met with approval. From Rembrandt's preliminary sketch, we can follow his original ideas for composition.

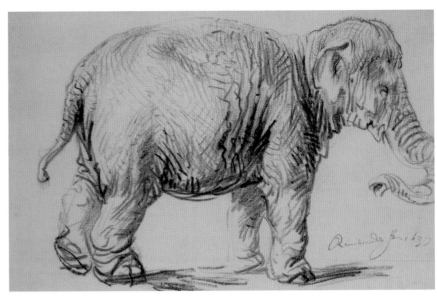

ART AND SCIENCE

A group portrait of medical practitioners gathered closely around a corpse in the process of dissection by the Amsterdam surgeon, Dr Nicolaes Tulp brought attention and fame to Dr Tulp, the practitioner, and to Rembrandt, the artist.

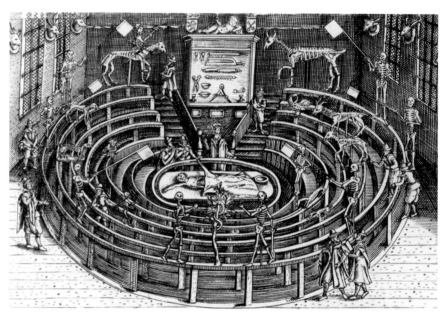

In the early 17th century, human dissections for public viewing were a rare occurrence, and rarer still was a group portrait to acknowledge the occasion. In *The Anatomy Lesson of Dr Nicolaes Tulp* (1632), Rembrandt enhanced his and the surgeon's reputation.

One of the earliest Netherlandish formal group portraits, *The Bones of John the Baptist* (1485–95), was centred on the bones of a dead body. It was painted by the Leiden-born artist

Above left: The Anatomy Lesson of Andreas Vesalius (1514–64) at the School of Medicine in Brussels, *frontispiece of* De Humani Corporis Fabrica, *published in Basel 1555.*

Geertgen tot Sint Jans (1460/65–90). At centre left, in the background, he portrayed the Haarlem Knights of St John grouped together, witnessing the exhumation and cremation of the bones of the saint. The distinguished

Above: The Anatomy Theatre, Leiden, 1610, *engraving, 16c., German School, after Jan Cornelisz Wodanus (c.1570–1615).*

members of the group were recognised individually in their portraits, and collectively as witnesses to the event. Geertgen is noted as the originator of the collective portrait in the Netherlands and his portrait-type influenced Pieter van Mierevelt, Rembrandt, Frans Hals (c.1580–1666) and Thomas de Keyser (c.1596–1667). Mierevelt portrayed *The Anatomy Lesson of Dr Willem van der Meer*, 1617, an early Dutch depiction of a dissection carried out in the anatomy theatre with surgeons present.

HUMAN DISSECTIONS

Artists often used symbols to denote a group of medical practitioners, or a group of distinguished men with

Left: Harmensz. van Rijn Rembrandt Knocking on the Door of the Theatrum Anatomicum Collegium Chiricurgicum, Amsterdam in 1633, 1864, *Christoffel Bisschop (1828–1904), oil on canvas.*

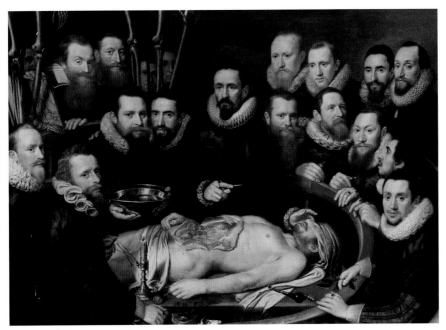

Above: The Anatomy Lesson of Doctor Willem van der Meer in Delft, *1617, Pieter van Mierevelt (1596–1623).*

a learned doctor. The inclusion of a human skull or skeleton was a recognizable device. (In *vanitas* painting, a skull would be included to symbolize mortality, a quite different meaning to the collective portraits of anatomical exploration.) In *The Anatomy Lesson of Dr Sebastian Eghertsz* (1619), painted by the Dutch artist Thomas de Keyser, six men are evenly spaced around the central figure of a human skeleton that is illustrated in three-quarter back profile. The off-centre figure of Dr Eghertsz is subtly denoted by his hand touching the skeletal bones as he looks toward the viewer. Others in the group either look toward the spectator to draw them into the group, or toward the doctor.

RESPECT FOR VESALIUS
The anatomy theatre was on an upper floor of the Anthoniesmarkt south tower, in Amsterdam. Rembrandt's portrait may have depicted a stage in the dissection before the lecture was open to the public because it was normal practice to start a dissection by opening the stomach and removing the

Right: The Anatomy Lesson of Dr. Nicolaes Tulp, *1632, oil on canvas, (detail).*

intestines. From there the physician would move on to the limbs and complete the procedure with an examination of the brain. Rembrandt and Tulp may have chosen to emulate an earlier depiction of a dissection, portraying the eminent Netherlandish physician Andreas Vesalius (1514–64) holding the dissected arm of an corpse in an illustration for his book *De humani corporis fabrica libri septem* (On the fabric of the human body in seven books, 1543).

DR NICOLAES TULP (1593–1674)
Claes Nicolaes Pietersz (Tulp) was born in Amsterdam on 11 October 1593, the fourth child of the wealthy Pietersz family of cloth merchants. He attended university in Leiden to study medicine and graduated in 1614. Returning to Amsterdam, he set up a medical practice. He affected the surname 'Tulp', taken from the word 'tulip'. On becoming a member of the Amsterdam Surgeons 'Guild in 1628 he was appointed to lecture to medical undergraduates and junior surgeons. Some lectures were open to the public. On 31 January 1632, he held a public lecture on dissection, performing it on the body of a criminal. The event was recorded by Rembrandt in the now famous *The Anatomy Lesson of Dr Nicolaes Tulp* 1632. Tulp published many medical books, including *Observationes medicae* (1641). He set up the first medical council in the Netherlands, to regulate the use of drugs and the practice of pharmacists.

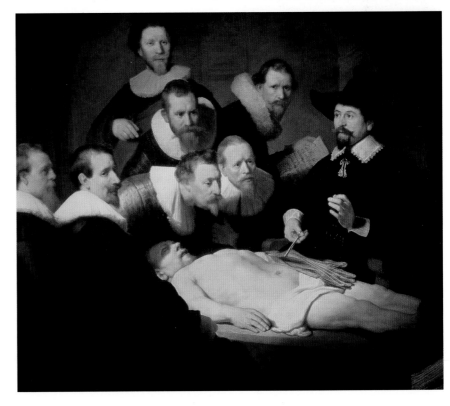

MARRIAGE AND FAMILY LIFE

A chance meeting between Rembrandt and Saskia van Uylenburgh, a young cousin of his business partner, Hendrick, led to romance between the couple and their engagement in 1633, which was followed by their marriage the following year.

After a one-year engagement the marriage took place on 22 June 1634 in the Regthuys, Sint Annaparochie, in the province of Friesland, where Saskia had been born. She was nearly 22 years of age at the time of the wedding.

THE VAN UYLENBURGH FAMILY

Saskia (Saarkje) van Uylenburgh (1612–42) was born into a prosperous Calvinist family, the youngest of eight children. She was baptized on 2 August 1612. Her mother, Siuckien Ulckedr Aessinga (Sjouke Ozinga), died in 1618, when Saskia was six. Her father, Rombertus van Uylenburgh

(1554–1624), was a respected lawyer and had been a burgomaster of Sint Annaparochie (Het Bildt), in the Dutch province of Friesland, where the family lived. In 1595, Rombertus had bought a house on the Ossekop, where Saskia was born. He had held the post of Attorney General of the Dutch Republic and at one time led a delegation to England, to confer with Queen Elizabeth I, to petition her to become sovereign of the Netherlands. Rombertus was one of the founders of the second university in the Netherlands (after Leiden), the University of Franeker, established in

Friesland, northwestern province of the Netherlands, in 1585. Working in the circle of William I, Prince of Orange (1533–84), and dining with him on 10 July 1584 at the prince's home in Delft (now the Prinsenhof), Rombertus witnessed the assassination of the prince by a gunman, Balthasar Gérard (1557–84), a supporter of the Spanish king Philip II.

SASKIA VAN UYLENBURGH

Rombertus died when Saskia was 12 years old. From 1628 Saskia lived with her older sister Hiskia (Hiskje) and her husband, Gerrit van Loo (c.1580–1641), a town clerk and lawyer, who had become her legal guardian. A move by Gerrit and his family, and Saskia, to Leeuwarden in 1632 was prompted by local riots. It was here that Saskia probably first saw paintings by

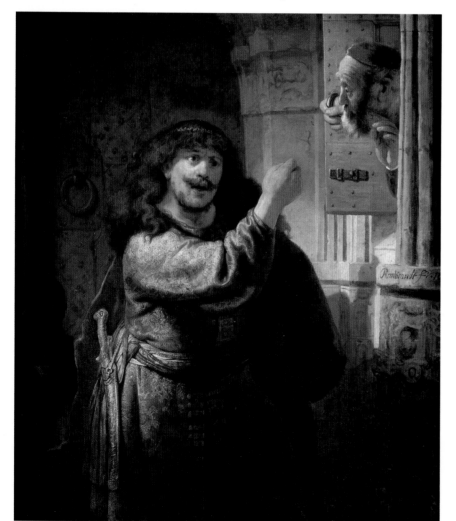

Left: Samson Threatening His Father-in-Law, *1635, oil on canvas, signed Rembrandt f.163(5).*

PORTRAITS OF SASKIA

Just a few days after their engagement had been announced, Rembrandt drew Saskia, possibly in honour of her 21st birthday. It is a 'Mona Lisa' portrayal of Saskia with an enigmatic smile. In *Portrait of Saskia in a Straw Hat* 1633, she leans on a ledge and looks out toward the viewer, her head shaded by a large sunhat adorned with flowers. Saskia holds a flower in her hand. A formal portrait of Saskia was also executed by Rembrandt soon after the engagement was announced. *Portrait of Saskia* 1633, captures a demure, serious young woman, staring directly at the viewer.

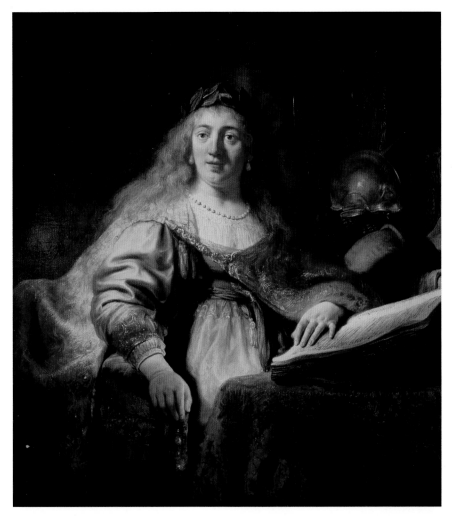

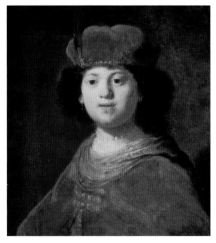

Above: Portrait of a Boy, *1634, oil on canvas.*

Haste, Repent at Leisure' served as a warning to couples about to embark on married life. Following registration, marriage licence applications were posted up as formal proclamations of intent. Rembrandt, alongside Jan Cornelius van Uylenburgh, a clergyman and cousin of Saskia, passed through the red door, with Van Uylenburgh acting on Saskia's behalf. To marry, Rembrandt needed official approval from his family, which his mother gave.

Above: Saskia as Minerva, *1635, oil on canvas.*

Rembrandt, for sale through her cousin Hendrick's art dealership. Saskia later visited Hendrick and his wife Maria in Amsterdam, and there she was introduced to Rembrandt. They became engaged in early June 1633.

THROUGH THE RED DOOR
In Amsterdam, from 1578 until 1648 (on completion of the new town hall), the commissioners for matrimonial affairs had their registry office located in the Sacristy of the Oude Kerk. To enter, one went through a side door of the church, which happened to be painted red, and the expression 'going through the red door' was associated with getting a marriage licence. Over the door to the Sacristy, the text 'Marry in

Right: Self-Portrait with Saskia, *1636, etching.*

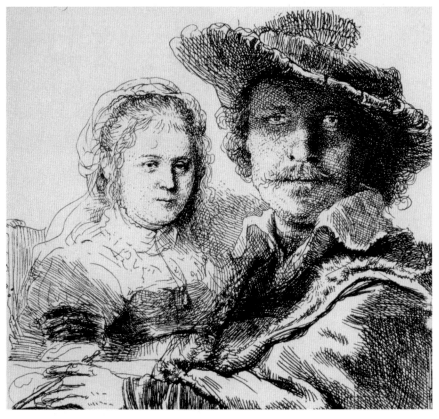

REMBRANDT AND SASKIA

Marriage to the wealthy Saskia brought Rembrandt a large dowry and elevated status. The couple moved into the family home of her cousin Hendrick, and stayed for two years, during which time two babies were born to Rembrandt and his wife.

From the time of their marriage, it is noticeable that Rembrandt painted and drew many more portraits of Saskia and her family than of his own relations. Some of the most beautiful paintings of Saskia were completed in the early years of their relationship.

FAMILY FINANCIAL MATTERS

Saskia's family were wealthy middle-class people. They enjoyed a higher social status than Rembrandt's relations. In Saskia's immediate family, her three brothers all had professional careers. One brother was an army officer and the other two were practising lawyers. Her sisters lived comfortable lives; one was married to a professor of theology, and one to a commissioner. Gerrit van Loo, the husband of her sister Hiskia, and formerly Saskia's legal guardian, was a lawyer and town clerk in Het Bild.

From the moment Rembrandt married Saskia and took her dowry, he was in charge of her finances. He instructed Hiskia's husband to collect outstanding payments owing to Saskia from her Friesland investments.

PORTRAITS OF SASKIA

During a two-year period Rembrandt created many depictions of Saskia in etchings, drawings and paintings. Following her engagement and marriage portraits, her youthful looks are captured in *Portrait of the Artist's Wife, Saskia Uylenburgh* (1635); and in two joint portraits, *Rembrandt and Saskia as the Prodigal Son in a Tavern* c.1635; and a small etching, *Self-portrait with Saskia*, 1636. Drawings from this period include portrayals of Saskia in the home, for example an impromptu sketch, *Saskia Seated before a Window, Looking up from a Book* c.1635, and

Right: Portrait of Saskia, *1634, ink and wash on paper.*

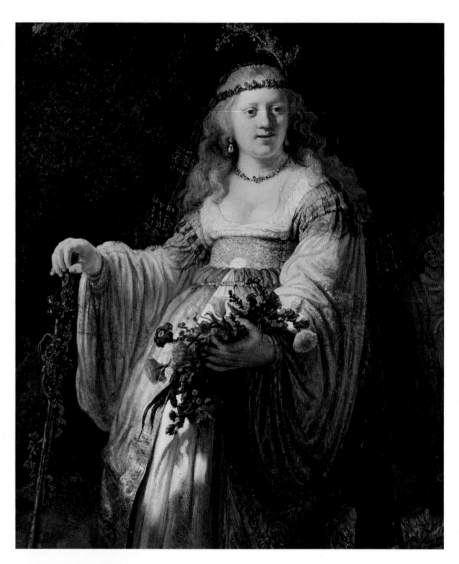

Above: Saskia van Uylenburgh in Arcadian Costume, *1635, oil on canvas.*

in her bed attended by a nurse, *Saskia Lying in Bed, and a Nurse* c.1635. In addition to personal portraits of Saskia, Rembrandt also used her as a model.

SASKIA IN ARCADIAN COSTUME

A year after their wedding, in 1635, Rembrandt painted a stunning portrait of Saskia, dressed as Flora, the Roman goddess of Spring. *Saskia van Uylenburgh in Arcadian Costume* 1635, one of two

PREGNANCY AND BEREAVEMENT

Eighteen months after the marriage of Saskia and Rembrandt, a son was born to them. He was named Rombertus, probably after the child's maternal grandfather, and baptized on 15 December 1635. He lived only two months, his death possibly connected to the plague epidemic sweeping through Amsterdam that year. The baby was buried in the Zuiderkerk on 15 February 1636. Nearly three years later, Saskia gave birth to a girl, Cornelia, possibly named after the child's paternal grandmother. The baby lived for only two weeks.

Above: Saskia Asleep in Bed*, 1635. A pen and ink drawing of Saskia when pregnant.*

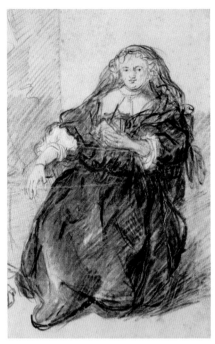

Above: A Woman Seated Holding a Letter in her Left Hand*, c.1633–35.*

paintings – the other, *Flora* 1634, is in the Hermitage Museum, St Petersburg, Russia – in which she is featured as Flora, highlights the contemporary fashion in Amsterdam for the pastoral, Arcadian myth of harmony with nature.

Rembrandt presents Saskia as a young goddess in a rustic setting. Interest in the idyllic pastoral genre spread through the middle and upper classes of Dutch society, first seen in Utrecht in the 1620s and spreading to Amsterdam.

Theatrical dress, seen on stage in pastoral plays, spread to street fashion with clothes that expressed the romantic ideal of country life and rural bliss, in fashionable shepherdess dresses. Accessories included wide-brimmed straw hats loosely decorated with country flowers, much like the straw hat worn by Saskia in Rembrandt's engagement drawing of her, which was a portrait called *Saskia in a Straw Hat.*

The pastoral was embraced in plays, poetry, books and paintings. In both paintings of Saskia as Flora, her long hair, floral garland and shepherdess crook are both theatrical and highly fashionable.

Right: Six Heads with Saskia van Uylenburgh *(1612–42) in the centre, 1636, etching.*

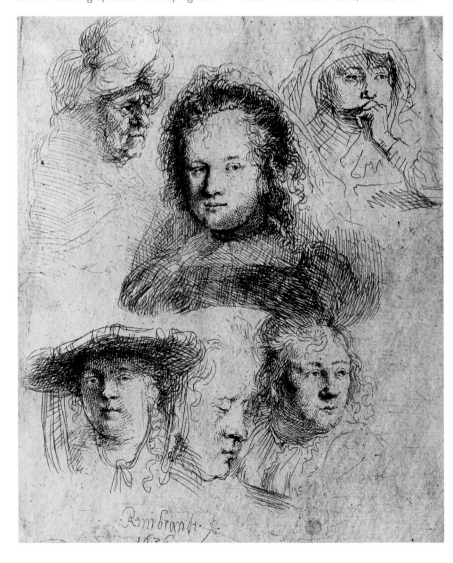

A NEW HOUSE

After years of living with relations, and in rented accommodation in Amsterdam, Rembrandt and his wife decided to buy a bigger house, large enough to bring up a family, entertain clients, and at the same time function as working space for the artist.

After two years living with Hendrick and his family, Rembrandt and Saskia moved out in February 1636, at the time of the death of their first baby. They moved into a rented house on the Nieuwe Doelenstraat, Amsterdam.

HOUSE MOVES.

Their first real home together was in a building close to the militia headquarters, the Kloveniersdoelen, for whom Rembrandt would paint *The Night Watch* in 1641. They moved again, in 1637, this time staying for two years next door to a house called the Sugar Bakery in the Binnen Amstel, on

Vlooienburg Island, at the eastern end of Amsterdam. The district, a Jewish quarter, was lively. The warehouses and wharves around their home were busy. The quay in front of their house was filled with boats and commercial craft.

A PRESTIGIOUS HOME

In 1639, Rembrandt and Saskia moved out of rented accommodation into their own home. It was a prominent house on three floors, at number 4

Below: Map of Amsterdam, *1662, engraving, Cornelis I Danckerts, (c.1603–56).*

Jodenbreestraat, in the Jewish quarter of Amsterdam, next door to Hendrick van Uylenburgh's art gallery. The light-filled house in the Jodenbreestraat was big enough for a large family and a studio. The purchase of a new house was an excellent public relations strategy as an outward sign of Rembrandt's prosperity but it was a costly move and a gamble. The reason for purchasing such a large house with its imposing frontage must have been to impress Rembrandt's clients, the wealthy regents, merchants and aristocrats of the city, and possibly also to match the lifestyle of the Uylenburgh

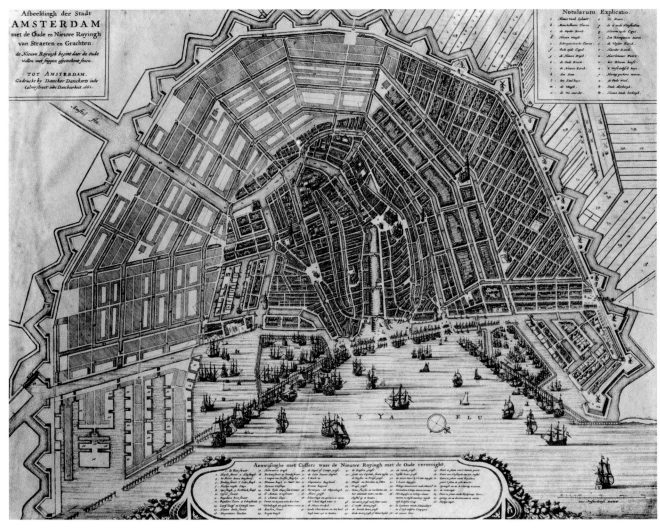

A HOUSE FOR A FAMILY

The house on Jodenbreestraat was Rembrandt's home for nearly 20 years. In choosing it, he may have been thinking not just about impressing clients, but also of the family he and Saskia wanted to have. It was in the new house, soon after the move that Saskia gave birth again, to a second daughter, Cornelia, in 1640. The baby died after a few weeks. Finally in September 1641, with Saskia and Rembrandt settled in their home, a second son, named Titus, was born, healthy.

family. Here was a house in which he could entertain the society of Amsterdam, all potential clients for his profession. The cost was 13,000 guilders. Rembrandt paid the owners 1,200 guilders deposit with an arrangement to pay the remainder over a period of time in instalments. The size of the deposit would have paid for a smaller house in total. With a healthy income generated from a full book of commissions, particularly portraits of wealthy Amsterdammers, Rembrandt must have felt secure knowing that he would be able to live comfortably, and that payment for the house was easily affordable.

SELF-PORTRAIT AS A SUCCESS

Rembrandt's move to his grand house seems to have been justified: he was courted by the wealthy middle classes for portraits, and schooled their sons to draw and paint. Soon after moving house, Rembrandt painted *Self-portrait Leaning on a Stone Sill* in 1640, perhaps painted using a stone sill in the new house. The composition is informed by Titian's superb portrait *A Man with a Quilted Sleeve* 1510, *Self-portrait* 1498, by Albrecht Dürer, and Raphael's *Portrait of Baldassare Castiglione*

Right: View of the Courtyard of the House of the Archers of the St. Sebastian Guild on the Singel in Amsterdam, *Jacob van Ruisdael, (1628/9–82), pencil & wash on paper.*

Above: The Sydelcaemer room in Rembrandt's House, Amsterdam, photograph.

(1514–15), who was a courtier, writer and poet. The style of Rembrandt's self-portrait links him to three revered painters, and to their subjects. It was probably intentional on Rembrandt's part, and the reference would be recognizable to art connoisseurs.

Above: Rembrandt House Museum, Sint Anthonisbreestraat, Amsterdam, exterior view, photograph.

In the painting Rembrandt reveals himself at the age of 34 as an older, more serious-minded man. He wears beautiful clothes, with close attention paid to the detail of the rich velvet coat trimmed with fur and the finely embroidered shirt he wears.

FAME AND FORTUNE

The 1630s–1640s were a period of comfortable prosperity for Rembrandt, largely owing to his dealership association with Hendrick Uylenburgh, and his prolific output of paintings, particularly set-piece portraits of wealthy Amsterdammers.

In the era of Rembrandt's life in Amsterdam, the city had become the centre of the arts market in Europe. In addition to Dutch art for sale through dealers and in the street markets, Italian art was fashionably popular in the city.

ART DEALERSHIP

Hendrick Uylenburg, an artist and art dealer, was running a successful business in artworks when he met Rembrandt. In Amsterdam, Hendrick employed artists to make copies of well-known prints and paintings, especially Italian artworks, to sell on. Rembrandt, living and working with Hendrick, also bought works from him. His large loan to Hendrick of 1,000 guilders, for which no reason is known, may have been for Hendrick to invest, either in the dealership or artworks, or setting up a studio, or it may have been simply a personal loan.

Whichever it was, Hendrick continued to promote Rembrandt, putting the artist in touch with key clients and new patrons. Rembrandt had the added aura of success through his dealings with Huygens and the Prince of Orange.

THE ELITE OF AMSTERDAM AT THE STUDIO DOOR

When the painting commissioned by the Surgeons' Guild of Amsterdam, to record the anatomy lesson given by Dr Nicolaes Tulp in 1632, was available to view, it established Rembrandt's career. The attention that this work brought secured more clients than he could paint portraits. A large body of portrait work was produced during the 1630s and 1640s, with many paintings of merchants, some with their wives, dressed in their conservative finery, rarely moving away from traditional white-lace ruffs or collars, and sedate black clothes, each earnestly portrayed.

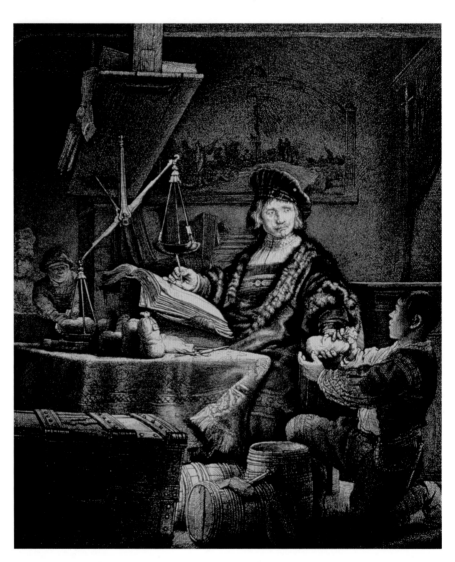

LOANS AND PAYMENTS

Records show that Rembrandt took loans from friends while awaiting payment for commissions. He took his time to complete contracts, which slowed down the amount of funds coming in. The writer Houbraken recorded that Rembrandt 'lived simply… content with some bread and cheeses or a pickled herring as a whole meal'. But he entertained his guests well, and spent vastly on his collections of curios, paintings, drawings, books, porcelain, statues, and a collection of weapons, which were to be used in his work.

Above: Jan Uytenbogaert, the Goldweigher, *1639, (detail), etching with drypoint.*

A BRUSH WITH ITALIAN ART

One work which came through Hendrick Uylenburgh's gallery was a print by the Italian illuminator and engraver, Giovanni Pietro Birago (1471/4–1513), known as the 'Master of the Sforza Book of Hours'. It was a copy of the *Last Supper* (1496–8), a fresco in Santa Maria delle Grazie, Milan, painted by Leonardo da Vinci (1452–1519). Rembrandt purchased

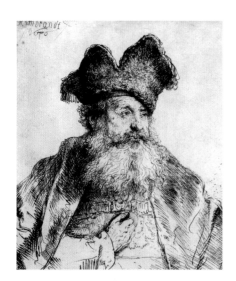

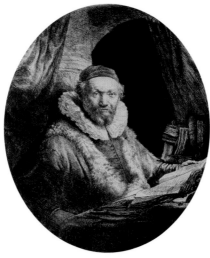

Above: Portrait of an Old Man with a Divided Fur Cap, *1640, (II states), etching with drypoint.*

Above: Portrait of Jan Uytenbogaert, Preacher of the Remonstrants, *1635, etching with drypoint and engraving.*

REMBRANDT HOUSE MUSEUM

The house at 4 Jodenbreestraat, Amsterdam, which Rembrandt purchased in 1639, an outward sign of his increasing prosperity (only to lose it to insolvency in 1656), is now the Rembrandt House Museum. The house was restored to its former glory by 1911. During the time of Rembrandt's occupation, the exterior façade had a Dutch step-gabled roof, replaced by a classical pediment in later years. The interior of the house had been gutted and it was difficult for restorers to judge how it had appeared during Rembrandt's occupation. His paintings and drawings were studied to identify which rooms were used for studio work and which were family rooms, bedrooms and guest rooms. The inventory drawn up in 1656, when creditors claimed the house and contents, was also used by the restorers.

the print and later made his own copy of it. At a later date, Rembrandt must have seen another copy of Leonardo's fresco, going over the lines of his original sketch to add in elements

Below: Rembrandt Visiting the Studio of Gabriel Metsu, *oil on canvas, Herman Frederick Carel Ten Kate, (1822–91).*

missing in Birago's copy. Although he did not attempt to paint his own version of the *Last Supper*, he used many elements of Birago's copy to inform his paintings.

It can be seen in the composition of the guests at table in *Samson Posing the Riddle to the Wedding Guests c.1638.*

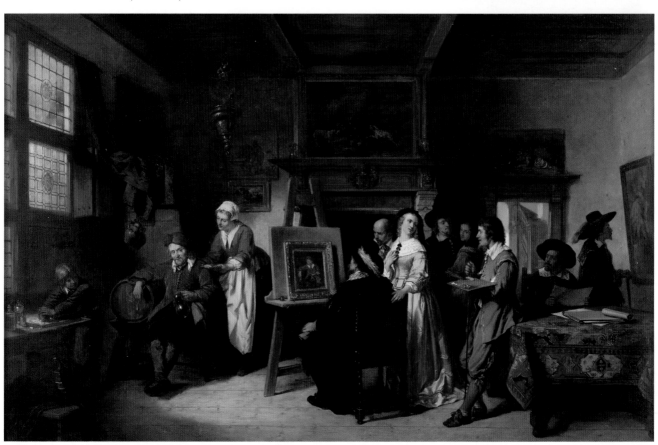

REMBRANDT'S SELF-PORTRAITS

Over 75 self-portraits of Rembrandt, a combination of drawings, etchings, and paintings, are in existence today, including three paintings made in the last year of his life. He painted portraits of himself more than any other artist of his era.

It was not uncommon for apprentices to practise portraiture by drawing or painting likenesses of their own features, or for established artists to include a self-portrait within a large artwork as a form of signature to denote artistic ownership.

Italian Renaissance artists, such as Benozzo Gozzoli (c.1421–97), Michelangelo Buonarroti (1475–1564) and Raphael (1483–1520), would often paint in an image of themselves, perhaps as an onlooker, or included as a historical figure in a large painting.

OBSERVING REMBRANDT
An early self-portrait by Rembrandt was obtained by Constantijn Huygens for Frederik Hendrik, Prince of Orange, to present through diplomatic channels to King Charles I of England. Some self-portraits were sold by Rembrandt to eager art collectors, some of whom, such as Cosimo de' Medici, came to view the artist and a self-portrait before purchasing the work.

Other self-portraits were kept as part of Rembrandt's personal portfolio; one or two were given to friends. Some portraits intended to capture a fleeting expression, seen in his etchings *Self-portrait Frowning*, c.1630, and *Self-portrait in a Cap with Eyes Wide Open*, 1630. Rembrandt portrayed himself in many guises, notably as a beggar, in *Self-portrait as a Beggar Seated on a Bank*, c.1630, or *Man in Oriental Dress*, 1632. He could equally appear as a potentate or a prodigal son. However, it is in the carefully measured portrayals, such as the early *Self-Portrait in a Plumed Hat*, 1629,

Left: Portrait of a Man, *c.1512, Titian (c.1488–1576), oil on canvas.*

A 'JOURNAL' OF REMBRANDT'S LIFE

The Dutch art scholar Seymour Slive comments (*Dutch Painting 1600–1700*, 1995), that the self-portraits created by Rembrandt over a 44-year period are like a journal of the artist's life in 'snapshots' taken during his long career. Younger artists often draw self-portraits to practise facial expressions or the fall of light on the face. Established artists might paint a self-portrait as proof to a patron of their ability to capture likeness. Rembrandt used both practices in his professional life. Some drawings and paintings illustrate him using his own features to create an unknown character, while the self-portraits record the essence of his personality.

Above: Portrait of Baldassare Castiglione (1478–1529) before 1516, Raphael (1483–1520), oil on canvas.

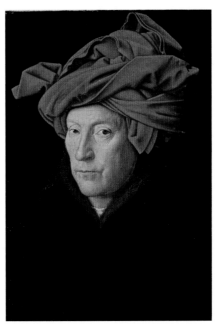

Above: A Man in a Turban, *1433, Jan van Eyck (date of birth unknown, but probably c.1395), oil on oak.*

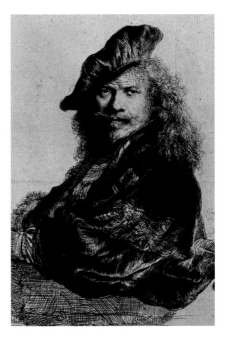

Above: Self-portrait Leaning on a Stone Sill, *1639, (detail), etching and drypoint.*

and *Self-portrait with Soft Hat and Gold Chain, c.1630,* or the much later *Self-portrait 1660,* that one observes Rembrandt clearly, eye-to-eye, face-to-face, seeing him as he saw himself.

A PORTRAIT FOR A KING

Following the inclusion of his self-portrait in *The Stoning of St Stephen,* (1626), Rembrandt began to appear more fashionably dressed around 1630, perhaps due to his association with Constantijn Huygens, who commissioned works for the Prince of Orange.

The oil-on-panel *Self-portrait with Beret and Gold Chain, c.1630–1,* was in the English Royal Collection in 1633, if not before. It was shipped soon after it was painted, and carried to the king, either as a gift from Frederik Hendrik, Prince of Orange, and supplied through Constantijn Huygens, the prince's secretary, or as a gift from Sir Robert Kerr (1578–1654), the first Earl of Ancrum, Lord of the Bedchamber and Master of the Privy Purse, who had been sent on a

Right: Portrait Sketch of Baldassare Castiglione, *1630, after Raphael, pen and ink and wash.*

diplomatic mission to The Hague. Whether or not it was a gift, the painting is recorded in the inventory of the English Royal Family in 1639, by the keeper of the King's pictures, Abraham van der Doort (1575/80–1640). He describes it as, 'being his owne picture & done

by himself in Black capp and furrd habit with a lit[t]le goulden chaine uppon both his Shouldrs. In an Ovall and a square black frame'. Two other works, presented to Charles I by Kerr, were originally thought to be by Rembrandt, but are now known to be by Jan Lievens.

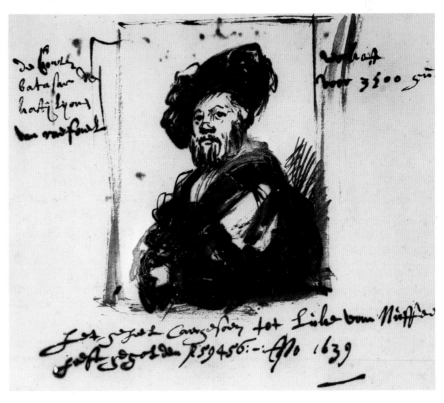

CAPTURING THE LANDSCAPE

Painted landscapes by Rembrandt total 14 artworks, produced from 1638 to 1648. Etched landscapes appear in two cycles, from 1640 to 1645, and 1650 to 1653. He also created many drawings of country scenes around Amsterdam; some of them depicting unknown locations.

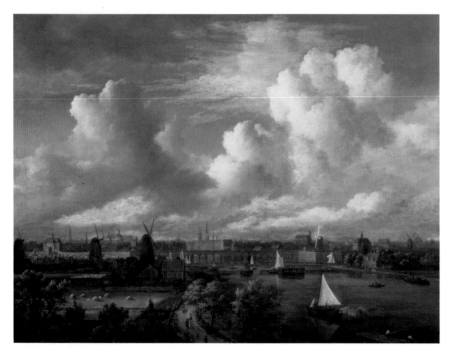

One only has to look at Rembrandt's drawing *Winter Landscape* (1646), to be transported to the Dutch lowland countryside. With a few strokes of a pen, he captures a snowy landscape under a large sky, in a hamlet with house roofs and land covered in a blanket of snow.

A PICTURESQUE VIEW

Winter Landscape, with a distant windmill on the horizon, captures the wide expanse of the snowy, rural landscape. The scene is realistic, yet many of Rembrandt's picturesque views of the Dutch countryside cannot be pinpointed to a specific location. His views of farmhouses, old farm machinery, windswept trees and solitary figures must have been taken from direct observation, but he probably created many of his idealized, romantic or desolate compositions in the studio.

Right: View of Amsterdam, c.1640, etching.

Above: View on the Amstel, Looking towards Amsterdam, c.1675, Jacob Isaaksz. van Ruisdael, oil on canvas.

PAINTING THE LAND AND SEA

In the late 1630s, Rembrandt turned his attention to landscape painting, drawing on rural scenes in the vicinity of his house as the basis of realistic depictions, or imagined scenery. He collected prints by Hercules

HERCULES SEGHERS

Rembrandt owned eight paintings and some copperplate etchings by one of his favourite artists, Hercules Seghers (1589/90–1633/8), a fellow Dutchman. Seghers, who was considered an eccentric artist by some, specialized in imaginary mountainous landscapes, his caprices combined real locations with unreal additions. The artist was known for his 'painted prints' on paper or canvas, produced from his etchings and popular with collectors. Rembrandt created a new, smaller etching from one of the Seghers copperplates he owned, *Tobias and the Angel* (c.1633), removing the two figures and replacing them with the Holy Family, for *The Flight into Egypt* (1653). Rembrandt created seven different states of the etching. It was not uncommon practice at the time to update or re-use old plates.

Seghers, an artist he admired, and copied them for his initial landscape drawings and etchings. One of the few works that can be pinpointed

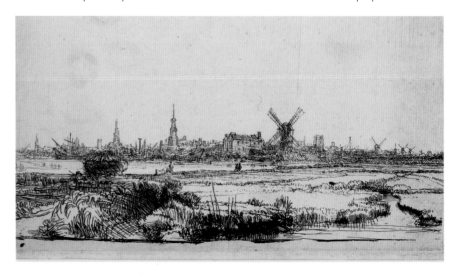

Right: Landscape with Gabled Cottages Beside a Road, *1650, etching and dry point on paper.*

to a location, *Landscape with a Stone Bridge* (1638) illustrates a view on a tributary of the Amstel River, near the Oudekirk, in Amsterdam. Rembrandt was inventive with colour, transforming what would be a neutral palette into vibrant contrasts, capturing the sunlight streaming through clouds. Mythical canals, rivers and pools feature in early landscape paintings, such as *The Abduction of Europa,* 1632, and *The Goddess Diana Bathing, with Actaeon Turned into a Stag, and Callisto's Brother Discovered,* 1634. Only one seascape painting is known, the portrayal of *Christ in the Storm on the Sea of Galilee (St Peter's Boat),* 1633. It shows the extent of Rembrandt's visual perception. The actions of the disciples on the boat, struggling to ride the waves in a stormy sea, address layers of symbolic meaning in the biblical narrative.

ETCHING THE LANDSCAPE

Two cycles of etchings, dated from 1640–5, and 1650–3, contain some of Rembrandt's best landscapes, possibly created to produce large numbers of prints for sale. Landscape was a popular genre for Dutch collectors. One landscape series, featuring a clump of trees, which he drew in different versions, produced perhaps his finest etching, *The Three Trees,* 1643. The scene of a storm clearing over a hill, on which stand three trees isolated from the landscape beyond, is seen as a representation of the three crosses at Christ's crucifixion. Rembrandt seems to have created imaginary landscapes based on views that were known to him.

For his landscapes Rembrandt chose a view that was known to him, and elaborated upon it. He ventured to the countryside near to his home on the Breestraat, crossing Anthoniesport, to Diemandyk. From here he could see canals, lakes and pools interspersed with trees, or a house or a solitary boat.

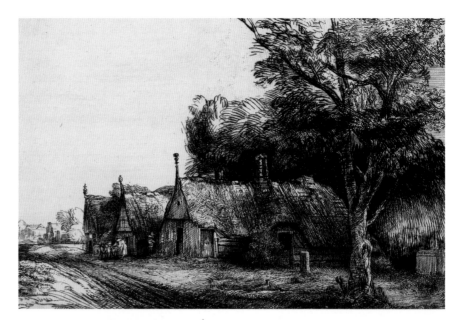

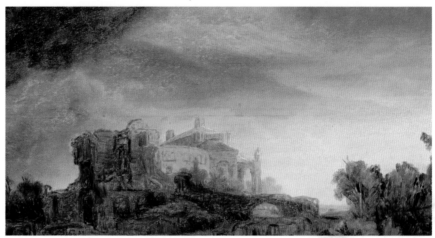

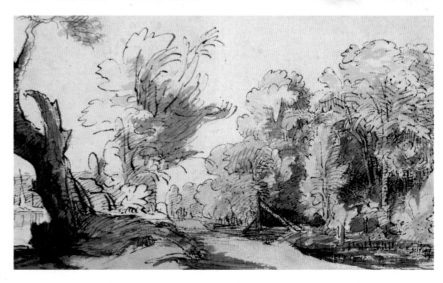

He created some desolate views of the distant city, such as *View of Amsterdam,* c.1640–2, which was perhaps influenced by his feelings during the illness, death and burial of Saskia in 1641–2.

Above: Landscape with a Path, an Almost Dead Tree on the Left and a Footbridge Leading to a Farm on the Right, *17th C.*

Above centre: Landscape with a Chateau, *17th century, oil on panel.*

REMBRANDT'S CRAFT

Rembrandt used *chiaroscuro*, light and shadow, to produce a dramatic effect, highlighting certain areas, and, with less striking effect, would also build up thick layers of impasto, creating ridges to catch the light. The viewer had to stand at a distance to discern the subject of the painting.

Rembrandt used thick layers of paint, skilfully slicked on or off with a palette knife, or moved around with the end of his paintbrush or maulstick, so that the brushwork was visible from close up, but his paintings were intended to be viewed from a distance.

REMBRANDT'S CRITICS
A pen and ink drawing titled *Satire on Art Criticism* 1641, appears to show Rembrandt's disdainful view of art critics. It portrays a crowded place, where many people hold frames of artworks, ready to be analyzed by an art critic seated on an empty barrel, with a painting at his feet. A small snake coils itself up his arm toward the critic's face, while on his head he wears a hat with ass's ears protruding; the animal's ears were a recognized symbol of stupidity. In the foreground to the right, a squatting man turns to the viewer and wipes his bottom with a sheet of paper, after defecating. The inscription reads: 'This quack of art finds foolish favour' ('*Dees quack van de Kunst is Jockich gunst*'). Interpretations of the work, which includes a date '1604' suggest the critic in mind may be Karel van Mander, whose theory on art, 'Foundations of the Noble, Free Art of Painting', was published in *Schilderboek*, a one-off publication, that year.

GERARD DE LAIRESSE
A reputed Dutch painter and etcher, Gerard de Lairesse (1641–1711), who turned to writing art theory when congenital syphilis made him blind in 1690, referred to Rembrandt's application of paint as 'liquid mud

IN PRAISE OF ROUGH STROKES

John Elsum (fl.1700–03), an English writer and poet, author of *The Art of Painting after the Italian Manner* (1703), praised Rembrandt's style in verse, in *Epigrams upon the Paintings of the Most Eminent Masters, Ancient and Modern* (1700). He must have appreciated the heavy impasto, rough brushstrokes, broken colour and finger-scumbling:

> What a coarse rugged Way of Painting's here,
> Stroaks upon Stroaks, Dabbs upon Dabbs appear.
> The work you'd think was huddled up in haste,
> But mark how truly ev'ry Colour's placed,
> Dith such Oeconomy in such a sort,
> That they each mutually support.
> Rembrant! Thy Pencil plays a subtil Part
> This roughness is contriv'd to hide thy Art.

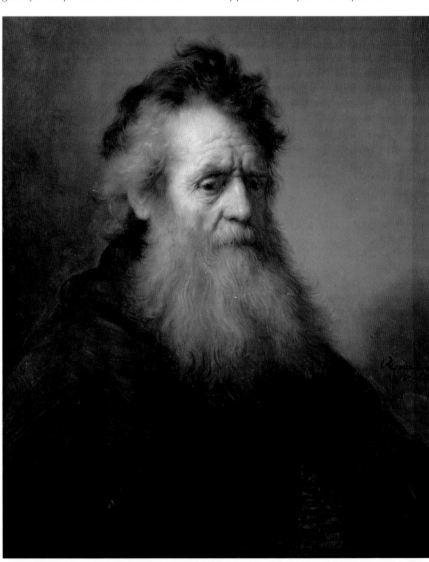

Right: Portrait of an Old Man, *1632, oil on panel.*

on the canvas'. Rembrandt painted a sensitive portrait of the painter, *Portrait of Gerard de Lairesse c.*1665, which shows in its broad brushstrokes, thick paint, and dark soft colours with muddied tones, the signs of syphilitic illness in Gerard de Lairesse's young face, not recognized as such during the period it was painted. In 1701, De Lairesse published *Grondlegginge ter Teckenkonst* (Foundations of Drawing). In *Het Groot Schilderboek* (The Great Book of Painting, 1707), he advocated using a thin brush to allow fine detail, the opposite to Rembrandt's style, which allowed the paint to run down the canvas 'like muck' (*gelyk drek*).

'PAINT SO THICK YOU COULD LIFT IT UP…'

Rembrandt highlighted the artifice of painting while producing portraits that explore the nature of realism. Up close one is astounded by the thickness of the paint and the ridges and troughs created by the short brushstrokes. Viewed at a distance the picture appears realistic, the technique no longer evident.

Rembrandt advised clients: 'Hang this painting in a strong light and so that one may look at it from a distance. The smell of the paint would make you sick.' The writer Arnold Houbraken said that Rembrandt's paint was 'smeared on as with a rough house-painter's brush' or 'a bricklayer's trowel', and that Rembrandt 'once painted a picture in which the paint was so thick that you could lift it up from the floor by its nose'.

The critics suggested that clarity could be achieved by extra layers of varnish, making paintings easier to view; this led to Rembrandt's daytime scene of Captain Cocq's guards on patrol being nicknamed *The Nightwatch* because it appeared to be a nighttime scene after it had received too much varnish.

Right: Rembrandt Self-portrait as a Beggar, *1630. This etching is similar to a print of a beggar by Lucas van Leyden.*

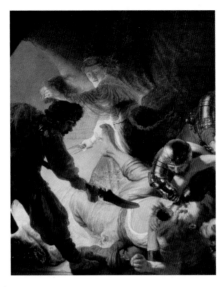

Above: The Blinding of Samson, *1636, oil on canvas.*

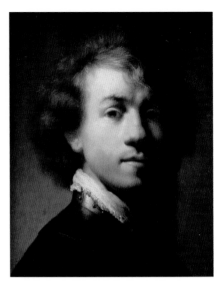

Above: Self-portrait, *1629, oil on canvas, produced when Rembrandt was 23.*

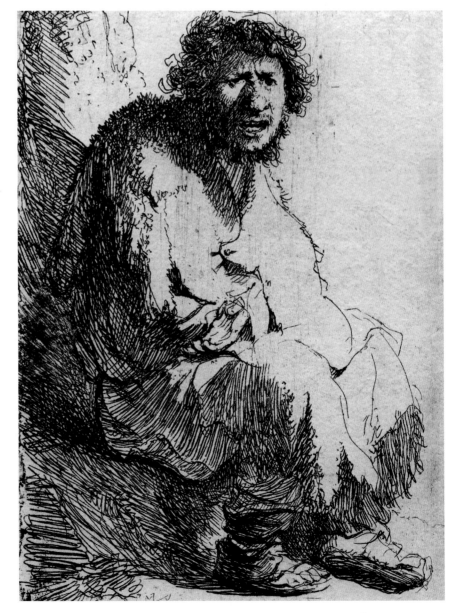

VISUALIZING MAN AND GOD

Raised in a family of mixed religion, both Protestant and Roman Catholic, Rembrandt studied the Bible and used his knowledge and understanding of it to paint powerful biblical narratives, such as scenes of the Nativity, which captured human emotion and frailty.

Rembrandt's father was a practising Reformant and his mother a Roman Catholic who recognized the Protestant religion of the Dutch Republic, and joined her husband in worship at his church. The religious tolerance that permeated his home life gave him a knowledge of both ideologies, and, like his mother, a devotion to the bible.

PAINTING PROTESTANTISM
The official religion of the Dutch Republic was the Protestant reformative religion, which disdained Roman Catholic adherence to outward signs of devotion, preferring the privacy of prayer. How was an artist to capture this difference? Post-Reformation the immediate action of the papal council

was to commission paintings that adhered to biblical narrative, only portraying the figures of persons mentioned in the Bible. Gone were patrons kneeling at the foot of Christ on the cross, or present at the birth of Jesus. Material wealth was not to be displayed as an outward sign for getting closer to God. For Protestants, ostentation and ceremonial were to be minimized, and prominence was given to the Holy Family, emphasizing the close bond between husband and wife, father, mother and child. Rembrandt repeatedly portrayed the figures of Jesus, Mary and Joseph, in scenes of the Nativity, their flight into Egypt, and Christ on the Cross. Despite the Catholic reformation veto on non-

biblical' portraits appearing within the biblical narrative of an artwork, Rembrandt painted himself in many of his religious works as a bystander or helper.

REMBRANDT'S BIBLE
Rembrandt's religious belief is hard to ascertain, with theories ranging from Calvinism to Anabaptism and interest in the Mennonites, all forms of Protestantism.

The majority of the religious paintings are his interpretations of Bible scriptures, additionally informed by other literary sources, previous works

Below: The Last Supper, *1495–97, Leonardo da Vinci (1452–1519), fresco.*

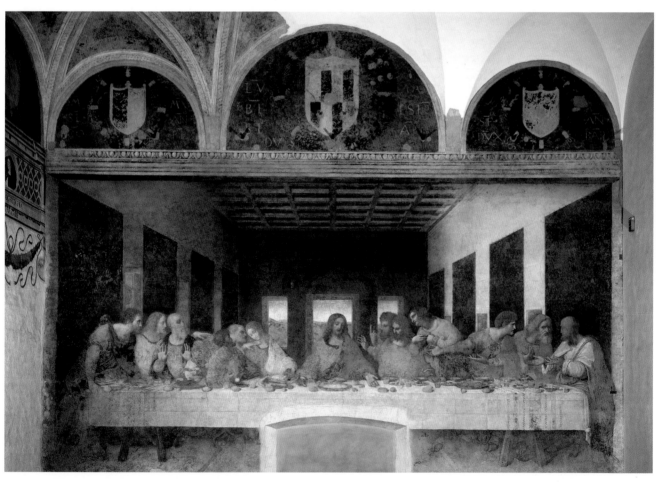

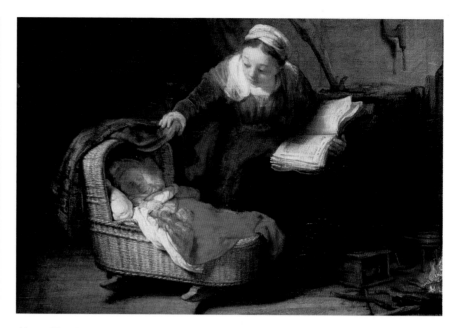

by other artists, and his own opinion. Some Rembrandt etchings of Bible scenes were copied – by Christoffel van Sichem II (1577–1658) or Christoffel van Sichem III (1618–59) – to illustrate *Bijbels Tresoor* (Treasures of the Bible), published in Amsterdam in 1646, which shows that his interpretations were approved by a wider audience than the buyers of his paintings.

PORTRAYING PREACHERS

Rembrandt created several portraits of his friend, the wealthy cloth merchant Cornelis Claesz. Anslo (1592–1646), a Waterlander Mennonite preacher of the Grojte Spijker Church in

Above: The Holy Family, *c.1645, (detail) oil on canvas.*

Amsterdam. The works included a superb double portrait of Anslo and his wife Aeltje Gerritsdr. Schouten, painted in 1641. An etching of 1640 was a solo portrait of the preacher seated at his desk, his left hand indicating an open Bible, the other holding a pen, resting on a book, as though momentarily interrupted from writing. Prints of it were perhaps for distribution to church followers. Joost van den Vondel (1587–1679), a fellow Mennonite, considered the greatest Dutch poet, was a close friend of Rembrandt and

Anslo. He disapproved of the portrait, believing that the preacher should convey the 'word' of God without seeking personal fame. He wrote a four-line stanza as critical comment:

O Rembrandt, draw Cornelis' voice.
The visible part is the least of him:
The invisible is known only by hearing,
He who would see Anslo must hear him.

Filippo Baldinucci, writing on Rembrandt in 1686, referred to the artist's interest in the Mennonite preachers of the 'Word'.

Baldinucci's source of information was the Danish painter Bernhard Keil (1624–1687), who worked in Rembrandt's workshop from 1642 to 1644.

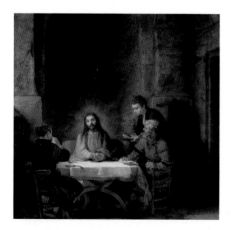

Above: The Supper at Emmaus *(detail), 1648, oil on panel.*

Right: The Last Supper, *c.1635, after the fresco by Leonardo da Vinci, red chalk on paper, black-and-white photograph.*

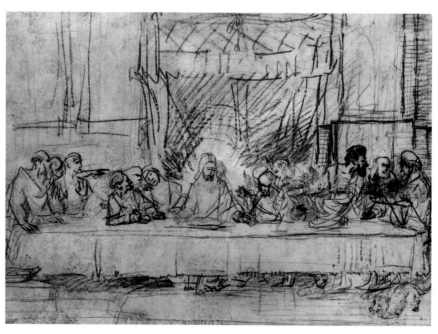

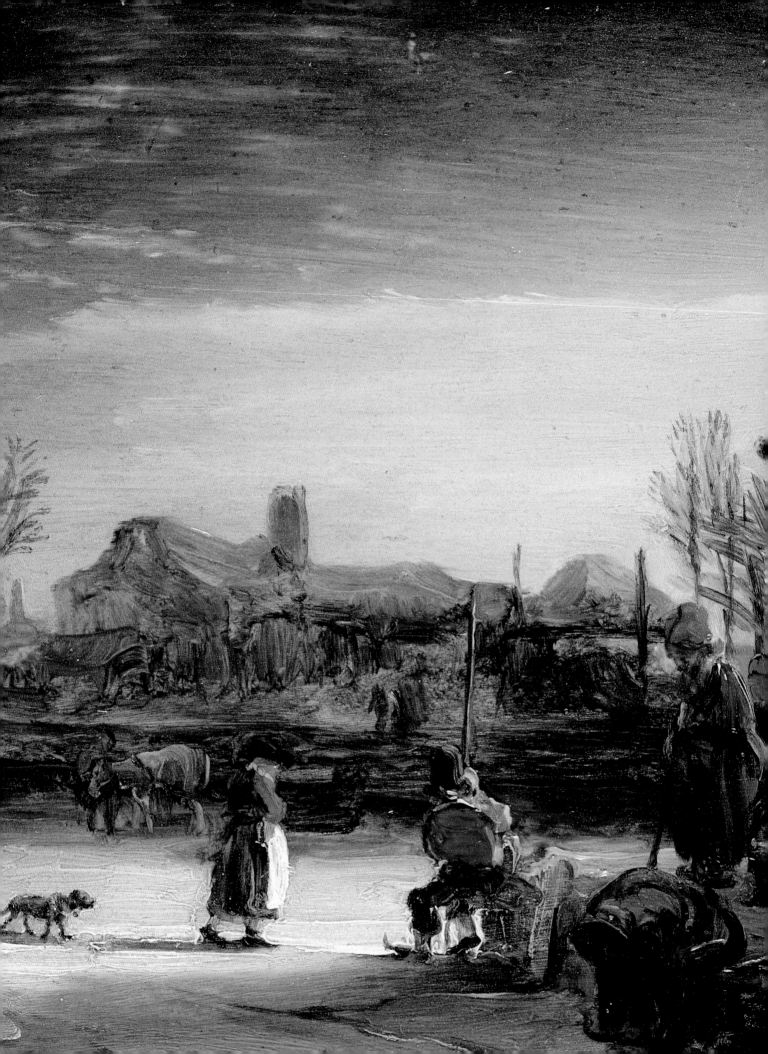

TRIUMPHS AND TROUBLES

In 1639, Rembrandt had moved to a grand house in Amsterdam. In his new home his wife Saskia gave birth to a son, named Titus, their first child to survive infancy. Rembrandt's lifestyle was enabled through the commercial expertise of his partner Hendrick Uylenburgh, who helped him to attract rich clients, as well as by his busy workshop with apprentices and assistants, and his school of pupils. His success fell away after the death of Saskia in 1642. After taking on a new relationship with Hendrickje Stoffels, his common-law wife, and the birth of a daughter, Cornelia, he was forced into insolvency in 1656. Through the support of his wife and son, Rembrandt continued to paint his commissions. They include some of his finest works. However, while his fame in Europe spread, in Amsterdam he lost contracts to younger artists, some to his former pupils. His last self-portraits reveal the face of a remarkable man, exhausted by life, but not beaten.

Above: The Nightwatch, *c.1642, (detail), oil on canvas.*
Left: Winter Landscape, *1646, oil on panel.*

REMBRANDT'S STUDIO

A stunning painting of Rembrandt's mother was created in Leiden by his first apprentice, Gerard Dou, who learned the subtleties of *chiaroscuro* from his master. Rembrandt set his apprentices and assistants to work in a busy workshop, and encouraged them to paint in his own style.

In Arnold Houbraken's three-volume book (1718–21), of the lives of Dutch artists, some of Rembrandt's assistants are named. His most famous pupils are known to us, such as Leiden-born Gerard Dou, Govaert Flinck (1615–60), who joined the workshop as a trained artist in 1633, and Ferdinand Bol in 1636–7. Carel Fabritius was another outstanding pupil; he died young, and much of his work was destroyed.

Rembrandt maintained an apprenticeship programme until the 1660s, inspiring a long list of professional artists.

A ROLL CALL OF FAME
The list of apprentices continues into Rembrandt's late years when Arent de Gelder (1645–1727) was a pupil from 1661–3. Over 50 apprentices, journeymen, and assistants of Rembrandt have been identified, by style if not by name; those unnamed are known as 'followers' of Rembrandt. A drawing by Constantijn Daniel van Renesse (1626–80), *Rembrandt's Studio with Pupils Drawing from the Nude c.1650*, illustrates the interior of Rembrandt's studio, with a large group of pupils observing a nude model for drawing practice.

A contemporary source cites Rembrandt renting a warehouse to convert to a studio, in order to accommodate his entourage of pupils.

JOACHIM VON SANDRART
From a brief biography of Rembrandt, written by a one-time assistant, Joachim von Sandrart (1606–88), we learn that wealthy families paid 100 guilders per year for their sons to be taught to paint by Rembrandt. Apart from this revenue, he sold the students' paintings, drawings and prints, realizing up to 2,500 guilders each year for his own account.

As discussed earlier, Guild of St Luke rules stated that apprentices could not sell or sign their own works until they had completed their three-year apprenticeship. This, however, did not stop the master of the workshop selling the works that students produced.

FERDINAND BOL (1616–80)
Growing up in Dordrecht, Ferdinand Bol first learned to paint there, or in Utrecht, under the supervision of Abraham Bloemaert (1566–1651), a painter and printmaker.

After 1630, Bol worked as an assistant in Rembrandt's studio in Amsterdam, opening his own workshop in 1642. A note in Rembrandt's handwriting on the back of a drawing by Bol refers to selling six artworks for a sum of 24 guilders and 6 stuivers. Three of the works were noted to be by Bol. Few artworks by the artist have survived, and some perhaps may have been misattributed to other artists.

Left: Portrait of a Husband and Wife, *1654, by Ferdinand Bol (1616–80), oil on canvas.*

Right: An Artist in his Studio, *17th century, by Carel Fabritius (1622–54), one of Rembrandt's most gifted pupils.*

A NOTABLE PORTRAIT

An oil-on-canvas *Portrait of Elisabeth Jacobsdr. Bas* 1640, the widow of Jochem Hendricksz. Swartenhont, painted by Bol, reveals his debt to Rembrandt, in the use of *chiaroscuro*, and the composition. The portrait depicts her in a skirt and jacket in black silk. In her hand she holds a handkerchief; on her head she wears a starched cap with wing tips, an old-fashioned type of headwear at the time the painting was created. This portrait, which closely follows Rembrandt's style, was painted shortly before Bol left Rembrandt's studio to set up his own workshop. The painting was thought to be by Rembrandt until research in the early 20th century revealed it to be by Bol.

A comparison in style can be made to Rembrandt's *Double Portrait of the Mennonite Preacher Cornelis Claesz. Anslo and his Wife Aeltje Gerritsdr. Schouten,* 1641. After he left Rembrandt's studio Bol's style changed, as can be seen in *Portrait of a Husband and Wife,* 1654, and his own *Self-portrait,* (1667), in which he is dressed as a prosperous burgher, wearing a Japanese robe.

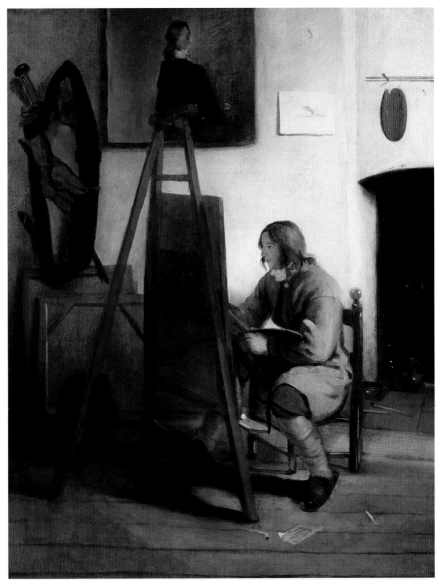

Above: Mother of Rembrandt, *17th century, Gerard Dou. This was one of his depictions of Rembrandt's mother.*

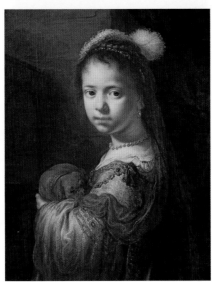

Above: A Little Girl with a Puppy in her Arms, *late 1630s, Govaert Flinck (1615–60), oil on canvas on panel.*

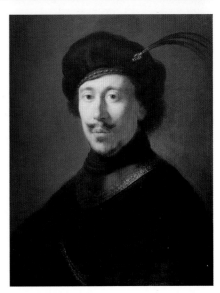

Above: Young Man in a Gorget and Plumed Cap, *1630s, Isaac de Jouderville, oil on panel.*

DEATH IN THE FAMILY

In 1641, Saskia gave birth to her fourth baby, a boy named Titus, the only one who lived more than a few weeks. Afterward, Saskia was weak and in ill health. Rembrandt produced some poignant drawings of her at this time. In 1642, at the age of 29, after eight years of marriage to Rembrandt, she died.

The death of Saskia van Uylenburgh left Rembrandt a widower and his only child Titus without a mother. He witnessed the deaths of many close family members between 1635 and 1642. Throughout this period Rembrandt continued to work on some of his finest paintings.

A PERIOD OF MOURNING

The death of Rembrandt's mother in 1640, and that of his beloved sister-in-law, Titia, added further grief to the earlier loss of three infant children born to Rembrandt and Saskia in 1635, 1638 and 1640. The death of Saskia, shortly before her 30th birthday, was a hard blow to Rembrandt. During 1630–42 he had produced a great many self-portrait prints, but he now turned to prints of the bleak Dutch landscape.

A DIFFICULT WILL

A few weeks before her death, Saskia drew up a will that left her share of their combined estate to their son Titus, to be handed over to him on coming of age. (It was eventually released to him when Titus was 24 years old.) In the intervening years, the interest gained from it was available to Rembrandt as the father and guardian of their son. Saskia further stipulated that if Rembrandt remarried, her share of their estate would fall to her sister, not Titus. This was an unusual arrangement but one which was binding in law. Her motives are not clear: she appears to have wanted to secure her son's future, but also to keep the money in her own family – even at the risk of Titus losing it, if Rembrandt remarried. (One can only guess at her reasons for trying to discourage such a marriage.) However, she would have had no reason to suspect that Rembrandt's success and prosperity would not continue.

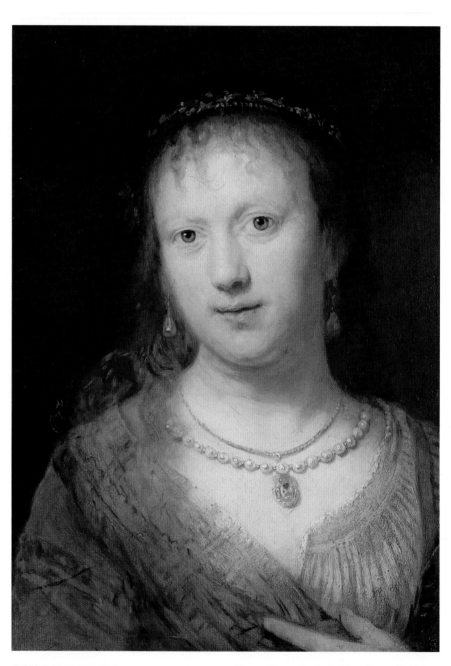

GEERTGHE DIRCX

Titus was nine months old when Saskia died. Rembrandt needed a nursemaid for his son. His mother, his wife and Titia, his sister-in-law, were dead. The position of nursemaid was given to Geertghe Dircx, the widow of a trumpeter. She is described by the biographer Arnold Houbraken

Above: Portrait of Saskia, after a Painting by her Husband Rembrandt Harmensz van Rijn, *Johann Andreas Joseph Francke, (1756–1804), oil on canvas.*

(1660–1719) as 'a little farm woman… rather small of person but well made in appearance and plump of body'. She entered the van Rijn household either

1642: ETCHINGS FOR SALE IN PARIS

At the time Rembrandt was experiencing anguish at home, in Paris, his prints were in demand. On 28 March 1642 the first purchase of Rembrandt etchings in Paris is recorded, in a sale of four prints to an Italian engraver and printmaker, Stefano della Bella (1610–64), born in Florence. The printmaker was said to be enchanted by the naturalism of Rembrandt's etchings. A series of prints of *Heads in Oriental Dress*, later created by Stefano, are informed by Rembrandt's work. He visited the Netherlands, including Amsterdam in 1647, with particular interest in Rembrandt and the Dutch School of Landscape painting. On his return from Paris to Florence in 1650, he worked for the Medici family and instructed the young Cosimo de' Medici (1642–73) in drawing. In 1667, Cosimo made a personal visit to Rembrandt in Amsterdam.

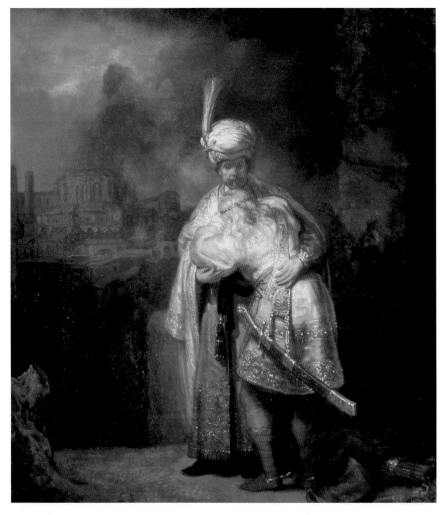

just before, or soon after Saskia died. Geertghe remained with him for seven years, looking after Titus and the house. The relationship between Geertghe and Rembrandt is difficult to unravel. Historians have speculated that she was living with Rembrandt, possibly as his common-law wife, but not much is known about this.

Below: The Angel Departing from Tobit and his Family, *1641, pen and ink on paper.*

Above: David and Jonathan, *1642, oil on panel.*

Below: Sick Woman in a Bed, *c.1640, Rembrandt van Rijn (or studio), pen and bistre on paper.*

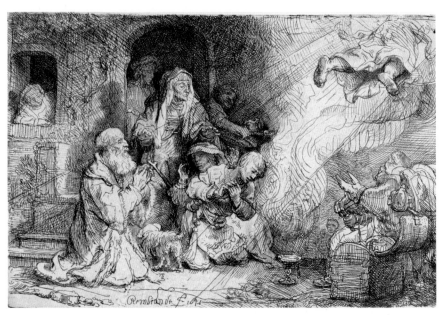

CAPTAIN BANNING COCQ

The vast canvas, *Officers and Guardsmen of the Amsterdam Civic Guard Company of Captain Frans Banning Cocq and Lieutenant Willem van Ruytenburgh*, painted in 1642, is recognized as one of Rembrandt's greatest paintings. It was famously, and erroneously, named '*The Nightwatch*', owing to the excess of varnish applied to the picture.

In the 1630s in Amsterdam, the Kloveniersdoelen, the new headquarters for the civic guard, was erected next to the older Svych Wtrecht tower, by order of the governors. On the first floor of the building, a large hall was planned, for meetings and banquets. The vast space of the 'Great Room' was to be used for official civic guard functions, to welcome official delegations, both domestic and foreign, and to receive royalty.

A SUBSTANTIAL COMMISSION

To commemorate the new building, a series of paintings of the six companies of civic guards was initiated. The large-scale paintings were contracted to a variety of artists: Govaert Flinck,

Nicolaes Elias, Joachim von Sandrart, Jacob Adriaensz. Backer, Bartholomeus van der Helst and Rembrandt. The honour of painting the troop of Frans Banning Cocq, the captain of the company that took the main position inside the city gates, fell to Rembrandt. Civic portraits of companies were usually commissioned just before the guards had finished their period of duty. A commemorative painting would be paid for by the guards and each member of the group would pay for his portrait, possibly as much as 100 guilders, and some less, depending where they stood or sat, and the time required to paint their portrait. Each member would visit the artist to have their portrait added to the picture.

'THE NIGHTWATCH'

The composition of Rembrandt's vast painting, *Officers and Guardsmen of the Amsterdam Civic Guard Company of Captain Frans Banning Cocq and Lieutenant Willem van Ruytenburgh*, or *The Nightwatch*, as it is familiarly known, shows the influence of an earlier militia group portrait, *Company of Captain Dirck Jacobsz. Rosecrans and Lieutenant Pauw* 1588, painted by Cornelis Ketel (1548–1616). The earlier painting portrays the 13 officers of the Arblast militia company in full-length portraits. Each militia man is indicated by his weapon. The captain of the company,

Below: The Nightwatch, c.1642, oil on canvas, Rijksmuseum, Amsterdam.

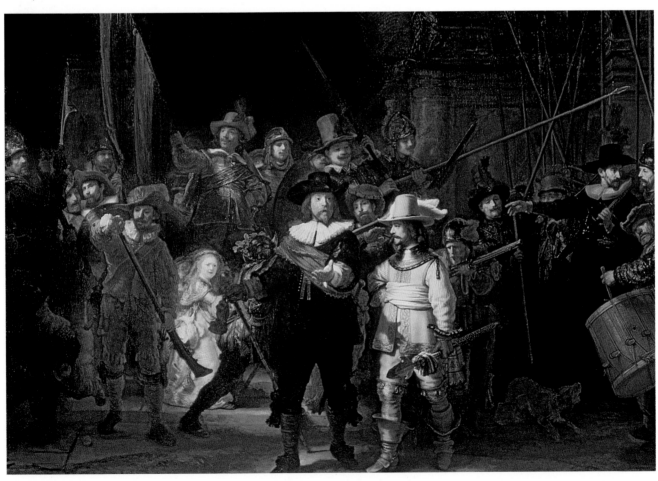

CAPTAIN FRANS COCQ

The commission was instigated by Captain Frans Banning Cocq. A text in his family album, relating to a watercolour drawing made after the painting, mentions a sketch of the picture in the Civic Guard House. Captain Cocq possibly commissioned a smaller copy painting of Rembrandt's original, executed by the Dutch artist Gerrit Lundens, *The Company of Captain Banning Cocq (The Nightwatch)* after 1642. The Lundens copy shows the original painting before it was cut down in size. This occurred when it was removed from the headquarters to the Town Hall. The painting was reduced on all four sides so that it would fit between two columns.

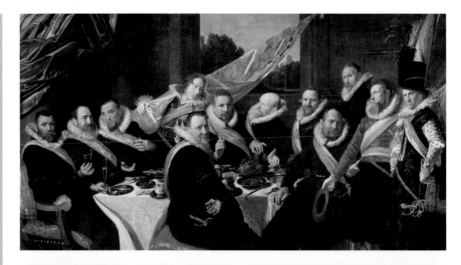

Dirck Jacobsz. Rosecrans, is the central figure. He carries a baton, and gestures toward the viewer with his left hand.

CAPTURING THE MOMENT

In Rembrandt's portrayal of Captain Cocq's men, he paints the assembled group and bystanders in full length. Other paintings in the series copy this format, and it may have been a general instruction to the group of painters, due to the floor to ceiling placement of the finished works in the Great Room of the Kloveniersdoelen. The portrait of each man was expected to be lifelike and easily recognized. Following the painting's completion many members of the company, with the exception of Cocq and Ruytenburgh, were not happy with the manner of their depiction individually, and as a company.

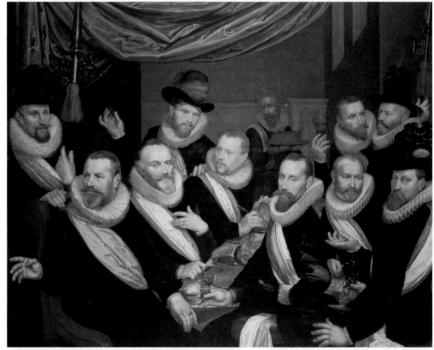

Top right: A Banquet of the Officers of the St. George Militia Company, *1616, Frans Hals (1582/3–1666).*

Centre right: Banquet of the Officers and Subalterns of the Civil Guard of San Jorge, *1618, Frans de Grebber, (1573–1649).*

Right: The Managers of the Haarlem Orphanage, *1663, Jan de Bray (c.1626–97).*

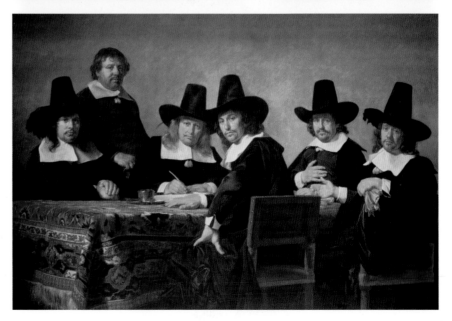

PORTRAITS IN DEMAND

To portray a person as if captured at a specific moment in time was a recent innovation in the Netherlands, and new qualities became apparent in Dutch artists' portraits of their sitters to highlight their intelligence, their devotion, or their moderate character.

The two main traditional categories of portraits were those painted for the private home, to mark an occasion such as birth, death, betrothal or marriage, and those produced to serve a public function. In the Dutch Republic, nobility and public achievement were the prime motivations for formal portrait commission, but private informal portraits were becoming fashionable.

PUBLIC FORMALITY

The oil-on-panel *Portrait of Prince Maurits, Stadhouder c.1625*, was painted by Michiel Jansz.van Miereveld (1567–1641), a native of Delft, when

Below: Jacob de Gheyn (c.1596–1641), *1632, oil on panel.*

Prince Maurits was commander-in-chief of the Dutch Republic in 1590. As befitting the highest military official, the Prince is depicted with military symbols: a sword, a shield, a plumed helmet, boots and spurs. In the portrait he wears a gilded suit of armour that the States-General had given him for a military victory at Nieuwpoort in 1600. He was instrumental in the removal of the Spanish army from the Dutch Republic. The portrait, showing the symbols of a successful military leader, is intended to claim the stadholder's indispensability to the States General and the Republic. This is the second portrait of the subject. The first was painted in 1607, in near three-quarter length, by the same artist.

FASHIONABLE INFORMALITY

A double portrait of a wealthy merchant, Isaac Massa, and his wife, Beatrix van der Laen, *Married Couple in a Garden*, 1622, was painted by the Haarlem-based painter Frans Hals, on the occasion of the sitters' marriage. It exemplified the new taste for informal double portraits. The traditional double portrait, a pair of separate pendant paintings, often cameos, would be hung together, with the profiles of the man and woman facing each other. The woman's portrait would hang on the right, to the side of the man's left hand. The left was symbolically the lesser side, with the man's right-hand side being the more valued position. While Hals conformed to this symbolic positioning

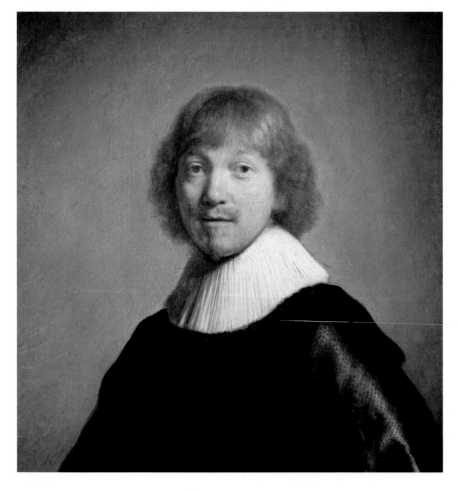

REMBRANDT, 'THE MISER'

Rembrandt produced many portraits of himself during his lifetime. However, the anecdotal 'portrait' painted of him by some former pupils, and retold by Arnold Houbraken, related to Rembrandt's miserly greed. Houbraken says that apprentices played tricks on the artist, to highlight his parsimony. After painting *trompe l'oeil* coins in various locations of the studio, they would watch him try to pick them up without others noticing. '…often for fun [the pupils] would paint on the floor or elsewhere, where he was bound to pass, pennies, two-penny pieces and shillings…' According to Houbraken, Rembrandt 'frequently stretched out his hand in vain, without letting anything be noticed as he was embarrassed through his mistake'.

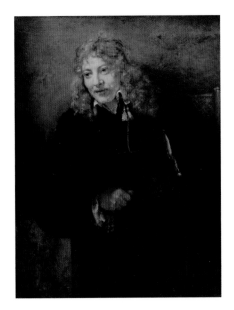

Above: Portrait of Nicolaes Bruyningh (1629–30 to 1680), 1652, oil on canvas.

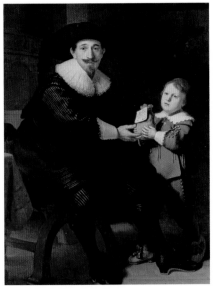

Above: Jean Pellicorne and his Son Caspar, c.1632, oil on canvas.

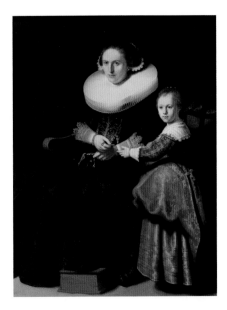

Above: Susanna van Collen, Wife of Jean Pellicorne with her Daughter Anna, c.1632.

of the woman on the man's left side, he introduced an informality; rather than portray them indoors in formal poses, he shows them outside, appearing at ease with one another. The facial expressions, demeanour and clothing of Hals patrons' excude confidence and prosperity. The portraits of this era also reflect the wealth and confidence of the new Dutch Republic. The touching of Massa's right hand to his breast was a symbol of fidelity. The thistles at Massa's feet and the ivy encircling the feet of his bride Beatrix were further symbols of fidelity and eternal love. An unusual feature is that Hals painted the couple smiling, which was a rarity at that time.

DOUBLE PORTRAITS

Rembrandt captured the essence of a relationship, at a specific moment in time, in his double portraits. The oil-on-canvas *Portrait of Jan Rijcksen and His Wife, Griet Jans* (*The Shipbuilder and His Wife*) 1633, is set in the residence of Jan Rijcksen, a shipbuilder. In his right hand he holds a geometry compass; his papers on the desk show drawings of ship designs. Part of the painting, a top section above the heads, since removed, enlarged the room. From an etching made by Johannes de Frey in

1800, one can see that it added a spatial awareness which is absent in the painting today. It was possibly removed in the early 19th century. The painting in its present state focuses solely on the couple, losing Rembrandt's portrayal of their surroundings. He created a pair of pendant double portraits, that of *Jean Pellicorne and His Son Caspar c.1632*, and

Susanna van Collen, Wife of Jean Pellicorne, with Her Daughter Anna, c.1632. The wife and daughter face toward the right, and the father and son toward the left. He also created many single pendant portraits, such as *Portrait of a Man Rising from His Chair*, 1633 and *Portrait of a Young Woman with a Fan*, 1633, representing a married couple.

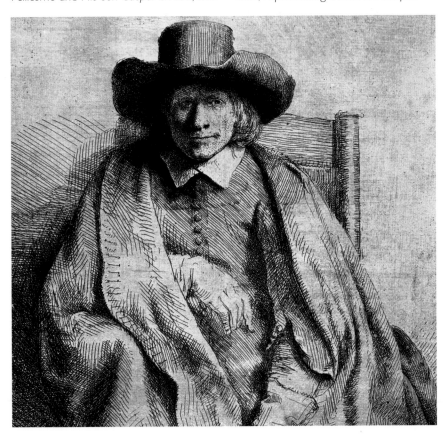

Right: Clement de Jonghe, *1651, etching, drypoint and engraving, (IV states).*

A PRESTIGIOUS COMMISSION

In 1652, a young gentleman from a wealthy merchant family, Jan Six, commissioned a portrait of himself to be painted by Rembrandt. The work is considered to be one of Rembrandt's finest portrayals, in its use of colour, light and realism.

Jan Six (1618–1700) was born into a wealthy family of cloth merchants. His status as an aristocratic gentleman allowed him to fraternize with the artistic community of Amsterdam, while collecting art, writing plays and poetry, and involving himself in city life.

PORTRAIT OF A GENTLEMAN READING

Rembrandt's association with the Six family may have begun in 1641, when he was commissioned to paint a portrait of Jan Six's mother. Following this, other commissions had fallen his way, including the production of the etching *Jan Six* 1647, illustrating a domestic interior with Jan Six standing, leaning back against a window ledge with his back to the light, reading. Drawings were made prior to the etching and Jan Six obviously knew exactly what impression he wanted Rembrandt to create. The picture shows a relaxed, intelligent-looking young man, and Six was pleased with it. He also insisted on keeping the etching plate, an unusual request – Rembrandt always kept his etched plates – but he may have wanted to make further copies, or to prevent Rembrandt doing so, and perhaps altering it without his knowledge. He commissioned Rembrandt for further work. One immediate contract was for an illustration of Jan Six's play *Medea* (1647), which was to be published. It is perhaps that work that Six reads in Rembrandt's portrayal of him.

AN *ALBUM AMICORUM*

In Jan Six's circle it was a popular pastime to compile an album of favourite literary extracts. In 1652, Rembrandt provided Six with two

illustrations for his family's *album amicorum*, one of Minerva and the other of Homer. The first showed a woman, probably Jan Six's mother, whom Rembrandt had previously painted, sitting reading. Surrounding her are symbols of the Roman goddess of wisdom, the mythical Minerva. The second illustration depicted the Greek poet, the blind Homer (*c.*8th century BC), reciting his heroic poetry to an attentive audience on a hilltop. Art historians have pointed out that the portrayal of Homer mirrors Raphael's depiction of Apollo and his Muses in the *Parnassus* fresco (*c.*1510), located in the Stanze della Segnatura of Pope Julius II, in the Vatican, Rome, which Jan Six may have seen.

FINANCIAL DIFFICULTIES

The following year Rembrandt asked Jan Six for a loan of 1,000 guilders, a loan which Six later passed on to another party, Gerbrand Ornia. This debt would be transferred again, to Lodewijk van Ludick, an art dealer who had guaranteed the original loan, and again to Herman Becker.

All the debt carriers were known to Rembrandt, some were already carrying other promissory notes from him, to be paid with paintings or etchings. It was well known that Rembrandt was in debt and heading toward bankruptcy. It signalled the beginning of a cooling of the relationship with Rembrandt's patron, Jan Six, yet in the same period Rembrandt offered to sell three

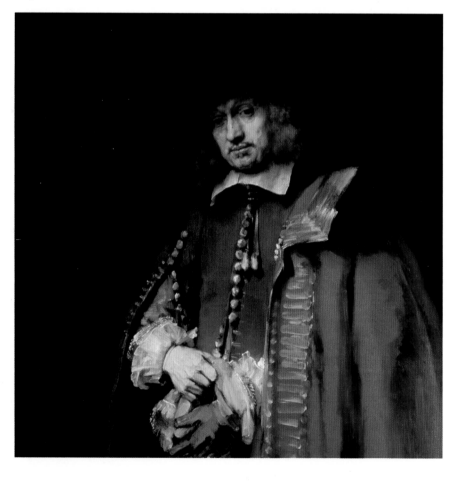

Right: Portrait of Jan Six *(1618–1700) 1654, oil on canvas.*

MEDEA

In 1647, Jan Six (1618–1700) wrote and produced a play, *Medea*, performed at the Schouwburgh, Amsterdam and directed by Jon Vos, a friend of Rembrandt. The following year the play was published in Amsterdam and Rembrandt was chosen by Six to produce a dramatic visualization for the frontispiece of the book. The etching *Medea* (1648), also known as *The Marriage of Jason and Creusa*, perhaps reflects the setting of the staged version but not the content, which had not featured the marriage of Jason and Creusa onstage. The architectural location of Rembrandt's drawing in some respects overpowers the figures, with the exception of Medea who lurks in the shadows at bottom right, holding the dagger with which she will kill her sons fathered by her former lover Jason, and a poisoned robe, her wedding gift to the bride Creusa, Jason's new love.

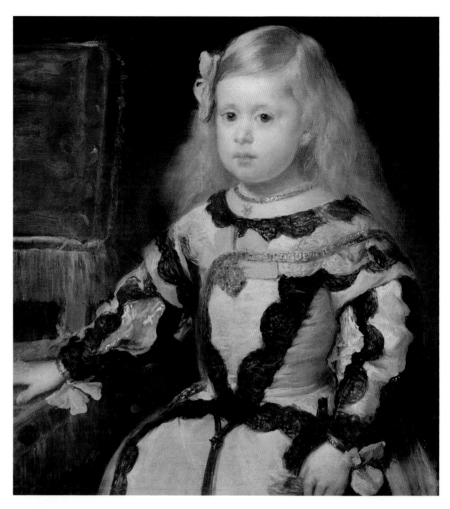

of his earlier paintings to Six, who was an avid art collector. One of these was a painting of Saskia, Rembrandt's wife, *Saskia van Uylenburgh in a Red Hat*, (1633–42).

PORTRAIT OF A PATRON

Following the many studies made of Jan Six, possibly as many as six preparatory drawings for the etching of Jan Six standing at a window reading, the

Above: Portrait of the Infanta Maria Marguerita (1651–73) 1654, Diego Velázquez, (1599–1660). Velázquez, a Spanish contemporary of Rembrandt, was also much in demand for portraiture by European nobility.

oil-on-canvas portrait that was contracted was quickly executed. Rembrandt chose to paint Six in three-quarter length, looking toward the viewer. *Portrait of Jan Six* (1654) is considered to be one of Rembrandt's finest works and yet the portrait illustrates a certain tension between patron and painter. Six looks impatient to be elsewhere, far from the painter's gaze. He stands with coat on and gloves in hand, as though he has stepped into the studio to ask a question before leaving for other business. The portrait did not cement the relationship between patron and artist. It was a final work for Six from his unmanageable painter. In 1656 he chose Govaert Flinck to paint a picture of his bride, to mark the occasion of his marriage.

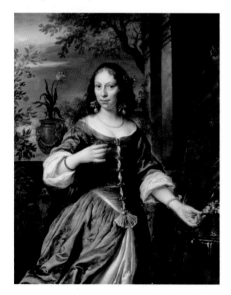

Above: Portrait of Margaretha Tulp as a Bride, 1655, Govaert Flinck (1615–60), oil on canvas.

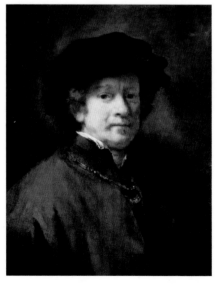

Above: Self Portrait with Cap and Gold Chain, 1654, oil on canvas, when the artist was around 48 years of age.

A NEW MISTRESS

In the late 1640s, a young Dutch girl serving as a maid entered the van Rijn household. Hendrickje Stoffels, aged 23, from Bredevoort, was the daughter of a soldier. She would become Rembrandt's mistress, supplanting the live-in housekeeper, Geertghe.

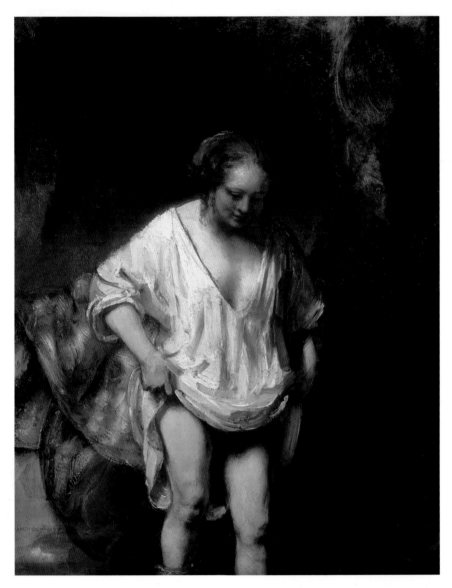

Left: Woman Bathing in a Stream, *1654, oil on panel.*

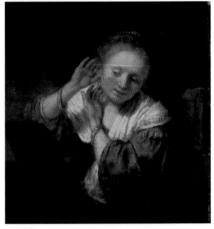

Above: Young woman Trying on Earrings, *1654–7, oil on panel.*

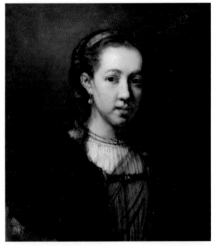

Above: Portrait of a Lady, *17th century, oil on canvas.*

Hendrickje's quiet, pleasing manner and youthfulness – she was 20 years younger than Rembrandt – endeared her to the family, particularly Titus, Rembrandt's son, if not to Rembrandt's live-in help, Geertghe. Hendrickje would usurp Geertghe in Rembrandt's affections, and become mistress.

COURT ACTION

Acrimony between Geertghe, who believed she had been cast aside by Rembrandt for Hendrickje, found the older woman taking Rembrandt to court for refusal to meet an unwritten agreement to marry her. This seemed unlikely because the details of Saskia's will ensured that should he remarry, Saskia's estate would return to the Uylenburgh family. When Geertghe was finally dismissed, she brought a lawsuit against him, stating that he had promised to marry her and had given her a betrothal ring, which was a rose ring inlaid with diamonds, and a marriage medallion, although it was not inscribed. She had tried to sell the ring but the Uylenburgh family claimed that the jewellery had belonged to Saskia, Rembrandt's deceased wife, and was part of the family possessions. Geertghe took the matter to the Dutch court, stating that she had lived in Rembrandt's house as his common-law wife. The accusation led to a judgement against Rembrandt, with the conclusion

A HOUSE IN HANDBOOGSTRAT

Documentation shows that in 1655 Rembrandt tried to raise a loan to buy a house in Handboogstrat. It was cheaper than his current home, and the move would help to reduce his debts. In the early 1650s, official papers show that he chased clients for money owed to him, and also sought repayment of money that he had loaned to others. The economic depression, caused by the 1652–4 Anglo-Dutch War, meant that money was in short supply. Rembrandt offered 7,000 guilders for the house in Handboogstrat – 4,000 guilders mortgage and 3,000 guilders paid in paintings and etchings – but the offer was not accepted. In 1655, he auctioned personal effects, etchings and drawings, but they failed to raise sufficient funds for the sale to proceed.

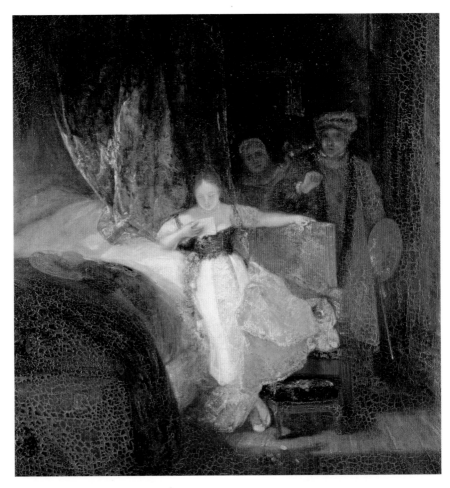

that he pay her 200 guilders per year, a sum he paid until 1655, at around the time he was battling against bankruptcy. Following the acrimonious settlement, in 1650 Geertghe was committed to an institution in Gouda. Rumours spread that her incarceration was connected to Rembrandt. She remained there for five years.

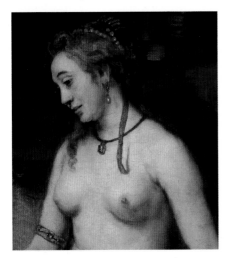

Above: Bathsheba Bathing *(detail), 1654, oil on canvas.*

BIRTH OF A DAUGHTER

In 1654, a case was brought against Hendrickje Stoffels by the Reformed Church, accusing her of whoredom and of living with a man, unwed. In between the legal suit, and the damages sought by Geertghe, Hendrickje became pregnant, proof that she was more than a maid in Rembrandt's house.

Above: A Young Woman Sleeping *(Hendrickje Stoffels), c.1654–5.*

Above: Rembrandt's Daughter, *1827, Joseph Mallord William Turner (1775–1851), oil on canvas.*

The Reformed Church of Amsterdam accused her of 'living in sin with Rembrandt the painter'. She and Rembrandt received a summons to appear before the Church Council. He was not an active member of the church, and the matter was dropped; Her punishment was banishment from special church occasions. A daughter was born to Hendrickje and Rembrandt on 30 October 1654. She was named Cornelia, possibly after Rembrandt's mother, or Rembrandt's two daughters born to Saskia.

COMMON-LAW WIFE, MOTHER AND ROLE MODEL

During this turbulent period, Rembrandt painted many pictures of his younger lover. He captures her beauty in paintings such as *Hendrickje Standing in a Doorway,* 1654, *Bathsheba Bathing* 1654, and *Hendrickje Bathing,* 1655.

FAMILY MATTERS

During a four-year period, from 14 July 1656, when Rembrandt claimed insolvency, until 15 December 1660, when he moved to a new home, the courts went through the process of selling his house, his collections and his household goods.

On 1 February 1568, Rembrandt's house in Jodenbreestraat was repossessed for non-payment of monies outstanding to the owner. Rembrandt and his family remained in the house while the courts sold his collections and household goods, to pay his debts.

Below: Portrait of Hendrickje Stoffels, *c.1656–7, oil on canvas.*

HOUSE MOVE

Prior to insolvency, Rembrandt had tried to avoid arbitration and pay off part of the loan with the sale of two paintings to Christoffel Thijsz. The deal fell through and the house was sold on 18 December 1660 to new owners. Rembrandt moved to a smaller, rented house on Rozengracht in the Jordaan district, paying a rent of 225 guilders per annum. Here he would spend the remaining nine years until his death. The area was less affluent than Breestraat. The house looked on to a park and pleasure garden. In the years during and following the insolvency, loss of possessions and the upheaval of a house move, Rembrandt created many portraits of his common-law wife and his son. Their mutual support is documented in these intimate portrayals.

THE ARTIST'S APPRENTICE

Rembrandt taught his son Titus to paint and draw, and his work must have helped family finances. Titus van Rijn inevitably followed his father, learning his craft. Rembrandt's portraits of his son, such as *Titus* (c.1655), showing a quiet, thoughtful boy at his desk, or the relaxed *Titus Reading* (c.1656), suggest a warm, intimate relationship between them.

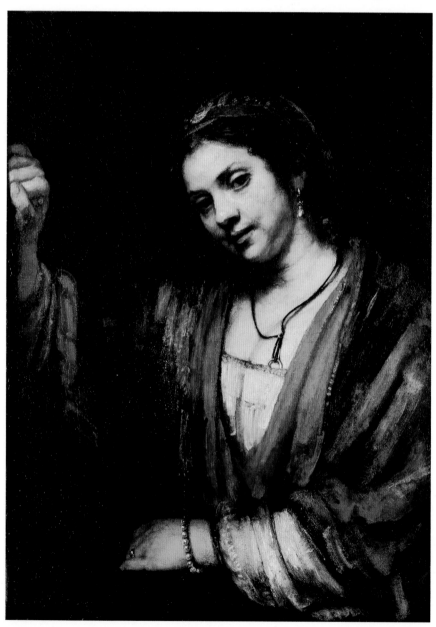

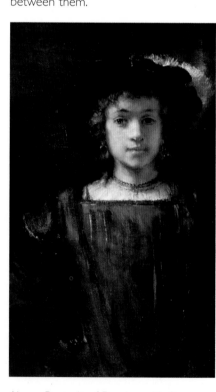

Above: Portrait of Rembrandt's Son Titus, *1655, follower of Rembrandt.*

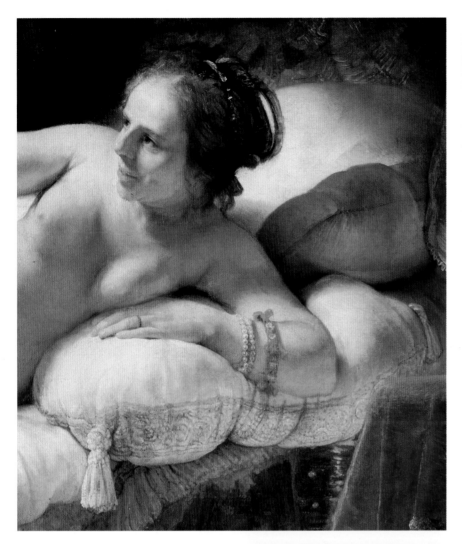

Above: Danaë, *1643, oil on canvas. The mythological figure is waiting for Zeus to come and shower her with gold.*

TITUS AS ART DEALER

Titus and Hendrickje took the running of Rembrandt's business seriously. In 1665, Titus reassured one prospective buyer that his father made not only etchings but engravings: '[he] has but recently engraved such a rare little woman with a pap-pot near her that all the world has been quite amazed by it' ('*heeft nu onlanghs sulcken curieusen vroutgen met een pappotgen by haer hebbende gesneden dat al de wereld daerover genouchsaem is ver-wondert*'). Rembrandt continued to paint portraits, but was still not earning enough money to finance his loans and debts.

Right: Portrait of Hendrickje Stoffels with a Velvet Beret, *c.1654, oil on canvas.*

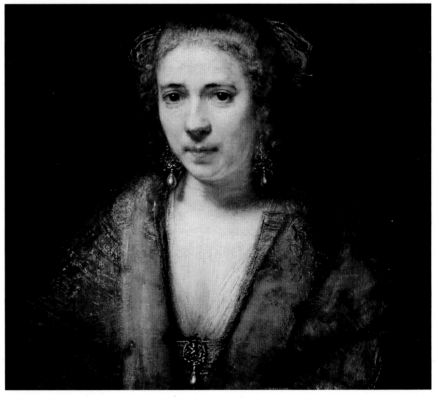

GENRE PAINTING

Dutch genre paintings focused on scenes of the everyday life of a vast cross-section of humanity: anonymous people, the peasants in the fields and at market, families within the home and drinkers at the inn. These works sold more easily than historical subjects.

Considered a term for small scale paintings that did not fall into a traditional classification such as history or portrait painting, 'genre' paintings' or 'drolleries', as the English traveller John Evelyn put it, were highly popular in the Netherlands. Rembrandt concentrated on 'tronies', which were a form of genre painting.

GENRE PAINTERS

There were many masters (and mistresses) of genre painting in Rembrandt's era, such as Frans Hals (1580–1666), Willem Pietersz. Buytewech (1591–1624), Adriaen Brouwer (1605–38) and Judith Leyster (1609–60), artists who painted a vast variety of different subjects. The Dutch did not have a single term to describe genre paintings, grouping them instead into types of scenario, such as *bordeeltjen* ('bordello'), *buitenpartij* ('outdoor party') and *geselschapje* ('merry company'). Their origin partly stemmed from popular emblem

paintings, which were realistic but carried a moral message that could be deciphered easily by the viewer.

TRONIES

The 'tronie' was a very popular type of art in the Netherlands in the 17th century. It was the term for a portrait of an anonymous sitter, usually a close-up of the head or face, or half-length. Rembrandt painted many tronies, for example *The Laughing Man* (1629–30), and *Man with a Feathered Beret c.*1635.

Tronies were usually painted or drawn from a live model, and often were a self-portrait of the artist in character, or perhaps a colleague, friend or family member. Tronies were non-commissioned works, created to sell in the Dutch art market. Many tronies were experimental, too: the artist might try out the effects of light and shade, different facial expressions and emotions, such as laughing or sadness, and poses in

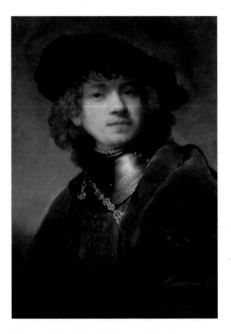

Above: 'Tronie' of a Young Man in Gorget and Beret, *(self-portrait of Rembrandt), 1639, oil on panel.*

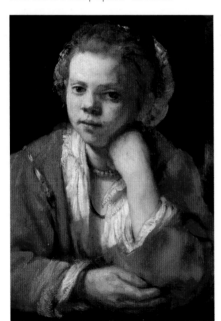

Above: The Kitchen Maid, *c.*1651, oil on canvas.

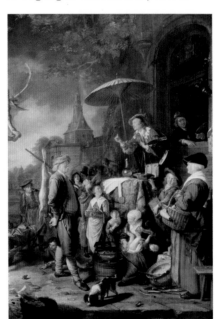

Above: The Quack, *c.*1652, Gerard Dou, oil on canvas.

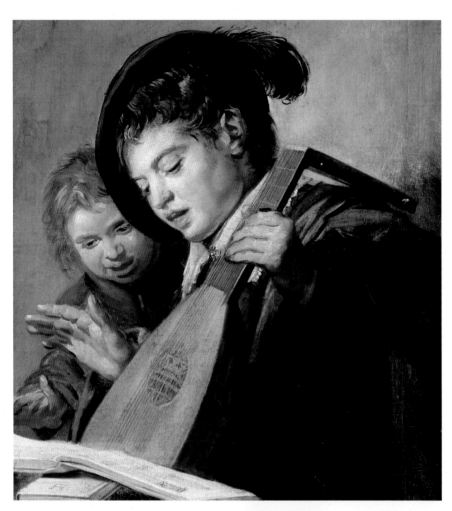

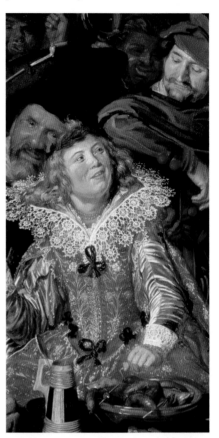

Below: Shrovetide Revellers (The Merry Company) *c.1615, by Frans Hals (1582/3–1666), oil on canvas.*

Above: The Singing Boys, *1623–27, Frans Hals (1582/3–1666), oil on canvas.*

which the model is typecast as rich or poor, or dressed as a soldier or shepherdess. Often a face or head from a larger work, such as 'Judas' in Rembrandt's *Judas and the Thirty Pieces of Silver,* was copied to make a tronie, and sold in paint or print form.

One of Rembrandt's 'tronies' *Man in a Gorget and Feathered Cap* (1629–30) was copied by an assistant, Johannes van Vliet (c.1610–88), to create a new tronie *Man in a Gorget and Cap with Feather, after Rembrandt,* (c.1630–1). The work was published erroneously as *Portrait of the Transylvanian Prince Georg Rákóczy,* (1591–1648), in 1631. Rembrandt did not receive royalties on any copies of his works.

Right: Beggars Receiving Alms at the Door of a House, *1648, drypoint engraving.*

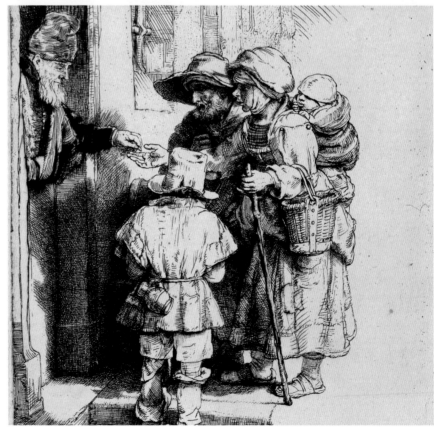

INSOLVENCY

Rembrandt made a decision to become insolvent - *cessio bonorum* - to avoid his creditors' claims against him. The action would give him time, and control of the sale of his possessions, rather than being pushed to bankruptcy.

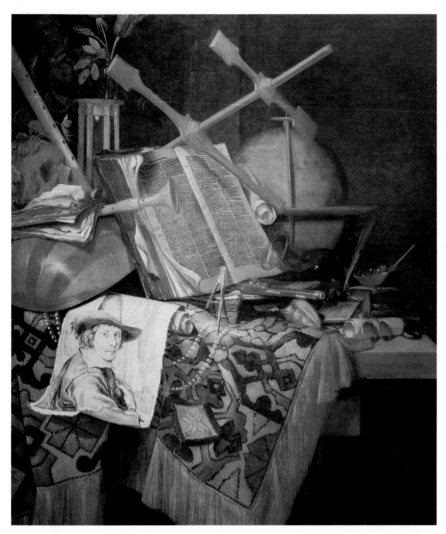

Left: Vanitas, 1656, Vincent Laurensz van der Vinne (Haarlem 1629–1702), oil on canvas.

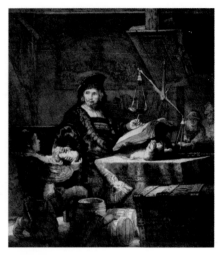

Above: The Dutch Banker, *1639, engraving, after Rembrandt Harmensz. van Rijn.*

On losing his house and his possessions to insolvency, it is a measure of Rembrandt's frame of mind that he did not let the legal procedures stunt his artistic creativity, knowing that some of his debts could be paid with paintings.

LEGAL NOTICES

The formal documentation of Rembrandt's possessions for sale was written by Frans Bruijningh, secretary of the Insolvency Office of Amsterdam, and headed: 'Inventory of the paintings as well as furniture and household goods found in the estate of Rembrandt van Rijn, living on the Breestraat near the Sint Antoniessluis.' The list was drawn up over 25 and 26 July 1656. To become insolvent, rather than bankrupt, would limit financial claims against Rembrandt. It would give him greater control over the selling of his possessions and the ability to buy another house. For present-day historians, the inventory drawn up by Bruijningh – the catalogue of Rembrandt's possessions prior to sale – illuminates the artist's interests in fine and decorative art. Included in the inventory are East Indian bowls, Chinese baskets and wind instruments, a Japanese helmet and weapons, shells and marine life specimens.

1656 INVENTORY

The household goods inventory was taken on a room-by-room basis. In the hallway were 12 paintings by Rembrandt, 4 by Jan Lievens and 4 by Adriaen Brouwer, 1 by Hercules Seghers, and 1 'finished' by Hendrick Anthonisz, and in the anteroom 42 further paintings, including history paintings, landscapes and seascapes by Rembrandt, Jan Porcellis, Simon de Vlieger, Jan Pynas, Lucas van Valckenborch and others. The inventory shows that the secretary moved on to the room behind the antechamber, to find 18 paintings and 2 drawings including a work by Jan van Eyck plus an oak press and 4 chairs. Then on to the back room or salon, which included a bed, and in reference to paintings, 'a small ox from life by Rembrandt' and a 'large painting of the Samaritan woman by Giorgione…', of which half belonged to an associate, 'Pieter la Tombe' (a seller of books and prints), one of two

works jointly owned by them. The inventory proceeded to list the objects 'in the large painting room', where paintings and a cast of a baby by Michelangelo were included; and then on to the painter's shed in the courtyard, finding two lion skins and other art props, and a small office, which contained a desk and a bed and more paintings by Rembrandt.

THE ART ROOM

The inventory secretary carried on up spiral stairs to the art room. Here, among 150 itemized objects, were many of Rembrandt's art props, including his near-complete collection of busts of Roman emperors, plus '8 large pieces of plaster cast from life', including a death mask of Prince Maurits of Orange. The list itemized a collection of medals, and 2 large globes – one possibly terrestrial, the other celestial, a selection of armoury pieces, including halberds, helmets and shields; natural history pieces, curios, and Rembrandt's vast collection of prints and drawings. This was contained in 25 albums and books. It is estimated that he owned about 9,000 separate sheets of his own

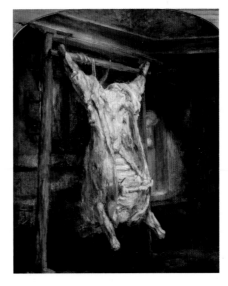

Above: The Slaughtered Ox, *1655, oil on canvas.*

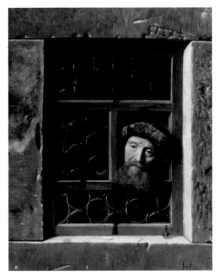

Above: Man at a Window, *1653, Samuel van Hoogstraten (1627–78).*

drawings, and 4,000 of his prints. In addition, around 1,500 prints in his collections were by other artists, mainly 16th-century Italian and Dutch works. In the list are books of drawings by Heemskerck and Mantegna. Two portfolios of drawings are further categorized by type such as nude studies, possibly drawn by Rembrandt during his students' life classes, or during his own

studies, and classed as 'A book full of drawings, by Rembrandt of men and women; they being naked.' The portfolios were divided into nudes, landscape and genre. The inventory of Rembrandt's possessions gives us insight into his taste in design, books, art and artefacts.

Below: An Allegory of Summer, *16th century, Lucas van Valckenborch.*

REMBRANDT'S ETCHED COPPERPLATES

Not listed in the 1656 inventory is Rembrandt's collection of etched copperplates. Some would have been in the hands of publishers, producing licensed prints, and some of the early copperplates had been sold, such as a second plate of *The Descent from the Cross*, 1633. However, it is possible that the courts allowed Rembrandt to keep most of them, to create further prints. Also missing from the inventory were his tools for etching, his prints from etchings, and his library. An alternative theory is that Rembrandt sold the etching plates in 1855, or he may have pawned them, in order to regain them afterward. This was a known ploy for those facing the immediate seizure of goods.

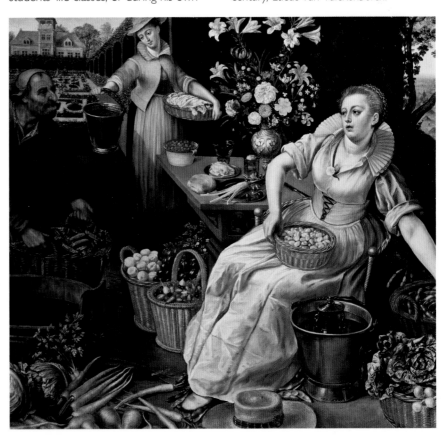

COLLECTIONS FOR SALE

In 1656, an inventory of Rembrandt's possessions was drawn up in preparation for their sale, to aid funding of his insolvency. The catalogue gives a snapshot of his life through the comprehensive listing of his most private possessions, which included his own etchings.

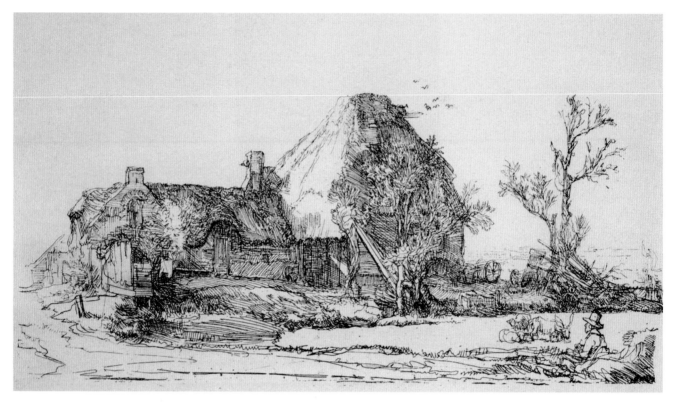

Baldinucci wrote that in the 1640s Rembrandt had purchased many of his own etchings 'at intolerable prices' and had them brought back to Amsterdam, 'from all over Europe, wherever he could find them, at any price'. The remark, if accurate, shows Rembrandt's insatiable appetite for collecting paintings, etchings and drawings, even his own.

POPULAR PRINTS

Houbraken, writing in 1718 on the popularity of Rembrandt's prints, stated that 'the passion was so great at that time that people would not be taken for true connoisseurs who did not have the 'Juno' with and without the crown, the 'Joseph' with the white and the brown face, and other such things. Aye, the woman by the stove, albeit one of his lesser works, each must have with and without the white cap, and with and without the stove-key.'

SELLING PRINTS AND DRAWINGS

To sell one or two works at a time could prove profitable, but a glut on the market would possibly have reduced the immediate value of works. For Rembrandt, it must have been difficult to watch an inventory clerk walking from room to room, drawing up a list of the artworks that he had accumulated throughout his working life, knowing that they were to be sold on. The total sum received at auction was less than their normal market value.

ITALIAN WORKS OF ART

Rembrandt's collection included eight paintings by Italian artists, or followers of them, and a more extensive collection of Italian prints and drawings, which he clearly studied and learned from. There were four books of prints by Antonio Tempesta (1550–1630), and Rembrandt's etching *The Lion Hunt*

Above: Landscape with Farm Building and a Man Sketching, *c.1645, etching with drypoint.*

'THE PRECIOUS BOOK OF ANDREA MANTEGNA'

The north-Italian early Renaissance artist Mantegna (c.1431–1506) inspired many Italian and European artists who knew his artworks. Rembrandt owned a print book of Andrea Mantegna's works. That this volume was noted as 'precious' in the 1656 inventory acknowledges the artist's respect for Azndrea Mantegna. Rembrandt's composition of *The Anatomy Lesson of Dr Joan Deyman* (1656) closely follows Mantegna's *The Lamentation over the Dead Christ* (c.1470–80).

Rght: The Entombment, *1658–9, first state etching.*

c.1629, closely relates to Tempesta's engraving *The Lion Hunt*, c.1590. Again, Rembrandt's etching, *Jupiter and Antiope*, c.1631, shows similarities to the etching *Jupiter and Antiope*, 1592, by Annibale Carracci (1560–1609).

The sale of possessions may have included some works by Federico Barocci (1528–1612), for there is a strong compositional connection between Barocci's etching *Virgin and Child in the Clouds*, c.1570–80, and Rembrandt's etching *Virgin and Child in the Clouds*, 1641, an unusual subject, and one which relates to Catholicism.

Below: Parable of the Ruthless Creditor, *17th century, pen & brown ink on paper.*

Below: Landscape with a Windmill, *17th century, pen & ink on paper.*

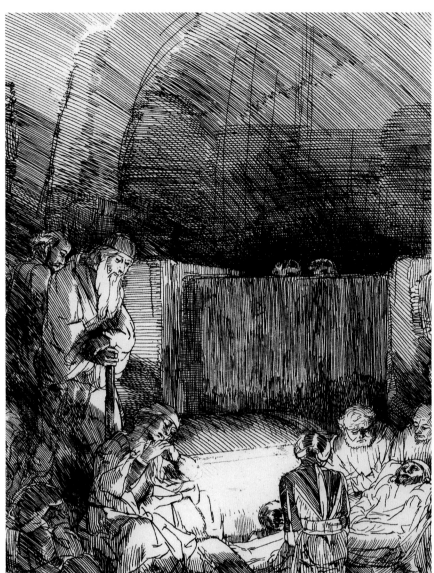

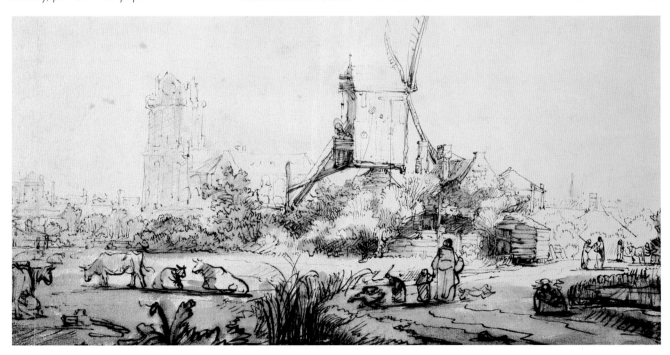

A NEW START

By December 1660, the legal matters involved with Rembrandt's insolvency finally came to a close. He was in a position to make a fresh start, but new regulations of the Guild of St Luke would not allow someone who was insolvent to trade in Amsterdam.

To avoid creditors and to conform to the Guild of St Luke's new regulations, Rembrandt arranged with Hendrickje and his son Titus, to become an employee of a company formed in their name, thereby not trading in artworks himself. In addition, it would mean that monies he earned went directly to the family, not creditors.

A FAMILY BUSINESS

Learning from the monetary mistakes he had made in the past, Rembrandt did not own anything that could be seized to pay creditors. The legal formation of the new company was witnessed by a notary. Hendrickje and Titus, acting as company directors, could trade in 'paintings, graphic arts, engravings and woodcuts as well as prints and curiosities'. Profits, losses and family possessions were equally shared. It removed the fear of bankruptcy from Rembrandt's shoulders. In addition, legally, he was allowed to live with

Below: The New Bridge at Amsterdam *(engraving), Dutch School, (17th century), Bibliotheque des Arts Decoratifs, Paris, France, black-and-white photograph.*

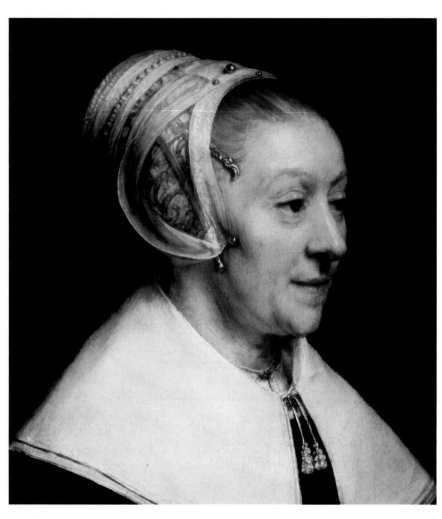

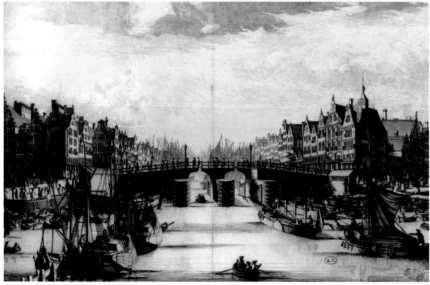

Above: Portrait of Catherine Hoogsaet (detail of head), *1657, oil on canvas.*

them, rent-free, with board, in return for a continuous supply of artworks as payment. A quirky addendum stated that should either of the company directors remove or take something from the house, a sum of 50 guilders could be taken from their salary. As the directors were Rembrandt's common-law wife for over ten years, and his beloved son, this clause must have been for the sake of the creditors, who still circled. The terminology added a professional distance between family and business, a perfect arrangement

Right: Amsterdam: Labore and Sumptibus, from Geographie Blaviane, 1662, Joan Blaeu, (1596–1673), hand coloured etching.

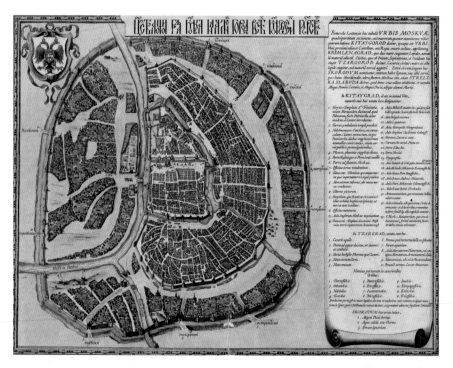

GUILD OF ST LUKE REGULATIONS

New regulations brought in by the Guild of St Luke in 1660 would not allow artists who had to sell up (through insolvency or bankruptcy) to trade in the city. It necessitated Rembrandt selling his artworks through Hendrickje's and Titus's new company. However, he evidently still had difficulty paying off his debts. His 1,000 guilder loan from Jan Six, sold on several times, was now with Harman Becker, a dealer and moneylender; and in 1662 and 1663 he received further loans from Becker in return for pledges of nine paintings and two books of drawings. Documentation dated 27 October 1662 shows that Rembrandt sold his deceased wife Saskia's grave plot in the Oude Kirk for 200 guilders.

which freed the family from the fear of bankruptcy. Once again, after many years in debt, Rembrandt was free to paint for profit.

A HUMAN DISSECTION

Rembrandt was contracted by the Surgeon's Guild in 1656 to paint another dissection, which was timely, owing to his shaky financial position. Dr Joan Deyman had succeeded Dr Nicolaes Tulp as *praelector anatomiae* in 1653 of the Guild of Surgeons, Amsterdam. *The Anatomy Lesson of Dr Joan Deyman*, 1656, was to be a dissection of the brain, a rarity in Dutch public dissections. The Guild of Surgeon's Anatomy Theatre records report that the day prior to the dissection, 'on 28 January 1656, there was punished with the rope Joris Fonteijn of Diest, who by the worshipful lords of the lawcourt was granted to us as an anatomical specimen'.

Right: An Actor Standing, c.1630–31.

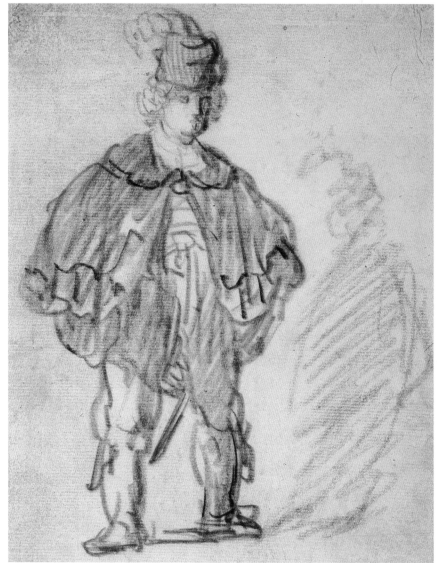

RECOGNITION IN PRINT

In contrast to the dire position that Rembrandt found himself in as an insolvent, his name and reputation were travelling beyond Amsterdam. Writers, art critics and art historians praised his work, and many came to The Netherlands to see his work and that of other Dutch artists.

Many foreigners visited Amsterdam, Utrecht, Haarlem, Delft and The Hague, to track down the Dutch artists whose fame had spread across Europe. In Amsterdam, the talented artists emerging from Rembrandt's school and workshop added weight to his reputation.

POSITIVE PRAISE

Overall, Rembrandt received praise from his countrymen, the writers and poets who followed his progress after Huygens' rapturous approval in 1628. There were dissenting voices too, primarily aimed at a particular work of art, rather than a personal criticism of him. Although historians of art consider that 'Dutch art' did not exist as a concise

Below: The Yarmouth Collection, *c.1665, Dutch School, oil on canvas.*

topic in the 17th century, in 1640 an English writer, Peter Mundy, on a visit to the Netherlands, wrote in his diary:

> As For the art off Painting and the affection of the people to Pictures, I thincke none other goe beyond them there having been in this Country Many excellent Men in that Facultty some att present, as Rimbranyy, etts. All in generall striving to adorne their houses, especially the outer or street roome, with costly peeces. Butchers and bakers not much inferiour in their shoppess, which are Fairely sett Forth, yea many tymes blacksmithes, Coblers, etts., will have some picture or other by their Forge and in their stalle…

Dutch poets and writers recognized Rembrandt's qualities in print too. A poem by Lambert van den Bosch

Below: Constantijn Huygens and His Clerk, 1627, by Thomas de Keyser (1596/7–1667), oil on panel.

Above: Still Life of Books and a Rembrandt Engraving, *17th century, Sebastian Stoskopff, (1596/9–1657).*

(1610–98) – also known as Lambertus Silvius – published in 1650 included Rembrandt's name in praise of his artwork in the collection of Martin

Kretzer, alongside the name of Peter Paul Rubens. His stanza on Rembrandt is simple in form:

*I will not attempt your fame
O Rembrandt, with my pen to scrawl
For the esteem you receive in every
hall Is known when I merely mention
your name.*

Above: Portrait of Signor Simone del Signor Alfonso Tucci, *1660, Filippo Baldinucci (1624–96), pencil and red chalk on paper.*

Below: Portrait of Maximilian I, Elector of Bavaria, *after 1641, Joachim von Sandrart (1606–88), oil on canvas.*

DIEGO D'ANDRADA

In spite of being in debt, or because of it, in 1654 Rembrandt had an altercation with a client, a Portuguese merchant named Diego d'Andrada, who threatened legal action. Rembrandt had been contracted by the merchant to paint a portrait of a young girl. An advance deposit of 75 guilders was paid. The painting did not please the client; he felt it was a poor likeness of the girl, a claim disputed by Rembrandt, who said he would ask Amsterdam's Guild of St Luke, to ascertain likeness. The merchant asked for the painting to be reworked or his deposit returned. Rembrandt refused to return the money, or alter the painting, only agreeing to take back the painting and sell it at auction if d'Andrada was still not satisfied. The outcome of the affair is unknown.

A RUINOUS COMMISSION

Rembrandt's only public commission for a history painting was one in a series of artworks commissioned for Amsterdam's new Town Hall in 1659. The history series was intended to decorate the lunettes in the Great Hall although it did not remain there for long.

At the end of the 80-year war for independence, the Treaty of Münster was signed in 1648, the same year that a symbolic civic building, a new town hall in Amsterdam, was instigated.

AMSTERDAM TOWN HALL

Rembrandt was contracted to depict *The Conspiracy of Claudius Civilis* (1661–2). The original contract had gone to Govert Flinck (1615–60), a former pupil of Rembrandt's who some believed had surpassed his teacher. He had been commissioned in 1659 to paint seven (or possibly twelve) lunettes, relating to the uprising of the

Right: The Conspiracy of the Batavians under Claudius Civilis, *c.1666, (detail), oil on canvas.*

Below: The Town Hall, Amsterdam, *1690, Gerrit Adriaensz Berckheyde (1638–98), oil on canvas.*

Batavians against the Romans, for a fee of 12,000 guilders. He had begun work on the project with a series of sketches but died unexpectedly. The contract was distributed to several artists. Rembrandt was contracted for one of the series. He was to paint an oath-

taking by Claudius Civilis and Batavian leaders in AD69–70, who were united in revolt against the Romans. The commissioners viewed this battle in the same light as the 1568 Dutch uprising, which was a revolt against the Spanish overlord Philip II of Spain.

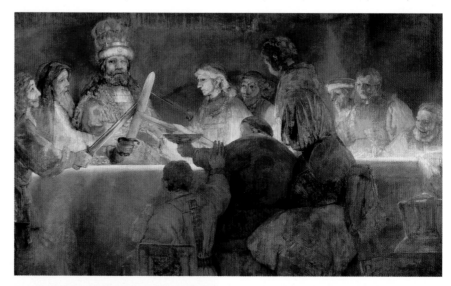

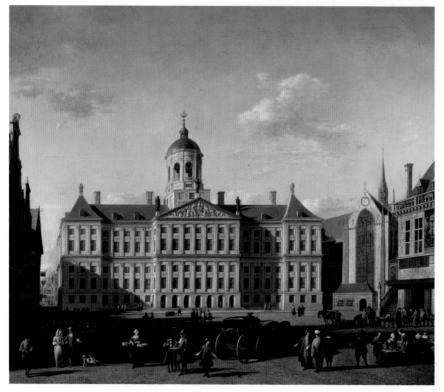

PROFILE PORTRAITS

Artists of the Italian Renaissance popularized profile portraits, copying the ancient Roman fashion for cameos. Piero della Francesca (c.1415–92) used this format to depict Duke Federigo da Montefeltro (1422–82). The duke had been shot through the right eye by an arrow. After the accident he was depicted in the majority of portraits from his left side, including one by the Netherlandish artist, Justus van Gent (Joos van Wassenhove; c.1410–80), *Federigo da Montefeltro and his son Guidobaldo* (c.1474–5). Rembrandt chose to ignore this type of vanity and fashion for the antique, and portrayed Claudius Civilis, as he was in life, blind in one eye.

PAINTING HISTORY

The oath-taking and battle were reported in *Histories* 4:68, written in AD109, by the Roman senator and historian, Tacitus (AD56–117). He recorded that Claudius Civilis, a member of Batavian royalty and a noted leader in the auxiliary Roman army, united with fellow Batavians in revolt against the Romans. The rebellion was suppressed by the Roman commander Quintus Petillius Cerialis Cesius Rufus. The Batavi, a Germanic tribe, lived close to the Rhine, in part of the modern-day Netherlands. Rembrandt closely followed Tacitus' account that 'Civilis collected at one of the sacred groves, ostensibly for a banquet, the chiefs of the nation and the boldest spirits of the lower class.' Tacitus records that Civilis was 'wont to represent himself as Sertorius (d.72BC) or Hannibal (248–183BC)' because he had the same disfigurement (the loss of one eye).

TACITUS AS A PRIMARY SOURCE

Rembrandt chose to interpret Tacitus' account closely. He set the banquet at night. The sacred grove was visualized with an architectural background. The night scene allowed him to utilize his mastery of *chiaroscuro*, to depict the one-eyed Civilis wearing a royal crown,

Below: Claudius Civilis Leaving the Women and Children to Go to Fight at Xanten, *1662, Jurgen Ovens.*

Above: Meeting between Claudius Civilis and the Commander of the Roman Army, *17th century, Frans de Jongh, (fl.1666–1705), oil on canvas.*

in a circle of Batavian leaders, their swords touching Civilis' sword, taking the oath of allegiance. The painting was originally much larger in size than it is today and at 5 × 5m (16 × 16ft) would have been Rembrandt's largest painting. A preparatory drawing by him, *The Conspiracy of the Batavians under Julius Civilis* in pen and ink, gives an insight into his plan for the full-size work.

AN UNFAVOURABLE RECEPTION

The finished artwork was not looked on favourably by civic leaders. Rembrandt's visualization was perhaps too realistic. The group looked rebellious and unruly. The depiction of the leader with one eye was not appreciated; a profile image, not showing the blinded eye, was perhaps what was expected, as in the painting by Frans de Jongh, *Meeting between Claudius Civilis and the Commander of the Roman Army.* Whatever the reason, Rembrandt's painting was removed in 1662 and replaced with a work by artist Jurriaen Ovens (1623–78). It was believed that he was not paid for the commission and later Rembrandt cut it down to 2 × 3m (6½ × 10ft). The reduction was possibly to make it more saleable, or to fit the walls of a private house.

Right: Fire at the Old Amsterdam Town Hall, 17th July 1652, *from a book* Firefighting in Holland, *published c.1700.*

FOREIGN PATRONAGE

Rembrandt's fame as an artist had rapidly spread across Europe, and he was held in greater esteem abroad than at home. Wealthy foreign buyers invested in his paintings and etchings, paying vast sums. Buyers and agents visited Amsterdam to seek further works.

Rembrandt never travelled very far from his home in Amsterdam, covering an area of perhaps 110km (68 miles) in circumference. His works, however, were seen all over Europe, even during his lifetime.

'ARISTOTLE' GOES TO SICILY

In 1653, Rembrandt put the finishing touches to a painting now referred to as *Aristotle*. It portrays a wealthy man, standing with one hand on his hip, looking toward a marble bust on a table. In the 18th century, it was thought to portray the ancient Greek philosopher Aristotle (384–322BC), contemplating a bust of the ancient Greek poet Homer (8th century BC). Nothing had been written by Rembrandt to corroborate this later view. The *Aristotle* painting was commissioned by a Sicilian nobleman, Don Antonio Ruffo (1610/11–78), a passionate art collector. His agent, Giacomo di Battista, negotiated the purchase of the work through Cornelis Gijsbrechtsz, a prosperous Amsterdam merchant.

An inventory taken in 1678 revealed that Ruffo's palace in Messina held a total of 364 paintings sourced from European artists.

DON ANTONIO RUFFO

Ruffo was interested in Rembrandt's work, paying 500 florins, a very high price, for the *Aristotle* work. It was shipped to Messina, Sicily, in 1654. Shortly afterward, it was catalogued in the palace inventory as a 'half-length figure of a philosopher, possibly Aristotle or Albertus Magnus'. Further commissions from Don Antonio Ruffo were issued to Rembrandt through Ruffo's agent but there was a certain tension and irritation in the relationship between artist and patron. Paintings did not materialize, possibly because

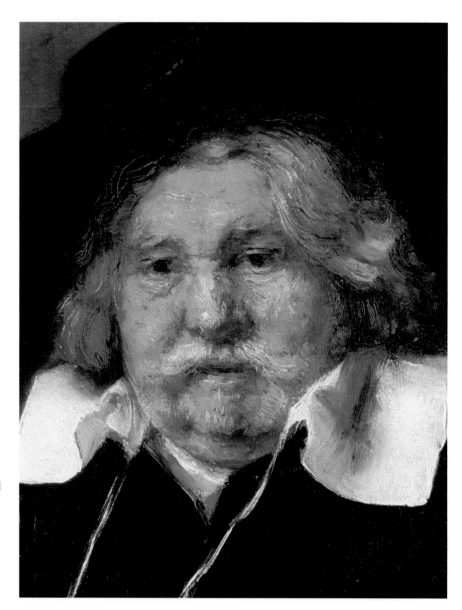

Rembrandt could not guarantee the date of starting or delivery. He liked to take his time; his strong-willed temperament would not allow patrons to dictate his method of working. This may also be a reason why some buyers bought his paintings from a selection that he had completed, not that he painted to order. In the 1660s, Ruffo's agent tried again, this time for paintings of 'Alexander the Great', now lost, and a painting of Homer. Shortly before

Above: Portrait of an Old Man, *1667, (detail), oil on canvas.*

Rembrandt died, Ruffo requested a collection of prints from Rembrandt's etchings; 189 prints were sent to Sicily.

GUERCINO PAINTS A PENDANT PORTRAIT

The respect that Rembrandt was given by Ruffo and Italian artists is proven in a letter, dated 13 June 1660 from

Right: Portrait of Cosimo III de Medici *(1642–1723), by Theodor Verkruis (1646–1739), engraving, frontispiece from* I Pregi della Toscana, *by Fulvio Fontana, published 1701.*

the Italian Baroque artist Giovanni Francesco Barbieri (1591–1666), popularly known as Guercino, to his patron Ruffo, six years after the arrival of the 'Aristotle' for Ruffo's art collection.

In the letter, Guercino eagerly agreed to paint a companion piece to Rembrandt's work, in the 'vigorous manner' of the 'Aristotle' painting. Rembrandt's reputation abroad was considerably higher than at home. Guercino told Ruffo that he was familiar with Rembrandt's etchings and admired them. A drawing of Rembrandt's 'Aristotle' was duly sent

to Guercino, who finished his pendant painting by October 1660, within four months of the initial contract. Guercino referred to

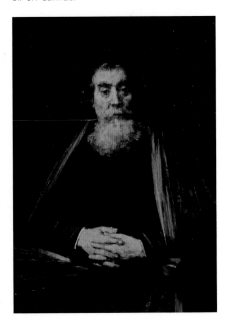

AN AUDIENCE WITH COSIMO DE' MEDICI

In December 1667, the young Cosimo de' Medici (1642–1723), later Cosimo de' Medici III, Grand Duke of Florence, travelled to the Netherlands and visited artists in Amsterdam. On 29 December, he paid a call on Rembrandt in his studio. In his travel diary the prince describes Rembrandt as a famous painter (*'pittore famoso'*). Cosimo had already acquired a self-portrait of Rembrandt, *Self-portrait* (1655; Galleria degli Uffizi, Florence, Italy), and was possibly seeking to purchase another. The Medici family were noted for their collection of artists' self-portraits, which continue to line the walls of the corridor above the Ponte Vecchio in Florence.

Rembrandt's painting as a portrait of a *fisonomista* (physiognomist). He referred to his own painting as a portrait of a cosmographer, to balance the microcosm and macrocosm, a humanist ideal.

Left: The Suicide of Lucretia, *1666, oil on canvas.*

Below: Portrait of an Old Man, *1665, oil on canvas.*

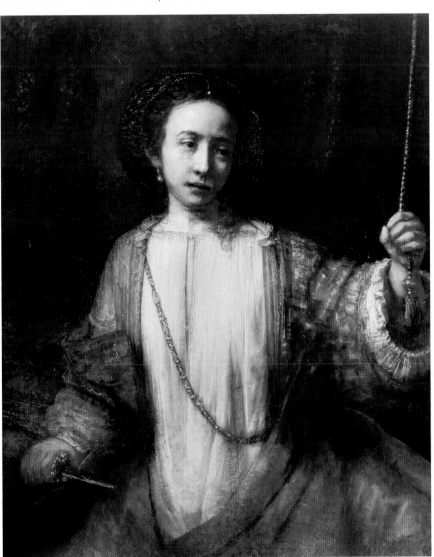

LATE WORKS

Paintings and drawings created during Rembrandt's last decade are a mix of portraits, religious subjects and street-life reality. The self-portraits from these years are regarded as some of his greatest works, but at the time they were produced, he was losing popularity.

Group portraits were a good source of much-needed income. In 1661–2 the controllers of the cloth samples, the sampling officials of the Drapers' Guild, approached Rembrandt for an official portrait.

THE SYNDICS OF THE DRAPERS' GUILD

The sampling officials, or syndics, are recorded as 'five sample masters, of four different religious beliefs, in brotherly unity around a table…' In his

portrait painting *The Syndics of the Drapers' Guild of Amsterdam* 1662, two of the seated men hold open a cloth sample book. It was their role to maintain quality consistency of dyed-cloth standards. The location was described in 1765 by a historiographer of Amsterdam, Jan Wagenaar 'Downstairs in the Staalhof [sample house]… is a large room where the cloth is sampled or leaded, and a courtyard where it is first

Below: Self-portrait, *c.1668–9.*

hung for inspection: a room where the five cloth wardens, also called syndics, appear in turn, one at a time, three times a week… to judge the materials and put their seal on the black and blue cloths that are the only kind brought to the Staalhof.' Wagenaar wrote: 'In this room hang six paintings of syndics from the 16th and 17th centuries. The oldest is dated 1559.' In each painting Wagenaar noted that five wardens were seated with the Staalhof steward standing. Rembrandt's picture followed this tradition.

'HUSBAND AND WIFE'

Two separate portraits, of Rembrandt and Hendrickje, possibly planned as pendants, not only reveal the personalities of the common-law husband and wife, but the artist's supreme mastery of portraiture. At this stage in his career one could say that Rembrandt outclassed Rubens, yet he was losing work to younger artists, some his former pupils.

Below: Portrait of the Artist at His Easel, *(detail), 1660, oil on canvas.*

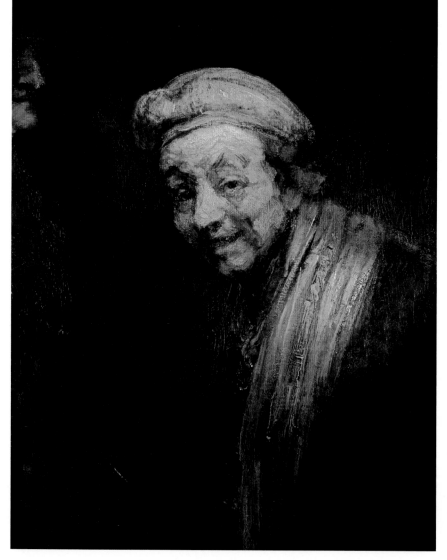

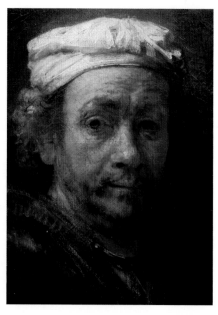

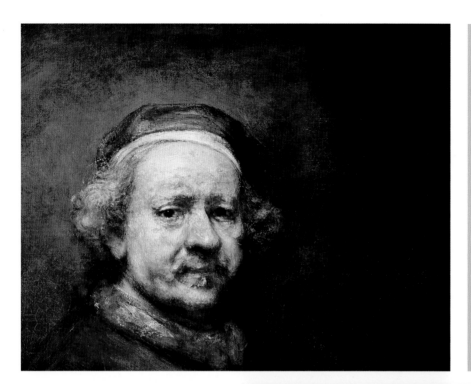

Above: Self-portrait at the Age of 63, 1669, oil on canvas.

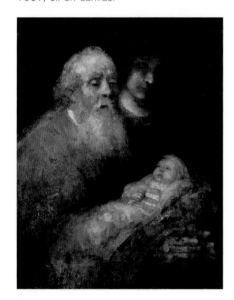

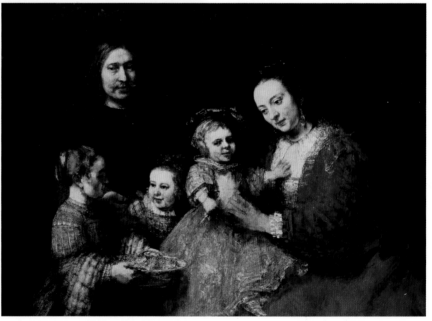

Above: Simeon in the Temple, *1669, oil on canvas.*

Self-portrait, c.1663–5, and *Juno*, c.1661–6, portray Rembrandt and Hendrickje in the final years of their lives. Rembrandt looks every inch an 'Old Master', the accolade given to him in later centuries; the younger Hendrickje poses as Juno, the ancient Roman goddess, a counsellor and protector, and wife of the chief of all gods, Jupiter. Was this how Rembrandt saw their relationship?

DEATH AT VOLEWIJK

In stark contrast to his mythological and religious paintings from this period, two pen-and-ink drawings show the punishment meted out to murderers in the city of Amsterdam in 1664. Rembrandt and fellow Amsterdammers witnessed the hanging of a young woman, and he made two drawings of *Elsje Christiaens Hanging on a Gibbet* 1664. An 18-year-old girl working as a maid, and berated by her landlady for being behind with her rent, chased her with an axe, whereby she fell to her

Above: Family Group, *1668.*

death down some stairs. As punishment the girl was slowly choked to death on a gibbet. The axe was displayed next to her head, and her body left hanging on the gibbet, on the gallows field at Volewijk, on the outskirts of Amsterdam. There the dead bodies of convicted criminals were displayed as a warning to visitors to the city. In a side and a front view, Rembrandt records the clothing, the bindings, the axe, and the facial expression of the dead Elsje.

DEATH OF TITUS

On 28 February 1668, Rembrandt's only son Titus (1641–1668) married Magdalena van Loo (1641–69), the daughter of a silversmith, and a niece of Hiskia van Uylenburgh, sister of Saskia, and an aunt to Titus.

The marriage returned Titus's share of Saskia's estate to the Uylenburgh family fold. Saskia's family had frequently accused Rembrandt of squandering her inheritance by his extravagant spending on his collections, but they ceased to do so when Titus married into the Uylenburgh family, although Rembrandt had had no access to the money left by Saskia to Titus.

HAPPINESS SHORT-LIVED

Following the marriage of the young couple – Titus was 26, his bride nearly 17 years old – Magdalena soon became pregnant with their first child, due early the following year. Titus did not live to witness the birth. After seven months of marriage he died of plague and was buried on 7 September 1668. The baby was born to Magdalena five months later and baptized in Nieuwezjds Chapel, Amsterdam, on 22 March 1669. She was named Titia after her father.

THE JEWISH BRIDE

The arresting painting known as *The Jewish Bride* (c.1667), a late work by Rembrandt, bears likeness in its composition to Titian's lost painting *Self-portrait with a Young Woman* (c.1525). Rembrandt may have been familiar with copies of Titian's painting, which showed the artist embracing his mistress, or van Dyck's detailed etching *Titian's Self-portrait with a Young Woman* c.1630. The stunning, intimate portrayal of a couple may reflect Rembrandt's happy years first with Saskia, and latterly with Hendrickje.

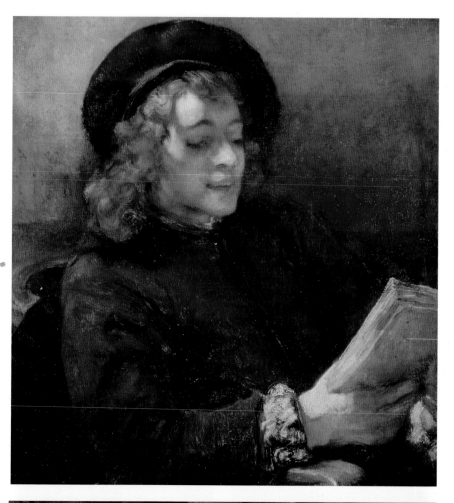

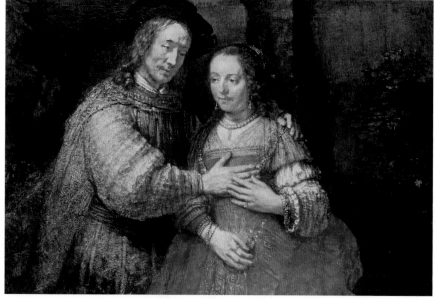

Above right: Titus Reading, c.1656–57, *oil on canvas.*

Right: The Jewish Bride, c.1667.

Rembrandt was named as her godfather. His daughter Cornelia was present. The untimely death of Titus, his only son, was a blow to a man who had bitterly experienced the infant deaths of his other children born to Saskia, the death of his wife Saskia, and the death of Hendrickje. Magdalena wanted to ensure that Titia would receive her share of Rembrandt's estate when he died. Her daughter was a legitimate heir, while Cornelia, in the eyes of the law, was illegitimate.

FRIENDS RALLY ROUND

A portrait of Jeremias de Dekker (c.1610–66), a Christian poet and writer, was painted by Rembrandt in 1666, a gift to the poet for the many kind words he had written about the artist and his paintings. The two were friends, and Dekker was a support to Rembrandt during his bereavements. Dekker wrote that he was pleased the 'Apelles' (a renowned 4th-century

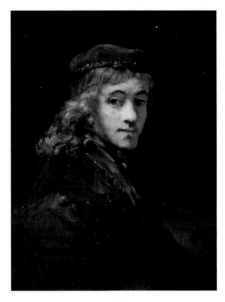

Above: Titus, the Artist's Son, *c.1662, (detail), oil on canvas.*

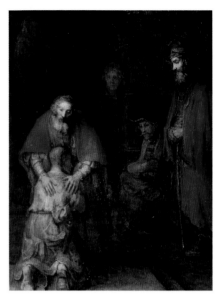

Above: Return of the Prodigal Son, *1636, pen and ink on paper.*

Greek painter) of his era had painted his portrait. He said he lacked the skill of the art historians Giorgio Vasari and Karel van Mander, but added it was not necessary for him to extol Rembrandt's greatness because he was known 'wherever Dutch ships sail'. He favourably compared his friend's talent to that of Michelangelo and Raphael, adding that Rembrandt's name was as well known in Rome as the Italian masters'.

'SHADOW-FRIENDSHIP'

Dekker had dedicated a poem to 'Friend Rembrandt' relating to Rembrandt's painting of *Christ Appearing to Mary Magdalene* 1638. Dekker praised the portrayal of the shadow of the rocks, and the figure of the resurrected Christ, describing it as 'dead paint so brought to life'. In a separate poem, 'Schaduw-Vrindschap' (Shadow-Friendship), Dekker berated 'friends' who only appeared when times were good and the sun shone. He declared that he was not a 'shadow-friend' to Rembrandt, presumably an allusion to the artist's increasing isolation from Amsterdam society. Other friends, present during wealth and poverty, emerge in the latter years, such as the apothecary Abraham Francen, and the warden of the Town Hall, Thomas Jacobsz. Haringh, both recorded in etchings by Rembrandt.

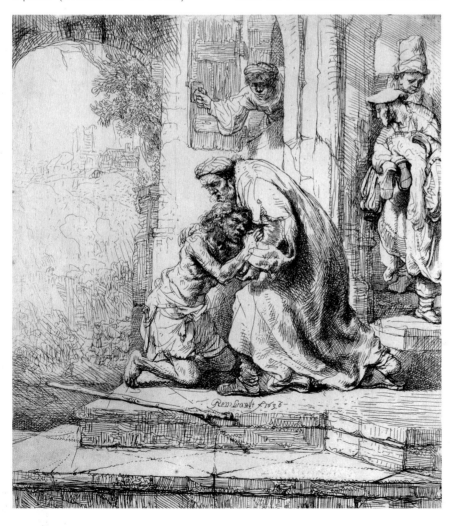

Left: Return of the Prodigal Son, *1636, pen and ink on paper.*

AN UNMARKED GRAVE

Rembrandt van Rijn died on 8 October 1669. The cause of his death at the age of 63 remains unknown. He left his daughter Cornelia, and infant granddaughter Titia. His daughter-in-law, Magdalena, died six weeks after Rembrandt's death.

Rembrandt was buried in the Westerkerk in an unknown rented grave. Following the death of Magdalena, an inventory of her effects included artworks by Rembrandt, itemized as 'three albums of priceless prints made by Rembrandt van Rijn during his life'. The business run by Titus and Hendrickje was now in the hands of Cornelia.

REMBRANDT – A COMMODITY

The wording of Magdalena's inventory confirms that Rembrandt's work was still highly collectable, saleable and noteworthy in the immediate aftermath of his death. His latter-day poverty seems a sad ending for a larger-than-life character who enlivened the city of Amsterdam with a remarkable portfolio of paintings, etchings and drawings. It is not known why the most popular painter in Amsterdam could fall to such a low level in public esteem, resulting in his burial in an unmarked grave. Contemporary accounts of Rembrandt, the man, describe him as both insensitive and arrogant, yet his art – particularly his self-portraits – displays great sensitivity and humility.

The works that remained in his studio after his death are a possible reflection on Rembrandt's state of mind in the latter years of his life. One of his last paintings, *The Prodigal Son* (c.1662) highlights a loving relationship between father and son. The subject of another work, an unfinished painting, *Simeon in the Temple* (c.1662) was sourced from the biblical narrative, Luke II:22-35.

Below: The Entombment, *17th century, oil on panel.*

Simeon, a holy man of Jerusalem, was told by the Holy Spirit that he would not see death before he had seen 'the Lord's Christ'. Seeing the child Jesus in the temple, he took him in his arms with the words, 'Lord, now lettest thou thy servant depart in peace.' A relevant epitaph for Rembrandt? Was this the last self-portrait of Rembrandt, depicting an ailing man holding his granddaughter, looked on by his daughter-in-law?

TITIA AND CORNELIA VAN RIJN

Following the death of her father Titus in 1668, and her mother Magdalena and grandfather Rembrandt in 1669, the infant Titia van Rijn (1669–1725), was raised within the Uylenburgh family. She was married at the age of 17 in 1686 to François van Bijler (b. c.1668), a jeweller, aged 20, the son of her

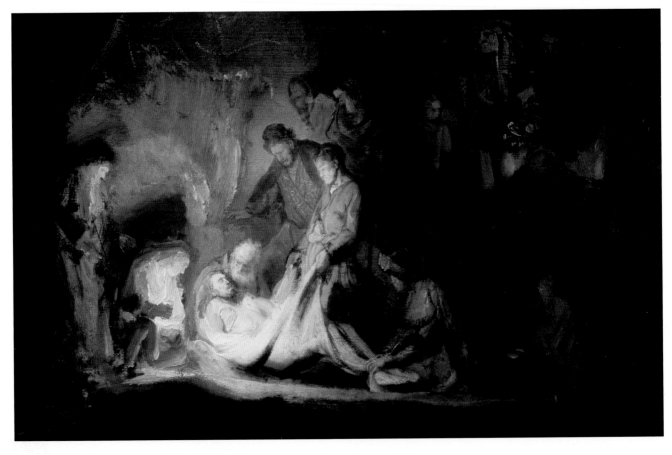

guardian. Cornelia van Rijn (1654–after 1678), the daughter of Rembrandt and Hendrickje, survived her parents and was present at their deaths. On 3 May 1670, five months after the death of her father, Cornelia married Cornelis Suijthof Schilder. She was given away by her guardian Abraham Francen (c.1612–after 1678), an apothecary and friend of Rembrandt, for whom the artist created a portrait in 1656. Cornelia gave birth to a boy and girl, in Batavia. Rembrandt Suijthof was born on 5 December 1673, and Hendrickje Suijthof on 14 July 1678. The family

Above: Westerkerk Church, Amsterdam, The Netherlands, built 1631.

remained in the Dutch West Indies. It was left to the guardians of both children, through lengthy arguments in the law courts, to divide Rembrandt's estate between his illegitimate daughter and legitimate granddaughter.

There are no extant contemporary accounts of Rembrandt's life written by Dutch artists or historians. The non-

Above: Still Life with a Skull, 17th century, oil on panel.

Dutch biographies that were written soon after his death contained inaccuracies that other historians later repeated without factual evidence to support claims. A balanced view of Rembrandt's life, based on evidence and placed in the context of the artistic world he inhabited, was not written until the 20th century.

PIETER VAN WIERINGEN BREDERODE

On 2 October 1669, two days before his death, Rembrandt was visited by the genealogist Pieter van Wieringen Brederode (1631–97) who recorded the event in his diary. He made an inventory of Rembrandt's artworks, antiquities and curios, which reveals to us that he had over a few years acquired new collections to replace those that he had been forced to sell between 1655 and 1660 to avoid bankruptcy.

Right: Still Life with a Hanging Cockerel and a Prowling Cat, 1669, Samuel van Hoogstraten (1627–78).

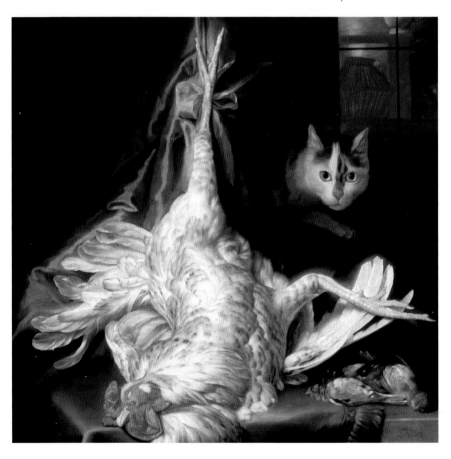

AFTERMATH

A claim to know Rembrandt, or to publish a biography of him, was noticeable by its absence in the immediate period following his death, particularly in the Netherlands where the Dutch were noted for their lack of interest in eulogies in print.

Visitors to the Netherlands had continued to impart their impressions of the culture of the Dutch art markets. In 1662, Jean Nicolas de Parival, a Frenchman who worked in Leiden as a schoolmaster for 20 years, commented, 'the houses are filled with very beautiful paintings and no one is so poor as not to wish to be well provided with them'. Historians argue that he may not have visited the very poorest of houses, and that his impression may have been based on the lower middle classes. However, de Parival's observation is confirmed by an English writer, William Aglionby, who, observing the art market, the elite and the working classes in The Netherlands, commented that, 'the Dutch in the midst of their Boggs and ill Air, have their Houses full of Pictures, from the Highest to the Lowest'. In addition, many inventories of the contents of Dutch houses in the 17th century are available to us, and these include many paintings.

BIOGRAPHIES EMERGE

In 1675 the German artist, Joachim von Sandrart (1606–88), published an account of Rembrandt, whom he had met when he worked in Amsterdam from 1637–40. It was a short appraisal of 800 words and contained inaccurate statements, based on Sandrart's opinion, not factual evidence. His 'facts', such as that '[Rembrandt] could read only Netherlandish and hence profit but little from books', were transferred to later biographies in negative appraisals of the artist. Sandrart claimed that the reason Rembrandt drew on the poorer elements of society in his work was because he had not visited Italy, nor studied the antique, or the theoretical rules of art. Ironically, Sandrart saw Rembrandt's interest in the poor as a fault, whereas it is one of the reasons why his art is revered today.

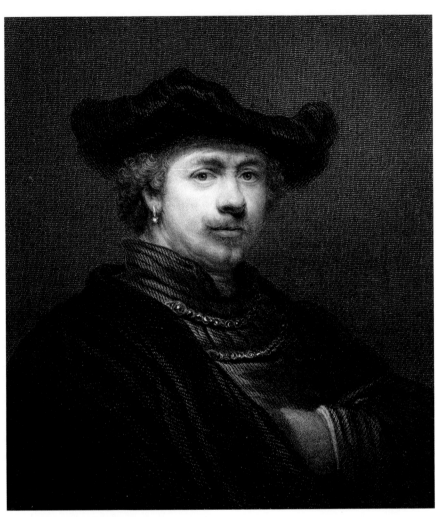

Above: Portrait of Rembrandt Harmens van Rijn, *1833, by English School, from* 'The Gallery of Portraits', *engraving.*

FILIPPO BALDINUCCI

Seventeen years after Rembrandt's death, the Italian art historian Filippo Baldinucci (c.1624–96) wrote an appraisal of Rembrandt, based on his discussions with one of Rembrandt's former pupils, Danish artist Bernhard Keil (1624–1687). It formed part of his history of the graphic arts, *Notizie de Professori del Disegno, da Cimabue in qua, Secolo V. dal 1610. al 1670* ('Notice of the Professors of Design, from Cimabue to now, from 1610–1670). In a third-hand memoir of Rembrandt, inaccuracies, such as the artist working for the Swedish Court, still appeared. However, some of Keil's reported statements ring true, for

example that when Rembrandt started to paint, nothing stopped him working: 'he would not have granted an audience to the first monarch in the world'.

A COLLECTOR OF CURIOSITIES

Filippo Baldinucci, in his conversations with Keil, discussed the interior of Rembrandt's studio and the artist's penchant for collecting. He wrote:

He [Rembrandt] often went to public sales by auction; and here he acquired clothes that were old-fashioned and

AFTERMATH 93

THE 'GREAT THEATRE OF NETHERLANDISH ARTISTS'

In 1718, the Dutch painter and writer, Arnold Houbraken (1660–1719), wrote *De groote schouburgh der Nederlantsche kunstschilders* ('The great theatre of Netherlandish Artists'). His intention was to revive interest in the Dutch artists of the 17th century, and his appraisal of Rembrandt seems to have achieved its objective. However, the biography contained many inaccuracies, including the place of Rembrandt's birth. Since its publication, documentary evidence has been scrutinized more closely.

Samuel van Hoogstraten, a former apprentice to Rembrandt, emerged as a superb painter. He wrote a book in 1678: *Introduction to the Academy of Painting*.

In reference to Rembrandt's painting, *St John the Baptist Preaching* (1634–6), he wrote: 'I recall having seen, in a certain nicely composed piece by Rembrandt, representing John the Baptist, the wonderful attention of the listeners from all sorts of classes: this is most praiseworthy; but one also saw a dog there that was mounting a bitch in an indecent way. To be sure, this is normal and natural, but I say that it is an execrable impropriety in a History...'.

Below: Portrait of Duke William of Baden-Baden *(1593–1677), Samuel van Hoogstraten (1627–78), oil on canvas.*

Above: Recreation of Pigments and Palette used by Rembrandt, on display in Rembrandt's House Museum, Amsterdam, photograph, 2006.

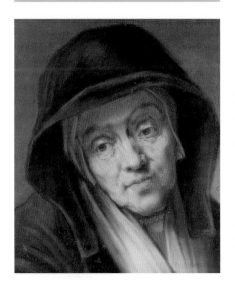

Above: Copy of a Portrait by Rembrandt of his Mother, *1776, Jean-Baptiste Chardin, pastel on paper.*

disused as long as they struck him as bizarre and picturesque, and those, even though at times they were downright dirty, he hung on the walls of his studio among the beautiful curiosities which he also took pleasure in possessing, such as every kind of old and modern arms – arrows, halberds, daggers, sabres, knives and so on – and innumerable quantities of drawings, engravings, and medals and every other thing which he thought a painter might ever need. . .

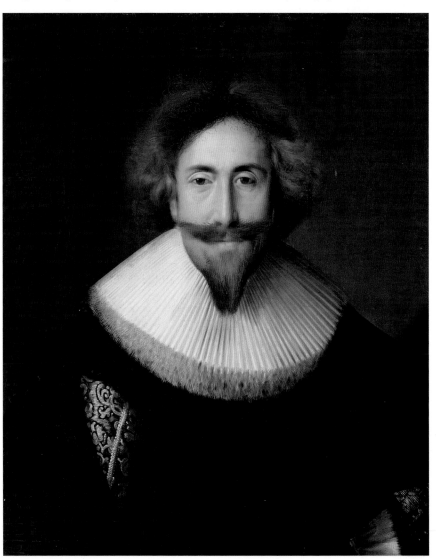

NEW LOOK AT AN OLD MASTER

Rembrandt van Rijn, a respected name in the distant 1600s, was later remembered for his portraits of well-endowed women. His work was seen as non-classical and old-fashioned, until a reappraisal in the 19th century. There was also a move to put beyond doubt the ownership of many works of art.

In the 19th century, historians began to look again at the 'Old Master'. Establishing the provenance of many paintings, etchings and drawings proved to be a difficult task for the cataloguers working in museums and galleries and auction houses. At one point over 1,000 paintings were attributed to the artist, a feat hardly achievable.

FINDING REMBRANDT VAN RIJN

Serious research eliminated paintings that did not bear his signature. Many works in the style of Rembrandt were re-catalogued as painted by 'followers'

of Rembrandt, most likely his students and apprentices who could not put their name on works until the end of their apprenticeship. Rembrandt sold works under his name that had been produced in his studio by his pupils, apprentices, assistants and journeymen. It was common practice at the time. Very few of Rembrandt's drawings are dated, which forces attribution and date to be agreed by close inspection of the style and provenance of each work.

In the early 19th century, his paintings in Amsterdam were still severely judged. The city council offered

his painting of the *Syndics of the Drapers Guild* (1661–2) to their National Gallery. It was turned down by its director, Cornelis Sebille Roos (1754–1820), as a dull work that only showed 'five gentlemen all in black not doing a blessed thing but sitting to have their portrait painted'. Records of Roos' own purchases show his preference for the style of Johannes Vermeer (1632–75), such as *Girl Interrupted at her Music*, (1658–61), which stayed in his collection for several years. However, artists of the mid-19th century who had visited The Netherlands, and had seen Rembrandt's

Below: Copy of a Rembrandt Self-portrait, 1869, Gustave Courbet (1819–77).

Below right: Self-portrait , *Sir Joshua Reynolds, c.1779–80. oil on panel.*

Bottom: The Artist as Rembrandt with Titus, fl. 1960, Tom Keating (1917–84).

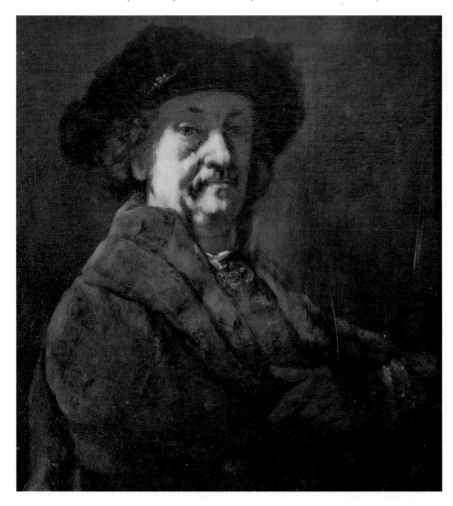

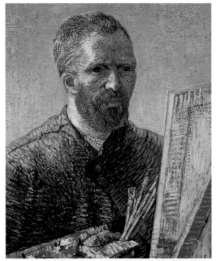

Above: The Anatomy Lesson, *c.1856, after Rembrandt, Édouard Manet (1832–83).*

Far left: Head of an Angel, after Rembrandt, *1889, Vincent van Gogh (1853–90), oil on canvas.*

Left: Self-portrait as an Artist, *1885, Vincent van Gogh (1853–90).*

works, among others, took a different view, considering Rembrandt to be one of the greatest and most inspiring artists.

GUSTAVE COURBET

Many European artists of the mid- to late 19th century studied Rembrandt's work. His decision not to go to Italy, to study the antique, drew like-minded anti-art-establishment artists to him. Gustave Courbet (1819–77), one of the first French artists to break away from the academic tradition in France, visited The Netherlands in 1846–7. It greatly influenced his style, particularly through the works of Rembrandt, whom he held in great respect. Courbet's arresting portrait *Self-portrait (The Desperate Man)* 1843–5, with its wide-eyed stare, resembles a small etching of self-analysis by Rembrandt, *Self-portrait 'Wide-Eyed'*, 1630. Courbet painted his own copy of a Rembrandt self-portrait in Munich, *Self-portrait, after Rembrandt* 1849, signed 'Copie Musée de Munich'. It was Rembrandt's supreme ability to capture the very moment a drawing or painting was created, like a snapshot, which gained him admiration from European artists in the 19th century.

ÉDOUARD MANET

Manet (1832–83) who famously attracted attention to himself for his paintings of modern life in *Le Déjeuner sur l'Herbe,* 1862–3 and *Olympia,* 1863, painted *The Anatomy Lesson, after Rembrandt* 1856, inspired by Rembrandt's ability to capture the essence of life in 17th-century Amsterdam.

VINCENT VAN GOGH

Rembrandt's fellow Dutchman, Vincent van Gogh, declared: 'I'd give ten years of my life to sit for fourteen days in front of *The Jewish Bride* with barely a crust of dry bread to eat… What an intimate, what an infinitely sympathetic picture it is… Rembrandt is so deeply mysterious that he says things for which there are no words in any language.' Rembrandt's paintings, drawings and etchings were a great exemplar to the young Van Gogh (1853–90). Letters to his brother Theo van Gogh (1857–91) are full of references to Rembrandt, including small sketches of Rembrandt etchings. *The Raising of Lazarus (after Rembrandt)* 1890, was directly taken from Rembrandt's painting *The Raising of Lazarus, c.*1630. Perhaps the greatest self-portrait painted by Van Gogh, *Self-portrait as an Artist* 1888, was inspired by Rembrandt's *Self-portrait as an Artist* 1660, whereby both artists proudly proclaim their profession in paint. Many works by Van Gogh, such as *Head of an Angel* 1889, were initiated by a Rembrandt work, and made new through his inspirational use of colour and light.

AN 18TH CENTURY 'ARISTOTLE'

In the mid-18th century in England, the Royal Academy, inaugurated in 1768, chose as its first president the Englishman Sir Joshua Reynolds (1723–92), a portrait painter to the aristocracy. When he painted his self-portrait, he paid homage to Rembrandt. In *Self-portrait* 1780, Reynolds emulates Rembrandt's *Aristotle,* 1653. The Rembrandt painting was later sold at auction at Christie's in London on 17 February 1810, for £79 1s 7d., with the title *Sculptor with a Bust.*

REMBRANDT'S LEGACY

Today, visitors to Amsterdam almost always go to the Rembrandt House Museum and the Rijksmuseum, to view Rembrandt's paintings and, in particular, the vast canvas of *The Nightwatch*, which was admired much less in his own time.

Tastes in art change. Rembrandt was appreciated in the 17th century by his patrons and contemporaries for much of his art, but not all of it. In the 18th century, Rembrandt's portraits inspired would-be Old Masters, notably Sir Joshua Reynolds, to emulate his style.

NINETEENTH-CENTURY APPRECIATION

Younger artists in the 19th century looked to Rembrandt for his inspirational use of *chiaroscuro*, and his ability to capture a moment in time on canvas. For these artists the onset of photography from 1839 made his works all the more interesting. The more artists studied his works, the more they appreciated his superb skill. Rembrandt's fellow Dutchman, Vincent van Gogh, read as much as he could to find out about Rembrandt, and looked for his works and copies of his works as inspiration for his own paintings and drawings.

Right: A group of visitors at the Rijksmuseum Amsterdam, in front of The Nightwatch, *by Rembrandt, photograph.*

Above: The entrance hall of Rembrandt House Museum, Amsterdam, photograph.

A SAFE PURCHASE

Today, in a world where purchasing art is viewed as an investment, Rembrandt is a secure purchase. He will not fall out of fashion again. On 15 November 1961, at auction in New York, Rembrandt's painting

Above: Statue of Rembrandt Van Rijn, 1852, by Louis Royer (1793–1868), bronze, Amsterdam, The Netherlands.

Aristotle (1653) fetched a record-breaking price of $2,300,000. Today the figure would probably be closer to $100,000,000. showing that Rembrandt has staying power that goes beyond the contemporary.

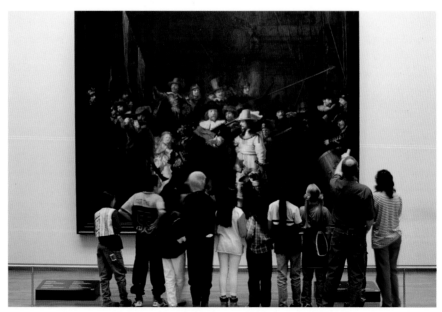

FACE TO FACE WITH A GENIUS

In his lifetime Rembrandt created over 70 portraits of himself. Scholars continue to debate why he produced so many, particularly the oil-on-canvas paintings, which took many hours of work. While this question can never be fully answered, it is through his self-portraits that a viewer can come face to face with a genius. Each work reveals the essence of the man in a variety of ways: in youth, robustness and strength, in prosperity, happiness and uncertainty, in frailty, grief and old age. It is in these works that Rembrandt lives on, to enthral his privileged spectator.

REMBRANDT IN AMSTERDAM

In 1852, the city council of Amsterdam erected a life-size statue of Rembrandt in the Rembrandtplatz, a monument to one of their greatest residents, in a square named after him. Interest in Rembrandt has not diminished since that time. Today, the Rijksmuseum is as popular as the Van Gogh Museum in Amsterdam. Both Van Gogh and Rembrandt exemplify the richness of Dutch art, from the early 17th to the late 19th century. Joining Rembrandt's artworks at the Rijksmuseum one can find those of his good friend Jan Lievens from Leiden and a strong group of his former assistants and journeymen. To step into the Rijksmuseum is to appreciate the essence of what made Dutch art so popular in the 17th century. Students of fine art and art history come to see *The Nightwatch*, and go on to visit the Rembrandt House Museum, created within the grand house he had to leave in 1658.

REMBRANDT IN LEIDEN

In Leiden, visitors walk to the area where the Van Rijn family had their homes and mill. The tourist board offers a walking route, with theme boards along the way, to take the visitor past Rembrandt's birthplace, his first

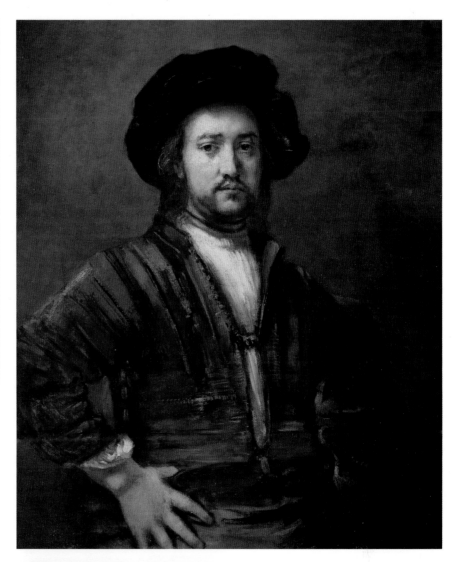

Above: Portrait of a Man with Arms Akimbo, *1658, oil on canvas.*

Above: Using images of Rembrandt, 'Leiden euro' were created in 2006, for the 400th anniversary of Rembrandt's birth. This euro can only be used in Leiden.

'master' Jacob van Swanenburgh's studio, and to the Latin School that Rembrandt attended. Although the Van Rijn family does not feature in his life after his move to Amsterdam and his marriage to Saskia, Leiden is what spurred him on to paint and draw.

REMBRANDT'S 400TH ANNIVERSARY

The name of Rembrandt attracts many visitors to both Amsterdam and Leiden. In 2006, a global celebration of the 400th anniversary of his birth attracted artists who came to pay homage, and Rembrandt scholars to research further aspects of his life and work, to maintain and elevate his reputation.

In Leiden, his birthplace, a special Rembrandt 'Leiden Euro' was issued as legal tender in the city, to honour their most famous citizen – a gesture that the commercially-minded Rembrandt might have appreciated. His paintings, drawings and etchings continue to inspire artists, art historians and admirers all over the world.

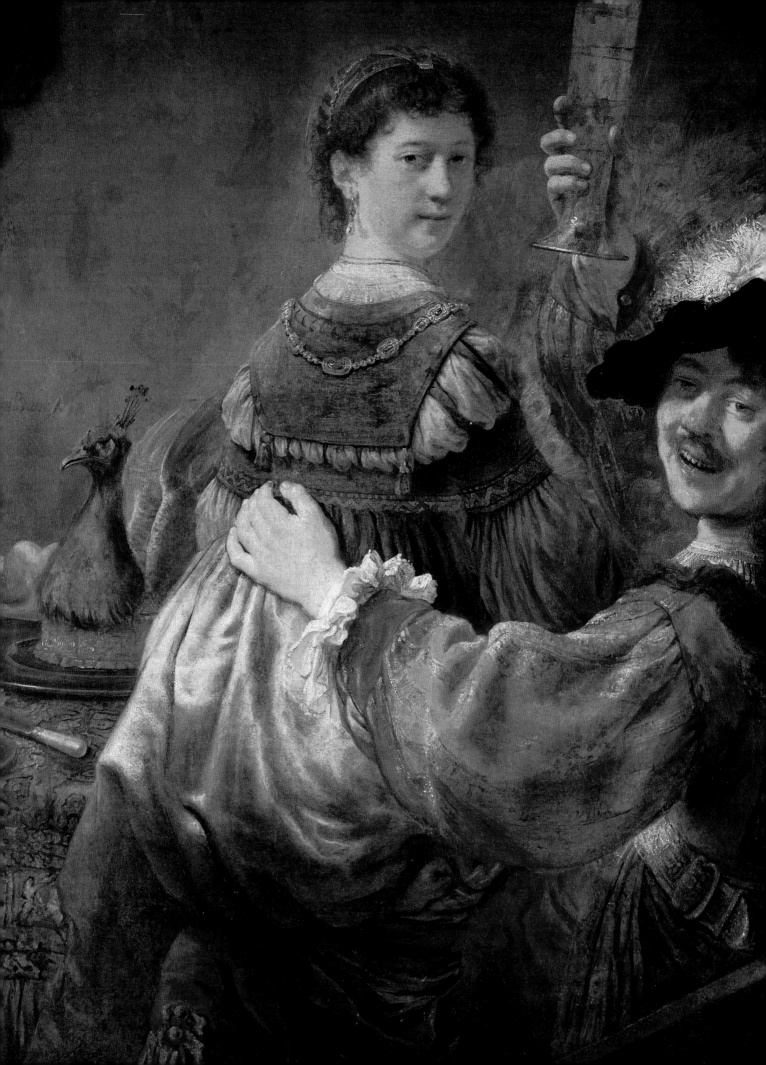

THE GALLERY

The Gallery has been divided into three sections to reflect the chronological stages in Rembrandt's life and work: 'The Early Years 1620–1630' establish Rembrandt's rise to fame. The chosen paintings, drawings and etchings focus on the beginning of his professional career as an artist and the visible effect of Rembrandt's tutor and mentor Pieter Lastman. During these years Rembrandt worked as an apprentice to Lastman before returning to his birthplace Leiden to open a studio, at times working in partnership with the artist Jan Lievens. The second section of the Gallery: 'The Middle Years 1631–1648', highlights the art produced in this prosperous period of Rembrandt's life following his permanent move to Amsterdam, c.1631. The third section: 'The Latter Years 1649–1669' focuses on the paintings, drawings and etchings created during years of happiness and prosperity mixed with the turbulence of insolvency, and the deaths of Hendrickje and his son Titus. Art works created in the last decade of his life prove that his creativity continued almost until his death in 1669.

Left: Self Portrait with Saskia in the Parable of the Prodigal Son, *c.1635, (detail of Saskia and Rembrandt),* oil on canvas, Gemäldegalerie Alte Meister, Dresden, Germany, 161 x 131 cm (63.4 x 51½ in).

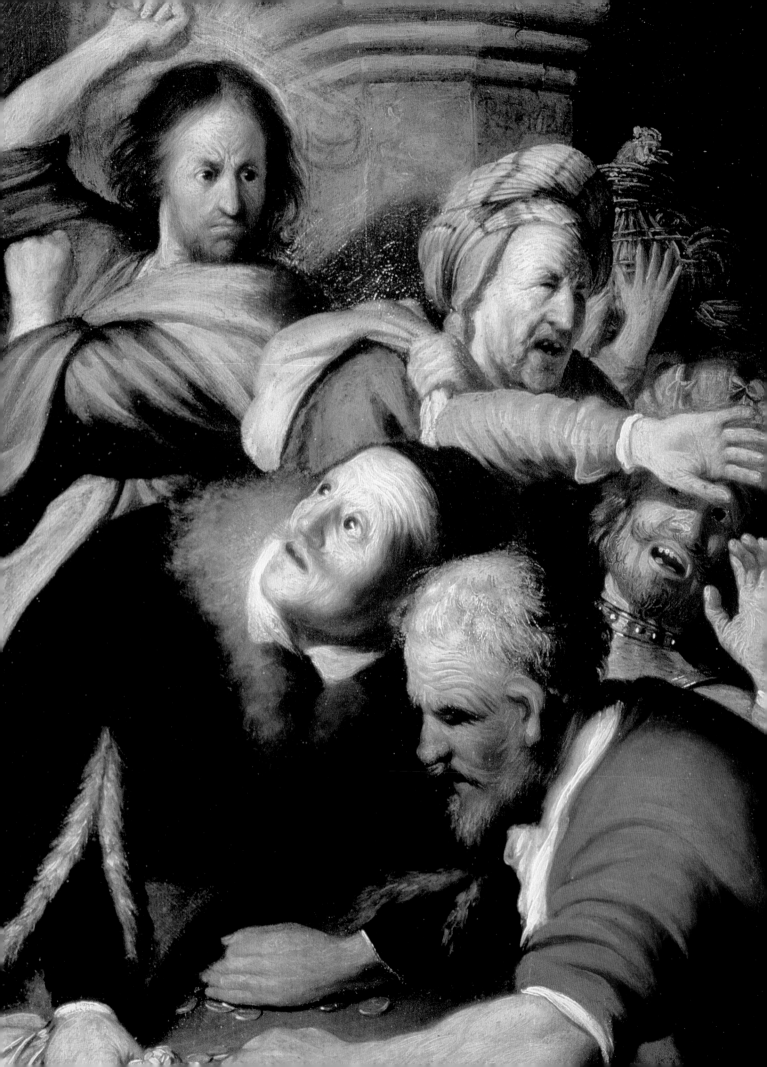

1620–1630

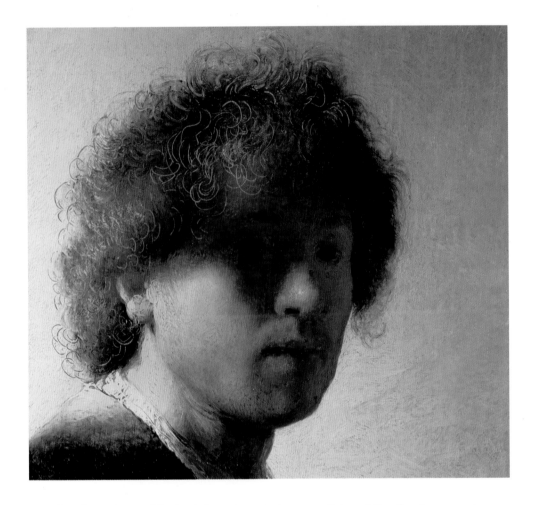

Rembrandt van Rijn had the talent to be an artist and the flamboyance to
be a commercially successful artist. Following an apprenticeship in
Amsterdam with Pieter Lastman – a follower of the Italian Baroque painter
Michelangelo Caravaggio da Merisi (1571–1610) – it was to be expected
that he would seek to master the technique of both artists, before creating
his own style. His early paintings were mainly religious in subject matter,
such as *The Stoning of St Stephen*, 1625. He constantly practised the art of
portraiture and drew, etched and painted his own portrait many times.

Above: Self-portrait as a Young Man, *c.1628, oil on panel, Rijksmuseum, Amsterdam, The
Netherlands, 22.5 x 18.6cm (9 x 7in) [detail].*

Left: Christ Driving the Money-changers from the Temple, *1626, oil on canvas, Pushkin
Museum, Moscow, Russia, 43 x 33cm (17 x 13in).*

*Self-Portrait with Gorget and Beret, c.*1629, oil on panel, Indianapolis Museum of Art, IN, USA, 42.5 x 34cm (17 x 13½in)

Rembrandt portrays himself wearing a gorget, a steel or leather collar, part of a soldier's uniform designed to protect the throat, although the artist never served in the militia. It was used in several Rembrandt 'tronies' of military figures. There are several versions of this portrait created by Rembrandt's students and assistants, who must have been encouraged to paint it as copy-practice work. In this work, Rembrandt's signature style, scratching through the paint surface, highlights some of the curls of the hair and hair of the chin.

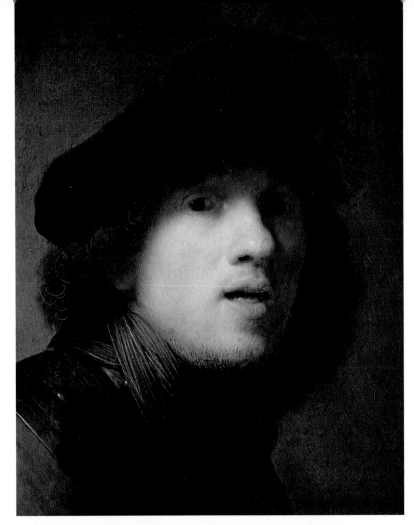

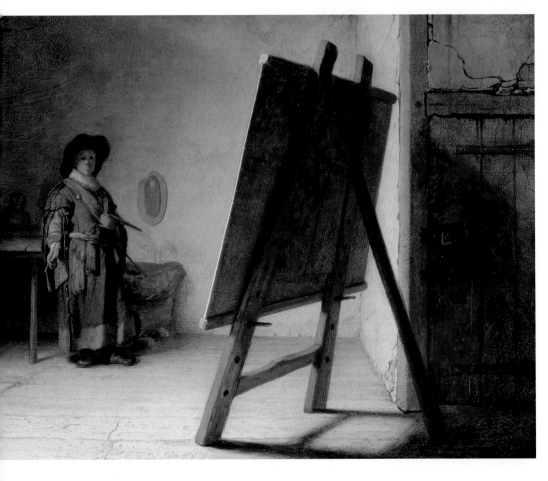

*Artist in his Studio, c.*1627–9, oil on panel, Museum of Fine Arts, Boston, MA, USA, 25.1 x 31.9cm (10 x 12½in)

An easel dominates the right foreground of the self-portrait of Rembrandt in his studio. To the left, the figure of the artist has stepped back to look at the painting. Rembrandt said that his paintings were best viewed at a distance. The light that floods the room from an unseen source marks the distance between easel and painter. The artist holds a palette, maulstick and brushes. Each object relates to the artist's profession: the whetstone behind the figure used for mixing paints, spare palettes hang on a nail on the wall, and bottles for oils and varnishes are on the table.

Self-portrait, Open-mouthed,
1628–9, pen and brown ink,
brush and grey paint, British
Museum, London, UK,
12.7 x 9.5cm (5 x 3¾in)

The youthfulness of the
artist is apparent in this
portrait. The open mouth
and raised eyebrows of the
young man draw attention to
the face. It gives the portrait
a sense of immediacy,
as a snapshot of the
moment it was produced.
The sombre facial features
are framed by tousled curly
hair. The strong light that
focuses on the right side
of the face and upper body
adds a theatrical effect
to the depiction.

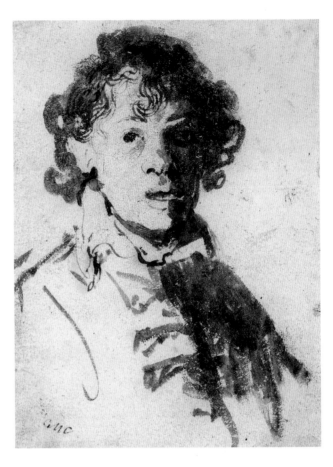

Self-portrait, 1629, oil on
canvas, Mauritshuis,
The Hague, The Netherlands,
37.9 x 28.9cm (15 x 11½in)

Followers of Rembrandt, his
students and assistants, closely
copied Rembrandt's paintings,
even his self-portraits. Here,
in this portrait by a follower,
one can see the similarity to
Self-Portrait as a Courtly Squire
c.1629, by Rembrandt. The
face expresses surprise, in the
raised eyebrows, and attentive
eyes, that turn and fix a gaze
on the spectator. The mass of
curly hair is unruly and hangs
forward over the forehead.
The mouth is slightly open as
if to speak, adding spontaneity
to the facial expression. The
clothing is beautifully captured
in loose, quick brushstrokes.
The thickness of the paint
accentuates the fringes of the
creamy white collar.

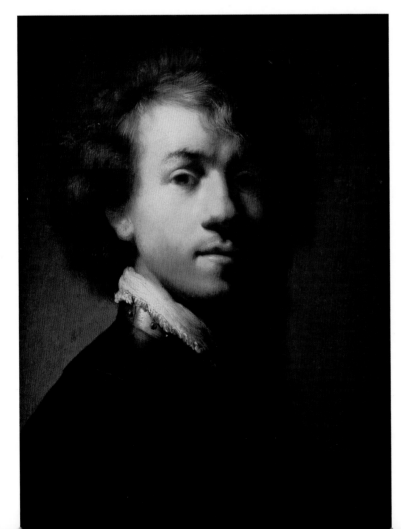

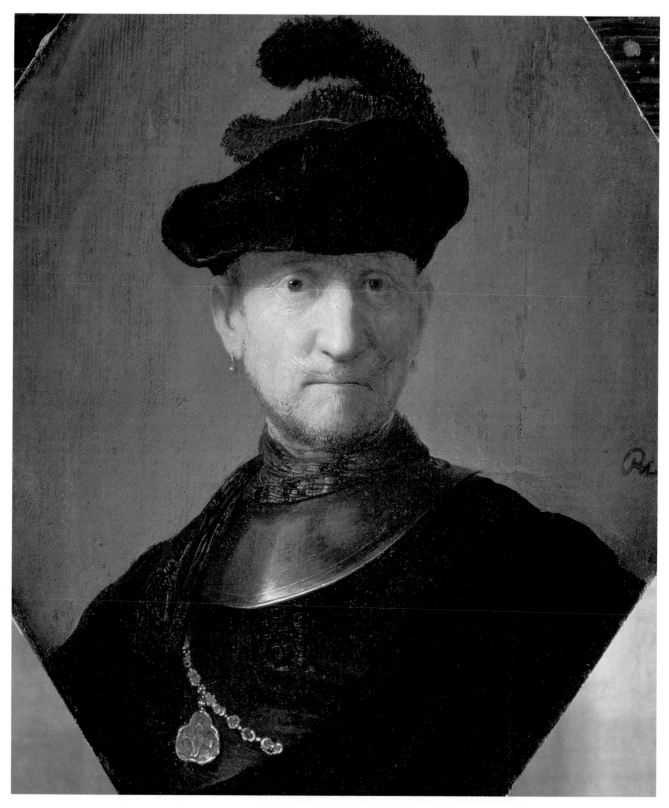

Old Warrior (formerly Rembrandt's Father), 1629, oil on canvas, The State Hermitage Museum, St. Petersburg, Russia, 36 x 26cm (14 x 10in) Signed with the monogram *RHL.*

The facial features of the sitter: the strong jawline, protruding nose and piercing dark eyes, all characteristic features of Rembrandt's style, created interest in this painting as a possible portrait of Rembrandt's father.

The attribution has not been proven. The bust-length portrait depicts an older man wearing a gorget at his neck and a medal on his dresswear. On his head he wears a striking plumed beret.

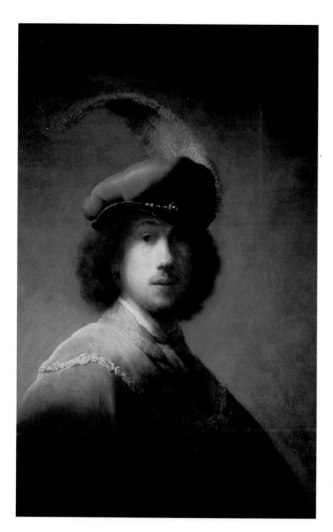

Self-portrait with Plumed Beret, 1629, oil on panel, Isabella Stewart Gardner Museum, Boston, MA, USA, 89.7 x 73.5cm (35 x 29in) Monogrammed and dated lower right RHL...9

This is a distinguished portrait of the artist wearing a plumed beret pulled forward on his head, keeping his mass of curly hair in place. He faces the onlooker in three-quarter pose. The mustard–gold cloak he wears is topped with a mayoral-type of gold chain. At his neck he wears a coiled scarf, the gold thread of the weave is picked up in the strong light that focuses on the head and shoulders. The painting is a 'tronie' (a depiction of an anonymous person, although we know it is Rembrandt.) The formal pose is possibly linked to Rembrandt's recently elevated status in association with Constantijn Huygens, Secretary to Frederik Hendrik, Prince of Orange.

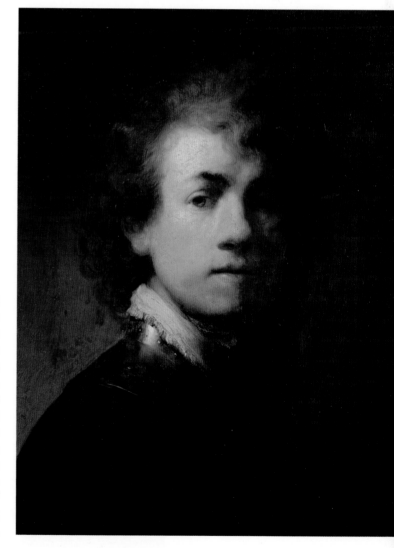

Self Portrait as a Courtly Squire, c.1629, oil on panel, Germanisches Nationalmuseum, Nuremberg, Germany , 38.2 x 31cm (15 x 12in)

For many years this portrait of a 'courtly squire' was considered a copy of *Self-portrait with Gorget*, c.1629, in the Mauritshuis. In latter years it has been revealed to be an original painting by Rembrandt, and the Mauritshuis version to be a copy of it by an unknown artist. The portrait depicts the artist wearing dark clothing, a gorget and a white collar with fringing. The title 'courtly squire' links to the artist's associations at this time with Constantijn Huygens, who may have smartened up Rembrandt's looks and attire for an audience with the Prince of Orange, Frederik Hendrik; or it is a title for a 'tronie'.

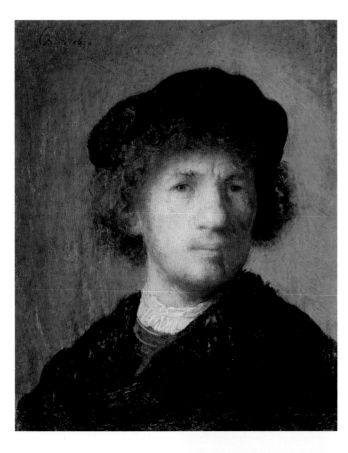

Self-portrait, 1630, oil on copper, Nationalmuseum, Stockholm, Sweden, 15.5 x 12cm (6 x 4½in)

This small portrait is painted onto copper covered with a tiny layer of gold leaf; a similar composition to two other paintings of the same period, *Old Woman at Prayer,* c.1629–30, and *The Laughing Man (or Laughing Soldier),* c.1629–30. Rembrandt used small, neat brushstrokes for the facial area and larger, looses strokes for the clothing. The gold leaf on copper gives a burnished opulence to the skin, highlighting the watchful eyes and determined expression of the sitter. Painted on the cusp of his rapidly escalating career, Rembrandt looks confident in this *self-portrait.* The composition closely relates to his other self-portraits of 1629 and 1630, with the exception of the use of copper plate. This portrait may have been a sample work, to test the application. It also relates to the oil-on-panel *Self-portrait with Soft Hat and Gold Chain,* c.1630.

Tronie of an Old Man, oil on panel, c.1630–31, Mauritshuis, The Hague, The Netherlands, 46.9 x 38.8cm (18½ x 15in)

Possibly created by Rembrandt and his studio. The 'tronie' depicts the head and shoulders of a well-dressed old man. He wears a dark fitted cap on his head, possibly added at a later date. An etching, *Man Wearing a Close Cap (The Artist's Father?),* dated 1630, closely relates to the painting.

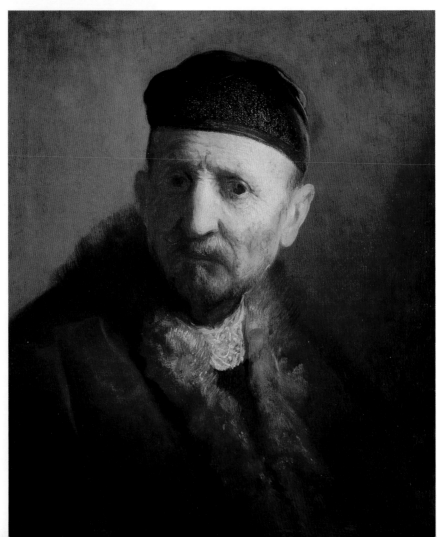

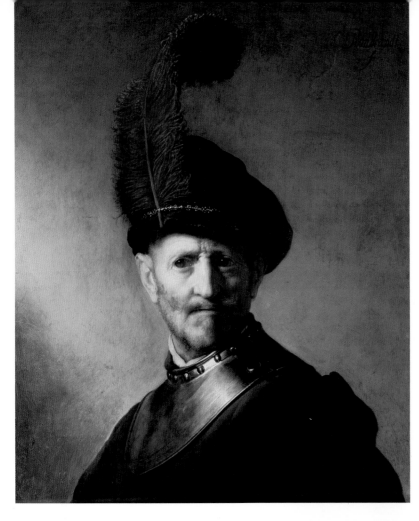

An Old Man in Military Costume (formerly called *Portrait of Rembrandt's Father*), c.1630, oil on panel, J. Paul Getty Museum, Los Angeles, CA, USA, 65 x 51cm (25½ x 20in)

The facial features of the sitter are comparable to *Old Warrior*, 1629. Both paintings were originally accredited as portraits of Rembrandt's father, due to similar facial features found in self-portraits of Rembrandt. In this portrait, the male figure wears a military gorget, and there is a stunning plume on the wearer's hat. In his subtle use of *chiaroscuro*, Rembrandt captures the glint of the gorget's metal. X-rays reveal another head to the right of the sitter.

Head of a Man, 1630, oil on canvas, Gemäldegalerie Alte Meister, Dresden, Germany, 48 x 37cm (19 x 14½in)

A beautifully observed portrait bust of a face that is full of character. Many different suggestions for the identity of the sitter have been offered: from Rembrandt's father, to his brothers Gerrit and Adriaen, but none have been confirmed as correct. The unseen light source shines directly on the facial features of the man, highlighting the wrinkles and creases of his face, and drawing attention to the intense gaze of the sitter.

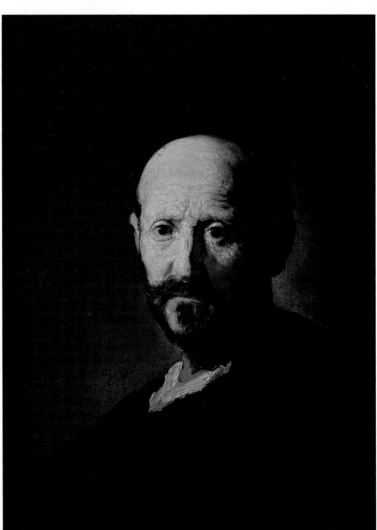

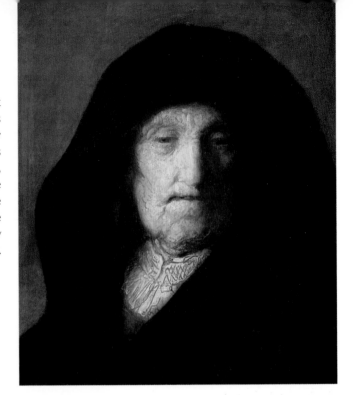

The Artist's Mother, c.1628,
oil on panel,
Private Collection,
35 x 29cm (14 x 11½in)

Historians link this composition to an etching, *The Artist's Mother: Head Only, Full Face,* dating the painting to about the same time. There is no proof that either depicts Rembrandt's mother. The face is heavily lined; Rembrandt focuses light onto the delicate, wrinkled skin, highlighting the effects of old age and the serene expression of the lady. She is portrayed many times by the artist.

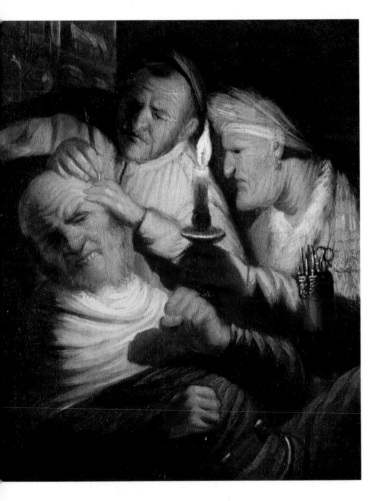

The Sense of Touch: The Stone Operation, c.1624–6,
oil on panel,
Private Collection,
21.6 x 16.7cm (8½ x 6½in)

In the early years of his career, Rembrandt wanted to portray the senses; sight was represented by a man selling glasses; sound by music makers; and touch by the process of an operation on a man's head. Here, the heads of three men fill the picture space. At the centre is a patient, behind him a doctor, and to the right a man watching the operation. In this colourful work, similar to the others in the series, the artist, in a deft use of *chiaroscuro,* bathes the faces of the men in light.

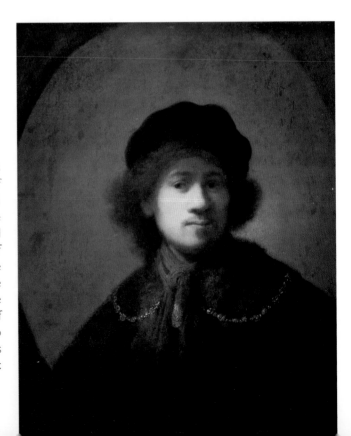

Self Portrait with Beret and Gold Chain, 1630–1, oil on canvas, Walker Art Gallery, National Museums Liverpool, UK, 69.7 x 57cm (27½ x 22½in)

The facial expression is inquisitive, it reveals a discerning young man, one who can wield the tools of his profession, to provide an honest likeness. And yet, within this work, one sees Rembrandt project himself in finer clothing, the facial features are refined, the bulbous nose is diminished through subtle lighting of the face. Prospective patrons would recognize Rembrandt's ability to create an amenable image of himself, enhanced to reveal his best features and character.

Portrait of Rembrandt's Mother, 17th century, oil on canvas, Collection of the Earl of Pembroke, Wilton House, Wiltshire, UK, 74 x 62cm (29 x 24½in)

The attribution to Rembrandt is debated, and it is possibly a collaboration between Rembrandt and one of his pupils. The painting mirrors many other works by Rembrandt that feature the old woman, considered by many scholars to be the artist's mother. Here the woman leans over a large open book, probably the scriptures; Rembrandt's mother was a devout Christian. The use of *chiaroscuro* highlights the face of the woman in a supremely adept use of brushwork.

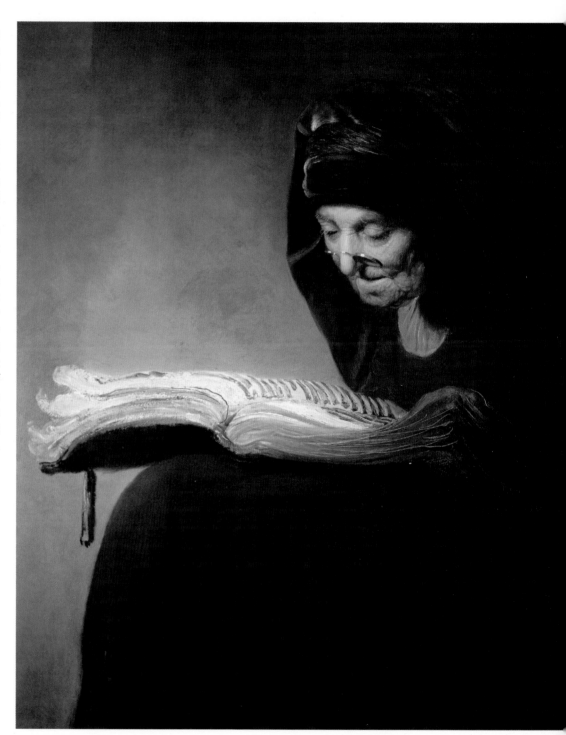

Christly Driving the Money-changers from the Temple, 1626, oil on canvas, Pushkin Museum, Moscow, Russia, 43 x 33cm (17 x 13in)

The story of Christ driving the commercially-minded money-changers from the temple appears in all four Gospels: Matthew: XXI:12-17; 23-27 and John II:13-16, both disciples of Christ; and followers, Mark: XI:15-19 & 27-33 and Luke:XIX:45-48 & XX:1-8. Rembrandt depicts Christ visiting the Temple of Jerusalem, a most sacred temple, to find the 'money-changers' enjoying a lucrative business in the forecourt. It displeased him, and he drove them out. In painting, the narrative was popular with patrons, highlighting their own abstemious behaviour.

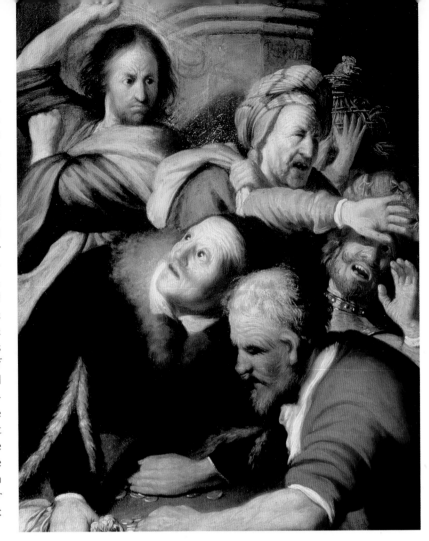

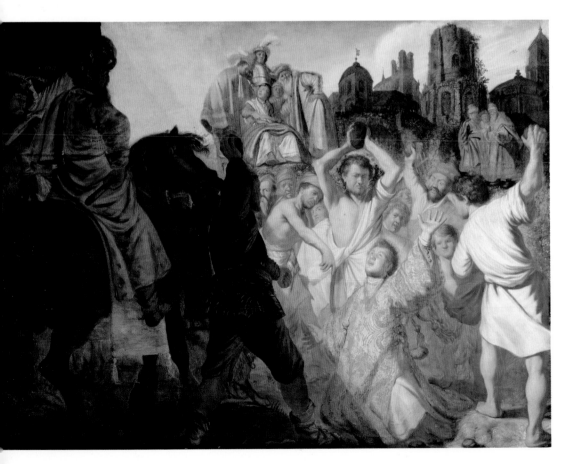

The Stoning of St. Stephen, 1625, oil on panel, Musée des Beaux-Arts, Lyon, France, 89 x 123cm (35 x 48½in) Signed R f. 1625

The Stoning of St Stephen is recognized as Rembrandt's earliest dated painting. The *chiaroscuro* composition of the work was possibly informed by Adam Elsheimer's oil-on-silvered-copper painting of the same title, *c.*1602–5. The vivid colour of the composition belies the dark subject of the death of the first Christian martyr. Rembrandt captures the enthusiasm of the rock throwers. The raw energy carries the reality of death by stoning, the artist adhering to the bible text (Acts VII:57-8).

Anna Accused by Tobit of Stealing a Kid, 1626, oil on panel, Gemäldegalerie, Berlin, Germany),
20 x 27cm (8 x 10½in)
Signed *Rembrandt f. 1645*

A companion oil-on-wood panel painting to *Joseph's Dream in the Stable in Bethlehem,* 1645, and of the same size. The subject of the painting is taken from the apocryphal Book of Tobit. The elderly man Tobit, who has recently lost his sight, falsely accuses his wife of stealing a kid goat when she brings one to the house. She rebukes him.

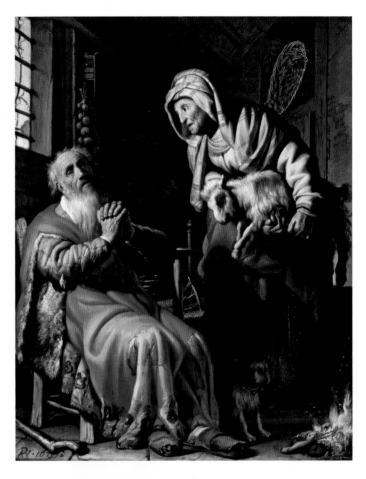

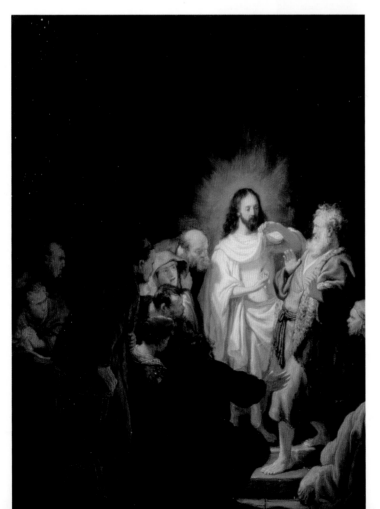

The Incredulity of St. Thomas, 1634, oil on panel, Pushkin Museum, Moscow, Russia,
53 x 51 cm (20.9 x 20.1 in)
Signed *Rembrandt f. 1634*

The painting portrays at centre the figure of the risen Christ. The bible narrative (John 20:27) states that Christ asked the apostle Thomas, who doubted that Christ has risen from the dead, to observe the wounds in his hands and on his body. Rembrandt portrays Christ lifting his cloak to reveal the upper body wound received during his crucifixion. Thomas's incredulity is portrayed in his expression of astonishment. Surrounding the two central figures are Christ's apostles. John, who narrated the story, is in the right foreground.

The Apostle Paul in Prison,
1627, oil on canvas,
Staatsgalerie,
Stuttgart, Germany,
73 x 60cm (29 x 23½in),
black and white photograph
Signed *R f.1627*, and
on a page of a book,
Rembrandt Fecit

This is one of an early series
of singular figure paintings
of the apostles. Rembrandt
was 21 when he painted
this fine work. The artist
depicts St Paul in prison,
deep in thought
as he writes his epistles.
St Paul was put to death
in Rome by the Emperor
Nero, during the
latter's persecution of
Christians. The sword,
which is depicted propped
up beside the saint,
is a symbol of his death
by beheading,
c.AD 62–66.

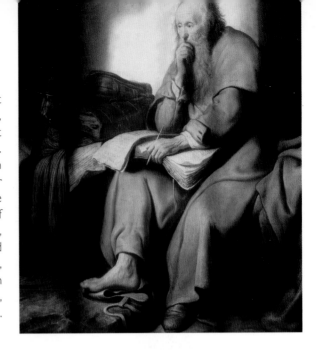

*David Offering the Head of
Goliath to King Saul,* 1627,
oil on panel, Kunstmuseum,
Basel, Switzerland,
27.5 x 29.5cm (11 x 11½in)

In works of religious
subjects, Rembrandt
favoured the Old Testament.
In this portrayal of the
shepherd David, slayer of
the Philistine giant, Goliath
of Gath, Rembrandt
portrays the moment that
the head of the giant is
handed to King Saul (Samuel
I: 51-7). In this colourful
portrayal, Rembrandt
depicts Saul, surrounded
by his troops, receiving
the head from David,
who kneels at his feet.
Rembrandt adds a realistic
touch in the forefront
of the composition, where
an excited dog is attracted
by the dead flesh of the
giant's head. The painting
possibly symbolized the
fledgling Dutch Republican
territories overcoming
Spanish rule.

The Circumcision, 1630,
(II states),
pen & ink on paper,
City Art Gallery,
Leeds, U.K,
8.8 x 6.4cm (3½ x 2½in)

The scene, informed by the
biblical text, Luke II: 21-22,
refers to the circumcision of
Christ, eight days after the
birth. The scene depicts the
baby surrounded by the
Elders with Mary and Joseph
looking on. In the
foreground a pair of birds
rest on a dish, a reference
to Luke II:22, 'and to offer
a sacrifice... [of] a pair of
turtledoves, or two young
pigeons'. The second state
of the print was inscribed
*Rembrandt f. I.P.
Berendrechex.* This was an
addition by the Haarlem
print publisher Johannes
Pietersz. Berensdrecht, who
sold copies of both versions.

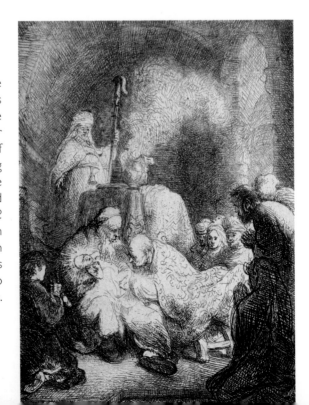

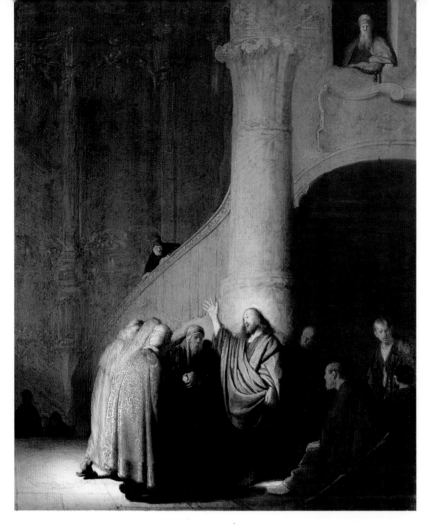

The Tribute Money, 1629, oil on panel, National Gallery of Canada, Ontario, Canada, 42 x 33cm (16½ x 13in)

Rembrandt creates a soft, circular beam of light to highlight the halo around the head of Christ, and the small crowd gathered around him. The painting illustrates the New Testament narrative, Luke XX, in which scribes and chief priests, questioning Christ's authority, ask if they should pay taxes to the Romans. In order to avoid a comparison between the greater power: Caesar or God, he responded that as their coinage was stamped with the head of Caesar, '...render to Caesar the things that are Caesar's; and unto God the things that are God's.'

Simeon and Hannah in the Temple, c.1627, oil on panel, Hamburger Kunsthalle, Hamburg, Germany, 55.5 x 44cm (22 x 17in)

Rembrandt depicts a scene from the bible narrative Luke II:21-38. Simeon, an old man, not far from death, holds the infant Christ in his arms. Simeon was foretold that he would see the Son of God before he died. In line with Jewish law, Mary and Joseph had brought their firstborn to be consecrated. Anna, a prophetess, reacts to seeing the halo of the infant. This painting reveals Rembrandt's mastery of *chiaroscuro*; the soft, warm light from an unseen window creates its shadow on the wall, while highlighting the figures of Simeon and the infant Christ.

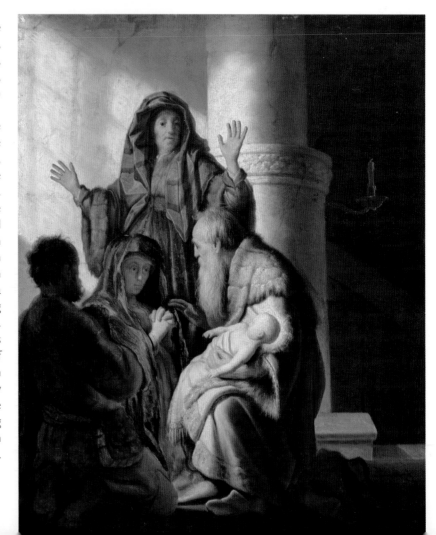

The Lion Hunt with One Lion,
*c.*1629, etching, City Art
Gallery, Leeds, U.K,
15.8 x 11.7cm (6 x 4½in)

In this dramatic depiction
of a lion hunt with two
horseman, the lion has
launched an attack on
one horseman and pulled
his horse to the ground.
The rider is depicted at left
with his spear aimed at the
lion's head. The other
horseman, riding to help, has
his foot on the lion's back
and his dagger poised to
strike the lion.

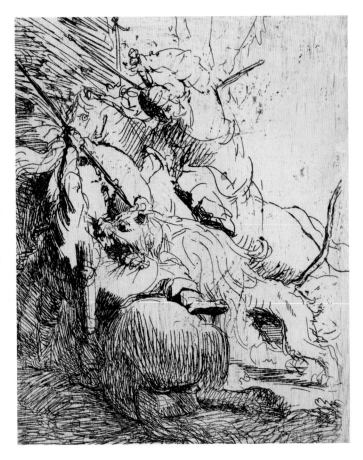

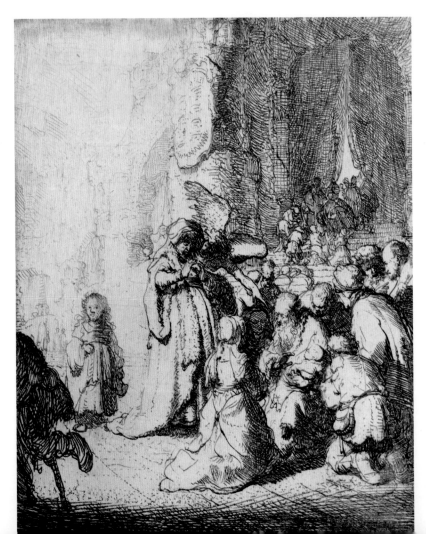

Presentation in the Temple,
1630, etching (11 states),
City Art Gallery, Leeds, UK,
10.3 x 7.8cm (4 x 3in)
Signed *RHL 1630*

Informed by the biblical text,
Luke II: 25-30, the scene
represents the infant Christ,
presented to the Elders in
the temple, as was the
custom. The figure holding
the baby is probably the
elderly holy man Simeon,
who was foretold by God
that he would see the 'Lord's
Christ' before he died. At his
feet are Mary and Joseph
with the figure of Anna, the
prophetess looking on, while
a crowd gather around the
Holy Family.

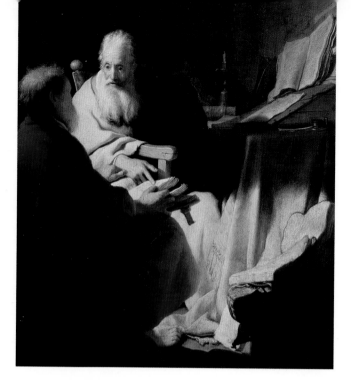

Two Old Men Disputing, 1628, oil on wood panel, National Gallery of Victoria, Melbourne, Australia, 72.4 x 59.7cm (28½ x 23½in)

Two old men, said to be depictions of St Peter and St Paul, are seated close together, facing each other, near a table on which are strewn open books. Rembrandt sets a scene that is in process. He highlights the central figure of St Peter, facing the spectator, who points to a text in the book held by St Paul. His expression reveals that the two men are in the middle of a vibrant debate on the scriptures.

Anna and the Blind Tobit, c.1630, oil on oak panel, National Gallery, London, UK, 64 x 48cm (25 x 19in)

This painting is attributed to Rembrandt. The apocryphal 'Book of Tobit' reveals the life of Anna and her husband, Tobit. In a poignant narrative, to test their faith, God reduced the couple to poverty and, as a consequence of poor living conditions, Tobit lost his sight. For the Dutch people, the story was a positive Christian example of piety under duress and hardship. Rembrandt created many sketches, drawings and etchings of Tobit and his family, due to the popularity of the religious tale, and his own interest in it.

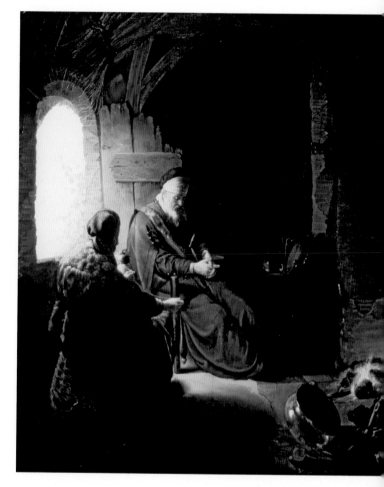

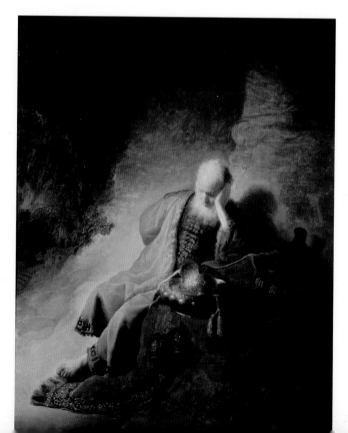

Jeremiah Mourning over the Destruction of Jerusalem, 1630, oil on canvas, Rijksmuseum, Amsterdam, The Netherlands, 58 x 46cm (23 x 18in)

This is a possible self-portrait of Rembrandt, posing as the prophet Jeremiah, who sits contemplating the destruction of Jerusalem within a cavern outside the Damascus Gate. Here, Rembrandt uses *chiaroscuro* to portray the darkness of the cave, a symbol of the destruction of Jerusalem, and to highlight the 'holy' aura of light, which shines on the lonely man.

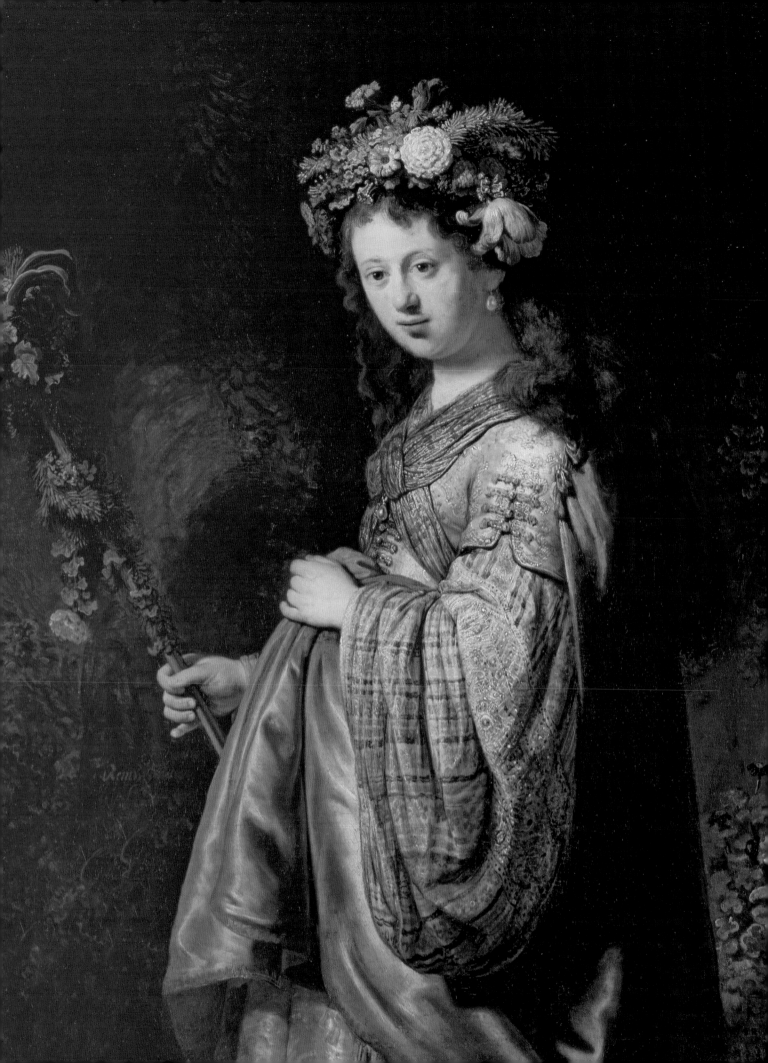

1631–1648

Rembrandt's move to Amsterdam c.1631 motivated him to engage with the rich patrons of the city. Numerous works from this highly prosperous middle period of his professional career include the outstanding *The Anatomy Lesson of Doctor Nicolaes Tulp*, 1632, and the vast large-scale painting *Officers and Guardsmen of the Amsterdam Civic Guard Company of Captain Frans Banning Cocq and Lieutenant William van Ruytenburgh* (*The Nightwatch*) c.1642. It was created in the year his beloved wife Saskia died.

Above: Cottages Before a Stormy Sky, *pen and ink, 1635–40, Graphische Sammlung Albertina, Vienna, Austria, 18.2 x 24.5cm (7.2 x 9.6in). Rembrandt depicts the sky clearing as dark storm clouds move away from a hamlet of Dutch cottages and outbuildings nearby.*

Left: Saskia as Flora, *1634, oil on canvas, The State Hermitage Museum, St. Petersburg, Russia, 125 x 101cm (49 x 40in) Rembrandt's young wife Saskia is richly depicted as Flora, the Roman goddess of spring and of flowers. He bedecks her head in a glorious garland of flowers.*

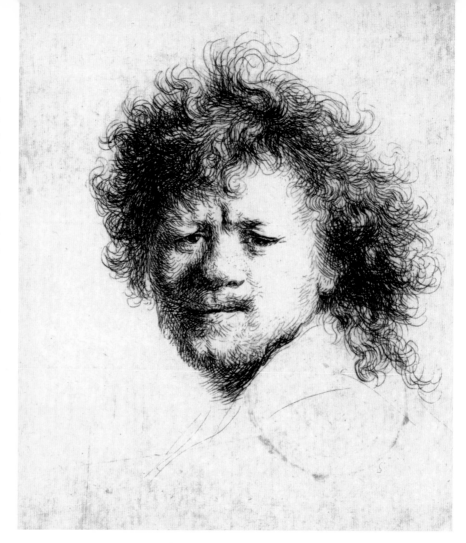

Self-portrait with Long Bushy Hair: Head Only, c.1631, etching (VI states), Rijksmuseum, Amsterdam, The Netherlands, 6.5 x 6cm (2½ x 2½in)

The second state of six different editions of this etching. It depicts Rembrandt in a head–only portrait with flowing hair swept across his forehead, trailing on to his collar, looking slightly dishevelled. His eyes squint at the viewer, creating a quirky, quizzical expression.

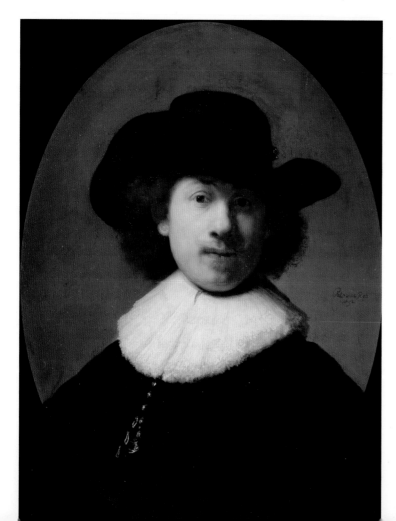

Self-portrait, 1632, oil on panel, Burrell Collection, Glasgow, Scotland, UK, 63.5 x 46.3cm (25 x 18in) Signed RHL van Rijn. 1632

Rembrandt is dressed in formal clothing; a gentleman's wardrobe of fashionable broad brimmed hat with gold hatband, a doublet with gold buttons worn under a cloak of wool and velvet, and a pure white ruff that lays on the clothing. The portrait was painted during the period that Rembrandt moved from Leiden to Amsterdam. It shows a prosperous young man, skilled in his profession of painting. The shorter hair and trimmed moustache and beard alter his appearance from the Bohemian look of his earlier self-portraits.

Portrait of Rembrandt's Father (?), 1631, oil on panel, Birmingham City Art Gallery, UK, 61 x 52cm (24 x 20½in)

Many paintings and drawings of a distinguished man in his later years, painted by Rembrandt, are thought to be possibly portraits of the artist's father. However, there is no proof that any are of the mill owner, Harmen Gerritszoon van Rijn (c.1568–1630), who died on 27 April 1630. It is possible that Rembrandt painted a posthumous portrait of his father, or that it is a portrait of his brother, Adriaen.

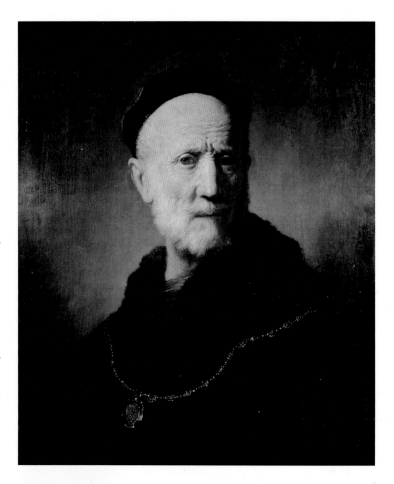

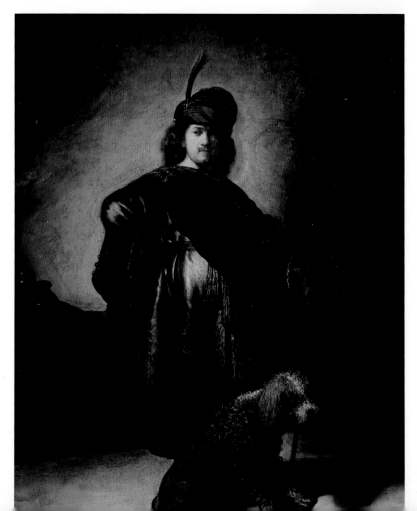

Self-portrait in Oriental Costume, 1631, oil on panel, Musée de la Ville de Paris, Musée du Petit-Palais, France, 66 x 52cm (26 x 20½in)

Rembrandt portrays himself as a rich oriental potentate of the East, a figure full of opulence. He is dressed in a magnificent three-quarter length dress robe of shining silk-satin, tied at the waist and topped with a luxurious fur cloak tied at the right shoulder. His stunning turban has a jewelled plume feather. He sports a small moustache and goatee beard. At his feet a dog sits, possibly included to add princely status. The dog is finely painted to reveal its curly coat. It is placed at centre, yet looks away as if its attention has been caught by something unseen.

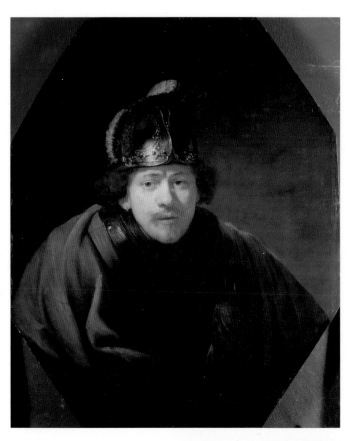

Self-portrait with Helmet, 1634, oil on panel, Gemäldegalerie Alte Meister, Kassel, Germany, 80.5 x 66cm (32 x 26in)

This half-length portrait, a *tronie*, is of a soldier wearing a helmet with two plumes, and a gorget around his neck. What we see are the familiar features of Rembrandt's head with the crush of curly hair under the helmet, the wispy moustache and furrowed brow, and the sharp eyes that penetrate the face. Shrouded in a cloak, he leans forward on a sill and looks beyond the viewer to something, or someone unseen. The lower part of the painting may have been added at a later date by another artist.

Self-portrait with Hat and Gold Chain, 1633, oil on panel, Musée du Louvre, Paris, France, 70 x 53cm (28 x 21in) Signed Rembrandt f. 1633

The oval self-portrait closely resembles the composition and styling of the bare-headed self-portrait of Rembrandt, created in the same year. In the composition, the artist adorns his rich red hair with a peaked beret decorated with a small gold chain. The body is positioned in three-quarter profile, while the head, with chin slightly down, faces toward the spectator. Rembrandt wears a cloak with gold chain braiding; his left hand, wearing a glove, is held to his chest.

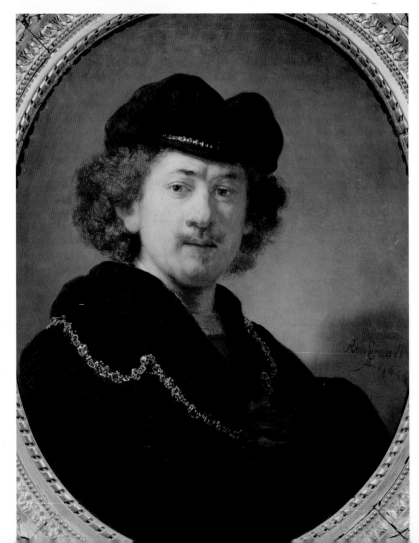

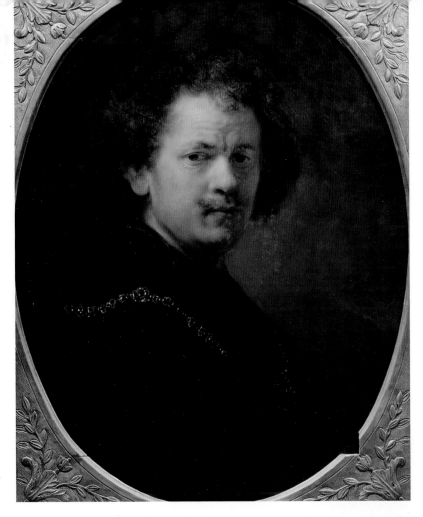

Self-portrait, 1633, oil on panel, Musée du Louvre, Paris, France,
60 x 47cm (23½ x 18½in)
Signed *Rembrandt f.* 1633

This self-portrait, bare-headed and in semi-profile, is oval in shape. The warm colour tones of the background complement the rich red hues of Rembrandt's loosely worn curly hair. His face is bathed in a golden light. He has a small moustache, which is neatly trimmed. At his neck he wears a military gorget – although Rembrandt never enlisted to serve in the militia – and a cloak adorned with a gold chain.

Portrait of a Man with a Gold Chain or, *Self-portrait with Beard*, 1634–36, oil on panel, Museu de Arte, São Paulo, Brazil,
57.5 x 44cm (22½ x 17in)
Signed *Rembrandt*

This portrait is attributed to the artist, albeit with some reservations, by Rembrandt scholars. The semi-oval portrait illustrates Rembrandt wearing a beret with banding, his hair is groomed and he has a short growth of beard on his chin. The face has a quizzical expression, with frown lines visible. The clothing is that of a prosperous gentleman wearing a beautiful high-neck shirt, and a coat of fur adorned with a gold chain.

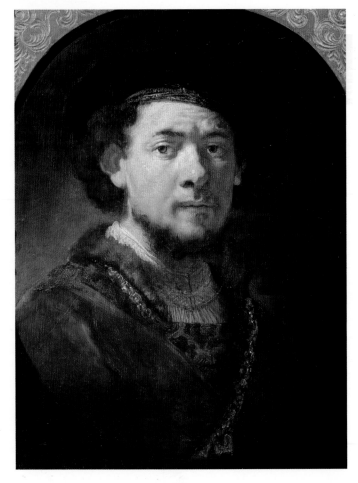

Portrait of Saskia Uylenburgh, 1633, silverpoint on prepared vellum, Staatliche Museen zu Berlin, Germany, 18.5 x 10.7cm (7 x 4in)

According to the inscription written by Rembrandt on this drawing, it was created on 8 June 1633, days after his engagement to Saskia was announced. She wears a large straw hat with floral brim, an accessory in keeping with the contemporary fashion for the Pastoral. She holds a single flower in her right hand, and stares intently at the artist, her fiancé, Rembrandt. The text reads: 'This was drawn after my wife at the age of 21; on the third day after getting engaged, on 8 June 1633.'

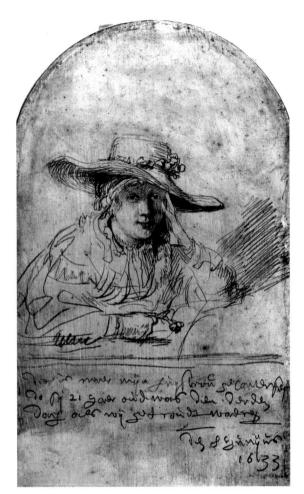

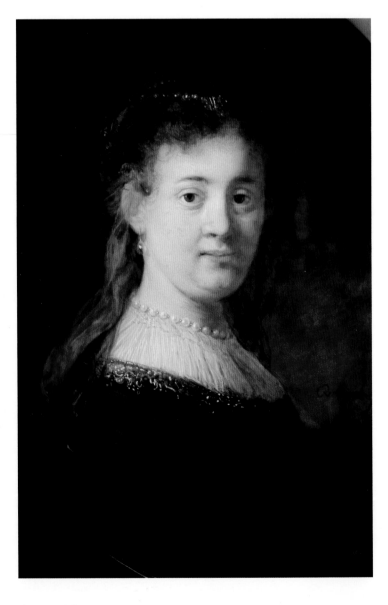

Portrait of Saskia, 1633, oil on panel, Rijksmuseum, Amsterdam, 66.5 x 49.5cm (26 x 19½in) Signed Rembrandt ft 1633

A half-length portrait of Saskia, created during the period of her engagement to Rembrandt. She is depicted in profile with her head turned toward the viewer. It is a delicate portrayal of a young woman. She turns her head as if in conversation with the artist. He captures her shy expression, casting light on to her head and face. It catches the pearl beads of her necklace and her earrings.

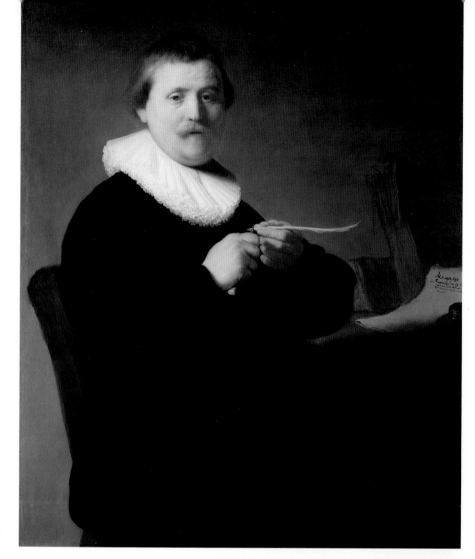

Man Sharpening a Quill,
1632, oil on canvas,
Gemäldegalerie Alte
Meister, Kassel, Germany
101.5 x 81.5cm (40 x 32in)
Signed on the letter RHL
van Rijn

The sitter is thought to be
Lieven Willemsz. van
Coppenol (1599–after
1677), a Mennonite writing
master and calligrapher,
noted to be 'a half-witted,
conceited calligrapher'. The
quill alludes to his profession.
Rembrandt produced
possibly two etchings of
Van Coppenol too.
The calligrapher is posed,
sharpening his quill. On the
desk lies a letter.

Man Sharpening a Quill,
1632, oil on canvas, (detail),
Gemäldegalerie Alte
Meister, Kassel, Germany,
101.5 x 81.5cm (40 x 32in)

Lieven Willemsz. van
Coppenol (1599–after
1677), a writing master and
calligrapher, is portrayed
holding the tool of his trade,
a writing quill. Coppenol
requested an etched
or engraved portrait of
himself from many artists in
Amsterdam. Following this,
he commissioned poets to
write about himself, in order
to write the poems on the
etching or engraving prints.
Four poems were written
to accompany portraits of
Coppenol by Rembrandt.

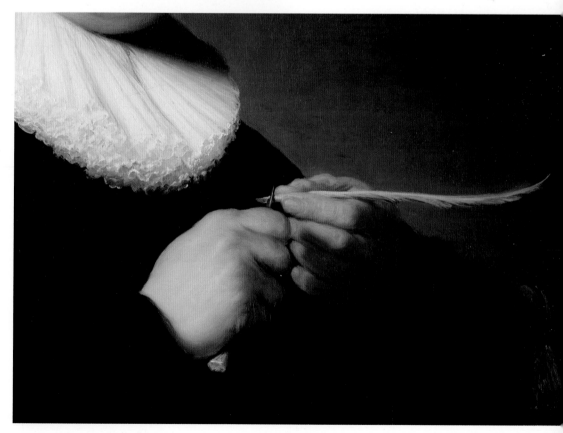

Portrait of Titia van Uylenburgh, 1639, pen and bistre, Nationalmuseum, Stockholm, 17.8 x 14.6cm (7 x 6in) Inscribed Tijtsya van Ulenburch 1639

Titia, an elder sister of Saskia, spent time in the Rembrandt household when Saskia was pregnant. The sisters were close. Here, Rembrandt sketches an intimate portrait of his sister-in-law. Her head is bent over a piece of sewing.

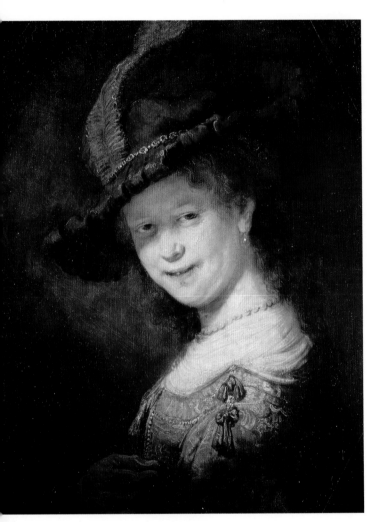

Portrait of Saskia, 1633, oil on panel, Gemäldegalerie, Dresden, Germany, 52.5 x 44.5cm (21 x 17½in)

A bust-length portrait of Saskia, prior to her marriage to Rembrandt. The composition fills the picture space. She is depicted in profile with her head toward the viewer. She smiles coquettishly and with charm toward the onlooker, and dips her hat. The hat is large with a brim that shades her eyes. It is adorned with a large feathery plume. The decorative details on the shoulder of her dress are visible.

Portrait of Princess Amalia van Solms (also known as *Portrait of Saskia van Uylenburgh*), 1632, Musée Jacquemart-André, Paris, France, 68.5 x 55.5cm (27 x 22in) Signed RHL van Rijn 1632

Historians debate whether the painting is a portrait of Amalia van Solms (1602–75), wife of Frederik Hendrik, Prince of Orange or, a portrait of Saskia van Uylenburgh, wife of Rembrandt. Amalia van Solms was an avid collector of art, from porcelain to paintings. She owned 13 works by Rembrandt.

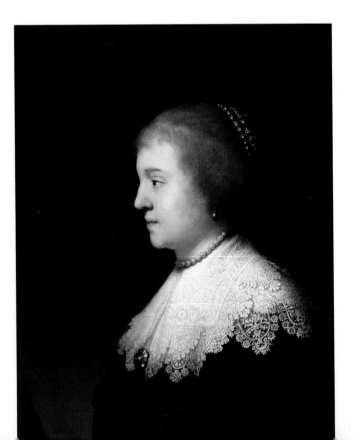

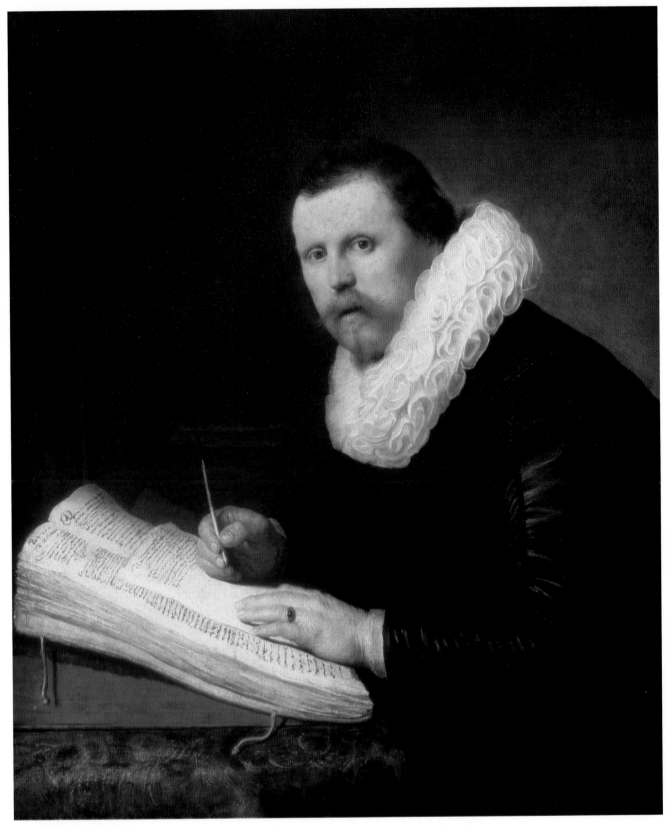

Portrait of a Young Man at his Desk, 1631, oil on canvas, Hermitage Museum, St Petersburg, Russia, 104 x 92 cm (40.9 x 36.2in)

The painting, dated 1631, is signed with the monogram RHL. The unknown sitter viewed in profile is seated at his desk. His head is turned toward the onlooker and his facial expression denotes that he is aware of a person unseen. He is captured with pen poised in the process of writing. The paper he writes on is placed on top of a large open book which rests on a support. Light from an unseen source highlights the man's face, the large ruff he wears, and the pages of the book.

Baldassare Castiglione, after Raphael, 1639, pen and brown ink, touched with white, on brown prepared paper, Graphische Sammlung Albertina, Vienna, Austria, 16.3 x 20.7 cm (6½ x 8in)

In 1630, the artist Peter Paul Rubens (1577–1640), a major rival to Rembrandt, made a copy of Raphael's painting of *Baldassare Castiglione* (c.1528). Rembrandt's sketch is a quick copy of Raphael's original painting, which he viewed in 1639, at an auction house in Amsterdam, prior to its sale to the wealthy Amsterdam collector, Alfonso Lopez.

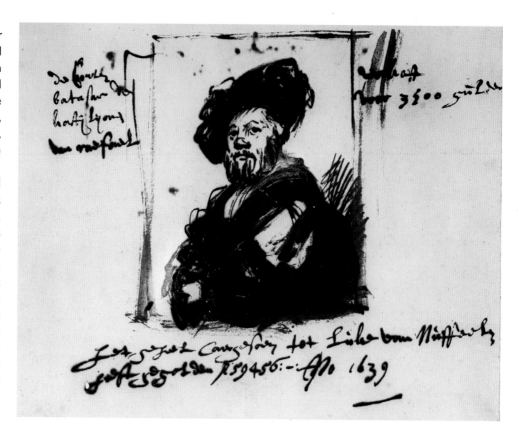

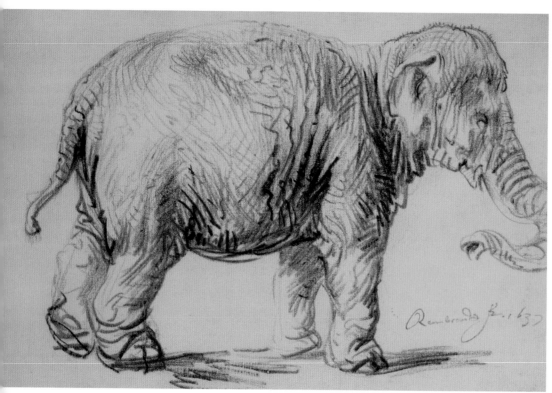

An Elephant, 1637, black chalk on paper, Graphische Sammlung Albertina, Vienna, Austria, 23.5 x 35.4cm (9 x 14in) Signed *Rembrandt ft.1637*

The chalk medium highlights the wrinkly textures of the elephant's skin and its rounded torso. This work is one of four extant studies of an elephant by Rembrandt, and his most masterful. The body of the elephant fills the picture space. It is drawn from life and pictures of Hansken, an elephant that was part of a travelling show, visiting Amsterdam. She was about seven years of age when Rembrandt drew her.

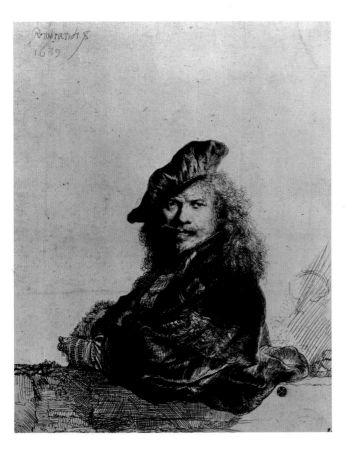

Self-portrait Leaning on a Stone Sill, 1639, (II states), etching and drypoint, British Museum, London, UK, 20.5 x 16.4cm (8 x 6½in). Signed and dated top left, *Rembrandt f 1639*

At the time Rembrandt created *Self-portrait Leaning on a Stone Sill*, 1639, the painting *A Man with a Quilted Sleeve*, 1510, by Titian (c.1487–1576), was in Amsterdam in the collection of Alfonso Lopez. Rembrandt, informed by Titian's artwork, depicted himself in 16th-century Renaissance dress, including a dashing velvet cap. His left shoulder and elbow lean across the stone sill toward the viewer. It takes compositional elements from Titian's work and *Portrait of Baldassare Castiglione*, c.1528, by Raphael (1483–1520), which was at auction in Amsterdam in 1639, and purchased by Lopez, for the sum of 3,500 guilders, which Rembrandt took note of. His *Self-portrait*, 1639, combines elements of both works.

Portrait of Maria Trip, 1639, oil on panel, Rijksmuseum, Amsterdam, 107 x 82cm (42 x 32in) Signed *Rembrandt f. 1639*

A distinguished portrait of Maria Trip, the 20-year-old daughter of a wealthy Amsterdam merchant, Alotta Adriensdra. Her delicate features are captured in the soft light that falls on her face, drawing attention to her beautiful eyes. The light captures the glister of her pearl necklace, drop earrings and pearl bracelets. The opulent gown is further enhanced with a lace shawl-collar and cuffs. Maria Trip's left hand rests on the edge of a balustrade. X-rays show that Rembrandt originally painted the balustrade along the length of the painting but shortened it for the finished work.

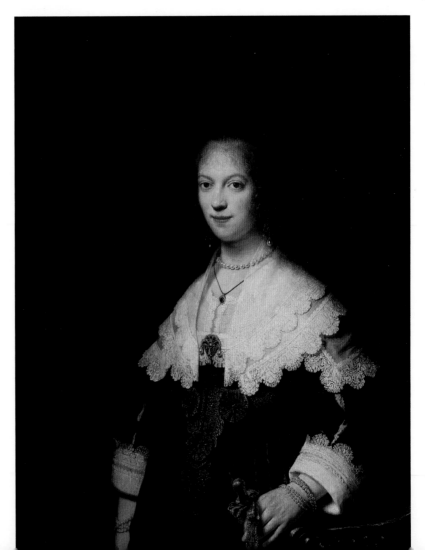

Portrait of a Man and Woman in Black or *Jan Pietersz. Bruyningh and his Wife, Hillegont Pietrsz. Moutmaker*, 1633, oil on canvas, Isabella Stewart Gardner Museum, Boston, MA, USA, 131.6 x 109cm (52 x 43in)

The large double portrait is thought to depict Jan Pietersz. Bruyningh, a Mennonite preacher, cloth merchant and art collector. He stands at the centre. To his left, his wife Hillegont is seated, in three-quarter profile. An X-ray of the painting showed a young boy between the two figures. The figure was painted out, possibly owing to premature death. The chair in the foreground to the left may symbolize the child's absence.

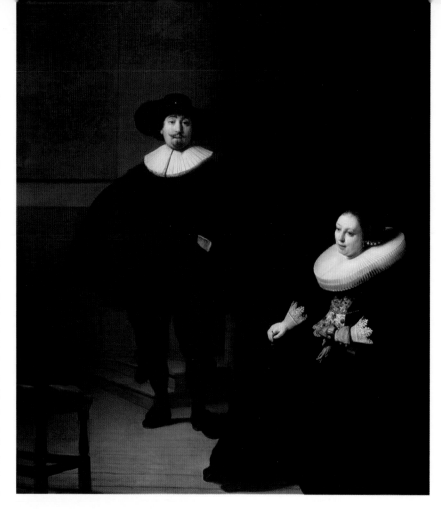

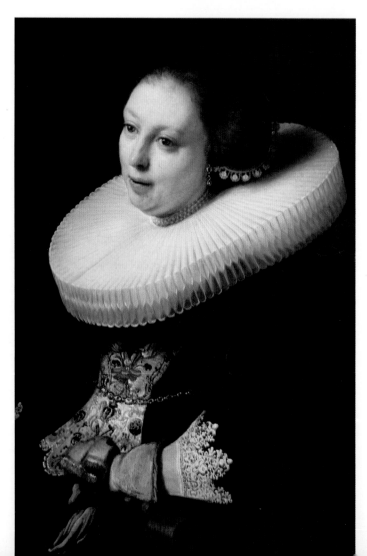

Portrait of a Man and Woman in Black or, *Jan Pietersz. Bruyningh and his wife, Hillegont Pietrsz. Moutmaker*, 1633 (detail), oil on canvas, Isabella Stewart Gardner Museum, Boston, 13.1 x 10.7cm (5 x 4in)

A detail of the head and upper body of a woman in black, possibly Hellegont Pietrsz Moutmaker, wife of the cloth merchant, Jan Pietersz.Bruyningh.

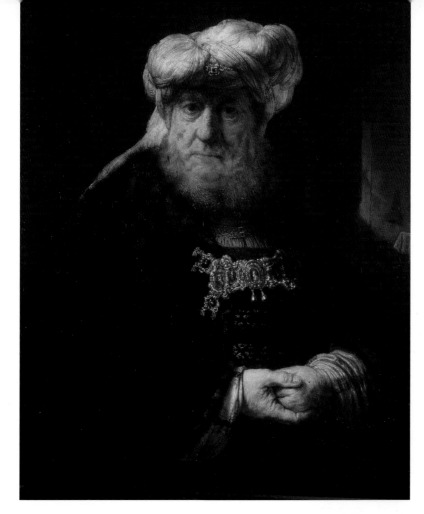

*A Man in Oriental Costume,
(Uzziah Stricken with
Leprosy)*, 1635, oil on wood
panel, Chatsworth House,
Derbyshire, UK,
103 x 72.4cm (40½ x 28½in)
Signed *Rembrandt f. 1635*

Some scholars consider the
portrait to depict King
Uzziah (II Chronicles XXVI:
18-19), which narrates the
story of the king, who was a
brilliant military man, but
proud and arrogant. He
insisted on burning incense
on the temple altar – a task
reserved for priests – then
was struck with leprosy and
cast out. The sitter wears
fine robes and a splendid
turban, possibly part of
the artist's collection of
costumes. Several copies
of this portrait are extant.

*Jan Uytenbogaert, the
Goldweigher,* 1639, etching
with drypoint, (II states),
Private Collection,
26.8 x 22.1cm (10½ x 9in)

Rembrandt depicts Jan
Uytenbogaert, 'the
Goldweigher', seated at a
table covered with a heavy
cloth. On the table are a
large pair of scales, and a
book rest on which sits an
open ledger. Uytenbogaert
has weighed a bag of
money; he records it in his
ledger, and hands the bag to
an assistant, who is kneeling
at his side. In the distant left,
two figures, a man and a
woman, look toward
Uytenbogaert, while waiting
at the opened door, holding
their bags of money.
The 'goldweigher' is the tax
collector Jan Uytenbogaert,

an associate of Rembrandt.
They possibly met while
Uytenbogaert was studying
law at Leiden in 1626–32, at
the time Rembrandt was
living in Leiden. In 1638,
Uytenbogaert succeeded to
the position of 'Collector of
National Taxes' based in
Amsterdam. In 1639, the
year the etching was
created, Uytenbogaert
intervened on behalf of
Rembrandt to retrieve
payment from Prince
Frederick Hendrik, who had
not paid for two works of
art. Rembrandt needed the
money to pay toward the
deposit on his new house in
Breestraat. The etching
copper-plate remained in the
Uytenbogaert household
until 1760. The 'goldweigher'
title was introduced in
the 18th century.

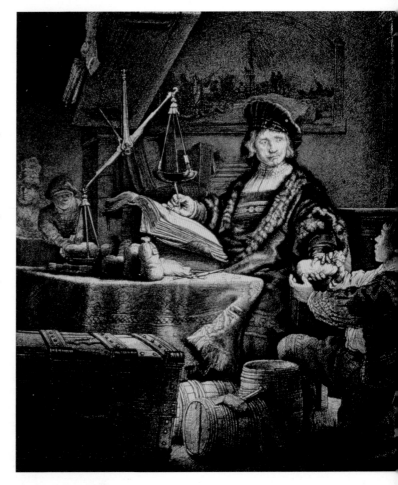

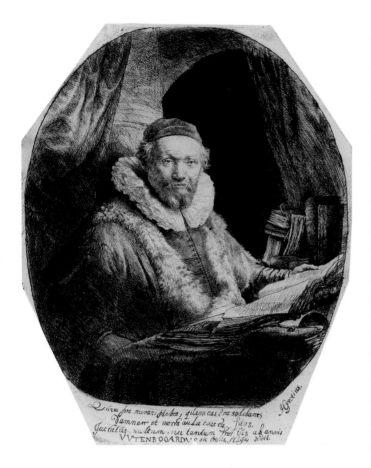

Portrait of Jan Uytenbogaert (1557–1664), Preacher of the Remonstrants, 1635, etching with drypoint and engraving, (IV state). Private Collection, 22.7 x 18.5cm (9 x 7in)

The portrait was produced as an etching and an engraving for an oval-shaped portrait. The fourth state of the etching (illustrated) adds darker shading to the drapes that frame the half-length figure of Uytenbogaert. He sits at a table with a large open book in front of him. Other books are stacked nearby. Uytenbogaert was 78 at the time of the portrait. The caption at the base of the work relates to Uytenbogaert's exile in 1618, due to religious intolerance, and his return to The Hague

Self-portrait with Saskia in the Parable of the Prodigal Son, c.1635, oil on canvas, Gemäldegalerie Alte Meister, Dresden, Germany, 161 x 131cm (63½ x 51½in)

Rembrandt's portrait with Saskia is the largest self-portrait he painted. Created during a period of great success with a full book of commissions, the portrait is unusual in its subject matter. Rembrandt the 'prodigal son' [Luke XV:11-32], is depicted with a 'harlot' in a brothel. A 'madam', originally painted between the pair, was later removed. Saskia perches on Rembrandt's knee. Does he see himself as the 'prodigal son' of the Van Rijn family? The couple turn to the spectator and he raises a near-full glass to the beholder.

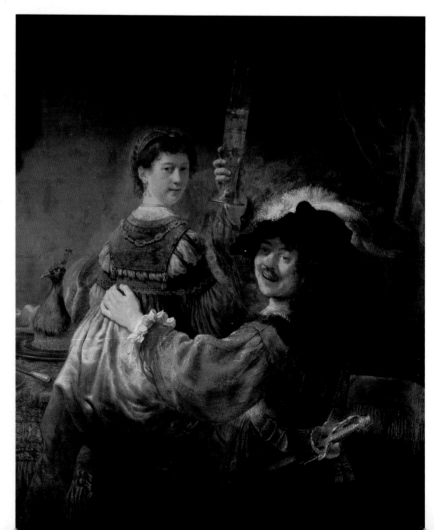

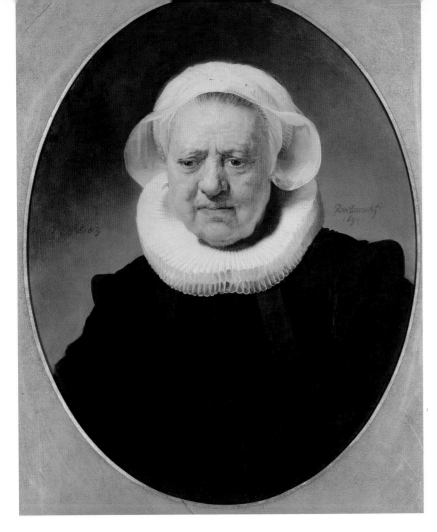

Portrait of Aechje Claesdre,
1634, oil on oak panel,
National Gallery,
London, UK,
71.1 x 55.9cm (28 x 22in)
Signed, dated and inscribed
Rembrandt f. 1634

Aechje Claesdr was depicted
by Rembrandt at the age of
83. She was the widow of
the Rotterdam brewer, Jan
Dammaszn. Pesser. Her son,
Dirck Jansz. Pesser and his
wife commissioned a portrait
from Rembrandt in the same
year as this work. For
Aechje's portrait Rembrandt
used his favourite medium,
bone black pigment, which
produced the darkest black
for the wearer's clothing,
highlighting the purity of the
white ruff and headcap.

*Portrait of a Man in Oriental
Costume,* 1633, oil on panel,
Alte Pinakothek,
Munich, Germany,
85.8 x 63.8cm (34 x 25in)
Signed *Rembrandt f. 1633*

The painting is possibly the
depiction of a biblical
character. The half-length
portrait of a rich potentate
in oriental costume, is
painted in three-quarter
profile. Rembrandt
graphically illustrates the
richly jewelled turban and
the drop-earrings the old
man wears. A luxuriant cloak
patterned and threaded in
gold is placed around his
shoulders. In his left hand he
holds an incised ceremonial
stick. Rembrandt had many
oriental clothes in his
collection, mainly used as
props for paintings.

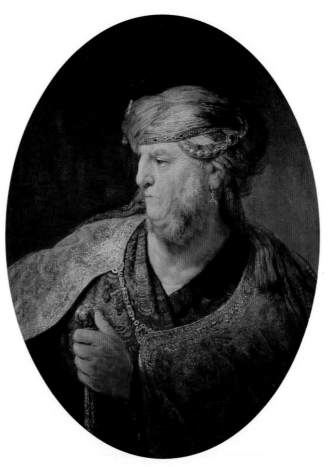

Self-portrait with Saskia in the Parable of the Prodigal Son, c.1635, (detail of Saskia), oil on canvas, Gemäldegalerie Alte Meister, Dresden, Germany, 161 x 131cm (63½ x 51½in)

A detail of the painting *Self-Portrait with Saskia in the Parable of the Prodigal Son,* c.1635, which reveals the new wife of Rembrandt, the polite, charming, refined Saskia, playing her role as the 'harlot' to Rembrandt's 'prodigal son'. The reason for depicting themselves in such roles remains a mystery but it does reveal the pleasure they enjoyed in each other's company. Saskia is seductive as she turns to acknowledge the onlooker.

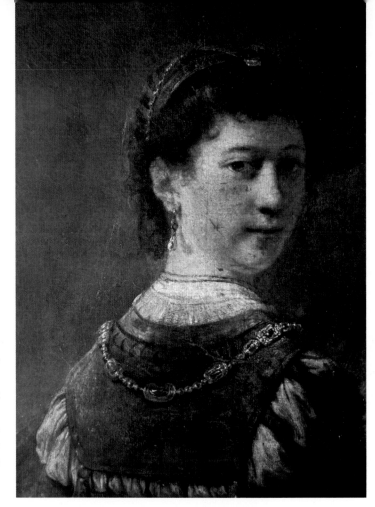

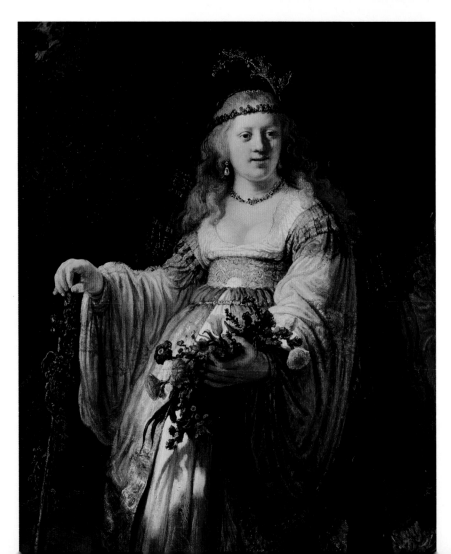

Saskia van Uylenburgh in Arcadian Costume, 1634–5, oil on canvas, National Gallery, London, UK, 123.5 x 97.5cm (48½ x 38½in)

Saskia portrays Flora, the Roman goddess of Spring, goddess of fertility and flowers, which are represented in the floral bouquet she carries. Her dress highlights the contemporary fashion in Amsterdam for the pastoral of Arcadian myth. Rembrandt presents her as a young goddess in a rustic setting. Interest in the pastoral genre spread through Dutch society in the 1620s, and theatrical dress, seen on stage in pastoral plays, spread to street fashion that embodied the romantic ideal of country life.

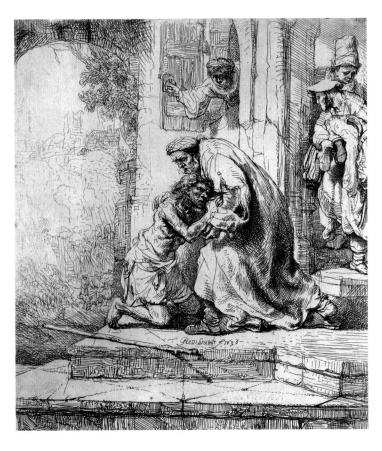

Return of the Prodigal Son,
1636, pen & ink on paper,
City Art Gallery,
Leeds, U.K.
15.6 x 13.6cm (6 x 5½in)

A starkly different view
of the prodigal son in
Rembrandt's *Self-portrait with
Saskia in the Parable of the
Prodigal Son*, in which the
'son' enjoys the material
pleasures of life prior to
returning to his family. A pen
and ink drawing, dated 1636,
shows Rembrandt's masterful
depiction of human kindness,
in the display of remorse of
the son and forgiveness of
the father. This poignant
drawing and a later
painting of 1668–9, affirm
Rembrandt's religious beliefs.

The Stoning of St. Stephen,
1635, etching (II states),
City Art Gallery,
Leeds, U.K,
9.5 x 8.5cm (4 x 3in).
Signed and dated,
Rembrandt f. 1635

Rembrandt revisits an earlier
work of the same subject,
which was produced as a
painting in 1625. The etching
concentrates on the central
characters. The work is
informed by the bible
narrative, Acts VII: 58-60,
to explore the raw and
emotive scene of the first
Christian martyr, St Stephen,
being stoned to death by a
raucous crowd. Central to
the composition, the dazed
face of Stephen, kneeling
on open ground, looks
toward the spectator with
arm outstretched.

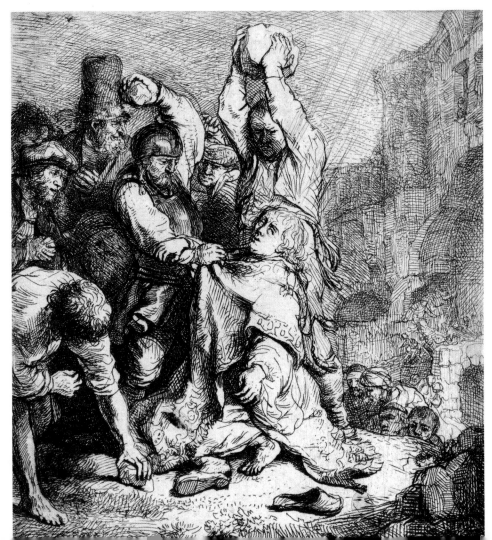

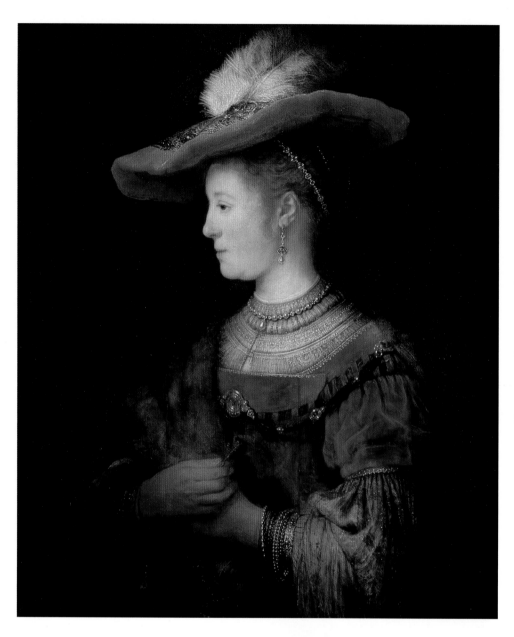

Portrait of Saskia in a Red Hat, 1633–4, oil on panel, Gemäldegalerie Alte Meister, Kassel, Germany, 99.5 x 78.8cm (39 x 31in)

The vibrant colour of Saskia's dress and hat enrich a beautiful portrait of Rembrandt's fiancée. Her hair, neck and wrists are bejewelled; a dashing hat, lightly placed on the crown of the head, is dressed with magnificent feathers. The three-quarter length portrait captures her profile, and a luxuriant fur wrap, held by a clasp, is worn over her right shoulder and arm; it was a late addition to the painting. In 1652, Rembrandt sold the painting to his associate and patron Jan Six.

Portrait of Saskia in a Red Hat, 1633–4, oil on panel, (detail of dress) Gemäldegalerie Alte Meister, Kassel, Germany, 99.5 x 78.8cm (39 x 31in)

The rich fabric of Saskia's red dress, fine blouse and heavy fur wrap are carefully painted in detail. This is a masterful portrait of Rembrandt's fiancée.

Portrait of Saskia in a Red Hat, 1633–4, oil on panel, (detail of hands) Gemäldegalerie Alte Meister, Kassel, Germany, 99.5 x 78.8cm (39 x 31in)

Painted in the year of Saskia and Rembrandt's engagement, the painter places Saskia's hands clasped together under the bust. There is no evidence of a betrothal ring. The original intention may have been to use Saskia as a character model. X-rays show there to be a dagger held in one hand, possibly a link to the biblical character Judith.

Portrait of Saskia in a Red Hat, 1633–4, oil on panel, (detail of earrings) Gemäldegalerie Alte Meister, Kassel, Germany, 99.5 x 78.8cm (39 x 31in)

Rembrandt delicately painted the pearl-drop earring that Saskia wears. The earrings, necklace and bracelets are possibly part of the dowry of jewels that Saskia brought on her marriage. After her death, her jewellery was the subject of contention, and possibly they were the same jewels that Rembrandt gave to Titus's nursemaid Geertghe Dircx, which she later tried to sell.

Portrait of Saskia in a Red Hat, 1633–4, oil on panel, (detail of bracelets) Gemäldegalerie Alte Meister, Kassel, Germany , 99.5 x 78.8cm (39 x 31in)

The wrists of Saskia are adorned with sparkling bracelets, which catch the light. Painted after her engagement to Rembrandt and in the year of her marriage to him, it is likely that the jewellery she wears was part of her marriage dowry. Was it an engagement painting? If it is, Rembrandt paints Saskia at her most beautiful, an enchanting young girl, richly adorned in beauty and wealth.

Portrait of a Man, (possibly the poet Jan Hermansz. Krul), 1633, oil on canvas, Gemäldegalerie Alte Meister, Kassel, Germany, 129 x 101cm (50½ x 40in) Signed *Rembrandt f. 1633*

This full-length portrait is possibly of the Catholic poet Jan Hermansz.Krul (1602–46), a locksmith and author, living in Amsterdam. He became a full-time writer and poet, theatrical director and a bookseller. Rembrandt's use of light focuses on the young man's facial features, the pure white neck ruff, and the brilliant sheen of the fabric of his clothing. He holds his right glove in his gloved left hand.

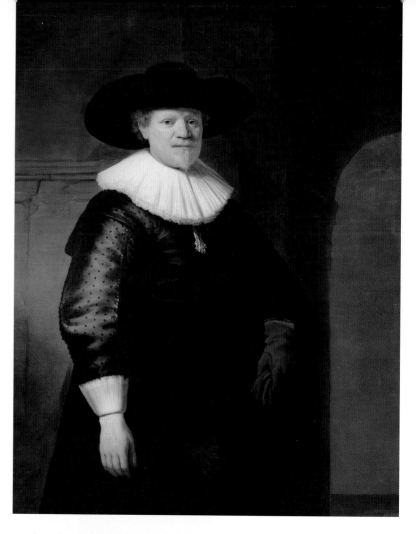

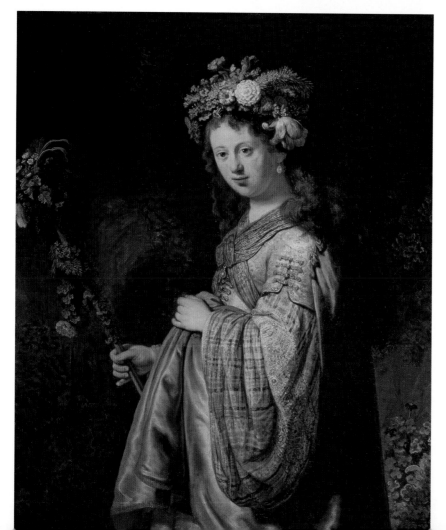

Saskia as Flora, 1634, oil on canvas, The State Hermitage Museum, St. Petersburg, Russia, 125 x 101cm (49 x 40in)

This was the first portrait of Saskia van Uylenburgh portrayed as 'Flora', depicting the Roman goddess of fertility, and the season of spring and flowers. Rembrandt bedecks his new bride Saskia in a glorious halo of flowers garlanding her hair. She wears a sumptuous costume, in the theme of the Arcadian pastoral, capturing the height of fashionable taste in the Dutch Republic for pastoral plays, poetry, prose, and costume. In tune with popular taste, Rembrandt demonstrated his commercial instincts in this painting.

Studies of Old Men's Heads and Three Women with Children, c.1635–36, pen and brown ink, brown wash and red chalk on paper, The Barber Institute of Fine Arts, University of Birmingham, UK, 22 x 23.3cm (9 x 9in)

Dominating the superb sheet of drawings is a fine sketch of the portly face of an old man. He wears a large hat and a fur around his shoulders. One hand, holding a glove, is drawn in. Around this sketch, other figures to the left show the heads of two younger men, one in profile. To the right are three smaller sketches of a woman, who holds and feeds an infant at her breast.

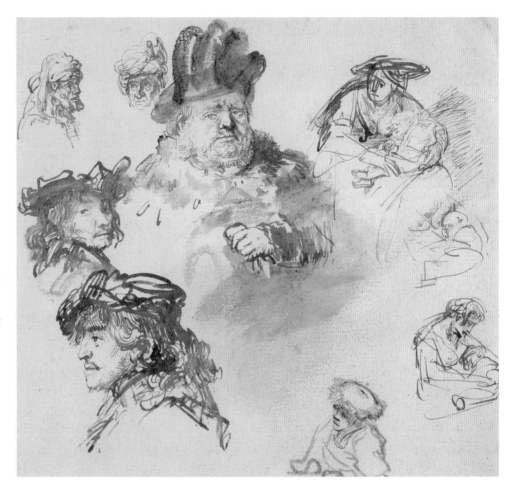

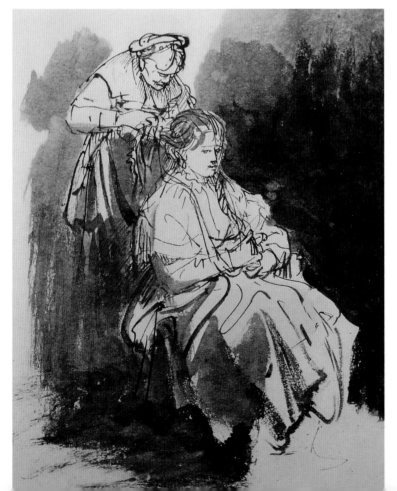

Young woman at Her Toilette, c.1632–5, pen and brown ink, brown and grey wash, Albertina, Vienna, Austria, 23.8 x 18.4cm (9½ x 7in)

This superb drawing from life, which captures the characters of two women in a domestic setting, is a vibrant sketch of an everyday activity. The seated woman is having her hair plaited and braided; she is unknown but historians surmise that she may be Saskia, Rembrandt's wife, or Lisbeth, his sister. Rembrandt created a second drawing of the same scene.

Saskia with her First Child Rumbartus, 1635–36, red chalk, Samuel Courtauld Trust, The Courtauld Gallery, London, UK, 14.1 x 10.6cm (5½ x 4in)

There is no proof that this is a portrait of Saskia with her firstborn baby, but in comparison to similar drawings of her, this sketch is possibly drawn from life. A young woman is depicted sitting up in bed holding her new baby. She looks toward the viewer. If it is Saskia, the baby boy would be Rumbartus, who died in 1635 at the age of two months.

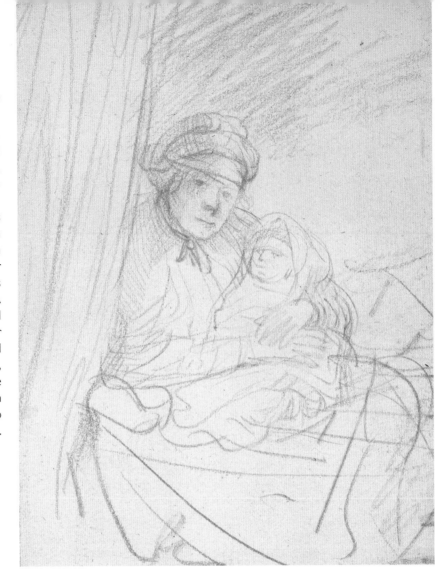

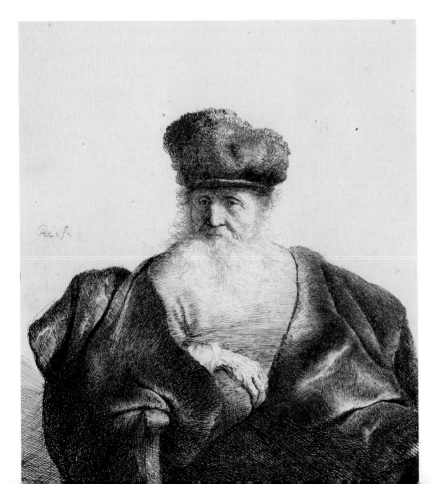

An Old Man with a Beard, Fur Cap and a Velvet Cloak, c.1632, etching, Museum of Fine Arts, Houston, TX, USA, 15 x 13.1cm (6 x 5 in)

At the centre of the composition an old man is seated. The man is almost engulfed by the size of his velvet cloak and large fur cap. The different fabrics allow the artist to display his skill as a master of textural drawing. The profusion of textures does not hide the frail, sagging skin on the hand or the lined features of the face, or the fluffiness of the beard. The etching is possibly a pendant to *The Artist's Mother Seated at a Table*, c.1631; if it is the artist's father, it would be posthumous.

Portrait of a Boy, c.1634, oil on panel, Hermitage, St Petersburg, Russia, 67 x 47.5cm (26½ x 19in)

The painting is attributed to Rembrandt – with some reservations. The identity of the boy has been debated. One suggestion is that he is Gerrit, the son of Hendrick Uylenburg, Rembrandt's art dealer and friend, with whom the artist lodged in Amsterdam in the 1630s. There are several extant paintings of the boy depicted in this painting, mainly attributed to the Dutch artist Govaert Flinck (1615–60), a pupil of Rembrandt's for three years in Amsterdam.

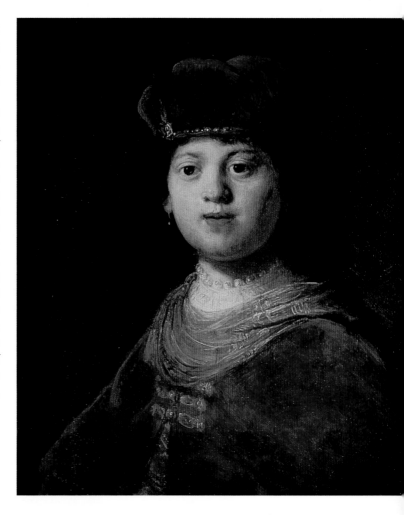

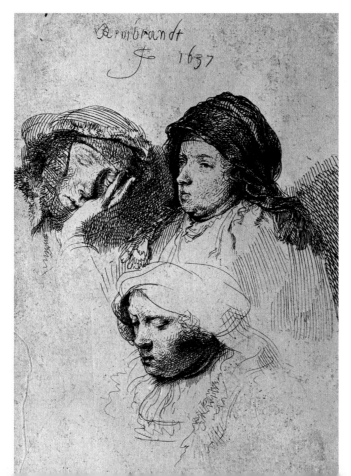

Three Female Heads, One Sleeping, 1637, etching, Musée de la Ville de Paris, Musée du Petit-Palais, France, 13.3 x 9.7cm (5 x 4in) Signed and dated *Rembrandt f. 1637*

This etching is one of a series of drawings of female heads; possibly character sketches. The significance of this small sheet of heads is that they were created as an etching, to sell prints. Such was Rembrandt's fame and prestige in 1637, print collectors would clamour for whatever he produced. Some heads may have been ideas for characters in another etching, such as *Christ Amongst the Sick, 'The Hundred-Guilder Print'*, 1646–9.

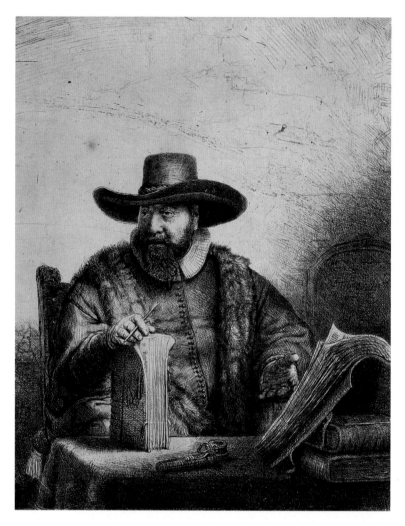

Cornelius Claesz Anslo (1592–1646) 1640, etching and drypoint, (II states), Musée de la Ville de Paris, Musée du Petit-Palais, France, 18.8 x 15.8 cm (7½ x 6in)

The Waterlander Mennonite minister Cornelis Claesz. Anslo (1592–1646), a prosperous cloth merchant in Amsterdam, was a friend of Rembrandt. Anslo is portrayed as a preacher seated at his desk, his left hand pointing to an open bible, the other hand resting on a book, as though momentarily interrupted from writing. Prints from the etching were possibly distributed through the Mennonite churches.

Portrait of Cornelius Anslo and his Wife, 1641, oil on canvas, Gemäldegalerie, Berlin, Germany, 176 x 210cm (69 x 83in)

This is a double portrait of Cornelis Claesz. Anslo and his wife Aeltje Gerritsdr.Schouten. It follows several solo portrait drawings and an etching of Anslo, a Mennonite preacher of the Grojte Spijker Church, in Amsterdam. Rembrandt portrays Anslo seated at a table, which is covered in a heavy cloth. A large book, probably the Bible, lies open on a bookstand. Rembrandt bathes the couple in warm light, creating a scene of intimacy and intellect.

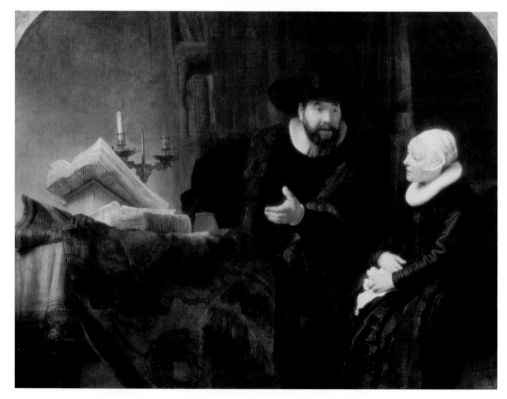

Saskia with a Red Flower,
1641, oil on canvas,
Gemäldegalerie Alte
Meister, Dresden, Germany,
99 x 82.5cm (39 x 32½in)

Rembrandt illustrated that
red is the colour of love in
his sensitive portrait of
Saskia in a Red Hat, 1633–4.
In this portrait of his
wife, painted in 1641,

Saskia looks toward the
artist with a loving
expression on her face; she
holds her left hand to her
breast, a symbol of love and
fealty; in her right hand she
proffers a red flower.
Similarities between this
portrait and Titian's *Flora,*
c.1515–20, on display in
Amsterdam at the time of
this artwork, can be seen.

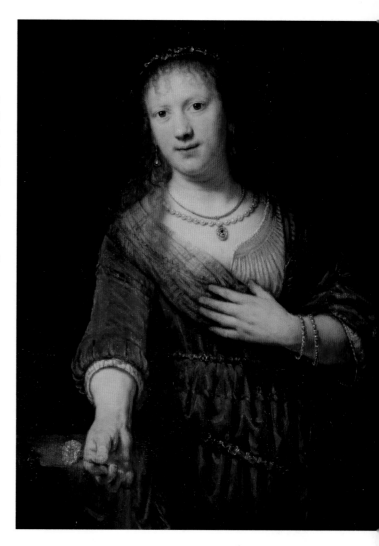

Old Lady with a Book, 1647,
oil on canvas, National
Gallery of Art, Washington
DC, USA,
110 x 91.5cm (43 x 36in),
Signed Rembrandt f. 1647

Attributed to Rembrandt
and his workshop, the
lady in the portrait, sitting
in an armchair, is unknown.

Her close-fitting cap throws
focus on to the facial
features of the woman;
her face, in repose, is bathed
in light, accentuated by
the white stiff circular
neckruff. The lady holds
her spectacles in one
hand, and in the other,
on her lap, is a solid book
with bindings.

Rembrandt's Maid: Girl at a Window, 1645, oil on canvas, Dulwich Picture Gallery, London, UK, 81.6 x 66cm (32 x 26in)

Rembrandt painted the maid leaning on a stone sill – one of his favourite compositions. It is recorded by Roger de Piles (1635–1709), that Rembrandt 'amused himself one day by making a portrait of his servant to display in the a window and fool passers-by… it was a few days before it was detected.'

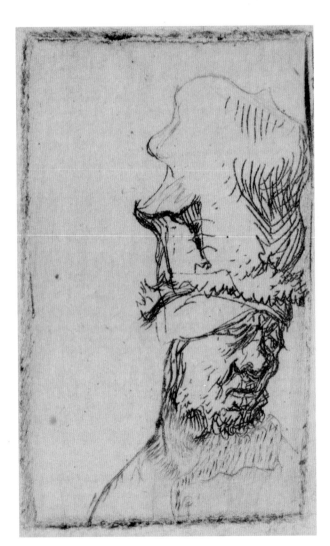

Head of a Man in a High Cap, (V states), *c*.1631, etching, City Art Gallery, Leeds Museums and Galleries, Leeds, U.K. 3.6 x 2.2cm (1½ x 1in)

One of many character sketches that Rembrandt created as an etching, and despite its small size and cropped format, this would have been a popular print to obtain. Rembrandt created five different states of the etching. Prints of his etchings were very popular as collector items. They included sheets showing various characters; heads of men in a variety of hats; women in three-quarter profile sleeping, or perhaps breastfeeding a child.

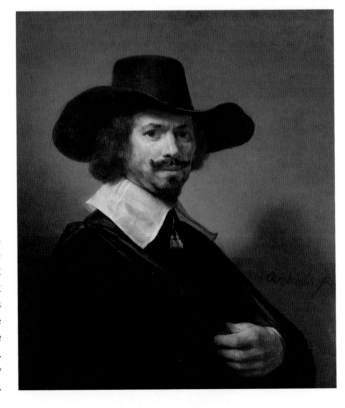

Portrait of a Man, c.1644–7, oil on panel, Collection of the Duke of Westminster, England, UK, 73.6 x 67.3cm (29 x 26½in), Signed *Rembrandt f. 164(7)*

This painting is recognized as a portrait of the painter Hendrick Martensz. Sorgh (1609/11–70). Sorgh was a noted artist of genre paintings, particularly street market scenes and peasant interiors. The portrait is possibly a pendant to the portrait of Adriaentje Pieters Hollaer, Sorgh's wife. Her portrait was painted by Rembrandt in 1647.

Ephraim Bonus, Jewish Physician, (II states), 1647, etching with drypoint and burin, Musée de la Ville de Paris, Musée du Petit-Palais, France, 23.6 x 17.7cm (9 x 7in)

The portrait of the Portuguese physician, writer, translator and poet, Ephraim Bueno, or Bonus (1599–1665), is also called 'The Jew with the Banister'. The exquisitely etched depiction captures the character of the man, and his mode of dress. Rembrandt concentrates on the variety of textures from his plain jacket to his fur cloak and the sharp brim of his hat. The use of *chiaroscuro* adds an aura of dignified contemplation to the features of the physician standing at the foot of the stair.

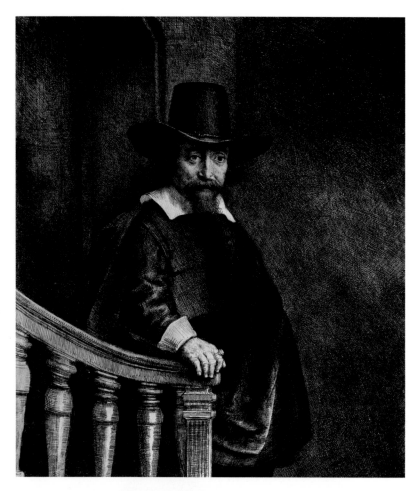

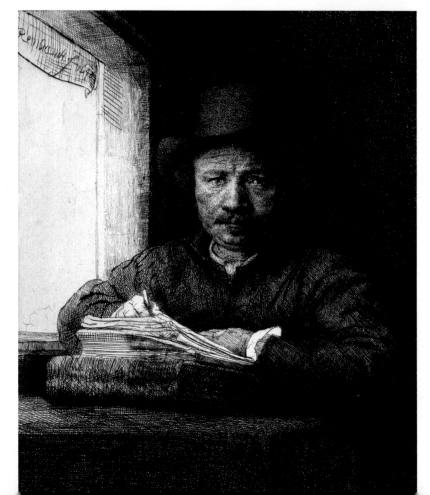

Self-portrait Drawing at a Window, (V states),1648, etching with drypoint and burin, Musée de la Ville de Paris, Musée du Petit-Palais, France, photograph 16 x 13cm (6 x 5in)

Rembrandt depicts himself in ordinary clothing, the dark heavy hatching in monotone shades forces focus on to the lighter areas of the head and facial features, and on to the pages of the drawing book. Rembrandt sits at a window, where the landscape is glimpsed beyond the sill. His eyes are fixed on the spectator. It is a serious gaze, and one that imparts the artist's view of himself. It draws comparison to the earlier etching, *Self-portrait Leaning on a Stone Sill,* 1639.

Bust of an Old Man with a Gold Chain, 1632, (detail), oil on panel, Gemäldegalerie Alte Meister, Kassel, Germany, 59.3 x 49.3cm (23 x 19½in) Signed *RHL van Rijn 1632*

An exceptionally powerful study, which captures the beauty of the facial features of an elderly man. This is one of several portraits by Rembrandt of this man.

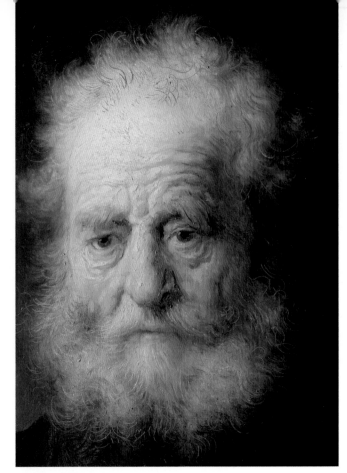

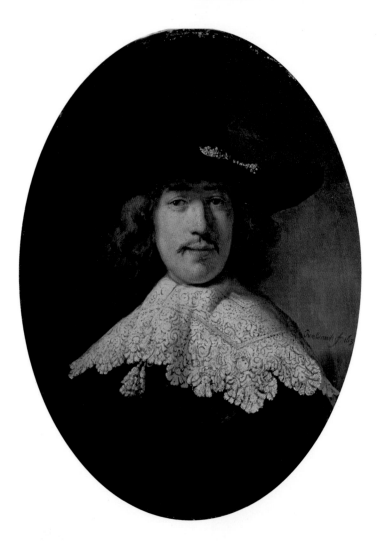

Portrait of a Young Man with a Lace Collar, 1634, oil on canvas, The State Hermitage Museum, St. Petersburg, Russia, 70 x 52cm (27½ x 20½in) Signed *Rembrandt f. 1634*

This is probably one of a pair of portraits, of husband and wife. In the 1630s, Rembrandt was in great demand for portraits such as this one. The sitter wears an exquisite lace collar over his jacket. In The Netherlands, in the 17th-century, lace-making was a thriving industry. The many hours taken to produce a lace collar, such as the one worn in this portrait, was a sign of the wealth of the person.

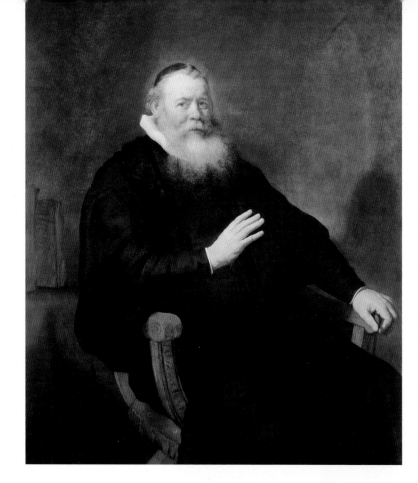

Portrait of the Preacher Eleazer Swalmius, 1637–42, oil on canvas, Koninklijk Museum voor Schone Kunsten, Antwerp, Belgium, 132 x 109cm (52 x 43in) Signed Rembrandt f. 1637

The minister Eleazar Swalmius is seated, looking toward the spectator with his right hand raised as if in greeting, adding realism to the vibrant work. The status of the work was disputed for many years, however, in recent years the painting has been restored and in 2009 Emeritus Professor Ernst van de Wetering of the Rembrandt Research Project, confirmed it to be a genuine work of Rembrandt.

Portrait of Maurits Huygens, 1632, oil on panel, Hamburger Kunsthalle, Hamburg, Germany, 31.2 x 24.6cm (12 x 10in)

Maurits Huygens (1595–1642) is portrayed in traditional black doublet and white ruff. He was the cousin of Contantijn Huygens, secretary to the Prince of Orange. The portrait was intended as a companion to that of Jacob de Gheyn (1596–1641), painted by Rembrandt the same year (now at Dulwich Picture Gallery, London, UK). The two young men were friends and each made a will to leave the other their portrait, whichever died first. Maurits received the portrait of Jacob in 1641.

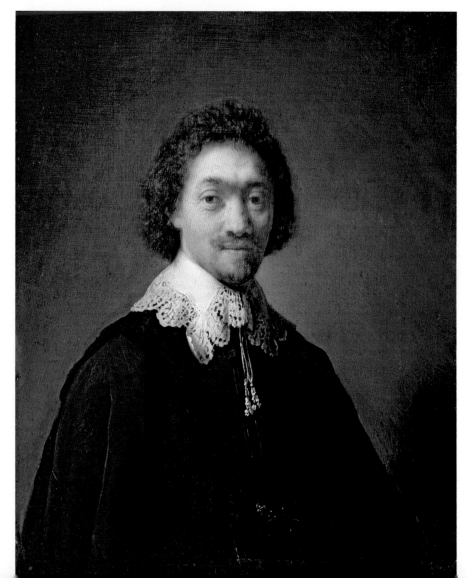

Portrait of Andries de Graeff, 1639, (detail) oil on canvas, Gemäldegalerie Alte Meister, Kassel, Germany , 199 x 123.5cm (78 x 49in) Signed *Rembrandt f.* 1639

Andries de Graeff was a very wealthy man. He commissioned his full-length portrait for the sum of 500 guilders. He may have planned to hang the portrait in a gallery of his ancestors' portraits in Ilpenstein Castle, Ilpendam, north of Amsterdam. However, for reasons unknown, de Graeff refused to take or pay for the portrait. He was sued by Rembrandt, and made to pay. Rembrandt won a court case against the patron, and received his fee.

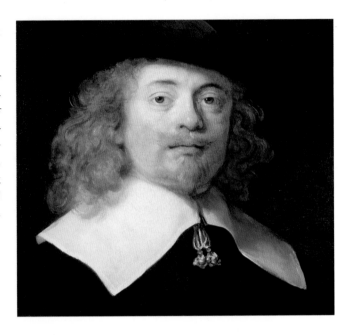

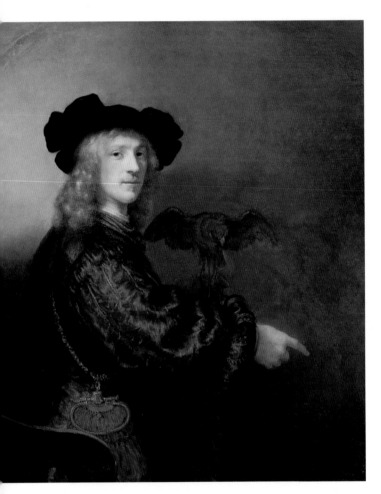

Portrait of a Man with a Falcon, 1643, oil on canvas, Private Collection 109 x 94cm (43 x 37in) Signed *Rembrandt f.* 1643

This portrait is attributed to Rembrandt with reservations. This is a pendant to *Portrait of a Woman with a Fan,* 1643. A striking profile portrait, depicting a young man posing with a falcon on his arm. He wears a stunning coat, which the artist has superbly depicted in a deft use of colour, light and shade. The man, as if caught in a moment of time, turns to look toward the viewer when the bird seemingly flutters to rest on his outstretched arm.

Portrait of a Woman with a Fan, 1643, oil on canvas, Private Collection, 109 x 94cm (43 x 37in), Signed *Rembrandt f.* 1643

Attributed to Rembrandt with reservations. The pendant to *Portrait of a Man with a Falcon.* Pendant portraits were fashionable in Amsterdam society. In this portrait of a beautiful young woman holding a fan, she wears contemporary dress with a fur wrap draped on her shoulders. The darkness of the background allows the light to focus on her head and face with its youthful complexion.

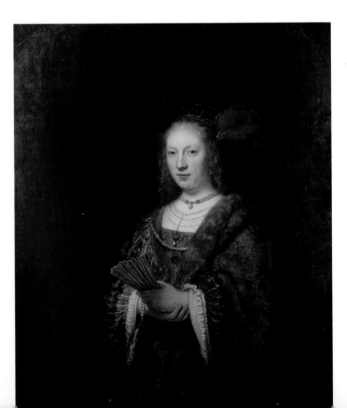

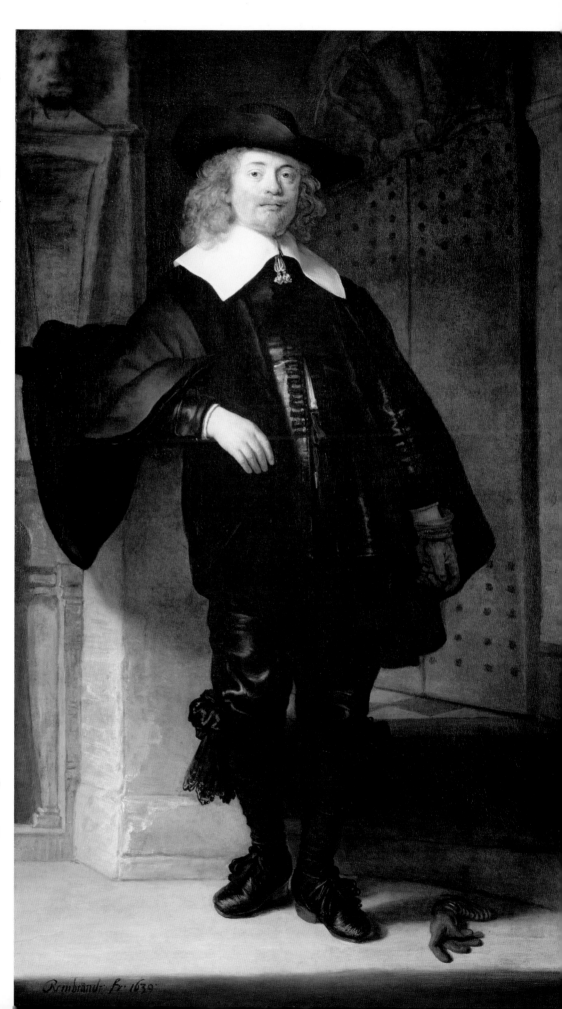

Portrait of Andries de Graeff,
1639, oil on canvas,
Gemäldegalerie Alte Meister,
Kassel, Germany,
199 x 123.5cm (78 x 49in)
Signed *Rembrandt f. 1639*

Andries de Graeff (1611–79)
a patrician of Amsterdam and
a future burgomaster of the
city, was the brother-in-law of
Frans Banning Cocq. Andries
de Graeff, a very wealthy
man, commissioned the
full-length portrait for the
sum of 500 guilders. It was
possibly planned to hang the
portrait in a gallery of his
ancestors in Ilpenstein Castle,
Ilpendam, north of
Amsterdam. However, for
reasons unknown, de Graeff
refused to take the portrait,
and would not pay for it, but
was sued by Rembrandt,
and made to pay. Rembrandt
won a court case against the
patron, de Graeff, and his
fee of 500 guilders for the
portrait, but none of the
close-knit group of
burgomasters of the city
commissioned him again.
De Graeff stands in front of
an open door of a grand
house, possibly Ilpenstein
Manor. Rembrandt portrays
him with a stiff white collar
worn over an elegant black
suit with breeches, which are
decorated with a black
rosette and lace at the knee.
De Graeff's ribboned black
shoes gleam in the dappled
light. He wears a short
outdoor cloak, and a glove on
his left hand. On the ground
in front of him is a dropped
glove from the right hand; the
index finger of the glove
points forward. Rembrandt
has painted a portrait of
conspicuous consumption, a
composition of wealth and
opulence.

Portrait of a Man Rising from his Chair, 1633, oil on canvas, Taft Museum of Art, Cincinnati, OH, USA, 121.6 x 98.4cm (48 x 39in) Signed *Rembrandt f. 1633*

Portrait of a Man rising from his Chair is a companion painting to Rembrandt's *Portrait of a Young Woman with a Fan,* 1633. The three-quarter-length portraits show the young man and young woman captured in motion, bringing a unique sense of vibrancy to their portrayals. The 1630s found Rembrandt with a full book of commissions for personal portraits, which now stands as a visual record of the life of wealthy Amsterdamers in the formative years of the Dutch Republic.

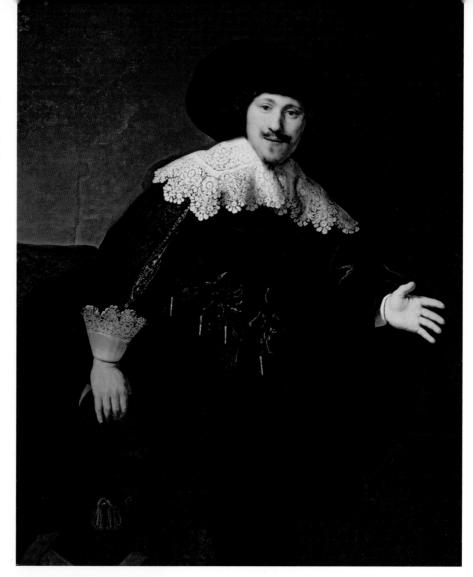

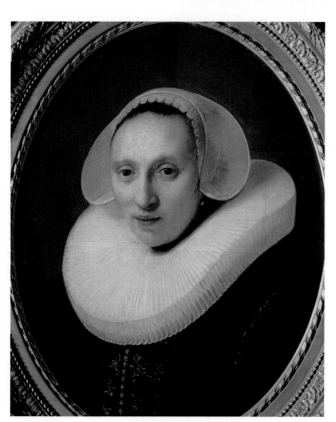

Portrait of Cornelia Pronck, Wife of Aelbert Cuyper, at the age of 33, 1633, oil on panel, Musée du Louvre, Paris, France, 60 x 47cm (23½ 18½in), Signed *Rembrandt ft. 1633*

Aelbert Cuyper was a wealthy merchant. He commissioned Rembrandt to paint a portrait of his wife at 33 years of age. Rembrandt captures every detail of the wealthy young woman's clothing, from the embroidery on her dress, to her delicate cap and fine ruff. Cornelia's face is captured in repose, highlighting her beautiful porcelain skin in this portrait of wealth and well-being.

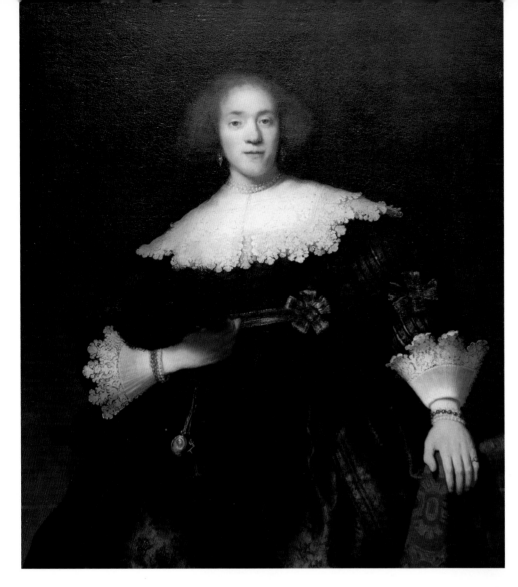

Portrait of a Young Woman with a Fan, 1633, oil on canvas Metropolitan Museum of New York, 125.7 x 101cm (49½ x 40in) Signed *Rembrandt (f) 1633*

The painting of a young woman holding a large fan is one half of a double portrait. Rembrandt focuses on the luxurious fabric of the sitter's dress and the dazzling whiteness of the lace collar which seemingly reflects light onto her face. The delicate workmanship and style of the lace collar and cuffs portrays her as a fashionable woman. The painting is a companion work to *Portrait of a Man Rising from His Chair,* 1633, which portrays a fashionably dressed young man in equally exquisite clothing.

Portrait of a Young Woman, 1633, oil on panel, Museum of Fine Arts, Houston, TX, USA, 65.3 x 49cm (26 x 19in) Signed *Rembrandt f. 1633*

The visually rich colour of the sitter's auburn-flame hair draws attention to the lush red of her lips, and highlights the porcelain quality of her fine skin.

She wears the latest fashion, worn at court, the exquisite heavy lace collar which covers her shoulders, a pearl choker, and on her dress is a rosette and a ribbon sash worn below the bust. Wealthy ladies of the Dutch Republic, particularly in The Hague and Amsterdam, followed the fashion of the royal court.

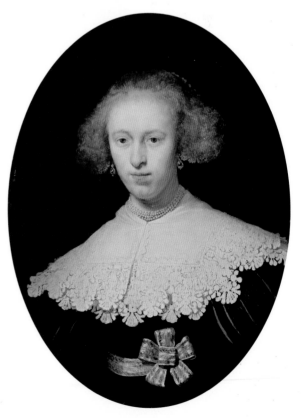

Portrait of Johannes Uytenbogaert, 1633, (detail) Rijksmuseum, Amsterdam, The Netherlands, 130 x 103cm (51 x 40½in) Signed *Rembrandt f. 1633*

The full-length portrait of the theologian and leader of the Remonstrants, Johannes Uytenbogaert (1557–1646), was one of several portraits commissioned by leading ministers of the church. Rembrandt portrays the stately Uytenbogaert standing next to a table, on which lies an open manuscript. A warm light falls onto the pages to illuminate the text. The minister is posed as if turning away from the book's text to speak to the onlooker.

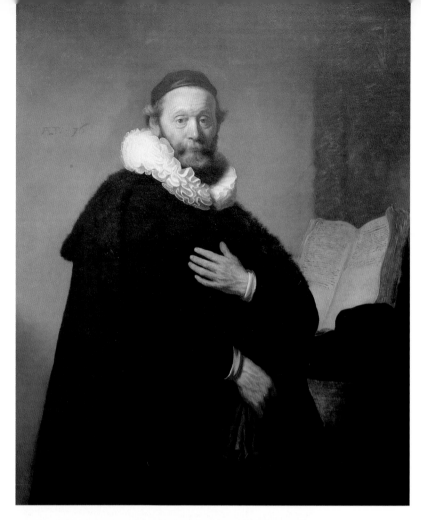

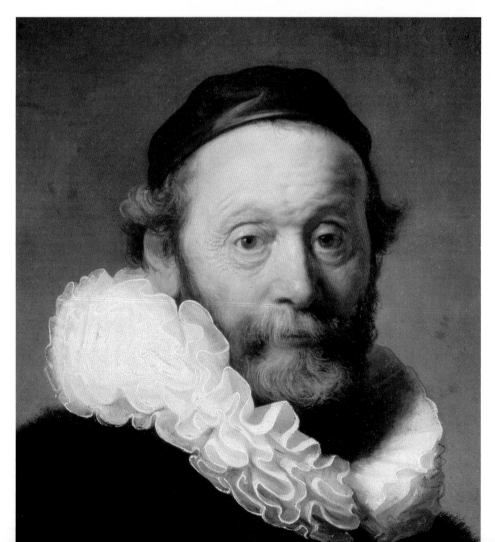

Portrait of Johannes Uyttenbogaert, 1633, (detail), Rijksmuseum, Amsterdam, The Netherlands, 130 x 103cm (51 x 40½in)

In the full-length portrait of the Remonstrant preacher Johannes Uyttenbogaert (1557–1646), Rembrandt reserves the strongest light source to focus on the elderly minister's facial features. It reveals the wrinkles and lines of a face full of character, lit against the pure sharp white of the magnificently pleated neck ruff. Rembrandt does not miss a detail of the head, from Uyttenbogaert's bright eyes and luminescent skin, to the carefully trimmed moustache and beard.

'Tronie' of a Man with a Feathered Beret, c.1635, oil on panel, Mauritshuis, The Hague, The Netherlands, 63 x 47cm (25 x 18½in), Signed *Rembrandt f*

The painting has been attributed as a self-portrait of Rembrandt, although the facial features look older than his 29 years. However, it may be Rembrandt using his theatrical clothing props, to create a 'tronie' – Dutch for 'face' – usually of a character in costume. Here, the tronie is of a bearded man in three-quarter profile, wearing a striking, feathered beret. 'Tronie' portraits were popular artworks for sale in the Dutch art markets. Rembrandt created many in different media.

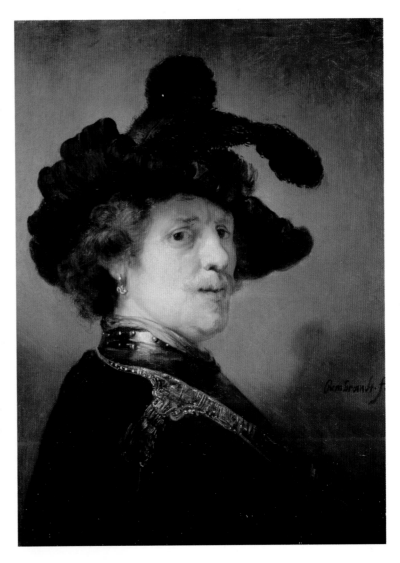

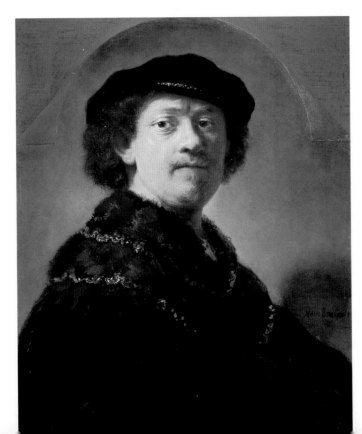

Self-portrait in a Black Cap, c.1637, oil on oak panel, Wallace Collection, London, UK, 63 x 50.7cm (25 x 20in) with apsidal arch, Signed *Rembrandt / f*

After the painting was de-attributed as a work of the artist by the Rembrandt Research Project in 1989, a new agreement by Rembrandt scholars has altered that opinion. It is now thought to be a genuine work by Rembrandt. It shows a more energetic style than that in Rembrandt's previous self-portraits of the early 1630s.

The Anatomy Lesson of Dr. Nicolaes Tulp, 1632, (detail of a head), oil on canvas, Mauritshuis, The Hague, The Netherlands, 169.5 x 216cm (67 x 85in)

The head is that of Hartman Harmensz. He looks toward the viewer as if looking up from the paper he holds. The paper originally illustrated an anatomical drawing, later altered to list the names of the guild members present in the painting – not doctors of medicine but barber-surgeons. It is likely that the arm dissection was carried out after the dissection of the body, which was normal practice. Recent cleaning has shown that Rembrandt painted the corpse with a slight greenish palor – *umbra mortis* (shadow of death) – in stark contrast to the healthy faces of the onlookers.

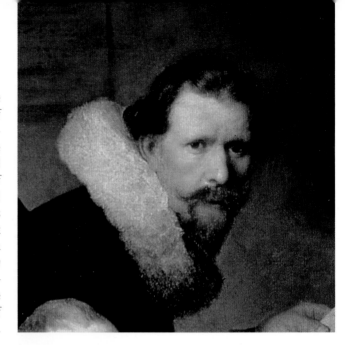

The Anatomy Lesson of Dr. Nicolaes Tulp, 1632, (detail of arm of cadaver), oil on canvas, Mauritshuis, The Hague, The Netherlands, 169.5 x 216cm (67 x 85in)

Dr Nicolaes Tulp demonstrates to his colleagues, and to the public audience, the anatomy of the lower arm and hand. In his right hand he holds forceps, lifting up a muscle. A minor problem for Rembrandt was that the arm of the corpse, Adriaan Adriaans of Leiden, ended in a stump. The artist finely painted a lower arm and hand to replace the missing limb.

The Anatomy Lesson of Dr. Nicolaes Tulp, 1632, (detail of Tulp's hands), oil on canvas, Mauritshuis, The Hague, The Netherlands, 169.5 x 216cm (67 x 85in)

Rembrandt illustrates Dr. Tulp, a professor of medicine, demonstrating the reflex of the arm muscle that moves the fingers of the hand, by holding his left hand in a position that imitates that reflex.

The Anatomy Lesson of Dr. Nicolaes Tulp, 1632, oil on canvas, Mauritshuis, The Hague, The Netherlands, 169.5 x 216cm (67 x 85in), Signed *Rembrandt f. 1632.* (This was the first painting to bear this signature. Rembrandt signed previous works RHL)

The group portrait, *The Anatomy Lesson of Dr. Nicolaes Tulp,* was commissioned by the Amsterdam surgeons' guild. For Rembrandt, at the age of 26 years, this was a major commission that established him as the foremost portrait painter in Amsterdam. He was to paint the portraits of the eminent men gathered around a corpse in the process of dissection by the Amsterdam surgeon Dr Nicolaes Tulp.

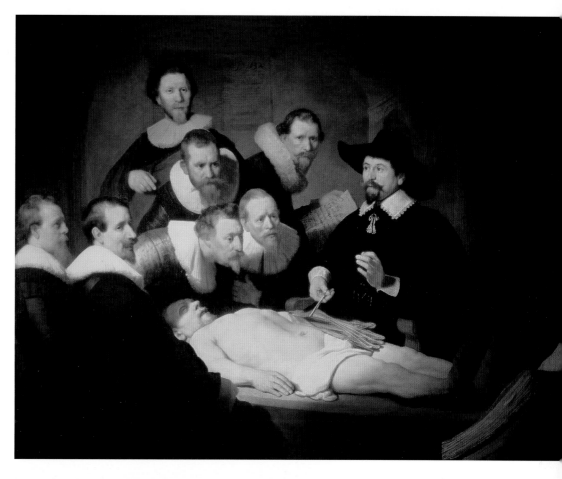

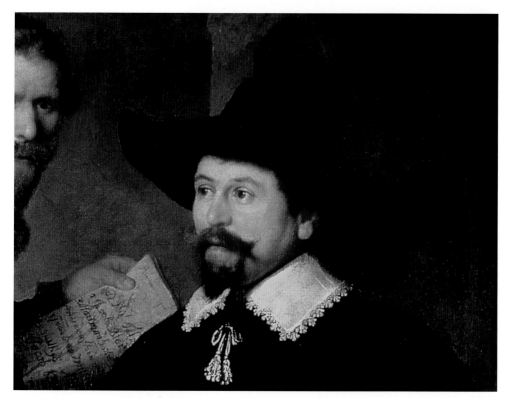

The Anatomy Lesson of Dr. Nicolaes Tulp, 1632, (portrait of Dr Tulp) [detail], oil on canvas, Mauritshuis, The Hague, The Netherlands, 169.5 x 216cm (67 x 85in)

Dr Nicolaes Tulp, a member of the Amsterdam Surgeon's Guild held a public lecture on dissection in 1632, performing it on the corpse of a criminal. Rembrandt recorded the dissection in *The Anatomy Lesson of Dr Nicolaes Tulp,* 1632. Tulp wanted to be portrayed dissecting a flayed arm, as seen in a woodcut in Vesalius' treatise *De humani corporis fabrica* 1543. To make the point, a book by anatomist Andreas Vesalius (1514–64) is propped against the feet of the corpse while Tulp carries out the dissection.

Self Portrait with Bittern,
1639, oil on panel,
Gemäldegalerie Alte
Meister, Dresden, Germany,
121 x 89cm (48 x 35in)
Signed and dated *Rembrandt
ft. 1639* at upper left

In the background a
three-quarter length
portrait of a young man
with a moustache, wearing
earrings, with a beret on his
head, proffers a dead game
bird toward the spectator.
He holds it by its legs, which
are tied together. The focus
of the painting is the beauty
of the bird and its plumage.
The open wings, colourful
feathers, and lolling neck and
head, have been captured by
Rembrandt's eye for detail.

*'Tronie' of a Young Man with
Gorget and Beret, c.1639,* oil
on panel, Galleria degli
Uffizi, Florence, Italy,
62.5 x 54cm (25 x 21in)
Partly signed at lower left
'...ndt. f.'

Formerly thought to be a
self-portrait of Rembrandt, it
has been renamed as a
'tronie' painting by the artist.
The half-length portrait
captures the gaze of a young
man who wears a fine
doublet with gorget. A cloak
is worn over the left
shoulder and attached by the
metal chain and an unseen
clasp. His auburn-gold hair is
semi-covered with a large
beret. It is unlikely to be a
self-portrait since the
sitter looks younger than
Rembrandt's 33 years.

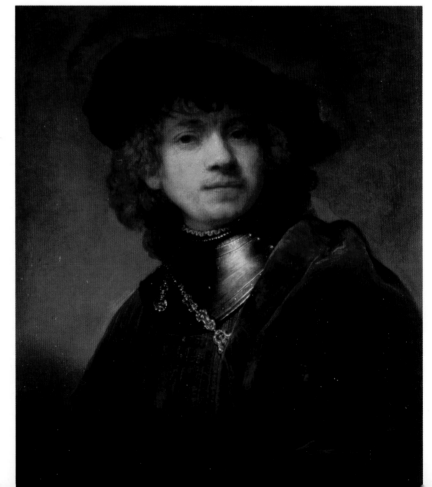

Officers and Guardsmen of the Amsterdam Civic Guard Company of Captain Frans Banning Cocq and Lieutenant William van Ruytenburgh (The Nightwatch)
c.1642, oil on canvas, Rijksmuseum, Amsterdam, The Netherlands, 363 x 437cm (143 x 172in)

The group portrait was painted at the peak of Rembrandt's career. It was part of a series of group portrait commissions. Rembrandt was to portray over 30 figures of the militia company of Captain Frans Banning Cocq; many were portraits paid for by each individual. The portraits were expected to be easily recognized, but some of the guard voiced their disapproval. The title *The Nightwatch* was given to the work; layers of varnish darkened the paint and it was thought to be a night scene. Cleaning to remove the build-up of varnish reveals it to be a daytime scene.

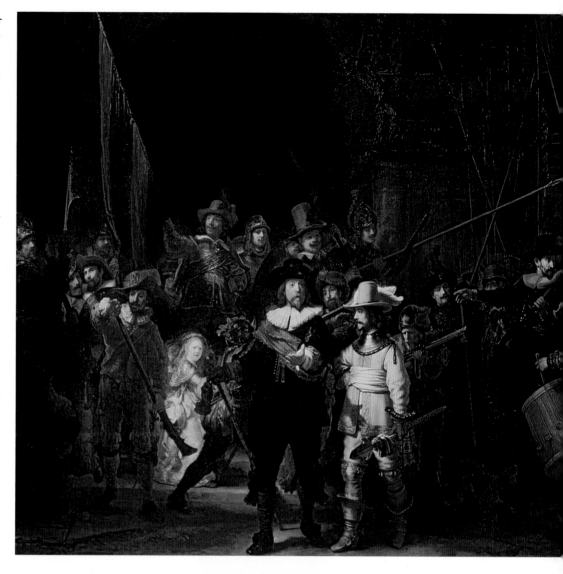

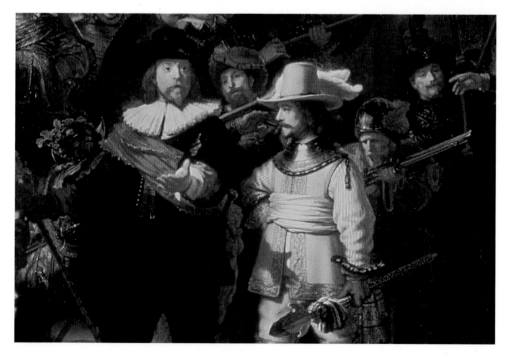

The Nightwatch) c.1642, (detail) oil on canvas, Rijksmuseum, Amsterdam, The Netherlands, 363 x 437cm (143 x 172in)

Central to this vast painting is the chief figure of Captain Frans Banning Cocq distinctive in his red sash, who is gesturing with his left hand in animated conversation with Lieutenant William van Ruytenburgh resplendent in yellow tunic and hat, portrayed to his left. There is no record of whether the captain and lieutenant paid extra to be portrayed so distinctly.

A Warrior, c.1630–40, oil on panel, Private Collection, 40 x 29.5cm (15½ x 11½in) Signed RH van Rijn

Attributed to Rembrandt with some reservations. The man stands with his shoulders in profile and turns his head toward the viewer. He wears an impressive hat adorned with feathers; worn at an angle it shrouds part of his face in shadow. The artist focuses the light on the face and neck of the man, catching the glint of the metal of the gorget around his neck, the trim of his moustache and the luxuriant feathers in his hat.

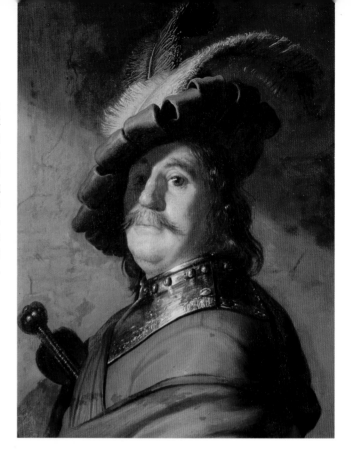

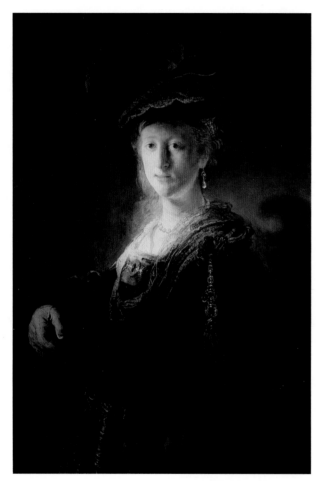

Young Woman in Fancy Dress, c.1635–8, oil on canvas, Private Collection, 98 x 70cm (38½ x 27½in) Signed Rembrandt f. 1638

Some sources attribute the woman depicted as Saskia, Rembrandt's wife. If so, the painting was created about four years after their marriage. Portraits of stylish men and women were in demand in Amsterdam and Saskia often modelled for Rembrandt. The young woman is posed in three-quarter profile. A soft beam of light captures the tilt of her head and stray soft wisps of hair that coil down to her shoulders.

Portrait of an Old Man with a Divided Fur Cap, 1640, (II states), etching with drypoint, Musée de la Ville de Paris, Musée du Petit-Palais, France, 14.4 x 13.5cm (6 x 5in) Signed and dated Rembrandt f.1640

The etching, in two states, is linked to an earlier series of chalk drawings from the 1630s, of male character sketches for use in paintings. The model for this etching appears in the chalk series. The half-length portrait depicts a bearded gentleman, wearing a cloak draped around his shoulder, and a large divided fur cap. He holds his right-hand closed fist to his heart, as if taking an oath.

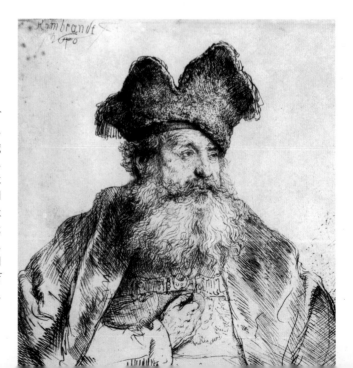

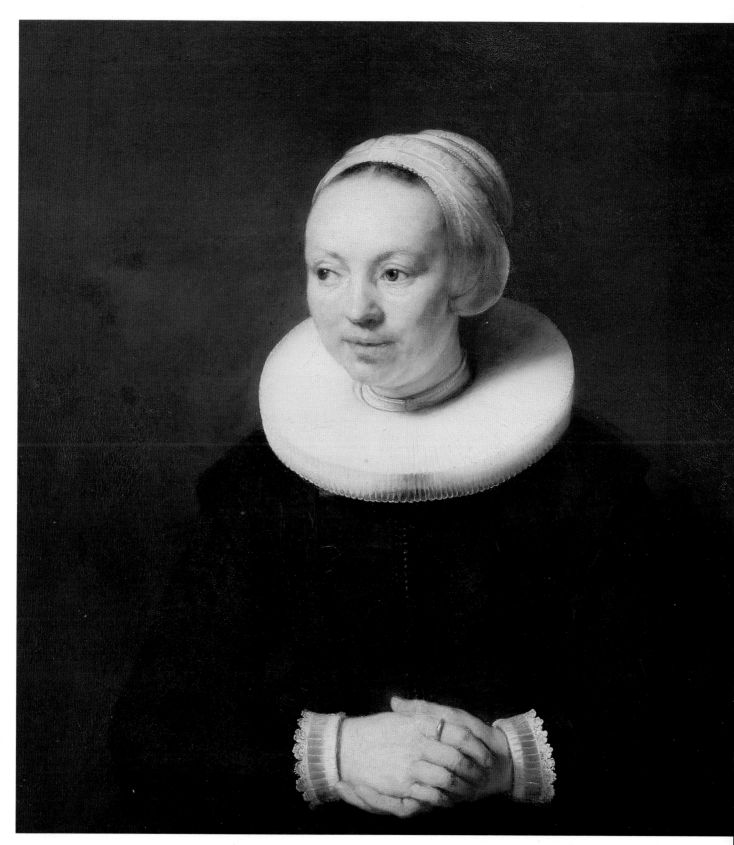

Portrait of a Lady, 1642–7,
oil on panel,
Duke of Westminster,
London, UK,
64 x 67.3cm (14 x 26½in)

In this half-length portrait, the adept use of *chiaroscuro* highlights her facial features, and her hands. Paintings attributed to Rembrandt have been subjected to scrutiny to confirm his hand. This work is attributed to Rembrandt with reservations that it may be the work of Carel Fabritius, one of Rembrandt's gifted pupils. If it was the work of Fabritius, one would see how closely Rembrandt's pupils followed his style.

An Old Man in Fanciful Costume Holding a Stick, 1645, oil on canvas, Calouste Gulbenkian Foundation, Oeiras, Portugal, 128 x 112cm (50 x 44in) Signed ... *f.1645*

A portrait of a bearded man in three-quarter profile, seated. His figure fills the picture space. Behind him to the right can be seen the upper corner of a building. The man wears a large hat with a plume and refined clothes. He steadies a cane between his hands.

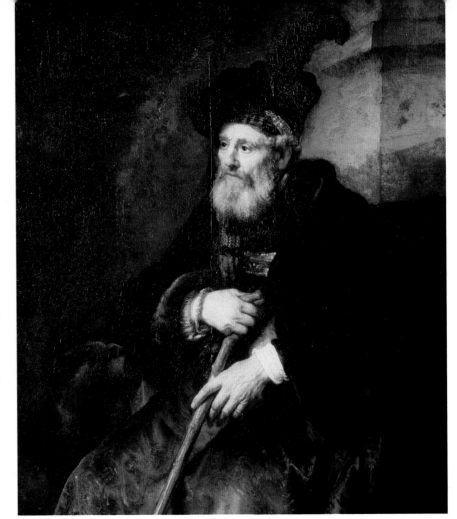

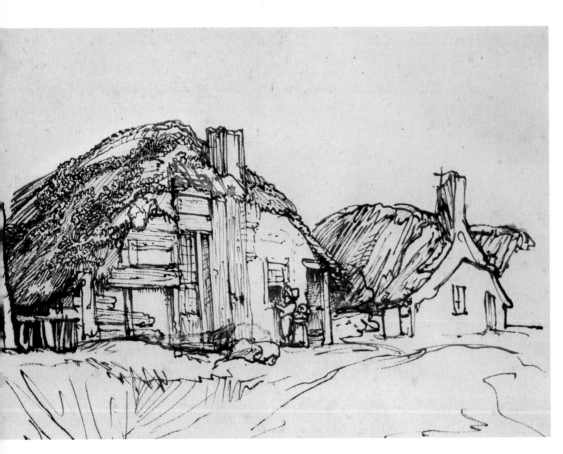

Two Thatched Cottages with Figures at the Window, c.1630–40, pen and brown ink with white body colour, Private Collection, 13.5 x 20.1cm (5 x 8in)

Through attention to detail and close observation of the natural landscape surrounding domestic buildings, located in the countryside around the city of Amsterdam, Rembrandt's depictions of weathered cottages captures the immediacy of the scene, including the daily life of the inhabitants, seen here as figures that appear at the window. With an adept use of the pen, the artist conveys the difference in the condition of the two cottages and the dirt road.

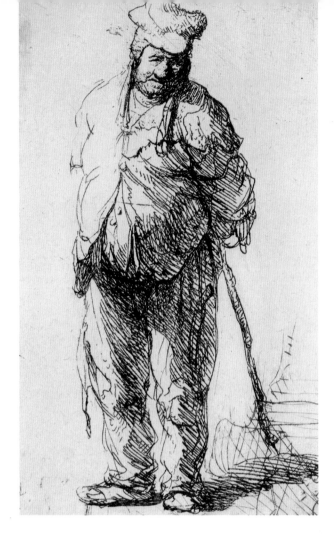

Beggar Leaning on a Stick, c.1630–9, etching with drypoint (VI states), City Art Gallery, Leeds, U.K, 9 x 7cm (3½ x 3in)

One in a series of genre sketches from life, capturing the characteristics of peasants and street beggars in Leiden and Amsterdam, for Rembrandt's portfolio. Here, a ragged peasant leans back on his stick surveying his surroundings. He wears a peaked cap on his head and a buttoned jacket that does not cover his large expanse of stomach.

Actor with a Broad-rimmed Hat (Pantalone), c.1635, recto, pen and ink wash on paper, Hamburger Kunsthalle, Hamburg, Germany 18.2 x 11.8cm (7 x 5in)

In the 1630s, Rembrandt's figurative drawings from life in Amsterdam reflected his interests – particularly in the theatre – in a series of drawings of actors. This figure is an actor in the role of the Italian commedia dell'arte character 'Panatalone'. He bows low, gesturing a greeting with his right hand, and the other lifting his long coat behind his back. He carries a flute and case around his waist and two balls.

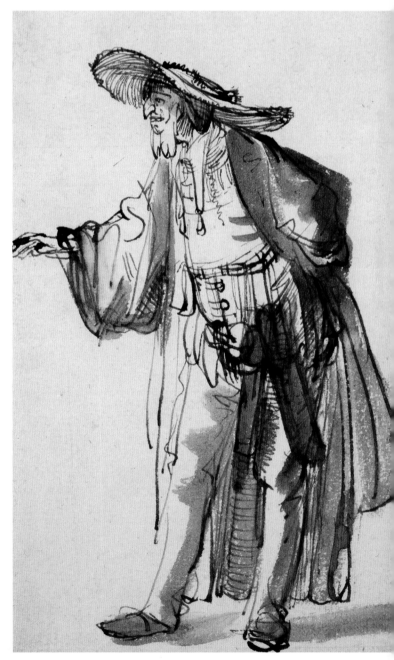

The Annunciation, c.1635, pen and brown ink with additional gouache, Musée des Beaux-Arts, Besançon, France, 14.4 x 12.4cm (6 x 5in)

In Rembrandt's drawings or etchings that feature angels, the angel's wings are impressively expansive, realistic and in movement. This drawing depicts the Angel Gabriel announcing the forthcoming birth of Christ to the Virgin Mary (Luke 1: 29-30). Rembrandt portrays the angel with wings fluttering, helping Mary who has sunk to her knees in shock. Rembrandt superbly captures a moment of concerned intimacy between the angel and young mother-to-be.

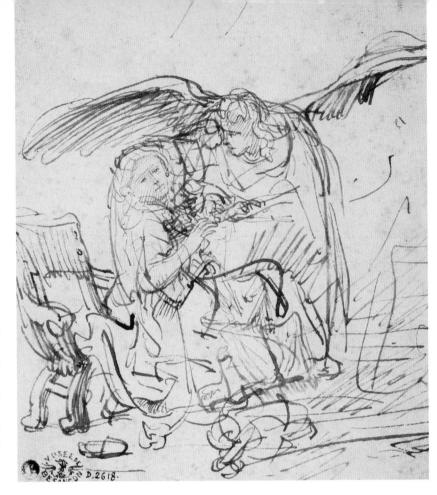

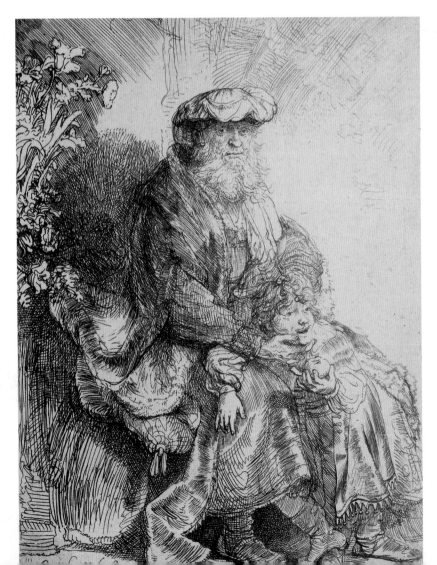

Abraham Caressing Benjamin (also known as Abraham Caressing Isaac), c.1631–7, (II states), etching, The Israel Museum, Jerusalem, Israel, 9.1 x 11.5cm (3½ x 4½in) Signed *Rembrandt f*

The artwork does not relate directly to an Old Testament bible text. The artist depicts an old man seated. At his knee stands an active young child who twists around to look to his left, toward something or someone unseen. 'Abraham' caresses the face of the child with his hand, while looking directly toward the spectator.

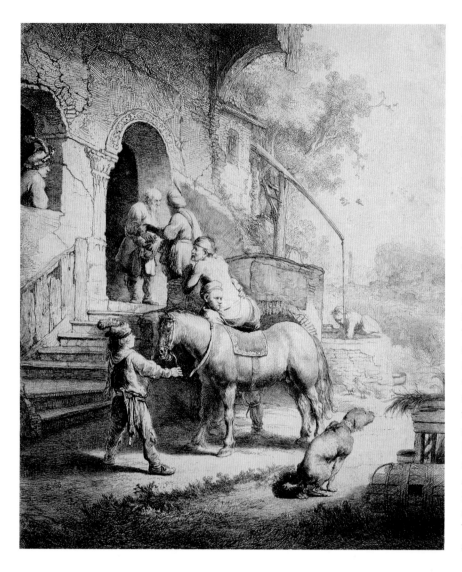

The Good Samaritan, 1633, (IV states), etching with burin, Wallace Collection, London, UK
25.7 x 20.8cm (10 x 8in)
Signed *Rembrandt inventor et Feecit. 1633,* on the first state of the etching

The artwork centres on the New Testament parable of *The Good Samaritan,* Luke X: 30-35. Rembrandt illustrates the Samaritan on the inn doorstep, about to pay for the traveller's lodgings, while another man helps the semi-naked traveller to dismount the horse. The addition of a dog at the forefront of the etching, illustrated in the act of defecation, has raised controversy. Why would the artist add this to the depiction of the narrative? Does it relate to the bible narrative or to events in Amsterdam? Was it drawn by Rembrandt, or added by another at a later stage? The questions remain unanswered.

Jews in the Synagogue in Amsterdam, 1648, engraving with drypoint (III states), Private Collection, 12.2 x 7.1cm (5 x 3in) Signed *Rembrandt f. 1648*

The title given to the etching in this print may be erroneous, since historians state that no synagogue existed in the city at that time. An alternative title is *Pharisees in the Temple.* The etching features men, standing, talking, sitting, or walking. Rembrandt creates a busy, vibrant scene in a small area of the building. Sections of architecture give a sense of scale and proportion.

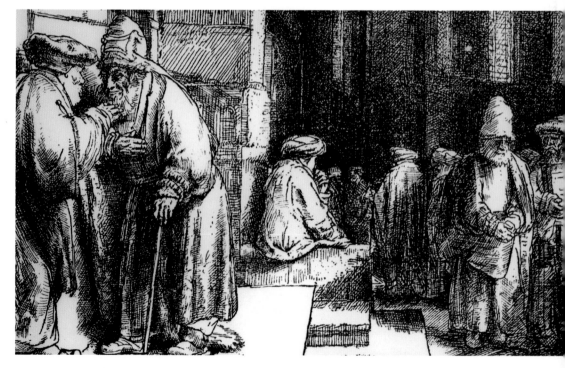

Study of a Nude woman as Cleopatra, c.1637, red and white chalk and watercolour, J. Paul Getty Museum, LA, USA, 24.7 x 13.7cm (10 x 5½in)

A nude study drawn from a life model. The person represented is unknown but the presence of a snake wrapped around the naked woman's lower limbs suggests a figure of the Egyptian queen Cleopatra, or possibly the mythical Greek goddess Hygieia, goddess of health, who from antiquity was often portrayed holding a large snake. The nude figure warrants comparison to 'Eve' in the 1638 etching *Adam and Eve*, by Rembrandt.

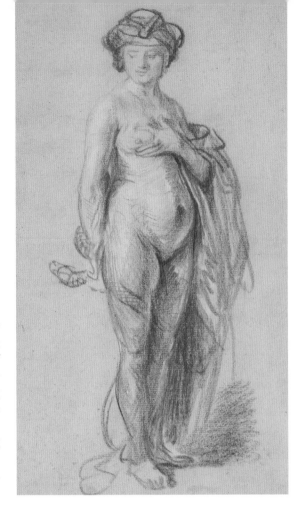

Christ Driving the Money Lenders from the Temple, 1635, (II states), etching, Private Collection, 13.6 x 17cm (5½ x 7in) Signed *Rembrandt f. 1635*

An illustration based on the New Testament text: John II: 13-17. On the eve of the Passover of the Jews, Christ, finding the temple in Jerusalem full of sheep, oxen and money lenders, physically attacks the usurers with a whip he makes from cords, in the process overturning their banking tables. Rembrandt captures the debacle with Christ at centre, arms raised, whip in hand. In the background the Elders of the temple turn to view the scene below.

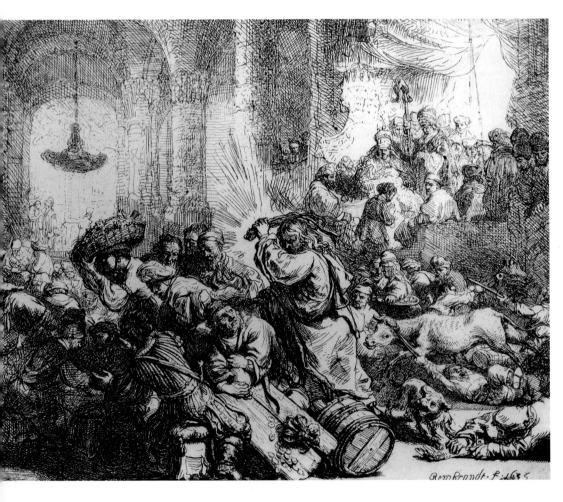

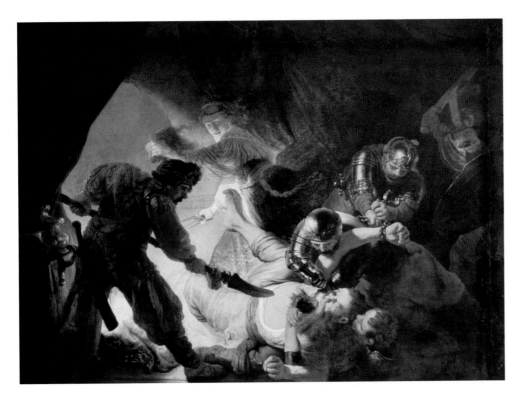

The Blinding of Samson,
1636, oil on canvas,
Stadelsches Kunstinstitut,
Frankfurt, Germany,
236 x 302cm (93 x 119in)
Signed *Rembrandt f. 1636*

A gory depiction of the bible
narrative of Samson and
Delilah, capturing the pivotal
moment when Samson,
awakened by Delilah is
attacked by the Philistines
she has summoned. He is
pinioned to the ground,
'…the Philistines seized him
and gouged out his eyes…'.
(Judges XVI:19-21). Delilah is
depicted fleeing the scene,
holding the hair she has cut
from Samson's head, to take
away his power and strength.

Adam and Eve, 1638,
etching, (II states),
Rembrandt House Museum,
Amsterdam,
The Netherlands,
16.2 x 11.6cm (6 x 4½in)

Rembrandt depicts the
naked Adam and Eve in the
garden of Eden, at a
moment prior to Eve biting
an apple, the forbidden fruit
from the tree of knowledge
of good and evil, (Genesis III:
1-24). The apple giver, a
winged serpent with claws,
watches intently from the
nearby tree. Rembrandt
follows the biblical narrative,
whereby the serpent does
not become a slithering
snake until after The Fall.
In the background an
elephant trumpets its way
through the Garden.

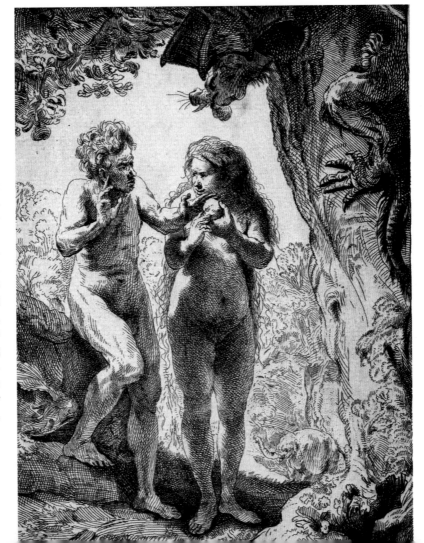

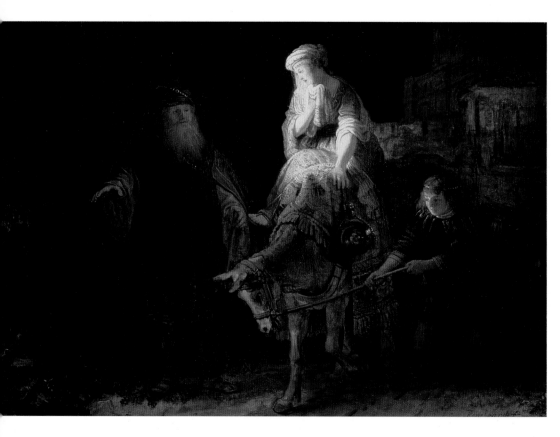

Abraham Dismissing Hagar and Ishmael (The Departure of the Shemanite Wife), c.1640, oil on canvas, Victoria & Albert Museum, London, UK, 39 x 53.2cm (15 x 21in) Signed *Rembrandt f. 1640*

Attributed to Rembrandt or his workshop, the title was originally *Abraham Dismissing Hagar and Ishmael* (Genesis XVI: 2-3; Genesis XXI:14) but in the 1960s it was changed to *The Departure of the Shemanite Wife* (II Kings 4:24), to relate to the biblical text. Recent scholarship and examination of the painting compares the work with an etching of the same subject created by Rembrandt in 1637.

Death of the Virgin, c.1639, etching and drypoint, (III states), Fitzwilliam Museum, University of Cambridge, Cambridge, UK, 41 x 31.5cm (16 x 12in) Signed and dated lower left: *Rembrandt f. 1639*

Rembrandt owned an impression of a woodcut, *Death of the Virgin,* 1510, by the German painter and engraver, Albrecht Dürer (1471–1528). In addition, a stained glass window in the Oude Kerk, Amsterdam, depicts the *Death of the Virgin,* 1561–5, created by Dirck Pietersz. Crabeth, a glass maker from Gouda. Rembrandt would have been familiar with it. There are similarities between Crabeth's and Dürer's depictions, and Rembrandt's later version.

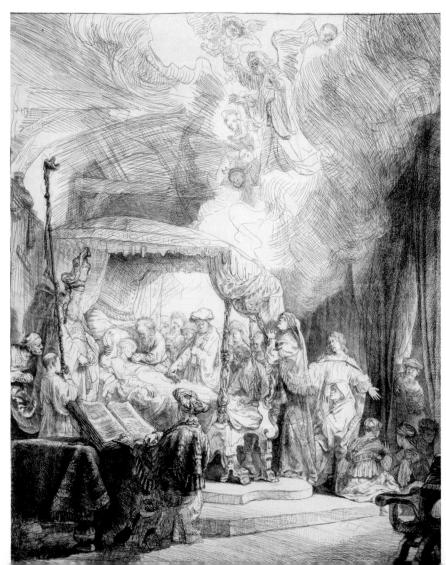

Presentation in the Vaulted Temple, 1639, etching with drypoint (III states), Musée de la Ville de Paris, Musée du Petit-Palais, France, 21.6 x 29cm (8½ x 11in)

The etching is also known as *Simeon with the Christ Child in the Temple*. It illustrates the presentation of the first-born son to the Elders of the temple, and it is preceded by the infant Christ and his mother Mary meeting Simeon, the holy man. Simeon recognizes the infant Christ, and sings a hymn of praise. Rembrandt's adept use of *chiaroscuro* bathes the temple congregation in a shaft of light guided by the Holy Spirit in the form of a dove, which emphasizes the dark recesses in the vaulted arches of the temple.

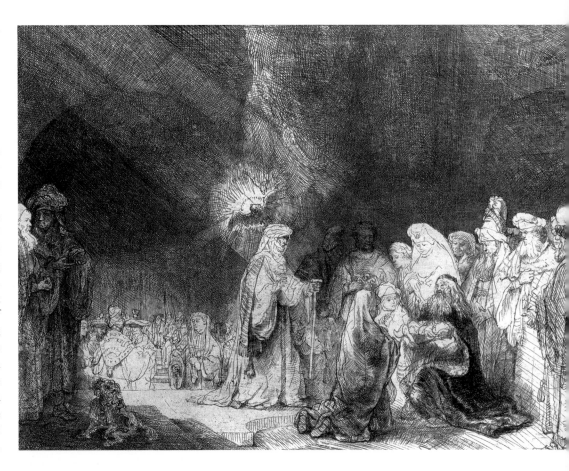

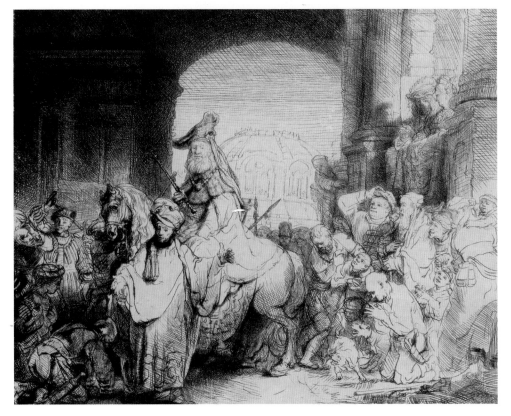

The Triumph of Mordecai, c.1640, etching and drypoint, The Israel Museum, Jerusalem, Israel, 17.4 x 21.5cm (7 x 8½in)

In the Old Testament, the Book of Esther (VI: 1-11) relates the narrative of the triumph of Mordecai, a Jew of the Benjamin tribe. Rembrandt depicts him in royal clothes, astride the king's horse, with gifts from king Ahasuerus, given following Mordecai's uncovering of a murder plot by two of the king's eunuch protectors. A further plot by Haman, an unruly henchman of the king, to kill Mordecai and all Jews in the king's provinces, was foiled by Mordecai and Esther. In Rembrandt's etching, the perplexed Haman, centre left, is unaware of his fate.

Christt on the Cross, 1631, oil
on canvas, Eglise du Mas
d'Agenais, France,
100 x 73cm (39 x 29in)
Signed *RHL.1631*

The painting was possibly
originally intended as a trial
piece for the 'Passion of
Christ' series of paintings
ordered by Constanijn
Huygens for Frederik
Hendrick, Prince of Orange.
Christ is depicted enduring
the agony of his crucifixion.
In this painting, Rembrandt
bathes Christ's body in light;
the proclamation is pinned
to the cross above Christ's
head. The announcement by
Pontius Pilate is written in
Hebrew, Latin and Greek,
'Jesus of Nazareth, the King
of the Jews'. (Matthew
XXVII: 27-50). The darkness
surrounding the cross
creates a charged
atmosphere, with the
focus on Christ's suffering.

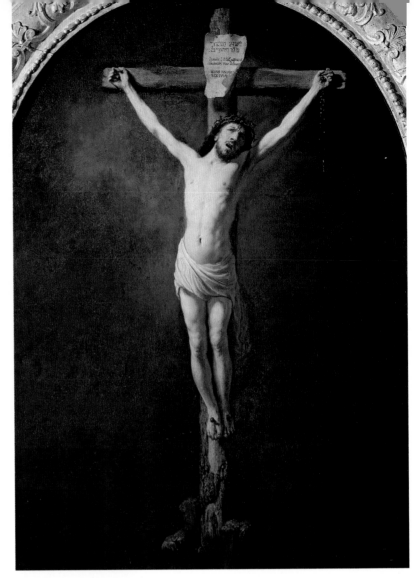

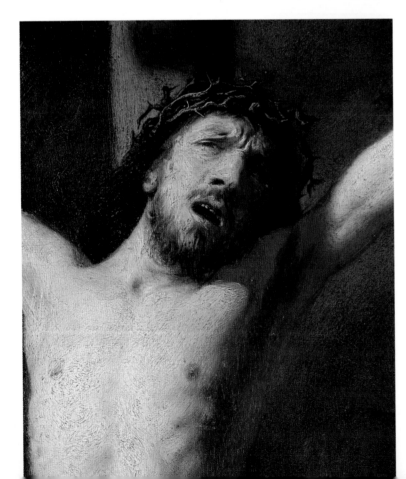

Christ on the Cross, (detail of
head), 1631, oil on canvas,
Eglise du Mas d'Agenais,
France,
100 x 73 cm (39 x 29 in)

The artist conveys the pain
and suffering of Christ during
his crucifixion. The eyes of
Christ look upward, toward
God in heaven, while
registering the agony of a
slow death. Blood seeps
from the 'crown of thorns'
on his head. His short beard
is covered in sweat.

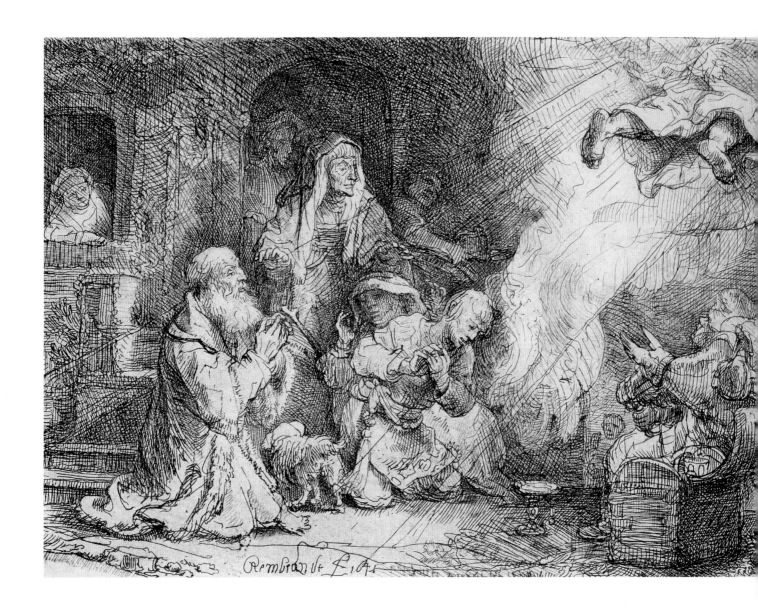

The Angel Departing from the Family of Tobias, 1641, etching with drypoint (IV states), Guildhall Library, City of London, UK, 11 x 15.4cm (4 x 6in), Signed *Rembrandt f. 1641*

The composition is based on a text from the apocryphal Book of Tobit XII:16-32. Blind, elderly Tobit and his son Tobias are kneeling; other members of the family, including Tobit's wife Anna, watch in awe as Azarias, who had accompanied Tobias on a long journey, is revealed as the Archangel Raphael, who departs toward the celestial sphere.

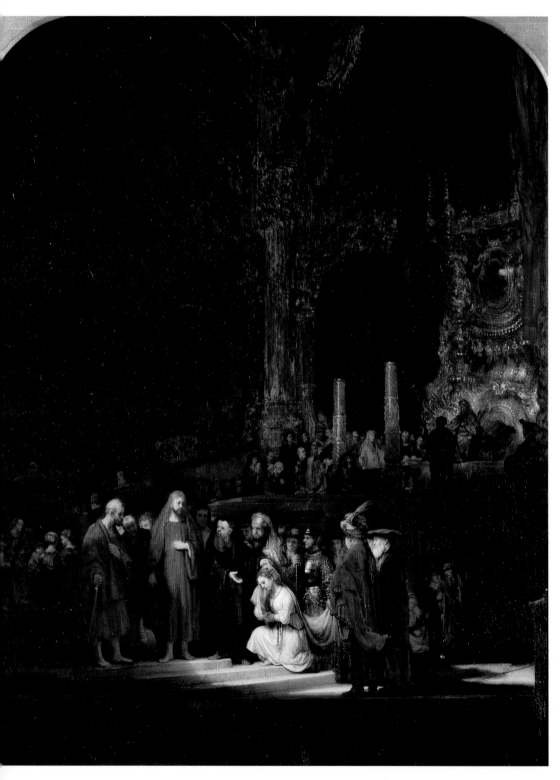

The Woman taken in Adultery,
1644, oil on oak, National
Gallery, London, UK,
83.8 x 65.4cm (33 x 25in)
Signed *Rembrandt f. 1644*

The symbolic nature of
Rembrandt's depiction of
The Woman Taken in
Adultery is that God forgives
sinners. It portrays the Bible
text John VIII: 3-7, whereby
scribes and Pharisees
brought into the temple a
woman who had been
caught in the act of adultery.
They asked Jesus for his
opinion to trick him into an
open denouncement of
religious law. The text relates
that they said to him,
'Teacher, this woman has
been caught in the act of
adultery. Now in the law
Moses commanded us to
stone such. What do you say
about her?' Jesus replied 'Let
him who is without sin
among you be the first to
throw a stone at her.'
Rembrandt depicts the taller
figure of Christ surrounded
by the throng with the young
woman kneeling before him.
The style of the painting,
particularly in the many
smaller figures in the
background and its attention
to interior detail, is
characteristic of Rembrandt's
art created in the 1630s.

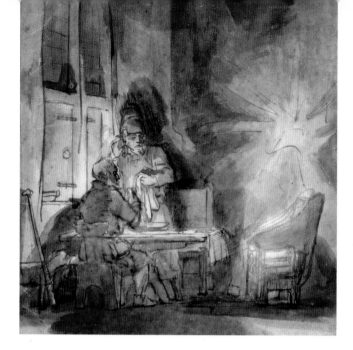

Supper at Emmaus, c.1648–9, pen and brown ink and brown wash with white body colour, Fitzwilliam Museum, University of Cambridge, UK, 19.8 x 18.3cm (8 x 7in) [No.2139]

The drawing may be a close copy of a lost work by Rembrandt. It is an unusual depiction of *Supper at Emmaus,* as told in the New Testament narrative: Mark XVI: 14-19. This work portrays Christ as a blinding flash of light and energy, which surprises the onlookers, a possible reference to Mark XVI: 19, 'So then the Lord Jesus, after he had spoken to them, was taken up into heaven…'

Supper at Emmaus, 1648, oil on panel, Musée du Louvre, Paris, France, 68 x 65cm (27 x 25½in) Signed Rembrandt f. 1648

Historians agree that Rembrandt, informed by the composition of Albrecht Durer's Small Passion, woodcut, 1511, made reference to it in this work, *Supper at Emmaus* (Luke XXIV: 30-32). The dark yet spacious room interior, with its classical arch framing the central figure of Christ, is bare except for a brightly lit table, and a few chairs on which sit Christ and two disciples, possibly Luke and Cleophas. A fourth person serves at table. Although the table is small the setting recalls the narrative of the Last Supper of Christ with his disciples (Matthew XXVI: 17-30).

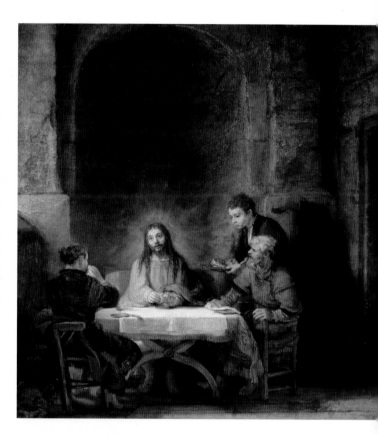

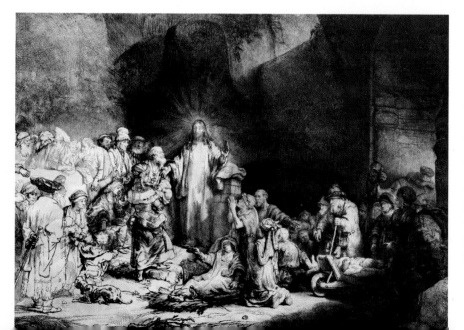

Christ Amongst the Sick, 'The Hundred-Guilder Print', 1646–9 etching with drypoint, Musée Conde, Chantilly, France, 27.8 x 38.8cm (11 x 15in)

This is one of a series of episodes from the Bible, St Matthew, chapter XIX, in which Christ heals the sick. Rembrandt cleverly fused together different biblical narratives, to highlight the impact of Christ's ministry.

The Deposition (Descent from the Cross) 1632–33, oil on canvas, Alte Pinakothek, Munich, Germany, 89.5 x 65cm (35 x 25½in)

The difficult and tiring task of taking down a dead body from a crucifixion cross, and the emotions caused by witnessing the cruel death of an inspirational man, is etched into the bodies of the mourners who remove Christ's body from the cross. The limp arms and forlorn expressions highlight the poignancy of the occasion, and are brilliantly captured by Rembrandt. The face of the man on the ladder is that of the artist, clutching the limp arm of Christ, an observer of the solemn and sad descent from the Cross.

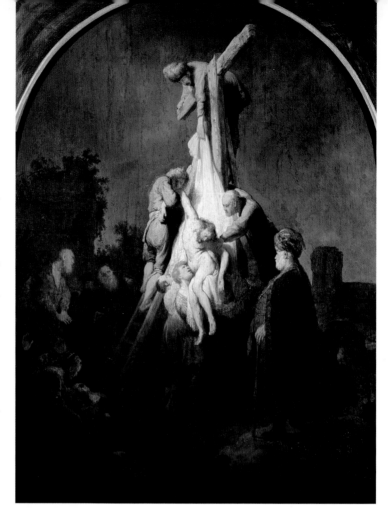

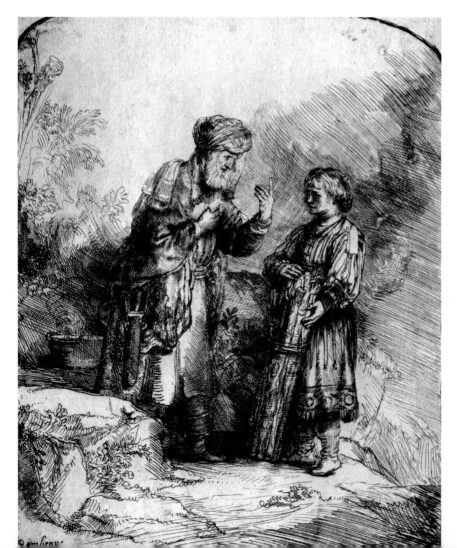

Abraham and Isaac, 1645, etching with drypoint, Musée de la Ville de Paris, Musée du Petit-Palais, France, 16 x 13.1cm (6 x 5in) Signed *Rembrandt 1645*

Rembrandt visualizes the ancient Hebrew patriach Abraham collecting wood with his son Isaac, prior to the intended sacrifice of his son on a pyre; a test of faith commanded by God, in the Old Testament narrative: Genesis XXII: 1-9. The artist created several versions of this story, in etchings, drawings and paint, choosing different moments of the test to portray Abraham's love of God overriding his fatherly love for his son.

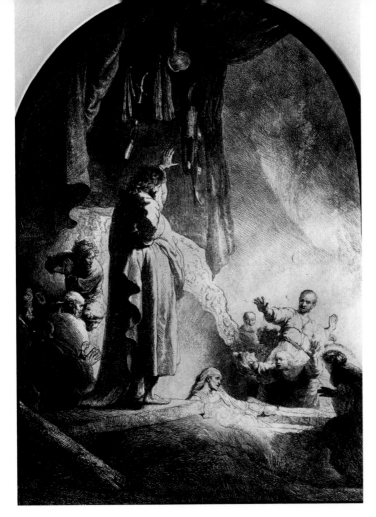

The Raising of Lazarus,
[larger plate], c.1632, etching
and burin, (10 states),
Musée de la Ville de Paris,
Musée du Petit-Palais,
France,
36.6 x 25.8cm (14½ x 10in)

The large-scale etching is
based on a painting, *The*
Raising of Lazarus, which
Rembrandt had created
c.1630–1. The figure of
Christ in profile dominates
the centre of the etching.
He stands on a stone slab,
looking down toward the
figure of Lazarus lying in his
mortuary linen clothes. The
face of Lazarus registers
shock as Christ, with hand
raised, calls: 'Lazarus, come
out'. His surprise is mirrored
in the faces of onlookers
standing opposite Christ.

The Storm on the Sea of
Galilee, 1633, oil on canvas,
Isabella Stewart Gardner
Museum, Boston, MA, USA,
162 x 130cm (64 x 51in)

A sensational painting that
captures the figure of Christ
and his disciples, as they
weather a storm on the
Sea of Galilee, based on the
text of Mark IV: 35-41.
Rembrandt depicts a fishing
boat pushed upward by high
waves and turbulent current.
Some of the fishermen, at
left, try to bring the boat
and its sails under control,
while to the right, other
fishermen question Christ's
ability to be calm in
the midst of the
tempestuous squall.

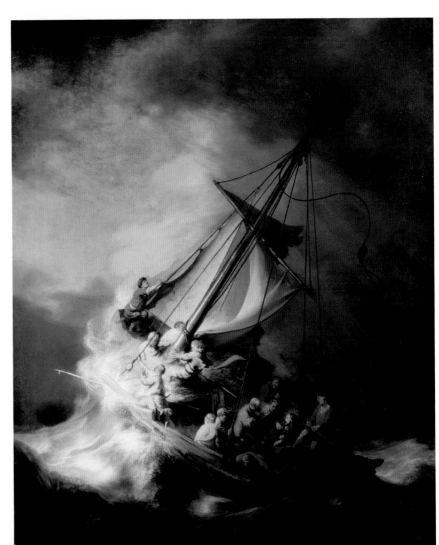

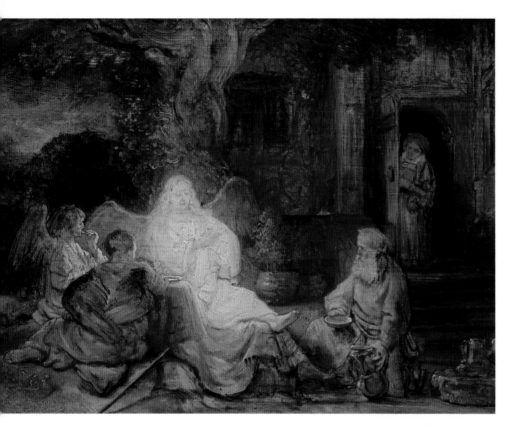

Abraham and the Three Angels, 1646, oil on canvas, The Aurora Trust, New York, NY, USA, 16 x 21cm (6 x 8in), Signed *Rembrandt f. 1646*

The Book of Genesis XVIII: 1-15, narrates that the elderly Hebrew patriarch Abraham received three visitors; God as a mortal and two angels. Abraham invites them to stay and dine at his table. Afterward he is promised the birth of a son by his ageing wife, Sarah. Rembrandt sets the narrative outside the house of Abraham. He kneels while serving the three angels. His wife is depicted listening at the open door.

The Raising of Lazarus, [smaller plate], (II states) 1642, etching, Musée de la Ville de Paris, Musée du Petit-Palais, France, 15 x 11.5cm (6 x 4½in)

The smaller plate of *The Raising of Lazarus*, copies the scenario of the earlier 1632 version, except to show the event from the opposite view. Here, Christ is seen from the front, standing above the sepulchre of Lazarus, with followers standing behind him. He raises his hands, and calls to Lazarus to rise. Based on the biblical narrative from John 11:1-44.

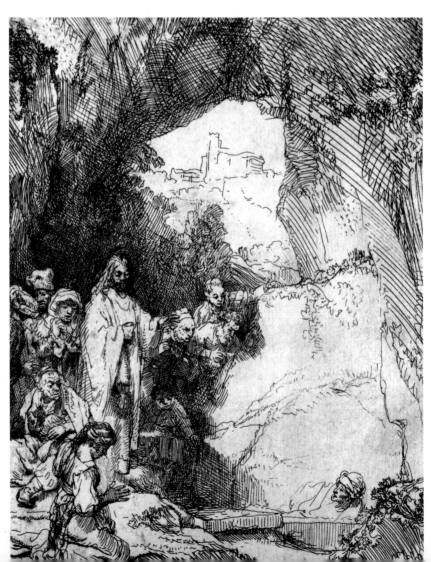

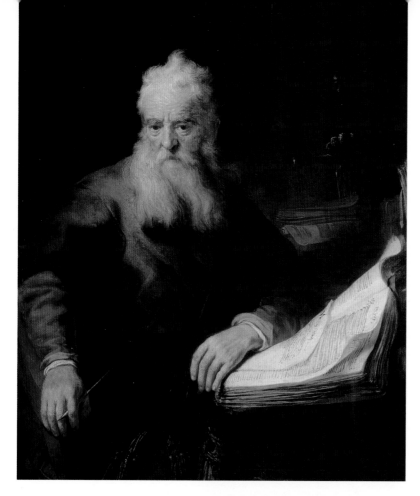

*The Apostle Paul, c.*1630s, oil on canvas, Kunsthistoriches Museum, Vienna, Austria, 135 x 111cm (53 x 44in) Signed *Rem…163…*

The portrait painting is attributed to Rembrandt. It depicts the apostle St Paul seated at a desk, and is most probably part of the early series of singular figure paintings of the apostles that Rembrandt painted in the 1630s. The elderly man, seated with pen in hand, looks out toward the onlooker. He leans across his books, which are open on his desk, a symbol of St Paul's prolific writing of epistles, to spread the word of Christ and the Christian faith.

Adoration of the Magi, 1632, oil on panel, The State Hermitage Museum Museum, Leningrad, Russia, 71 x 65.8 cm (28 x 26in)

The New Testament narrative, Matthew II: 1-2, states that 'wise men' came from the East to Jerusalem, following a star, to find the newborn 'King of the Jews'. Rembrandt pivots the composition around the three wise men in the act of acknowledging the infant Christ as the Son of God. One kneels at the feet of the Virgin and Christ child, in an act of humility and recognition; the others wait.

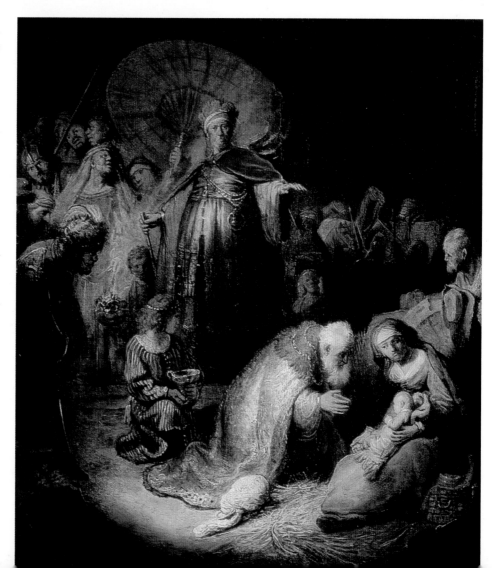

*Belshazzar's Feast c.*1636–38, oil on canvas, National Gallery, London, UK, 168 x 209cm (66 x 82½in)

The Old Testament Book of Daniel, V: 1-6; 25-8, narrates the tale of a feast given by Belshazzar, King of Babylon. His undoing was to serve wine in gold and silver vessels looted by his father Nebuchadnezzar from the Temple of Jerusalem. For this transgression a message from God in Hebrew appeared: MENE, MENE, TEKEL, UPHARSIN ('God has numbered the days of your kingdom and brought it to an end; you have been weighed in the balances and found wanting; your kingdom is given to the Medes and Persians'.) Rembrandt focuses on the moment that Belshazzar reads the message, which forecasts his immediate demise and death. The four words of text were placed vertically.

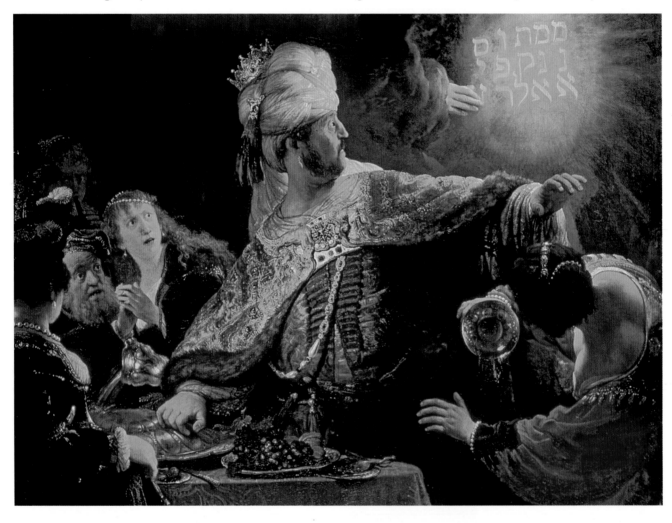

Ecce Homo, 1634, grisaille, oil on paper, National Gallery, London, UK, 55 x 44.5cm (21½ x 17½in)

The grisaille work, a preparatory drawing for an etching *Christ Before Pilate* (1634) is in monotone black and brown. In the bible narrative St John XIX: 5, Pontius Pilate presents Jesus Christ to the people with the words 'Behold the Man! (*Ecce Homo!*). Rembrandt depicts the priests who urge the crowd to choose death for Christ, as ugly, loathsome men, who clamber toward Pilate and turn to the baying crowd to sway opinion against Christ. The figure of Christ, alone amid a throng of guards, priests and Pilate, stands out; his body lit with 'heavenly' light.

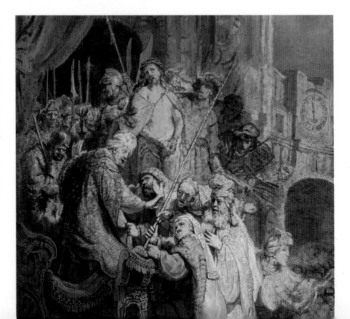

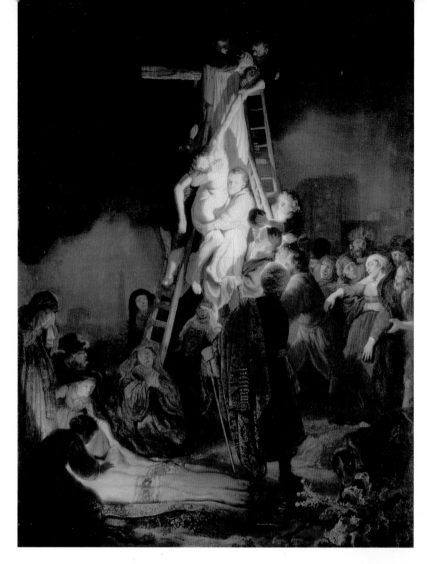

The Descent from the Cross, 1634, oil on canvas, The State Hermitage Museum, St. Petersburg, Russia, 158 x 117cm (62 x 46in) Signed *Rembrandt f. 1634*

The composition follows a painting of the same subject created by Rembrandt in 1633. In the 1634 work, he captures the sadness in the faces of mourners as the body of Christ is removed from the crucifix. Ladders are propped against the cross; onlookers gather around. One man is about to take the weight of the body as Christ's left arm is released by another helper. The adept use of *chiaroscuro* creates focal points of light, at the centre is the body of Christ; mourners lay out burial sheets on a bier; and Mary, mother of Christ, is held by mourners as she faints.

The Holy Family, 1634, oil on canvas, Alte Pinakothek, Munich, Germany, 183.3 x 123cm (72 x 48½in) Signed *Rembrandt f. 163*

The painting, in the Baroque style, depicts a bare-breasted Mary seated with the infant Jesus on her lap. Joseph attentively looks at the Christ child. To the left of the mother and child, the wooden crib is placed. From an unseen source to the right, Rembrandt swathes the heads of the Holy Family in light, painted to highlight the intimacy of a private moment between father, mother and newborn child.

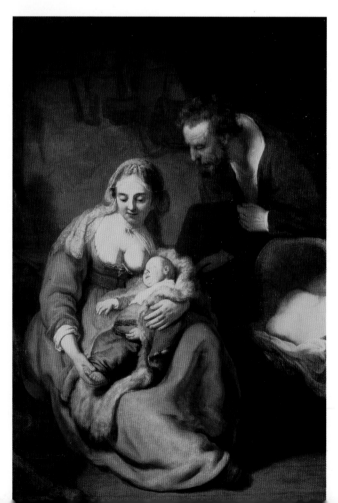

The Baptism of the Eunuch,
1636, oil on canvas,
Rijksmuseum, Amsterdam,
The Netherlands,
85.5 x 108cm (34 x 42½in)
Signed *Rembrandt ft. 1636*

The bible, Acts VIII: 26-40,
relates the story of the
apostle Philip travelling from
Jerusalem to Gaza. On the
road through a desert
landscape he met with a
high-ranking official, a eunuch
and a court servant of the
queen of Ethiopia, of the
palace of Candace. The
eunuch is baptized by Philip.
In Rembrandt's colourful
portrayal, a carriage with
horses perched on rocky
ground fills the upper space
of the composition.
Onlookers, part of the
entourage, watch as the
standing figure of Philip
baptizes the kneeling eunuch.

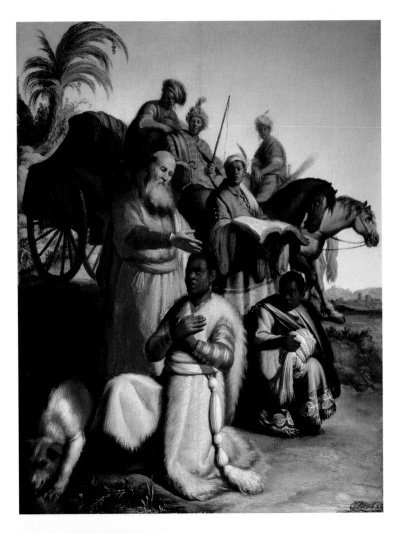

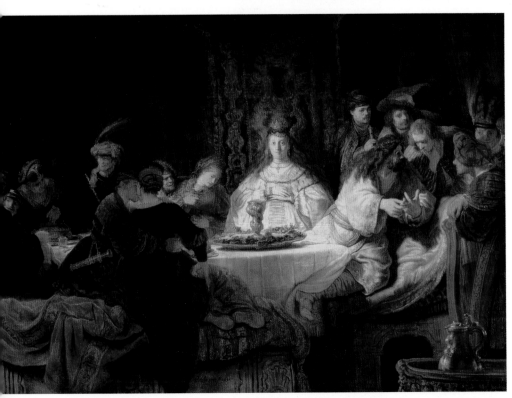

*Samson Proposing the Riddle
at the Wedding Feast,* 1638,
oil on canvas,
Gemäldegalerie Alte
Meister, Dresden, Germany,
126 x 175 cm (50 x 69 in)
Signed *Rembrandt f. 1638*

Central to the painting is the
wife of Samson who would
betray him. Samson is
portrayed at his wedding
feast. In the Old Testament
narrative, Judges XIV: 10-20,
he sets a riddle for his
guests; Samson's wife reveals
the answer to them; she and
the guests are punished for
deception. Rembrandt
depicts Samson in animated
conversation as he relates
the riddle.

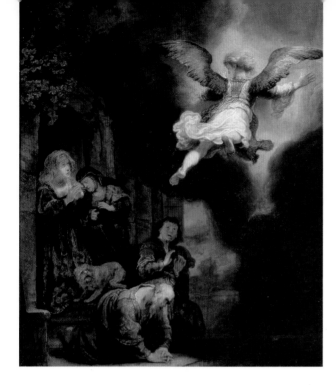

The Archangel Raphael Taking Leave of the Tobit Family, 1637, oil on panel, Musée du Louvre, Paris, France, 66 x 52cm (26 x 20½in)

Two focal points of the painting are the Archangel Raphael in flight, departing the family of the holy man Tobit, and the bowed head of Tobit who has fallen to his knees. Both are bathed in light. The apocryphal Book of Tobit relates the blind Tobit regaining his sight through the aid of his son Tobias and the Archangel Raphael.

The Entombment, c.1639, oil on panel, Alte Pinakothek, Munich, Germany, 92.5 x 70cm (36½ x 27½in)

This painting was one of the last commissioned for the 'Passion of Christ' series by Constantijn Huygens for Frederik Hendrik, Prince of Orange. Regarding this work, Rembrandt wrote to Huygens on 12 January 1639, describing it as 'the one in which Christ's body is being laid in the tomb…' He interpreted his composition as having the 'most natural movement' and the execution of it meant a late delivery of the work, for which he apologized.

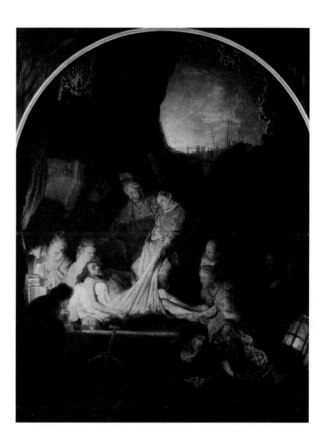

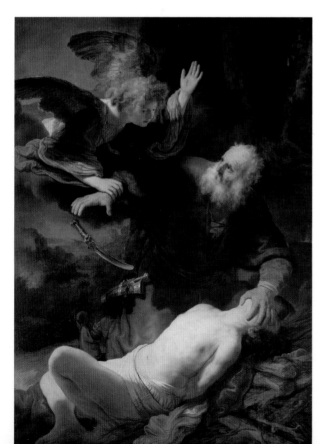

The Sacrifice of Abraham, 1635, oil on canvas, The State Hermitage Museum, St. Petersburg, Russia, 194 x 133cm (76 x 52in) Signed *Rembrandt f. 1635*

Rembrandt, visualizing the Old Testament narrative Genesis XXII, in which God commands Abraham to sacrifice his son Isaac, creates a semi-circular movement on three levels. The upper figure of the winged angel hovers above the figure of Abraham at the centre, in contrast to the immobile figure of Isaac, below. Rembrandt captures a pivotal moment as the angel grabs the arm of the distraught father, Abraham, who drops his knife. As a counterbalance to the dark theatricality of the angel and Abraham's actions, the body of Isaac is bathed in warm light. Rembrandt depicts Isaac lying down, on the sacrificial pyre, unable to see the angel, or his father's attempt to kill him, owing to the hand of Abraham on his face.

David and Jonathan (or, David and Absalom) 1642, oil on panel, Hermitage, St Petersburg, 73 x 61.5cm (29 x 24in) Signed *Rembrandt f.1642*

Attributed to Rembrandt with some reservations. The majority of Rembrandt scholars interpret the painting as a depiction of the Old Testament narrative of David and Jonathan parting (I Samuel XX: 1-42); the artist depicts an emotional scene. The oriental costumes collected by Rembrandt are used to full effect in this portrayal.

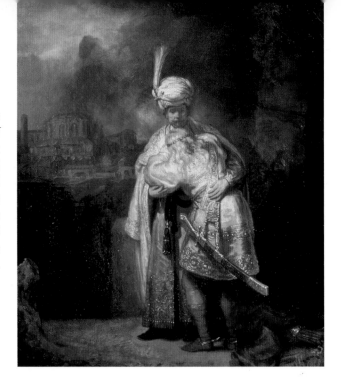

Joseph's Dream in the Stable in Bethlehem, 1645, oil on panel, Gemäldegalerie, Berlin, Germany, 20 x 27 cm (8 x 10½in) Signed *Rembrandt f. 1645*

A companion oil-on-panel painting to *Anna Accused by Tobit of Stealing the Kid* [goat], 1645. The Bible text (Matthew 1:18), refers to an angel visiting St Joseph as he slept in the stable, to reassure him that the infant Jesus was the Son of God, and that he should continue his role as husband to Mary. Rembrandt places the angel at the shoulder of Joseph, as both parents sleep. The brightness of the light around the angel makes it the focal point of the painting, with Joseph and Mary cast in shadow.

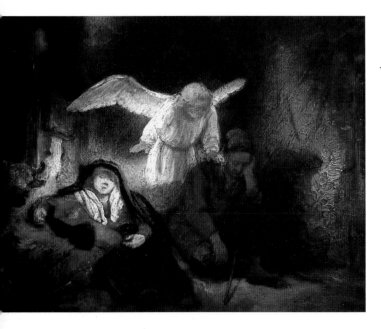

The Carpenter's Shop, 1640, oil on panel, Musée du Louvre, Paris, France, 41 x 34cm (16 x 13½in) Signed *Rembrandt f. 1640*

Rembrandt locates the scene in the workshop of Joseph, the carpenter and husband of Mary, the mother of Christ. The figure of Joseph stands near an open window. The composition centres on the seated figure of Mary breastfeeding the naked infant Christ, while her mother, seated next to her, lovingly looks on. The close tie between the women is evident as Mary's mother, St Anne, holding a book in her left hand, takes time away from reading, to rearrange the infant's blanket. Rembrandt captures the intimacy and bond between the new mother and her baby and the naturalness of the event taking place in the workshop.

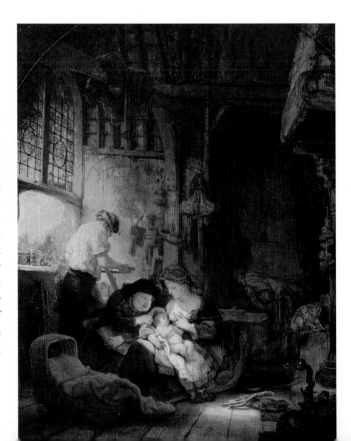

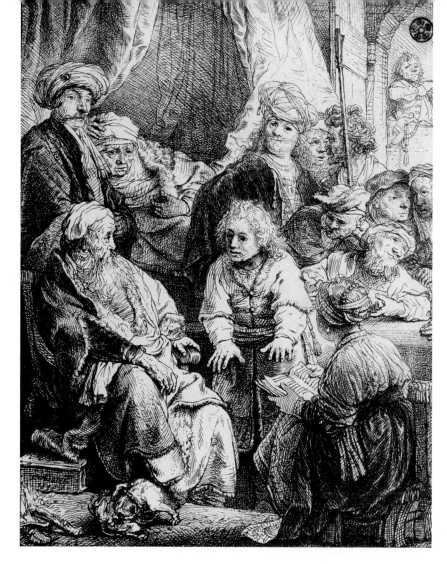

Joseph Telling his Dreams,
1638, etching (III states),
City Art Gallery,
Leeds, U.K.,
10.9 x 8.2cm (4 x 3in)
Signed *Rembrandt f. 1638*

A depiction of the Old
Testament narrative, (Genesis
XXXVII: 1-11) of Joseph, son
of Israel, telling his dreams
to his older brothers.
One dream reveals that they
would acknowledge him as
their superior, which was not
well received, 'they hated
him even more.' Rembrandt
places the young Joseph
central to the composition,
oblivious of his brothers'
envy and malice toward
him. The artist creates a
diversity of faces and facial
expressions for the brothers,
to register disbelief and
disinterest, in contrast
to the youthful, bright-eyed
face of Joseph.

*The Parable of the Labourers
in the Vineyard,* 1637, The
State Hermitage Museum,
St. Petersburg, Russia,
31 x 42cm (12 x 16½in)
Signed *Rembrandt f. 1637*

The artist depicts an interior
scene in a large building.
Light from a window to the
left illuminates the faces of
the men nearby. Taking the
bible text Matthew XX: 1-16
as a source, Rembrandt
visualizes the vineyard
workers discovering that
latecomers were paid the
same amount, that is, one
denarius, as those who had
worked all day. The subject
matter is difficult to express
visually; the artist depicts
men talking, and one with his
hand extended in debate
with the seated owner.

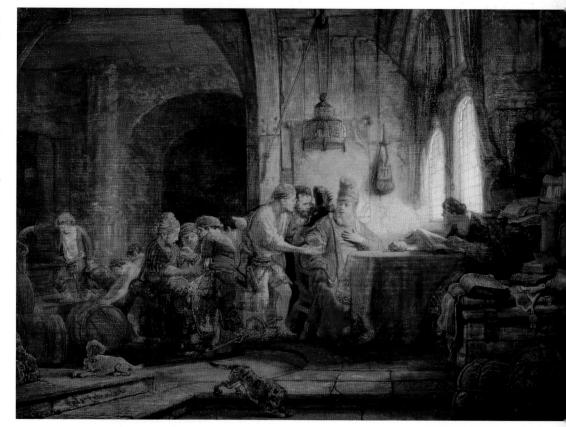

*The Holy Family, c.*1645, oil on canvas, The State Hermitage Museum, St. Petersburg, Russia, 117 x 91cm (46 x 36in)

Mary, mother of the infant Jesus, seated by his wicker cradle, interrupts her reading, to adjust a blanket which rests on the top of it. Above the cradle, angels descend to watch and protect him as he sleeps. In the background, Joseph can be seen at carpentry work. Behind him, the tools of his trade hang on the wall. In a stunning use of *chiaroscuro* that zigzags through the composition, Rembrandt highlights each figure in this tender depiction of the Holy Family.

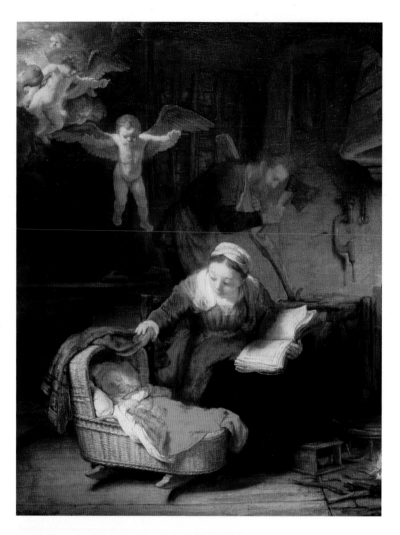

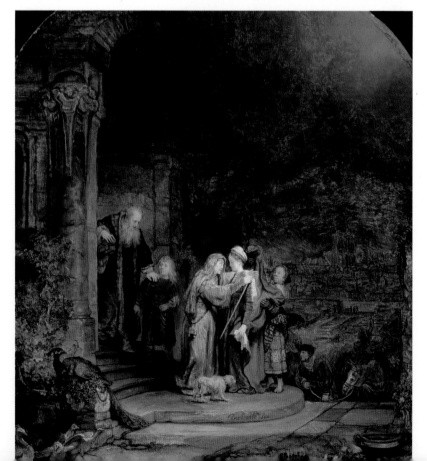

The Visitation, 1640, oil on panel, Detroit Institute of Arts, USA, 56.5 x 48cm (22 x 19in) Signed *Rembrandt 1640*

The Visitation (also known as *The Meeting of Mary and Elizabeth*), Luke 1: 39-56, depicts the Virgin Mary visiting her cousin Elizabeth, the mother-to-be of John the Baptist. Both women are pregnant. Rembrandt bathes both figures in light to highlight the intimacy of the meeting. He includes everyday details such as the tethered horses at bottom right of the painting denoting Mary's arrival, and Zechariah, the elderly husband of Elizabeth, descending the house steps to greet Mary.

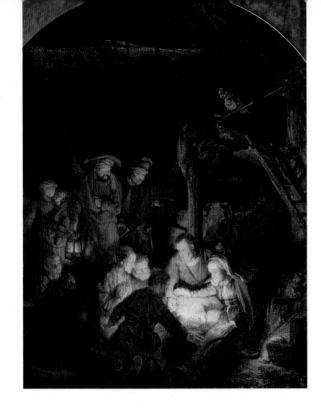

The Adoration of the Shepherds, 1645, oil on canvas, Alte Pinakothek, Munich, Germany, 97 x 71.3cm (38 x 28in)

Signed and dated 1645. The painting is probably one of a pair with a lost work, *The Circumcision,* both commissioned by the Stadholder Frederik Hendrik, Prince of Orange. The court inventory shows that the paintings were framed in 'black frames with oval tops and encircled by gilt carved foliage'. The painting depicts the Holy Family in the stable of the inn with the shepherds.

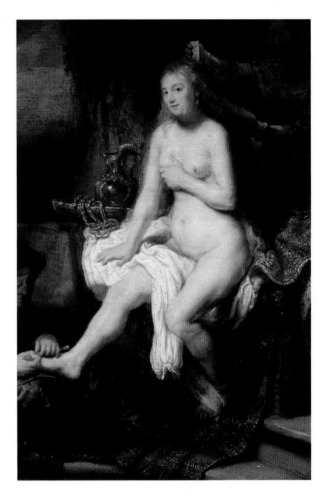

Bathsheba at her Toilet, 1642, (detail), oil on panel, Metropolitan Museum of Art, New York, NY, USA, 57 x 76cm (22½ x 30in) Signed *Rembrandt ft. 1643*

Attributed to Rembrandt with reservations. The figure of Bathsheba is part of a larger picture. The scene depicts a moment from the biblical narrative of King David and his lustful admiration of another man's wife. (II Samuel: Ch.11:1-27). In this scene Bathsheba sits after bathing. Surrounded by rich ornamentation, she is attended by maidservants, one dries her feet, another attends to her hair. On seeing the spectator, Bathsheba attempts to cover her naked body thus drawing attention to it.

*The Holy Family, c.*1645 (detail of angels), oil on canvas, State Hermitage Museum, St Petersburg, Russia 117 x 91cm (46 x 36in)

Angels tumble from heavenly clouds directly into the room where Mary, Joseph and the infant Jesus reside. The wind from their wings may be the reason for Mary adjusting the blanket on top of the baby's cradle. Or, it might be that from her reading of the scriptures she acknowledges her child as the 'Son of God'. Rembrandt leaves his interpretation to others, filling the painting with symbols of love and protection both worldly and heavenly.

Head of Christ, c.1648–50, oil on canvas, Gemäldegalerie, Berlin, Germany, 75.2 x 60cm (30 x 23½in) Unsigned or dated.

Attributed to Rembrandt. A three-quarter profile depiction of the head and shoulders of Christ, one of many portraits created in a closely similar style by the artist. It depicts a young man with long dark hair parted in the middle and a short full beard with small moustache. The face is pale and unlined, and the eyes look toward the distance to the right. The clothing is sombre in shades of brown.

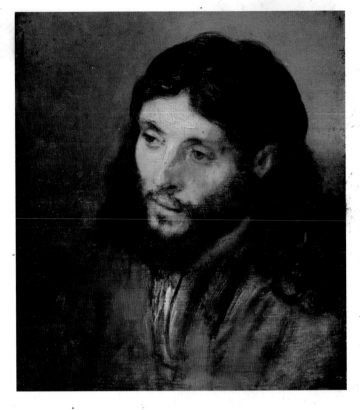

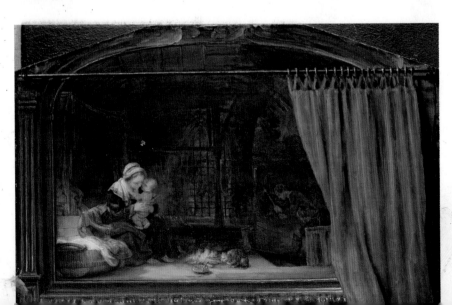

The Adoration of the Shepherds, (detail), 1646, oil on canvas, Alte Pinakothek, Munich, Germany 97 x 71.3cm (38 x 28in)

To centre right, a circle of light focuses on the images of Mary and Joseph who look down at their newborn infant. To the left, with some faces caught in the light, shepherds are depicted paying homage to the Christ child. They gather closely around the baby's crib. Rembrandt's fine use of *chiaroscuro* highlights the intent of the shepherds visit and the intimacy of the stable scene.

Holy Family (with Painted Frame and Curtain), 1646, oil on panel, Gemäldegalerie Alte Meister, Kassel, Germany, 47 x 68.4cm (18½ x 27in) Signed *Rembrandt fc.* 1646

A homely vision of the Holy Family, depicted with the theatrical addition of a *trompe l'oeil* picture frame and pulled-back curtain.

Holy Family with a Curtain, 1646 (detail of cat), oil on panel, Gemäldegalerie Alte Meister, Kassel, Germany, 47 x 68.5 cm (18 x 27in)

In an intimate scene of the Madonna and infant Christ child, a cat is placed at the centre forefront of the painting, warming itself by a fire. Close by an empty bowl and spoon, a possible reference to the baby having just been fed, is closely observed by the cat.

Susanna and the Elders, 1647, oil on mahogany panel, Gemäldegalerie, Berlin, Germany 76.6 x 92.7cm (30 x 36½in)

Rembrandt created a red chalk drawing, *Susanna Surprised by her Elders,* c.1636–7, after a painting of the same name painted by his mentor Pieter Lastman in 1614. The composition of the chalk drawing is loosely followed in this painting. Rembrandt removes objects, such as the marble sphynx, to concentrate on the actions of the lascivious Elders, whom he places close to the virtuous Susanna, surprised while bathing. The painting is in two layers, the earlier underpainting dates to c.1637; it is a composition close to Rembrandt's earlier work, *Susanna and the Elders,* 1637.

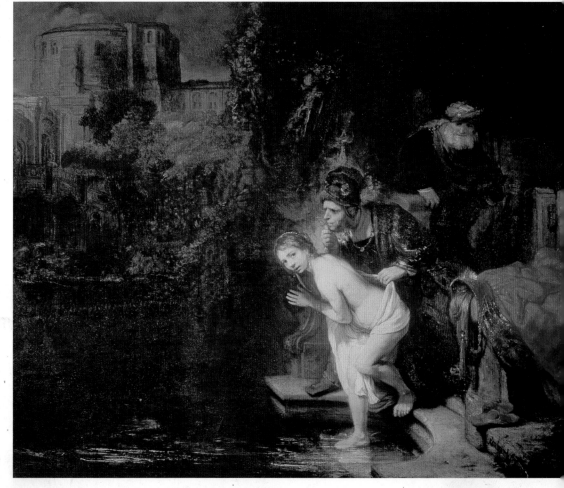

Still Life with Peacocks,
c.1639, Rijksmuseum,
Amsterdam,
The Netherlands,
145 x 135.5cm (57 x 53in)
Signed *Rembrandt*

A young girl standing behind a sill looks at two dead peacocks that have been placed in a pantry or cool place. They have recently been shot; blood is painted oozing from the lower one lying flat on a ledge. They would be hung up for a day or two before eating. The peacock hanging on the right is painted with its plumage on show. The light source focuses on the multifarious colours of its feathers. The artist captures the sad ending of the beautiful birds, shot for meat.

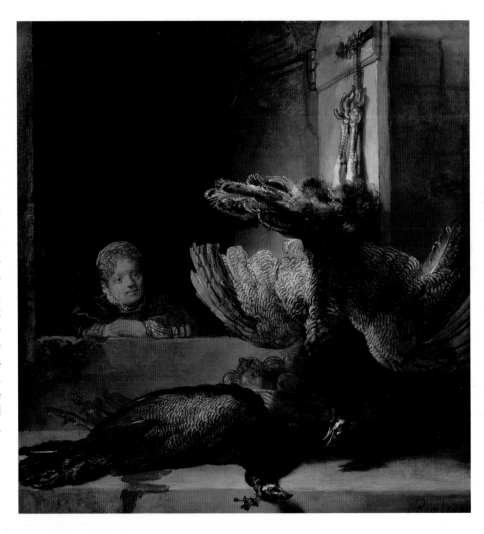

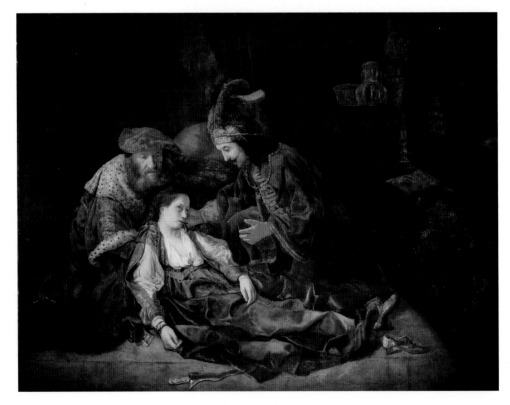

The Death of Lucretia, 1644, oil on canvas, Detroit Institute of Arts, USA, 174 x 220cm (68½ x 86½ in)

The suicide of Lucretia, is related by Roman historian, Livy (59BC–AD17), in his history of ancient Rome *Ab urbe condita libri* (27–25BC). Lucretia, a Roman noblewoman was raped by the son of the Etruscan king of Rome, Tarquin Superbus; she committed suicide to save embarrassment to her family. Her death led to the expulsion of the Etruscan kings and the birth of the Roman Republic. Lucretia asks her husband, father and friends to avenge her, before stabbing herself to death.

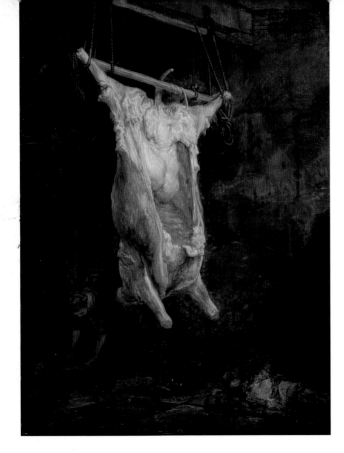

The Carcass of an Ox, late 1630s, oil on panel, Art Gallery and Museum, Kelvingrove, Glasgow, Scotland
73.3 x 51.7 cm (29 x 20in)

The graphic depiction of a slaughtered ox, with limbs tied to a crosspost, blood draining away is in contrast to the figure of a woman in the background, who stoops to wash the paving stones. The subject was popular with painters. Rembrandt painted the carcass with thick paint, scraped and cut through, to create uneven surfaces.

Woman Lying in a Bed, c.1635–40, pen and brown ink with brown wash, Musée de la Ville de Paris, France, 16.3 x 14.5 cm (6½ x 6in)

This small drawing depicts a young woman lying in a bed. Her facial features reveal the anguished expression of a person who is ill, or suffering. Historians consider that it might be Saskia, Rembrandt's wife. If it is, it is a deeply personal sketch. In the period that this sketch was created – Saskia gave birth to three babies who died soon after birth.

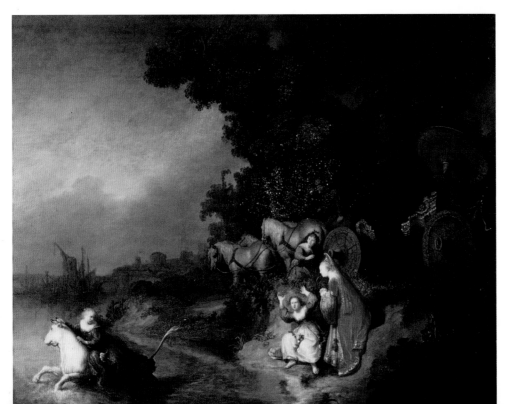

The Abduction of Europa (The Rape of Europa), 1632, oil on wood, Paul Getty Museum, Los Angeles, USA, 62.2 x 77cm (24½ x 30in) Signed RHL van Rijn 1632

The composition is derived from the ancient text Metamorphoses II: 836-75 AD8) of a Greek myth: Zeus, disguised as a white bull, seduces and abducts Europa, daughter of Agenor, king of Tyre. Europa is beguiled by a white bull on the seashore. Rembrandt depicts the shock of Europa and her attendants when they realize the bull is carrying her away.

Male Nude Seated before a Curtain, 1646, etching (II states), Fogg Art Museum, Cambridge, MA, USA, 16.4 x 9.7cm (6½ x 4in) Signed *Rembrandt f. 1646*

A semi-nude young male, wearing a loincloth is sitting with his hands clasped in his lap. Behind him a large draped curtain

hangs; it covers almost half of the picture composition. In about 1646, Rembrandt produced three etchings of young male nudes, a departure from his depictions of the female nude, and most probably produced as part of a lesson for the life-drawing classes he arranged for his pupils.

Two Male Nudes ('The Walking Frame'), c.1646, etching (III states). Staatliche Graphische Sammlung, Munich, 19.4 x 12.8cm (7½ x 5in)

A diversity of images in the etching shows a young man, semi-nude, both seated and standing. In the background, lightly sketched and in

profile, a woman kneels and gestures toward a young infant in a baby walker. The small child with outstretched arms tries to walk toward the woman. The young male model also appears in sketches created by Rembrandt's pupils, thus this and the other two etchings were probably created during Rembrandt's tutorials.

Male Nude Seated on the Ground, 1646, etching (II states), Fitzwilliam Museum, Cambridge, UK, 97 x 16.9cm (38 x 7in) Signed *Rembrandt f. 1646*

A young man, naked expect for a loincloth, is seated on a cushion or low seat, in profile, on the floor

with one leg outstretched. This was one of three male nude studies, created as etchings c.1646, probably during the life-drawing classes arranged for Rembrandt's pupils. The young male also appears in sketches that were created by Rembrandt's pupils

Two Studies of a Bird of Paradise, c.1639, pen and brown ink and brown wash on paper, heightened with white, Musée du Louvre, Paris, France, 18.1 x 15.4cm (7 x 6in)

Birds of paradise were imported to the Netherlands by the Dutch East India Company. Several drawings of animals were listed in the insolvency inventory of 1656, prior to sale, including 'a bird of paradise and six fans in a drawer'. The stuffed bird was probably used to create this drawing of *Two Studies of a Bird of Paradise*. The bird's feet are not illustrated, possibly because they were removed before taxidermy.

Woman in Bed, c.1647, oil on canvas, National Gallery of Scotland, Edinburgh, Scotland, 81.1 x 67.8cm (31 x 27in) Signed *Rembr... f. 164*

The model for this painting is thought to be Hendrickje Stoffels, Rembrandt's common-law wife. In the half-length portrait, a naked young woman lying in bed holds a bedsheet to her body and sits up leaning on a pillow. She holds back one of the richly woven bed drapes to look toward, or for, an unseen person. The strong light directed on the pale skin of the woman highlights the golden headdress she wears. The subject matter of the portrait is unknown.

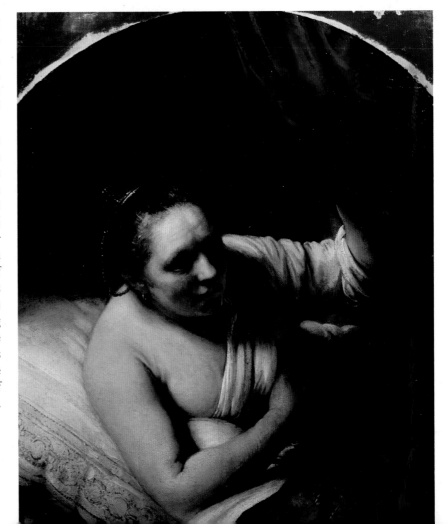

The Abduction of Ganymede,
c.1635, pen and brown ink,
brown wash on paper,
Staatliche Kunstsammlungen,
Dresden, Germany,
18.3 x 16cm (7 x 6in)

Rembrandt's depiction of the
infant Ganymede, abducted
by an eagle (the immortal
god Zeus, in disguise),
was intended to shock.
Rembrandt considered the
actuality of a child torn from
its parents; he captured the
terror of the young child in
its fearful, screwed-up face,
and helplessness. In the
sketch other figures look up
toward the scene, absent in
the etching. His depiction is
in striking contrast to other
artists visualizations, such as
The Rape of Ganymede, 1533
by Michelangelo Buonarroti.

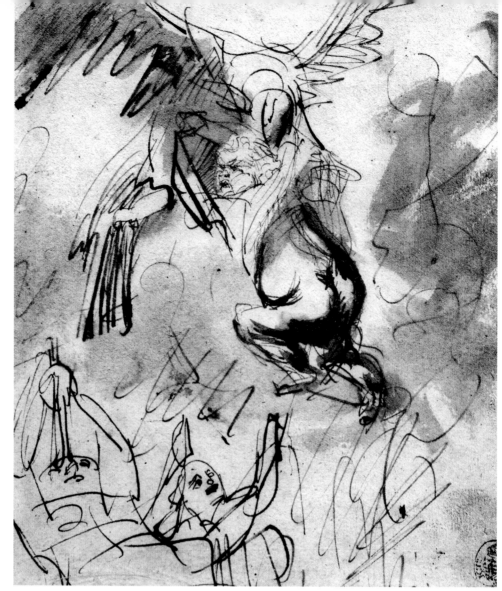

Cottages before a Stormy Sky,
c.1635–40, pen and brown
ink, brown wash with white
body colour, on brown
wash pre-prepared paper,
Graphische Sammlung
Albertina, Vienna, Austria,
18.2 x 24.5cm (7 x 10in)

A visually rich depiction of
sunlight shining on a group
of cottages after a rain
storm. The chimneys and
roofs are highlighted against
the storm clouds in the
distance. The dramatic use
of *chiaroscuro* sharpens the
composition. Between 1630
and 1650, Rembrandt
created a series of landscape
drawings and etchings, of
small hamlets, cottages,
outbuildings and dirt roads.

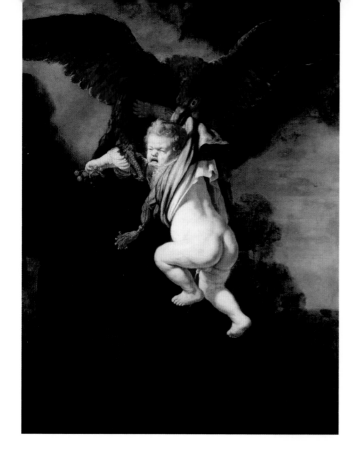

The Abduction of Ganymede, 1635, oil on canvas, Gemäldegalerie Alte Meister, Dresden, Germany, 171 x 130 cm (67 x 51in). Signed on shirt *Rembrandt ft. 1635*

In Greek mythology, Ganymede was the son of a Trojan prince and princess.

Because of his beauty, he was abducted by the god Zeus disguised as an eagle, to become a cup-bearer to the gods. Rembrandt, with an anti-classical viewpoint, focuses on the reality of a baby lifted into the air, screaming to be freed, torment is shown in his face, he urinates in fear.

The Ratcatcher (The Rat-poison Peddler), 1632, etching, (III states), Private Collection, 14 x 12.5cm (5½ x 5in) Signed *RHL 1632*

A genre portrayal of a ratcatcher at the door of a house. Dead rats hang from a basket on a pole, visible results of the ratcatcher's success. On his shoulder is a ferret (or terrier pup). The alternative title suggests that the he is selling poison to kill vermin. Rembrandt portrays the difference in lifestyle, placing a half-door between the tradesman and patron.

Landscape with a Church, c.1640–42, oil on wood, Collection of the Duke of Berwick and Alba, Madrid, Spain, 42 x 60 cm (16½ x 23½in)

Rembrandt created several landscapes in oil on wood panels. His use of a beam of sunlight breaking through the cloudy sky adds a magical touch, as though an onlooker is witnessing the scene at firsthand. The sunbeam lightly touches on several areas of the work; from the distant church to the horseman in the left foreground.

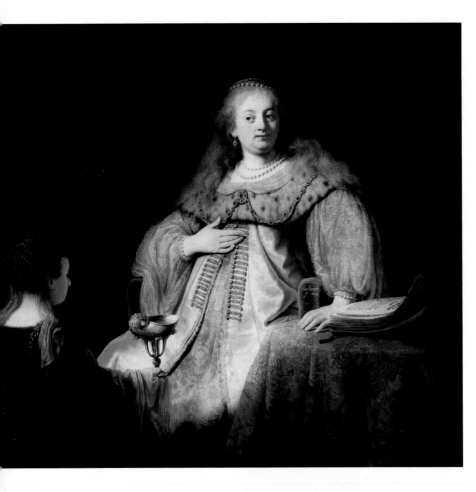

Artemisia, 1634, oil on canvas, Prado, Madrid, Spain, 142 x 152cm (56 x 60in) Signed *Rembrandt f. 1634*

A three-quarter length portrait of the mythological figure of 'Artemesia', wife of King Mausolos, who mixed the ashes of her dead husband with the wine in her cup (*Noctes Atticae* X, 18, 3). She is portrayed wearing sumptuous clothing of silk, brocade and fur. She is assisted by a handmaiden. The composition is similar to the oil-on-canvas paintings, *Flora,* 1635, and *Samson Posing a Riddle to his Wedding Guests,* 1638, both featuring Rembrandt's young wife Saskia von Uylenburg as the central figure.

The Great Jewish Bride, etching with drypoint and burin, 1635, (V states) 21.9 x 16.8cm (8 x 6½in). From the third state signed and dated, *R 1635. Haarlem*

The sitter for the etching is Saskia. Looking sombre, she is seated, and in three-quarter profile looks toward her right and toward the light which highlights her figure and casts a shadow on the wall behind her. She is richly dressed and her long hair is spread over her shoulders. She is possibly depicted as Esther, wife of king Ahasuerus, holding in her left hand an order to slay Jews, which is foiled through her intercession.

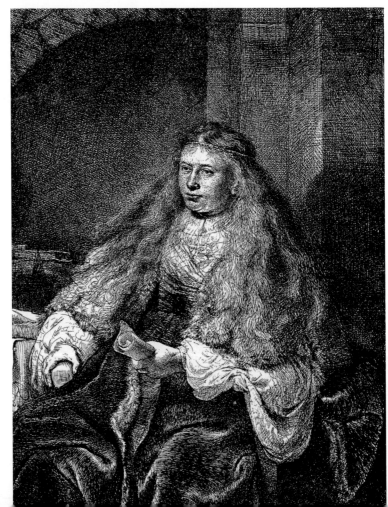

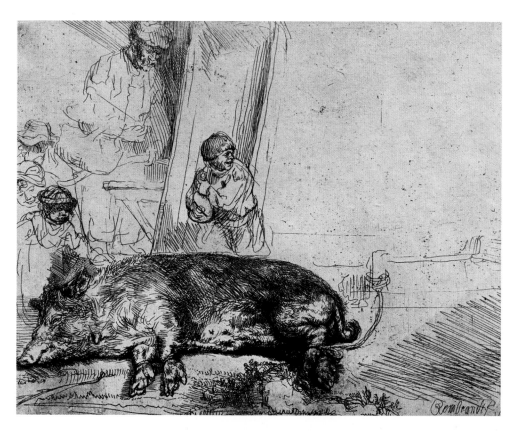

The Hog, 1643, etching and drypoint, Musée de la Ville de Paris, Musée du Petit-Palais, France,
14.5 x 18.4cm (6 x 7in)
Signed and dated *Rembrandt f 1643*

In the foreground, a pig is lying down. Its legs are bound with a rope attached to a post. In the background, a pig butcher is depicted with tools: an axe and a cambrel and a curved yoke. Near the man, a mother and children appear to be excitedly awaiting a spectacle. A family might slaughter their own pig, or use a travelling 'pig butcher'. An alternative title given to the etching is *The Sow*.

Philosopher in Meditation (Scholar in a Room with Winding Stair), c.1631–2, oil on panel, Musée du Louvre, Paris, France,
28 x 34cm (11 x 13½in)
Signed *RHL van Rijn 163*

Opinions differ on the subject matter of this painting. At centre left, a male philosopher or scholar sits near a window, deep in thought. He is seated in a room that has an exposed winding staircase. Light from the window highlights the figure of the man and the structure of the staircase. To the right, an old woman tends the fire. The inclusion of the figure of the woman has led to the possibility that the painting is of the biblical couple, blind Tobit and his wife Anna. The use of *chiaroscuro* superbly highlights the lone figure.

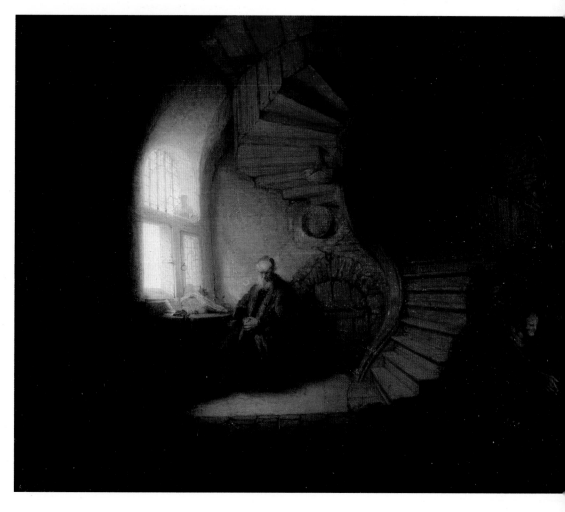

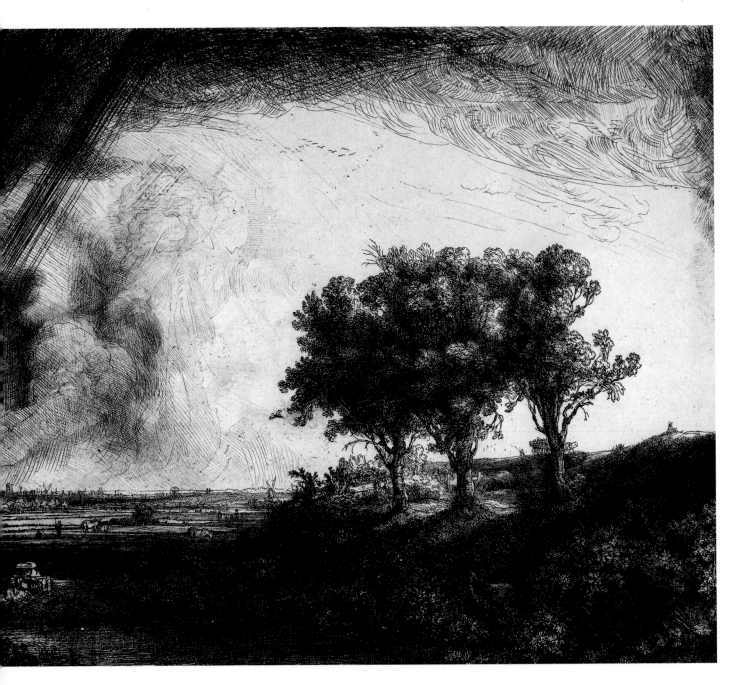

The Three Trees, 1643, etching, Fitzwilliam Museum, University of Cambridge, UK, (K5-292), 20.5 x 27.4cm (8 x 11in)

The composition of *The Three Trees* may be a symbolic interpretation of the three crucifixes of Christ and two thieves on Mount Calvary. However, in this etching Rembrandt adds two couples, who are woven into the landscape setting. To the forefront at the far left a fisherman and his wife are seated on a riverbank. To the forefront at the far right, practically hidden in the lush foliage, is a pair of lovers. The etching is thought to be one of Rembrandt's finest works.

Danaë, 1643, oil on canvas, The State Hermitage Museum, St. Petersburg, Russia, 185 x 203cm (73 x 80in) Signed *Rembrandt f. 16(3)6*

The composition of the painting relates to the later portrait of *Woman in Bed*, c.1645. This work portrays Danaë, the mistress of the god Jupiter. The original painting showed Danaë holding back a curtain with her right hand; later reworked by Rembrandt to take the curtain back to the edge of the painting. Here, above Danaë's head is a manacled bronze figure of Cupid. Danaë lies in a sumptuous canopied bed, with bronze-coloured drapes. She awaits her lover, who appears in the background.

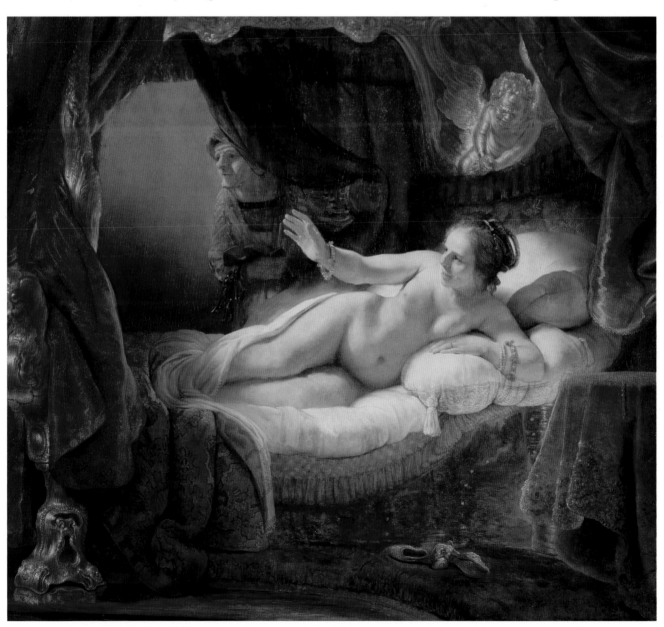

*Lion Resting, c.*1645–50, pen
and brown ink, brown wash,
on paper, Musée du Louvre,
Paris, France,
13.8 x 20.7cm (5½ x 8in)

Rembrandt adeptly uses pen
and brown ink to delineate
the rough fur of the lion's
mane in contrast to the finer
fur on the lion's body.
He portrayed the lion many
times, often in drawings and
etchings of St. Jerome.
Rembrandt may have visited
the zoo to sketch the lion,
and other animals, including
a lioness and an elephant,
which appear in his drawings.

*Cottage on the Outskirts of a
Wood,* 1644, pen, ink and
brown wash on paper,
Metropolitan Museum
of Art,
New York, NY, USA,
29.9 x 45.5cm (12 x 18in)
Signed and dated
Rembrandt f. 1644

In the 1640s, Rembrandt
applied himself to larger
landscape drawings. *Cottage
on the Outskirts of a Wood,*
1644, is the largest extant
landscape drawing that he
created. Rembrandt scholars
consider the vast area
of wash over the drawing
to be an outstanding
example. In addition, the
dating of the work and
Rembrandt's signature not
only add authenticity
but a unique characteristic as
the only landscape drawing
to be signed and dated.

Sketches of an Old Man with a Child, c.1639–40, pen and brown ink with brown wash on paper prepared with pale brown wash, British Museum, London, UK, 18.9 x 15.7cm (7½ x 6in)

In two small sketches, drawn from life, an old man seated, plays with a child on his lap. At his side, his stick is propped against the chair. The small child is standing on the man's knees and in the lower sketch tries to remove the man's hat. In the upper sketch the old man holds the child up in his arms, he is without his cap, which the child has successfully removed.

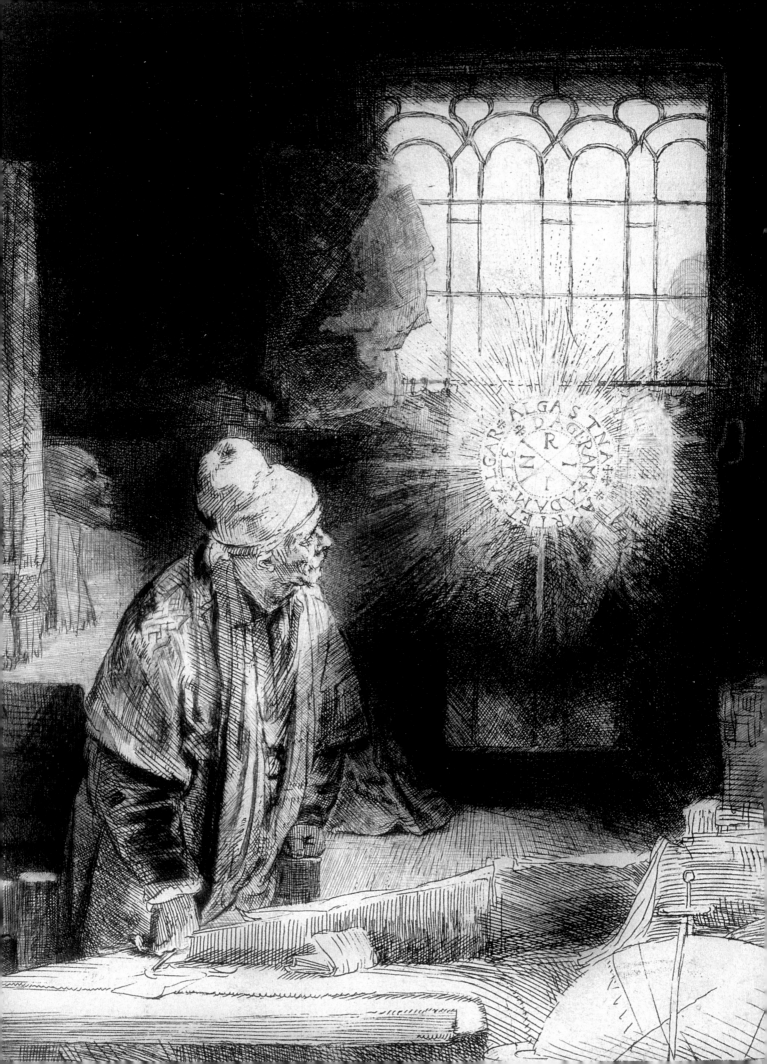

ALGA STNA
DAGIRAM
R
N · X · I
I
ALGAR
ADAM

1649–1669

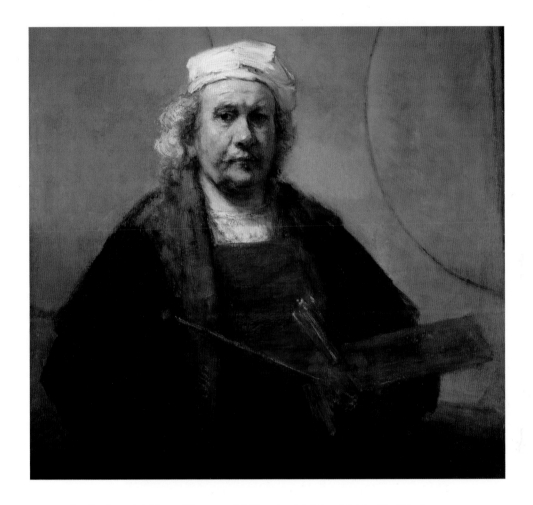

In the late 1640s, a 23-year-old Dutch girl, Hendrickje Stoffels, became
Rembrandt's common-law wife, giving birth to their daughter, Cornelia, in
1654. The happiness that the birth would bring to them was overshadowed
by his insolvency. In spite of his problems, he continued to create remarkable
paintings, bringing royalty to his door. Outstanding paintings from this period
include *Aristotle*, 1653, and the group portrait masterpiece, *The Syndics of the
Drapers' Guild of Amsterdam*, 1662. Up to his death in 1669, he continued to
paint personal portraits of his family and of himself.

*Above: Self Portrait with Two Circles, c.1665–9, (detail of head), oil on canvas. One of the final
self-portraits by Rembrandt, the face is sombre with the eyes directed at the spectator.*

*Left: Dr Faust in his Study, 1652, engraving. Painted in 1652, during a difficult period of his life,
Rembrandt etches a scholar in his study.*

Portrait of an Old Woman,
*c.*1650, oil on canvas,
Pushkin Museum, Moscow,
Russia, 82 x 72cm (32 x
28in) Signed *Rembrandt f*
16...

The portrait is of an
unknown female, seated in
three-quarter profile.
The expressive face of the
woman is powerfully lit
through Rembrandt's
dramatic use of *chiaroscuro*.
The light that captures her
face and hands subtly
highlights the rich textures of
her clothing, and her repose.
She sits in contemplation.
Rembrandt captures the
process of the woman
thinking and achieves great
depth in rendering the inner
spiritual life of his sitter.

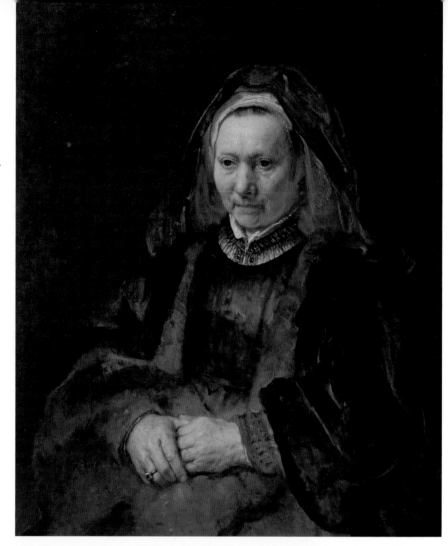

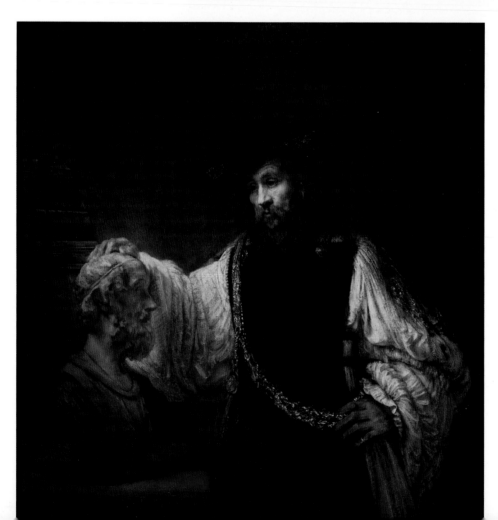

Aristotle with a Bust of
Homer, 1653, oil on canvas,
Metropolitan Museum of
Art, New York, USA,
144 x 137 cm (56½ x 54 in)

The painting, now known as
Aristotle with a Bust of
Homer, was created for a
Sicilian art collector Don
Antonio Ruffo (1610/11–78).
His agent, Giacomo di
Battista, negotiated the
purchase of the work
through Cornelis
Gijsbrechtsz, a prosperous
Amsterdam merchant.
A pendant painting, hoped
for by Ruffo, was not
forthcoming, possibly due
to the long length of time
that Rembrandt took to
complete works. The Italian
artist Guercino (1591–1666),
obliged Ruffo by painting a
pendant portrait of a
cosmographer.

Clement de Jonghe, 1651, etching, drypoint and engraving, (VI states), Musée de la Ville de Paris, Musée du Petit-Palais, France, 20.7 x 16.1cm (8 x 6in). Signed and dated *Rembrandt f. 1651*

The publisher and art dealer Clement de Jonghe (1624/5–79) sold the artist's prints from 1640–79. At his death, his business inventory recorded 74 Rembrandt copper-plates and many prints. In the three-quarter-length portrait, De Jonghe is seated on a tall chair, which lessens his height. The plainness of background and chair focuses attention on the sitter. He wears a large brimmed hat; a jacket and a white collared shirt. A cloak is around his shoulders and he wears gloves.

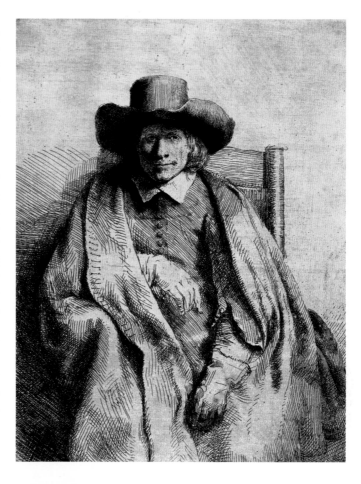

Head of an Old Man, c.1650, oil on canvas, Musée Bonnat, Bayonne, France, 55 x 44cm (22 x 17in)

The familiar nose and soot-black eyes in this three-quarter profile portrait may belong to one of Rembrandt's family members, possibly an older brother. The face looks worn. The eyes stare out to the distance. Rembrandt painted many portrait heads of old men, possibly for sale as tronie artworks, or religious portraits depicting saints and prophets.

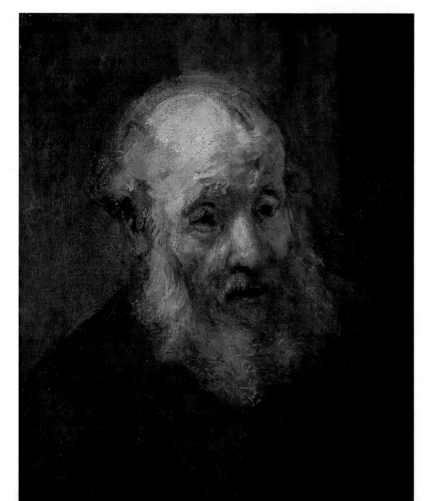

Self-portrait with Cap and Gold Chain, 1654, oil on canvas, Gemäldegalerie Alte Meister, Kassel, Germany, 72.5 x 59.3cm (28½ x 23in) Signed and dated *Rembrandt f. 1654*

A question of attribution hangs over this painting of Rembrandt. However, a previous owner, Valerius Röver (1686–1739), of Delft, the greatest Dutch art collector of the early 18th century, wrote that in his collection was a 'Portrait of Rembrandt… painted by himself in his best period.' The half-length portrait of the sitter, highlights the sombre face of Rembrandt, his soot-black eyes penetrating the gaze of the spectator.

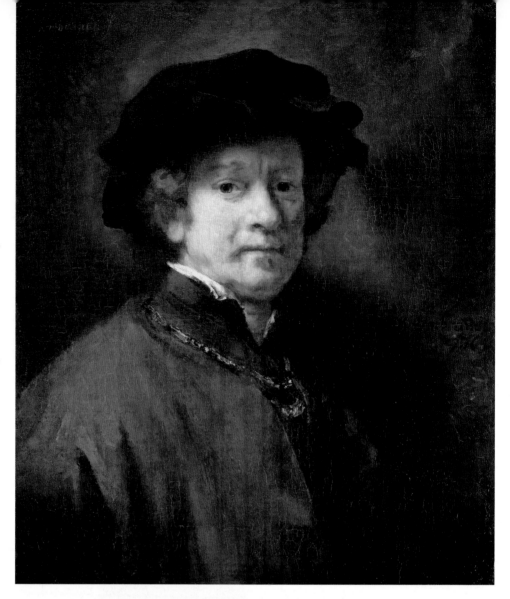

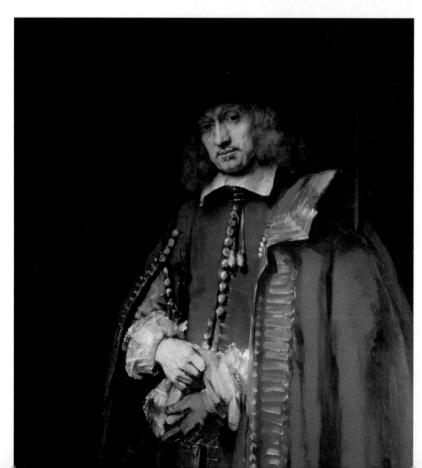

Portrait of Jan Six (1618–1700) 1654, oil on canvas, Private Collection, 112 x 102cm (44 x 40in)

Jan Six looks as though he is about to leave. He adjusts his glove. The head of this prestigious patron is painted carefully, yet Rembrandt applies the paint in broad strokes to create Six's scarlet cloak and dark grey-green jacket. The patron looks pensive, lost in thought. The hat brim shadows his eyes. This was Rembrandt's last work created for Six; their once close friendship had cooled, possibly over an outstanding loan; and the danger was the loss of clients as much as possessions.

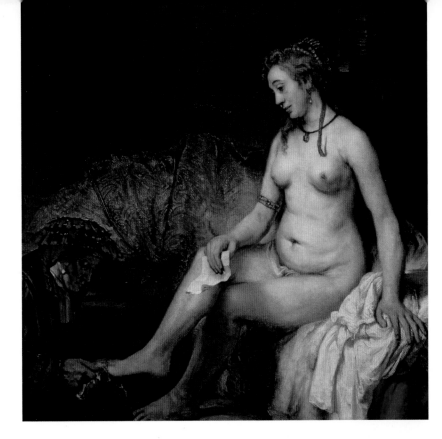

Bathsheba Bathing, 1654, oil on canvas, Louvre, Paris, France
142 x 142cm (56 x 56in)

Little is known about the origins of this masterful painting. Rembrandt creates a serene portrait of his common-law wife, Hendrickje, posing as Bathsheba. The scene depicts a moment from the biblical narrative of King David, (II Samuel: Ch.XI:1-27). Bathsheba is reading a letter from King David. Rembrandt's painting can be read to exude a moral and erotic narrative, highlighting Bathsheba as both a sinner and a victim.

Bathsheba Bathing, 1654, (detail of head and upper body), oil on canvas, Louvre, Paris, France
142 x 142cm (56 x 56in)

The bible narrative (II Samuel: Ch.XI: 1-27), is a tale of eroticism and immorality, which centres on King David, and his desire for Bathsheba, the wife of Uriah, the Hittite, a general in King David's army. The king saw Bathsheba bathing then sent servants to find her. 'She came to him, and he lay with her'. She became pregnant, and after her husband died in battle, she married King David and bore him a son.

Bathsheba Bathing, 1654 (oil on canvas) (detail of letter), Louvre, Paris, France
141 x 142cm (56 x 56in)

Rembrandt captures the moment that Bathsheba reads a letter from king David: a letter that is either a summons to him, or contains news of her husband Uriah's death. This depiction, a popular interpretation of the narrative, does not appear in the bible text, (II Samuel: Ch.XI:1-27). In the painting, Hendrickje portrays Bathsheba. She looks lost in thought. The artist paints her naked, as a beautiful young woman.

Shah Jehan on Horseback Holding a Falcon, c.1655–60, pen and ink and watercolour on paper, Musée du Louvre, Paris, France, 21.9 x 19.2cm (8½ x 7½in)

The sources of Rembrandt's drawings were far-reaching; drawn to Persian prints, he owned works by the artist Reza Abbasi (c.1565–1635) who worked at the court of Shah Abbas of Persia, who was an enthusiastic patron of the Arts. Abbasi is noted for his use of the calligraphic line; it informed Rembrandt's pen and ink drawing of Shah Jehan holding a falcon while out riding.

Woman Bathing in a Stream (Hendrickje Stoffels?), 1654, oil on panel, National Gallery, London, UK, 61.8 x 47 cm (24 x 18½ in)

The signed and dated sketch in oils is possibly a portrayal of one of the biblical characters, Bathsheba or Susanna. The consensus is that the model is Hendrickje Stoffels, Rembrandt's common-law wife. In the year of its creation Hendrickje became pregnant with her first child, born in October 1654. She endured the wrath of the church council the same year, when she was accused of living in sin with Rembrandt. The artist portrays her as he sees her; a beautiful woman, her opulent dress discarded behind her, looking at her reflection in the water as she lifts her chemise to bathe.

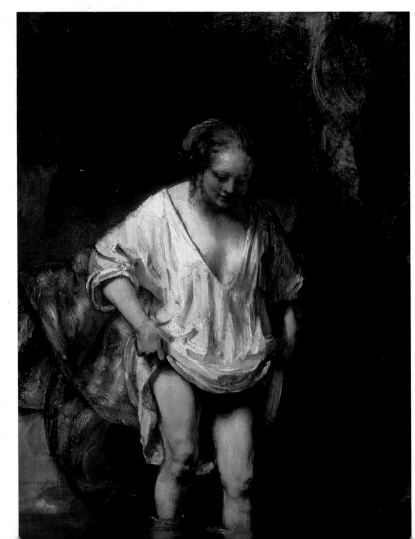

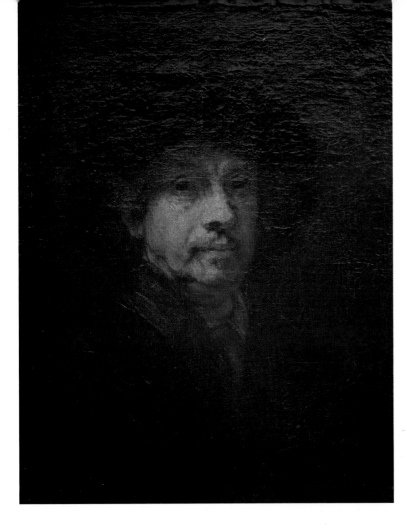

Self-portrait, c.1655, oil on board, Galleria degli Uffizi, Florence, Italy,
76 x 61cm (30 x 24in)

The portrait, painted over an earlier 'still life' is similar to *Self-portrait, c.1655*, except for the three-quarter profile composition. In this portrait, the use of *chiaroscuro* highlights Rembrandt's facial features, particularly the facial sagging of the skin on the jaw line, an indicator of ageing. The painting was, for many years, thought to be a copy. Recent examination and cleaning has confirmed it to be a genuine Rembrandt.

Beggars on the Doorstep of a House, 1648, etching, drypoint and burin, Musée de la Ville de Paris, Musée du Petit-Palais, France,
16.6 x 12.9cm (6½ x 5in)
Signed and dated lower right *Rembrandt f.1648*

At the entrance to a house, a man playing a hurdy-gurdy (a stringed violin-like instrument), a young boy, and a woman with a baby on her back, stand receiving alms from a well-dressed gentleman who passes money across the half-door threshold. The visitors are beggars. Rembrandt made many sketches of the poor, including beggars. What draws attention to this etching is the detail, from the exemplary back view figure of the young boy, to the fist-clenching gestures of the tiny baby.

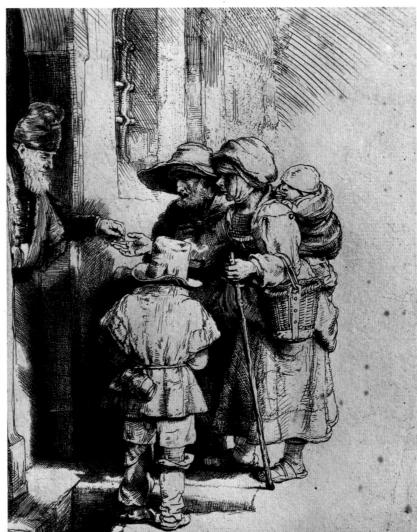

Hendrickje Stoffels as 'Flora', c.1650s, oil on canvas, Metropolitan Museum of Art, New York, NY, USA, 100 x 92cm (39 x 36in)

This is a quite different portrayal of Hendrickje Stoffels, as Flora, the Roman goddess of spring, of fertility and flowers, in comparison to two earlier portraits of his wife Saskia: *Saskia as Flora*, 1634, and *Saskia van Uylenburgh in Arcadian Costume*, 1634. Hendrickje, with head in profile, looks serious; her costume is simple, it is a contemporary 'Flora'.

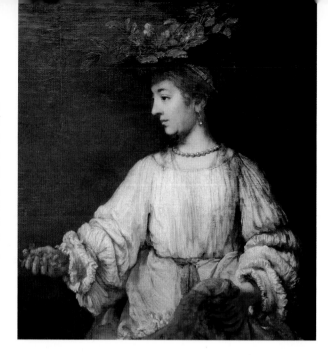

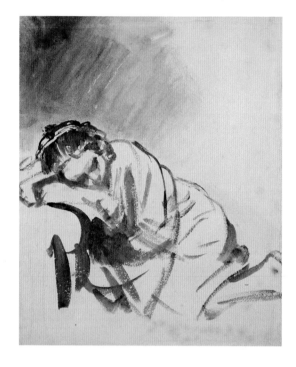

A Young Woman Sleeping (Hendrickje Stoffels) c.1654–5, brush and brown wash with white gouache on paper, British Museum, London, UK, 24.6 x 20.3cm (10 x 8in)

Rembrandt sparingly uses his brush to capture the young woman asleep. She is temporarily resting her head for a short nap, possibly on the arm of a sofa. Her knees are tucked up to allow her feet to rest on the furniture. The thick brush strokes outline her youthful body and her head, which rests on her crooked arm. Rembrandt shows his genius for capturing a moment in time, and the atmosphere and characteristics of the young woman, who is possibly Hendrickje Stoffels, his common-law wife.

Thomas Jacobsz. Haringh, c.1655–6, (II states), etching with drypoint and burin, Musée de la Ville de Paris, Musée du Petit-Palais, France, 19.5 x 14.9cm (8 x 6in)

Thomas Jacobsz. Haringh (c.1586/7–1660), was the concierge of Amsterdam Town Hall. He was in charge of the sale of goods from Rembrandt's insolvency in 1656. Rembrandt tried to sell some of his possessions by auction in the period from 25 December 1655 to January 1656, in a sale in the Kiezerskroon Inn in Kalverstraat, Amsterdam.

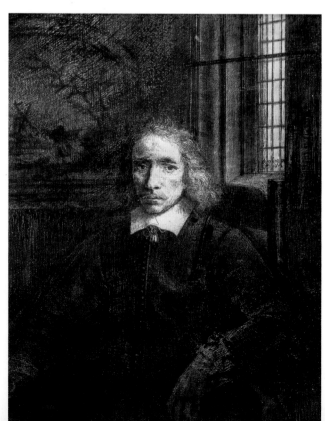

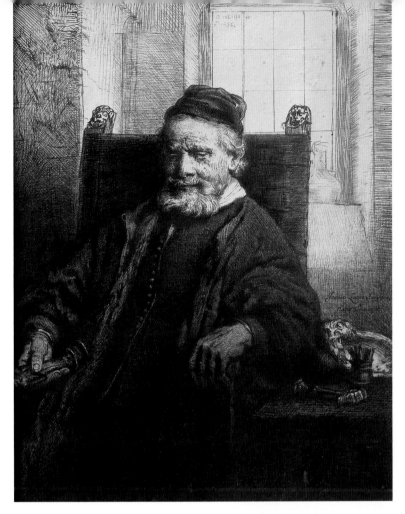

Jean Lutma, 1656, etching and drypoint (II states, with burin in second state), Musée de la Ville de Paris, Musée du Petit-Palais, France, 19.6 x 15cm (8 x 6in). Signed and dated upper left, *Rembrandt f, 1656*

Rembrandt poses Jan Lutma (*c*.1584–1669), seated. He looks toward the spectator. The tools of his silversmith trade, a pot and a hammer are on a table next to him. In his right hand Lutma holds a small silver statuette or candlestick. On the table is a beautiful silver drinking bowl, created by Lutma, who was a silversmith in Amsterdam since 1621. The etching has two states, one with a window, and one without.

*Portrait of Hendrickje Stoffels with a Velvet Beret, c.*1654, oil on canvas, Musée du Louvre, Paris, France, 74 x 61cm (29 x 24in)

A tender portrayal, in the Venetian style, of Rembrandt's common-law wife, Hendrickje, painted when she was about 20 years of age. The half-length portrait, possibly a pendant to Rembrandt's half-length *Self Portrait with Cap and Gold Chain*, 1654, portrays her as a beautiful young woman. She is adorned with rich furs and jewellery. A small velvet cap is worn on her head.

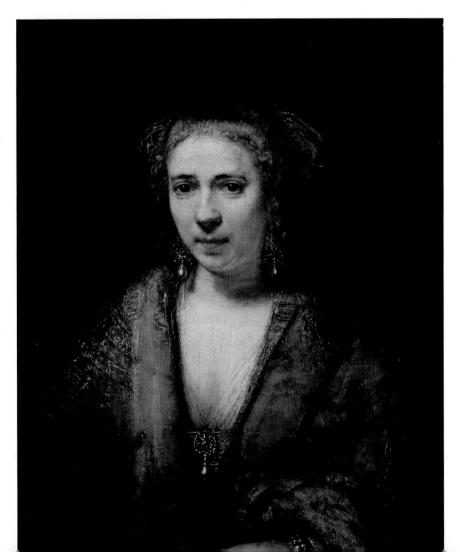

The Standard Bearer, 1654,
oil on canvas, Metropolitan
Museum of Modern Art,
New York,
138 x 113cm (54 x 44½in)
Signed *Rembrandt f. 1654*

The portrait is of the
standard bearer Floris Soop
(1604–57). He is dressed in
the regalia of an ensign in
the civic guard, with its
attributions: a flag he carries,
a fabulous plumed hat and a
sword belt. Soop was a
noted art collector and it is
fitting that Rembrandt would
paint him. However,
attribution to the artist has
wavered in the past. Another
noted collector of art, the
English painter Sir Joshua
Reynolds (1723–92), owned
the painting in the
18th century.

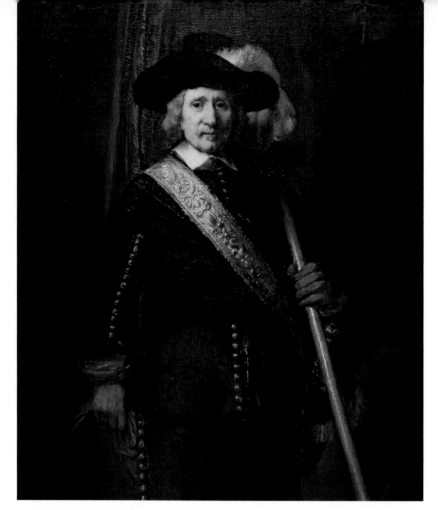

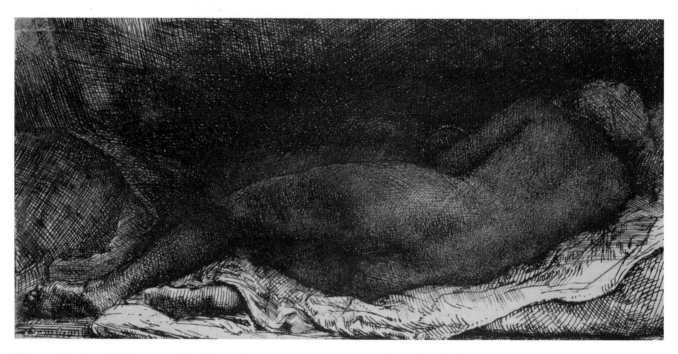

Woman Lying on a Bed,
1658, (III states), etching,
drypoint and burin with
surface tone, Fitzwilliam
Museum, University of
Cambridge, UK,
8 x 15.9cm (3 x 6in)
Signed *Rembrandt f. 1658*

The figure of a woman
is depicted lying down
on bedding with a sheet
beneath her. She has
her back to the viewer.
The horizontal layout
accentuates the curves of
her figure. Rembrandt

created several nude figure
studies as etchings and
drawings. For example he
produced *Jupiter and
Antiope, c.*1659, which was
an etching; and *Reclining
Nude c.*1658, in pen and
brush with wash.

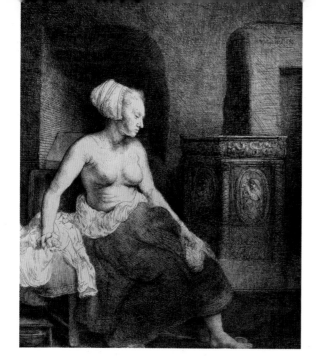

Woman Sitting Half-Dressed Beside a Stove, 1658, etching with drypoint and burin, (VII states), Fitzwilliam Museum, University of Cambridge, UK, 22.8 x 18.4cm (9 x 7in) Dated *Rembrandt f. 1658*

The etching shows a domestic interior typical in 17th-century Netherlands.

The cast iron stove bears the initials 'MM', a possible allusion to the prostitute Mary Magdalene. The figure sits half-dressed; the light spreads across her upper body, to highlight her naked torso and the blouse removed to the waist. Her foot rests on a slipper. In art, the slipper was an allegory for female genital organs.

Portrait of Catherine Hoogsaet (detail of head), 1657, oil on canvas, Penrhyn Castle, Bangor, Wales, UK, 126 x 98.5cm (50 x 39in) Signed *Catrina Hoog/Saet.out 50/Jaer. Rembrandt f. 1657*

The full-length portrait of a lady seated in three-quarter profile, is that of Catherine Hoogsaet, the wife of the Mennonite Hendrick Jacobsz.Hooleeuw. The detail shows the head of Catherine. She wears a delicate and intricately designed head cap, held in place with large ornate hair clips, which were a fashionable accessory among Amsterdam ladies at that time.

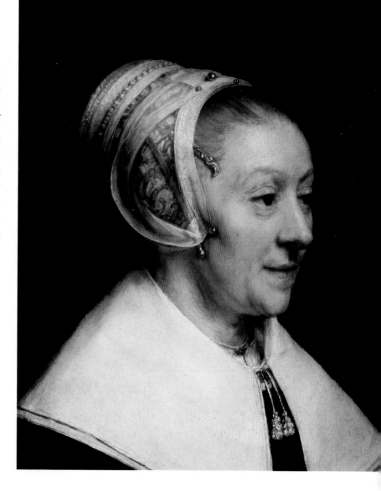

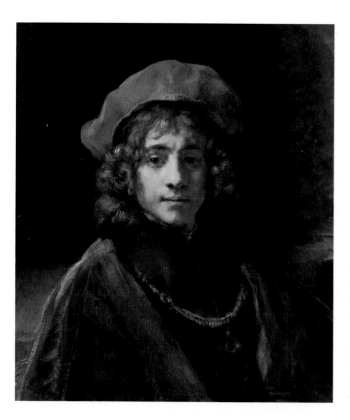

Titus, the Artist's Son, c.1657, oil on canvas, Wallace Collection, London, UK, 68.5 x 57 cm (27 x 22½ in) Signed *R*

A half-length portrait of Titus, the second son of Saskia and Rembrandt, and their only child to survive infancy. Rembrandt uses earthy brown colours and loose brushstrokes to paint an impression of the dark jacket and overcoat that Titus wears. The deep-red tones of the soft cap on his head are carried through to curly strands of the young man's hair and on his lips.

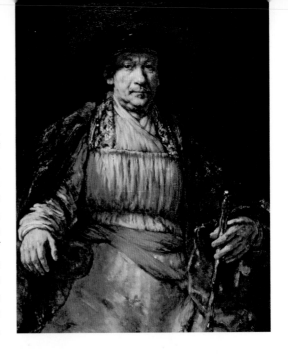

Self-portrait, 1658, oil on canvas, Frick Collection, New York, NY, USA, 131 x 102cm (52 x 40in) Signed *Rembran... f. 1658*

A superb life-size self-portrait that intimately reveals the character of the artist. He is seated and directly faces the viewer. The expression in his eyes reveals a cool observation of the onlooker.

The painting is in the grand manner, reflected in his rich clothing, which is of 16th-century Venetian origin, plus oriental accessories, all possibly part of his collection of costumes. In his left hand he holds a cane. The opulent use of jewel-like colours and the style and composition of the painting are informed by the artworks of the Venetian artist Titian (c.1490–1576).

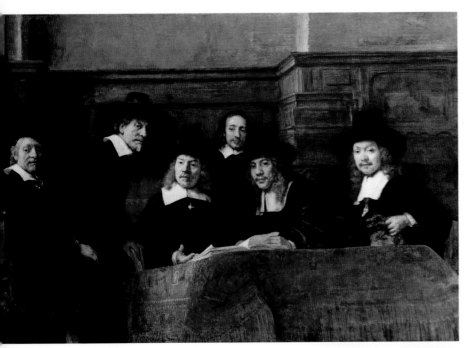

Syndics of the Draper's Guild, ('De Staalmeesters'), 1662, oil on canvas, Rijksmuseum, Amsterdam, 19.1 x 27.9cm (7½ x 11in) Signed *Rembrandt f. 1662*

In a group portrait are five sampling officials of the Draper's Guild. According to a Dutch source (1765), *staalmeesters* were cloth sampling officials who controlled the quality of dyed cloths for sale, and kept samples of the cloth for their records. The painting is considered by many art historians to be Rembrandt's finest group portrait.

Portrait of a Young Man, 1658, oil on canvas, Musée du Louvre, Paris, France 75 x 60.5cm (29½ x 24in) Signed *Rembrandt f. 1658*

The painting is attributed to Rembrandt with reservations. The painting may have been added to by a pupil, or the artist may have painted over a pupil's canvas. The under-painting is not by Rembrandt's hand. The half-length portrait reveals an unknown sitter.

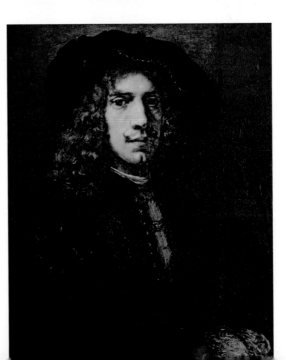

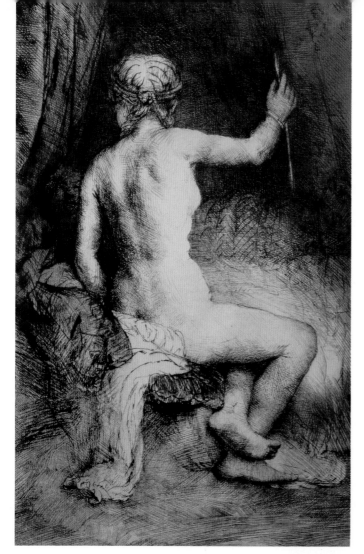

Nude with Arrow (Venus and Cupid) 1661, etching, Rijksmuseum, Amsterdam, The Netherlands, 20.5 x 12.3cm (8 x 5in)

One of a series of nudes produced in the last decade of Rembrandt's life, this work was most probably part of a life-drawing class for his pupils. The female sitter, drawn from life, sits on the edge of a draped bed with her back to the spectator. The softness of her skin is contrasted with the crisp clothing which lies on the bed. The nude, originally holding on to a rope, is transformed into Venus by the addition of an arrow in her right hand. The pose accentuates the litheness of her figure. The small face appearing in the background left is probably intended to be Cupid.

Portrait of the Artist at his Easel, 1660, oil on canvas, Musée du Louvre, Paris, France, 111 x 90cm (44 x 35½in) Signed *Rem…/ f. 1660*

The first of several self-portraits, dating from 1660 that depict the artist with the tools of his profession. With his body in three-quarter profile, he looks toward the viewer. He is seated in a chair in front of his easel. As if interrupted momentarily from his work, he holds a palette with blobs of paint, and his paintbrushes and maul stick. Rembrandt originally painted himself wearing a flat black cap – just visible in the underpainting – before changing it to a regular white cap.

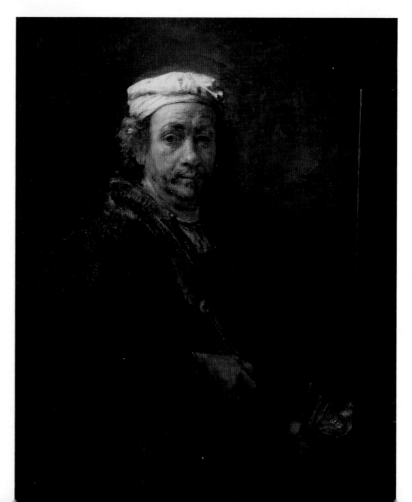

Portrait of Frederik Rihel on Horseback, 1663, oil on canvas, National Gallery, London, UK, 294.5 x 241cm (116 x 95in)

The full length, life-size equestrian portrait of Frederik Reyel (1621–81), a Lutheran merchant of Amsterdam, is a remarkable painting. It is one of only two known Dutch equestrian portraits from this period. Although Rihel originated from Strasbourg, he was known to be in Amsterdam from 1642. He was a prominent member of the civic guard. He wears a striking costume, with sash, sword and pistol. His horse, with front legs raised, performs a levade. In the background a procession of men can be seen.

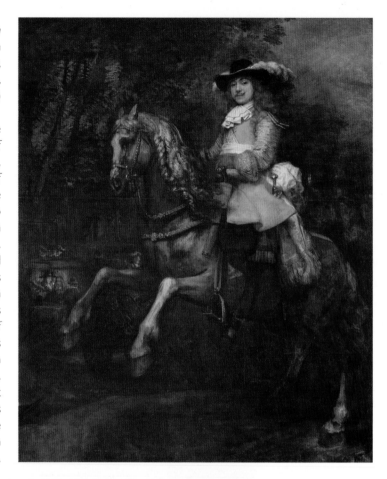

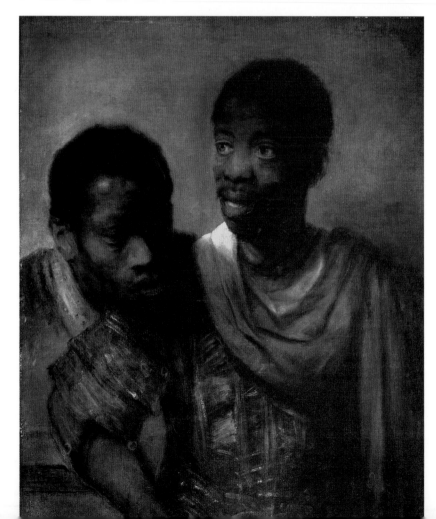

Two Moors 1661, oil on canvas, Mauritshuis, The Hague, The Netherlands , 77.8 x 64.4 cm (31 x 25½in) Signed *Rembrandt f.* 1661

Rembrandt's insolvency inventory of 1656 mentions a painting 'no.344 two Moors in one picture', leading some art historians to consider the date of the work to be earlier than 1661, with the conclusion that the work was unfinished in 1656 and completed in 1661. However, apart from the title there is nothing evident in the painting to confirm it to be the 1656 painting.

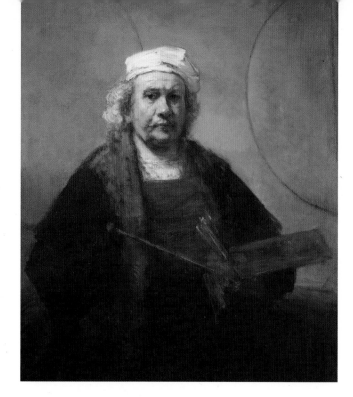

Self-portrait with Two Circles, c.1665–9, oil on canvas, The Iveagh Bequest, Kenwood House, London, UK, 114.3 x 94cm (45 x 37in)

A superb self-portrait of the artist, created in the last years of his life. He stands, looking out toward the viewer, holding the tools of his profession in his hands. On his head he wears a painter's cap and he is dressed in working clothes. The significance of the two circles in the background continues to cause debate. The circles were possibly part of the room decoration in his studio, drawn by him.

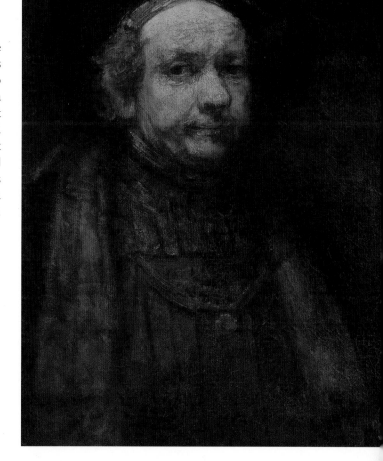

Self-portrait, c.1664–9, oil on canvas, Galleria degli Uffizi, Florence, Italy, 74 x 55cm (29 x 22in)

The painting is listed in the 1663–71 inventory of the Medici family in Florence. Cosimo de' Medici had visited Amsterdam in December 1667. Part of his itinerary included visiting the studios of respected artists to acquire paintings. Cosimo recorded in his travel diary a visit on 29 December a visit to 'Rembrant pittore famoso'. On the first visit Rembrandt had nothing in a finished state. It is possible that this portrait was obtained on a second visit in June 1669.

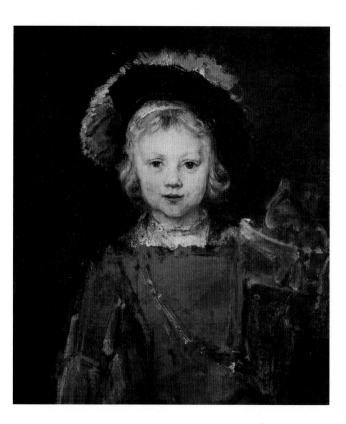

Young Boy in Fancy Dress, c.1660, oil on canvas, Norton Simon Collection, Pasadena, CA, USA, 64.8 x 56cm (25½ x 22in)

For many years it has been suggested that this portrait of a young boy depicts Titus, the son of Rembrandt. It has not been proven. The figure of the boy fills the picture space of the half-length portrait. He faces forward and looks at the viewer. His clothes are made of rich fabrics, and on his head he wears a beautiful hat.

A Man Embracing a Woman (The Jewish Bride), c.1665–7, oil on canvas, Rijksmuseum, Amsterdam, The Netherlands, 121.5 x 155.5cm (48 x 61in) Signed *Rembrandt f. 16…*

One of Rembrandt's final portraits is perhaps his most beautiful. He portrays a young couple dressed in fine clothes. The colours of his palette infuse warm tones of rich red and shimmering gold. The man embraces the young woman, gently holding her close. She lightly places her left hand over his right hand, which is at her breast. Rembrandt captures the couple's gestures of tenderness to each other.

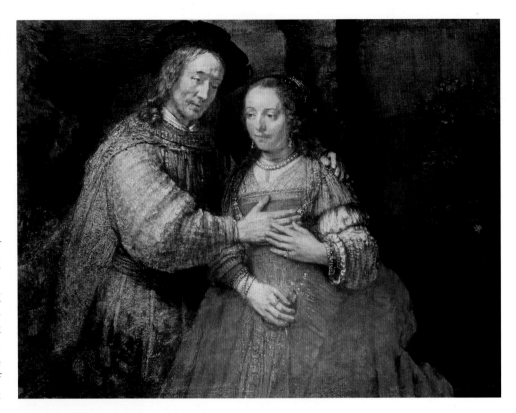

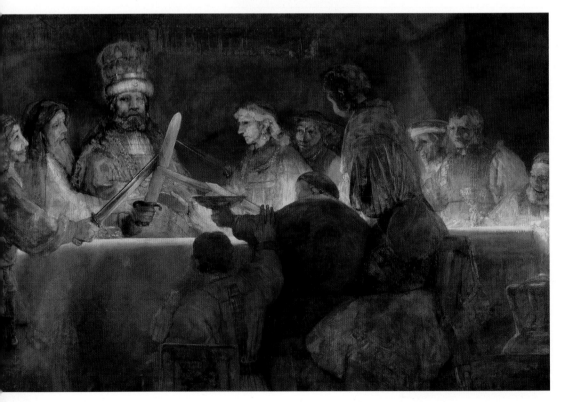

The Conspiracy of the Batavians under Claudius Civilis, c.1661–2, (detail), oil on canvas, Nationalmuseum, Stockholm, Sweden, 196 x 309 cm (77 x 122in)

The composition of Rembrandt's large historical painting *The Conspiracy of Claudius Civilis* was cut down in size from 580cm (228in), after the content had not met the approval of town councillors. He painted a visualization of an oath-taking by Claudius Civilis and Batavian leaders in AD69–70, united in revolt against the Romans. The commissioners compared this battle to the Dutch uprising against Philip II of Spain in 1568.

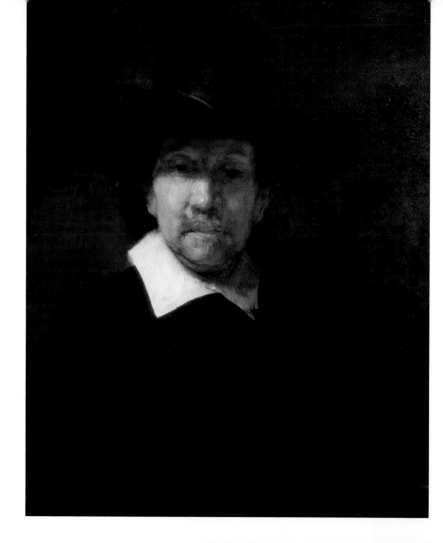

Portrait of the Poet Jeremias de Dekker, 1666, oil on wood, The State Hermitage Museum, St Petersburg, Russia, 71 x 56cm (28 x 22in) Signed *Rembrandt f. 1666*

The portrait of the poet Jeremias de Dekker (c.1610–66), was created in 1666. He was a great admirer of Rembrandt and wrote a poem 'To the excellent and world-famous Rembrandt van Rijn', to thank the artist for the work: '…Oh if I could reward your art with art, in place of gold/ and portray you as masterfully in my paper verse, as you drew me on a piece of wood/ I would not describe your face, mister Rembrandt, but your able mind…'.

*Family Group, c.*1666–8, oil on canvas, Herzog Anton Ulrich Museum, Brunswick, Germany, 126 x 127cm (49.6 x 50in) Signed *Rembrandt f*

The composition of *Family Group* portrays a man, his wife and three young children. Rembrandt creates a visually rich portrait in a luxuriant use of opulent colours such as red, green and gold. The use of loose brushstrokes across the canvas is far removed from the careful application and monotone austerity of his earlier portraits of couples in the 1630s.

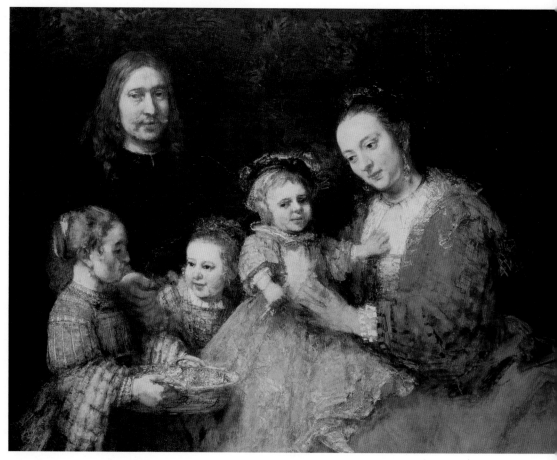

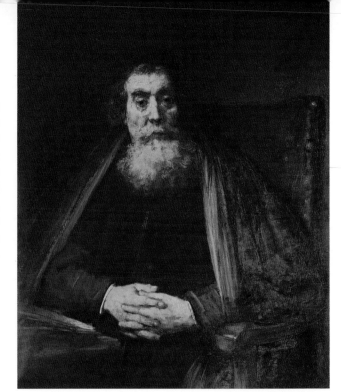

Portrait of an Old Man in an Armchair, c.1660, Galleria degli Uffizi, Florence, Italy, 102 x 73 cm (40 x 29 in) Signed Rembrandt f. 166

A powerful three-quarter-length painting of an unknown man seated in a high-backed chair.

His right arm rests on a table and his hands are clasped together. He looks beyond the spectator, as if in thought. The refined features of the man's face and dark hair on his head, contrast with the snowy white moustache and thick fluffy beard.

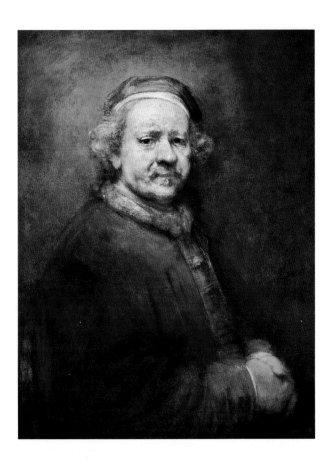

Self-portrait at the Age of 63, 1669, oil on canvas, National Gallery, London, UK, 86 x 70.5cm (34 x 28in) Signed at lower left ...t. f /1669

At least three self-portraits can be dated to Rembrandt's final year. In *Self-portrait at the age of 63*, the artist looks composed and in a pleasant mood. He paints himself in three-quarter profile looking toward the viewer. He wears a doublet with a fur collar. His hands are gently clasped together. The colour-scheme is a fusion of rich reds in lighter and darker tones. Light shines onto his face to highlight the brow, nose and mouth. X-rays of the painting show that he changed the design many times: from wearing a white collar, to holding in his right hand a thin stick-like object, most probably a paintbrush.

Self-portrait, 1669, oil on canvas, Mauritshuis, The Hague, The Netherlands, 63.5 x 57.8cm (25 x 23in)

This last work was created in Rembrandt's final year. The portrait bust is three-quarter profile, a favourite composition. Rembrandt portrays his face half lit. Light pours from above onto his right cheek, it highlights a tired gaze, bulbous nose and lengthening jowls. The light also captures the bright colours of Rembrandt's turban, which is painted with loose brushstrokes. X-rays of the painting show the turban to have been the painter's white cap, worn by Rembrandt in other portraits. Here he has disguised it as an elegant piece of headwear.

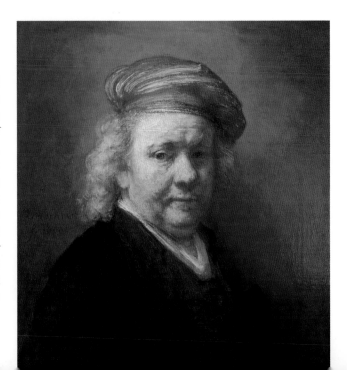

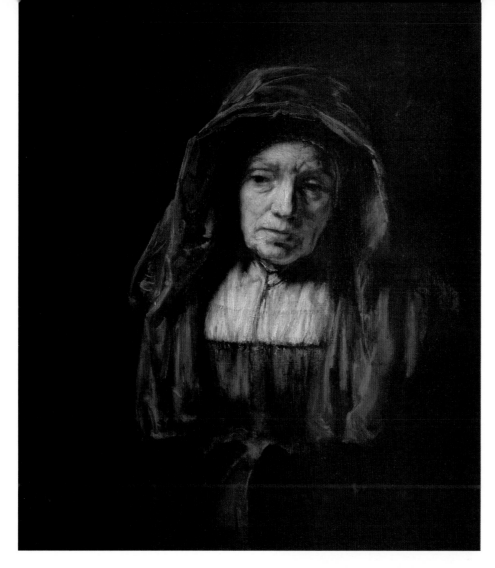

Portrait of an Old Woman,
1654, oil on canvas, Pushkin
Museum, Moscow, Russia,
74 x 63cm (29 x 25in)
Signed *Rembrandt f. 1654*

This painting is considered by
the greatly respected Dutch
art historian, Abraham
Bredius (1855–1946),
a scholar of Rembrandt,
and author of Rembrandt:
the *Complete Edition of the
Paintings,* to be 'one of
the finest of Rembrandt's
studies of old women'.

Portrait of an Old Man, 1667,
oil on canvas, Mauritshuis,
The Hague,
The Netherlands,
78.7 x 66cm (31 x 26in)
Signed *Rembrandt f. 1667*

Rembrandt portrays a man
seated in a chair. The sitter's
hands grip the armrests of
the chair. His brimmed hat is
at a jaunty angle and
he wears his collar undone.
The face is bloated and
shows its age, but the eyes
are bright and fix the
attention of the viewer.
The composition of the
work is similar to another
portrait commissioned the
same year, *Portrait of a Fair-
Haired Man,* 1667.

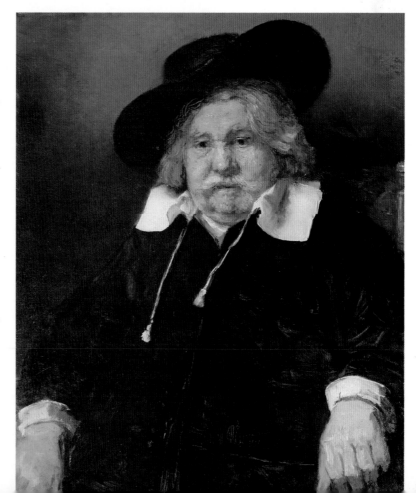

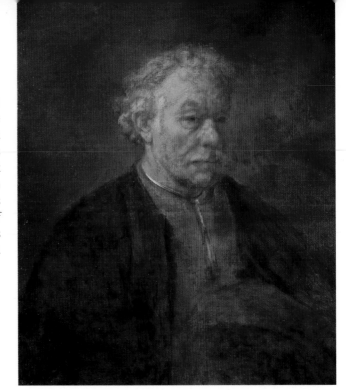

Study of an Old Man, 1650, oil on canvas, Mauritshuis, The Hague, The Netherlands, 80.5 x 66.5cm (32 x 26in) Signed *Rembrandt f. 1650*

Attributed to Rembrandt, the portrait bust depicts an elderly man in three-quarter profile, a composition favoured by the artist. The work was thought to be a portrait of Rembrandt's brother, Adriaen, but scant evidence remains to confirm it. The loose brushstrokes and thickly applied paint of Rembrandt's later style is apparent in this work.

Self-portrait Full-length, c.1650–4, pen and brown ink on brown paper, Museum Het Rembrandthuis, Amsterdam, The Netherlands, 20.3 x 13.4cm (8 x 5in)

The artist depicts himself full-length, wearing a belted coat with three-quarter sleeves, and hard-top hat. He stands in a frontal pose, with his hands on his hip, and legs astride, looking directly toward the viewer. An inscription, not in Rembrandt's hand, reads 'drawn by Rembrandt van Rijn after his own image/as he used to dress in his studio'. It is attached on a separate piece of paper.

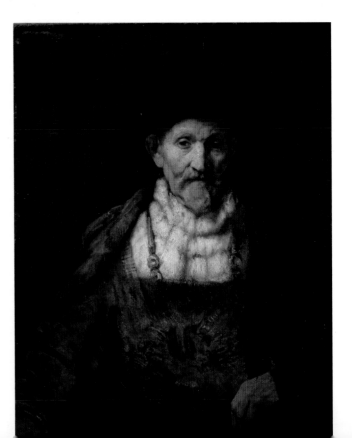

An Old Man in Fanciful Costume, 1651, oil on canvas, Chatsworth House, Derbyshire, UK, 78 x 66cm (31 x 26in) Signed *Rembrandt f. 1651*

Attributed to Rembrandt with reservations that the work might have been aided by one of his assistants or pupils. In the half-length portrait of an unknown man, the sitter fills the picture space. He is seated in an armchair and looks directly toward the viewer. He wears a large floppy hat and the pointed shape of his short beard emphasizes the contours of his cheeks and chin. He is attired in robes that reflect affluence.

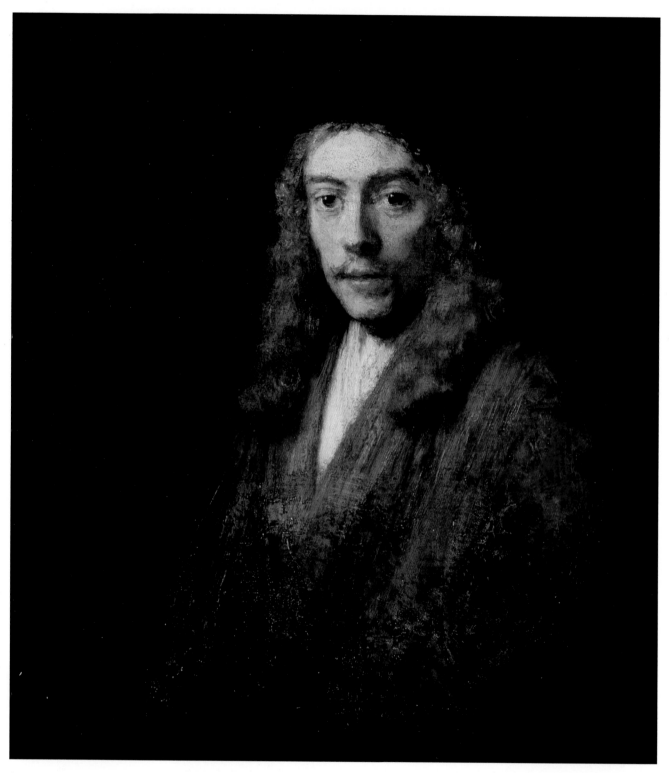

A Young Man, perhaps the Artist's Son Titus, c.1663, oil on canvas, Dulwich Picture Gallery, London, UK, 78.6 x 64.2cm (31 x 25in)

The attribution of the half-length portrait to Rembrandt is considered correct by some Rembrandt scholars, although not all. In addition, some historians think the portrait to be a depiction of the artist's son, Titus. The painting portrays a young man with wide expressive eyes and long hair, who looks earnestly toward the viewer. If it is Titus, he was painted in the year that Hendrickje Stoffels died, leaving him in sole charge of the company that he and Hendrickje created when Rembrandt became insolvent, which was a ploy to manage Rembrandt's artistic career after his enforced bankruptcy.

An Old Man in Red, c.1654,
oil on canvas, The State
Hermitage Museum,
St. Petersburg, Russia,
106 x 86cm (42 x 34in)
Signed *Rembrandt f.*
[no date]

Attributed to Rembrandt
with reservations voiced by
some Rembrandt scholars.
The portrait depicts an
elderly man seated in a high-
back armchair, looking
toward the onlooker. He
clasps his hands together, a
favoured pose by the artist.
The rich red of his doublet
highlights his snow-white
beard. The artist's use of
chiaroscuro focuses attention
on the lined face of the sitter
and his heavily veined hands.

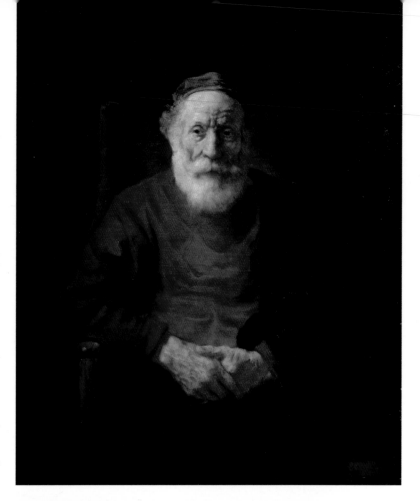

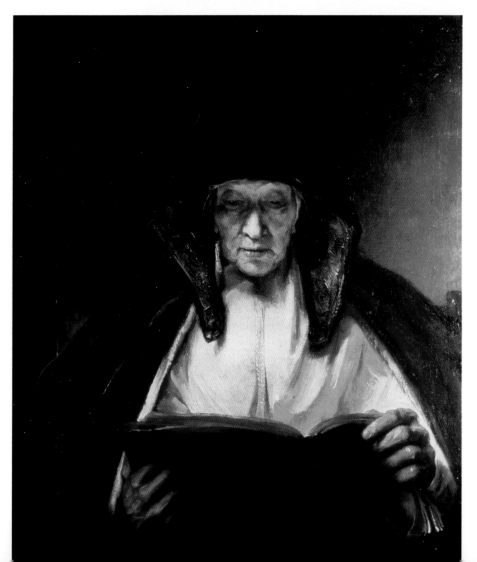

Old Woman Reading, 1655,
oil on canvas, Duke of
Buccleuch Collection,
Drumlanrig, Scotland, UK,
79 x 65cm (31 x 26in)
Signed *Rembrandt f. 1655*

The composition of this
painting, a half-length
portrait of a woman holding
open a large book and
reading from its pages, allows
her face to be bathed in
light as if the source of light
was the book's pages, a
symbolical association with
the reading of the scriptures.
The hooded headcap she
wears focuses attention on
her face and the act of her
reading, as if capturing a
moment in time.

Woman Asleep at a Window, c.1655, pen and brown ink on paper, brown wash with white watercolour, Nationalmuseum, Stockholm, Sweden, 16.3 x 17.5cm (6½ x 7in)

Sunlight streams onto the figure of the young woman at the window, she leans on the sill to take in the air. She has her eyes closed, possibly resting, or asleep. Utilizing a few strokes of his reed pen Rembrandt captures the character of the young woman and her facial features in repose.
In addition, he leaves the face and exposed arm unaltered, to highlight the strength of the sunrays.

Portrait of an Old Jew, 1654, oil on canvas, The State Hermitage Museum, St. Petersburg, Russia, 109 x 85cm (43 x 33½in) Signed *Rembrandt f. 1654*

In this half-length portrait, the patron is seated in an armchair. An unseen light source directs attention to the expressive facial features of the old man, and his veined hands, which are clasped together in his lap. The portrait is a companion painting to *Portrait of an Old Woman,* 1654; they were most probably pendants portraits of a husband and wife.

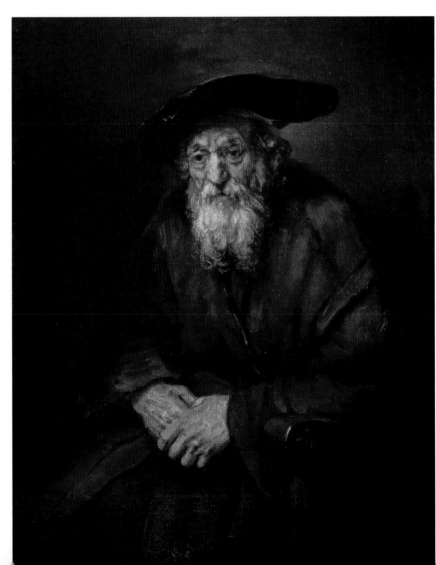

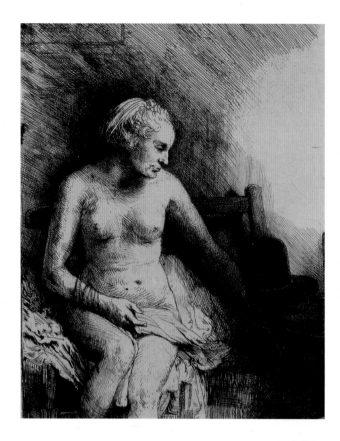

Woman at the Bath, with a Hat Beside Her, 1658, etching with drypoint and burin (II states), Private Collection, 15.5 x 12.9cm (6 x 5in)

There is nothing evident to show that the woman is bathing. Rembrandt used props from his studio to arrange the model, using the same young woman as *Young Woman Bathing her Feet at a Brook*, 1658. In the second state of the etching the style of the model's hat changed to a turban shape. One impression of this second state has the words *Voor't Chirurg*, which is a possible reference to the Surgeons' Guild, Amsterdam.

Young Woman Bathing her Feet at a Brook, 1658, etching with drypoint and burin, (only state), Fitzwilliam Museum, University of Cambridge, UK, 15.9 x 7.8cm (6 x 3in) Signed Rembrandt f. 1658

Possibly printed on Chinese paper. The etching's title alludes to an outdoor scene of a naked young woman bathing her feet in a small stream. A closer look, however, reveals content to show that the model was posed in a studio seated on a chair with a cushion. The composition of the scene compares to the etching *Woman Sitting Half-dressed by a Stove*, 1658. Rembrandt's use of heavy cross-hatching in the background highlights the nakedness of the woman's body.

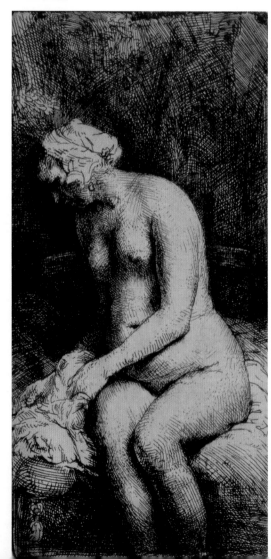

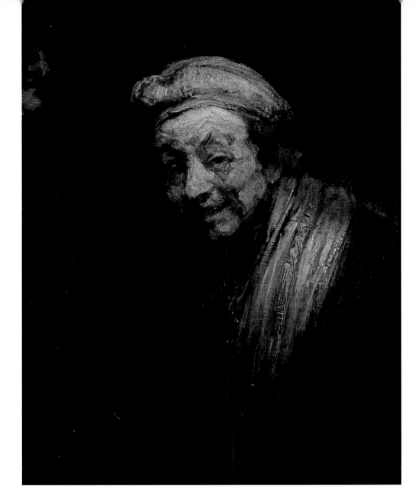

Self-portrait, c.1668–9, oil on panel, Wallraf-Richartz Museum, Cologne, Germany, 82.5 x 65cm (32½ x 25½in)

One of the last self-portraits, and considered to be Rembrandt in the role of the ancient Greek painter, Zeuxis (5th century BC), who was praised for his superb skills and noted for his sense of humour. Rembrandt portrays himself smiling in good humour. In the three-quarter profile composition, he is attired in his workwear with his head bent forward to look out toward the viewer. He holds a paintbrush in his right hand, which originally touched the herm sculpture, pictured to the left.

The Emperor Timur (1336–1405) on his Throne, (after an Indian miniature), c.1655–60, pen and ink and wash on Japanese paper, Musée du Louvre, Paris, France, 18.6 x 18.7cm (7 x 7½in)

Rembrandt created many drawings loosely copied from 17th-century Indian Moghal miniatures. In this work, the Emperor Timur (1336–1405), sits on his throne, holding court. At his feet, courtiers or visitors kneel in abeyance and listen to him speak. In the 1656 inventory of Rembrandt's possessions, a book of drawings was described as 'filled with curious drawings in miniature...' a possible reference to his sheets of drawings of Indian miniatures.

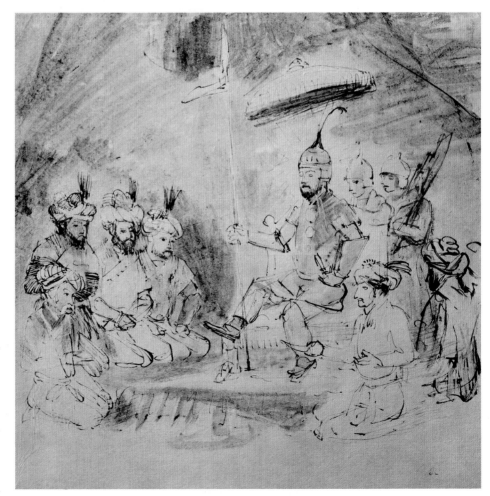

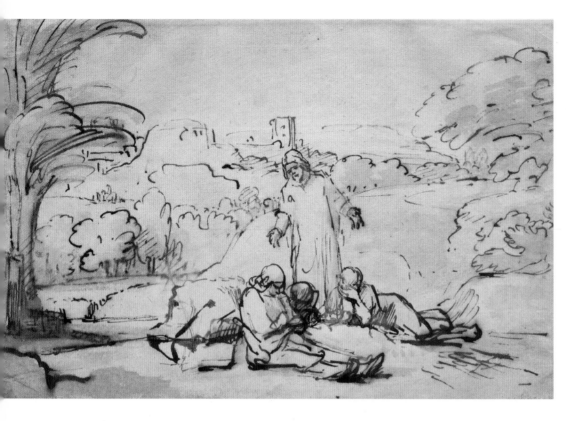

Christ Finding the Apostles Asleep, c.1654, pen and ink with wash on paper, Sterling & Francine Clark Art Institute, Williamstown, MA, USA, 18.8 x 27.9cm (7 x 11in)

Rembrandt depicts Christ as the central figure, returning to find his apostles asleep. The finely drawn work, created with a reed pen and brown ink with wash, captures the exasperating moment when followers of Christ are found wanting.

The Suicide of Lucretia, 1666, oil on canvas, Minneapolis Institute of Arts, MN, USA, 105.1 x 92.3cm (41 x 36in) Inscribed *Rembrandt f. 1666*

Livy (59BC–AD17), in his history of the formation of the city of Rome relates that Lucretia, a Roman noblewoman was raped by the son of the Etruscan king of Rome, Tarquin Superbus (6th century BC). After committing suicide to save her family embarrassment, her death leads to the expulsion of the Etruscan kings, and birth of the Roman Republic. In a half-length portrait, Rembrandt depicts the young Lucretia pulling a cord in her left hand, possibly to summon her family, in order to avenge her death, and in her right hand, the dagger to kill herself.

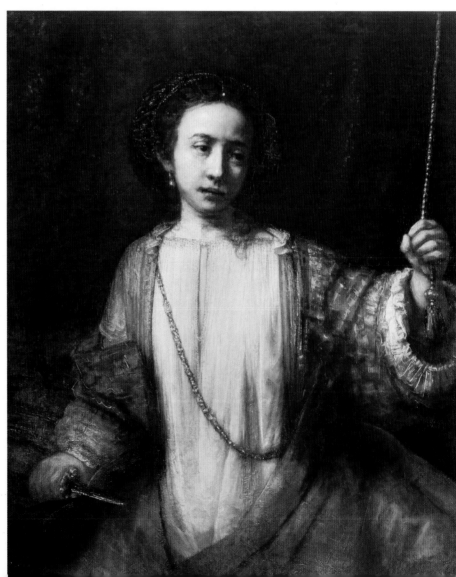

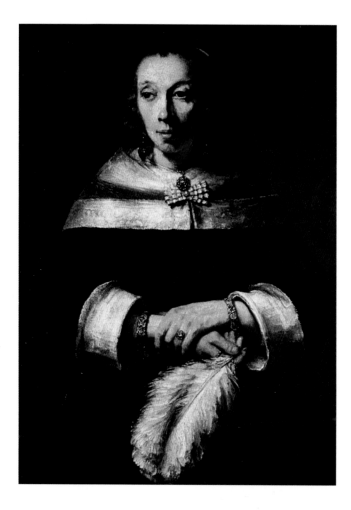

Portrait of a Lady with an Ostrich Feather Fan, 1660, oil on canvas, National Gallery of Art, Washington DC, USA 99.5 x 83cm (39.2 x 32.7in)

Portrait of a Lady with an Ostrich-Feather Fan, 1660, is a companion painting to *Portrait of a Gentleman with a Tall Hat Holding Gloves*, c.1658–60, also in the National Gallery of Art, Washington. The pendant portraits of husband and wife would have been displayed together. In this portrait by Rembrandt soft light filters in from the left to focus on the refined features of the lady's face. The deep black of the wearer's dress serves to highlight the opulence and purity of the dress shawl-collar, the deep cuffs and the fashionable ostrich-fan. Her pieces of jewellery glitter in the subdued light. The sitter is unknown.

Doctor Arnoldus Tholinx, c.1650–55, etching, drypoint and burin, (II states), Musée de la Ville de Paris, Musée du Petit-Palais, France, 19.8 x 14.9cm (8 x 6in)

Only one or two prints from the two states of this etching are extant; the light touch of the drypoint-burin components would not allow many to be created before loss of clarity. The sitter is Dr Arnoldus Tholinx, formerly an Inspector of the Amsterdam Collegium Medicum, Company of Physicians. Rembrandt would know him through Dr Nicolaes Tulp; Tholinx was married to Catharina Tulp, Tulp's eldest daughter. Tholinx then commissioned

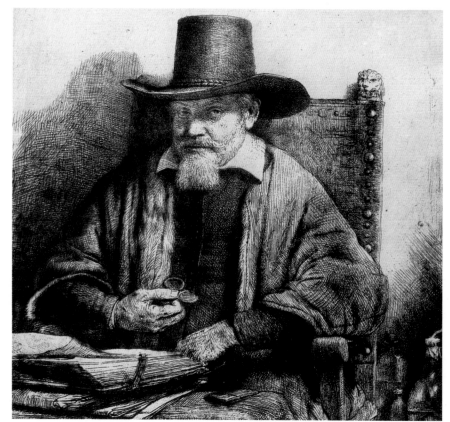

St Peter's Prayer before the Raising of Tabitha, c.1654-55, pen & ink on paper, Musée Bonnat, Bayonne, France, 19 x 20cm (7½ x 8in)

The Jewish woman Tabitha is part of a series of stories about St Peter in the Acts of the Apostles. In Acts IX: 36-42, a holy woman and a disciple of Jesus, Tabitha, dies. Her friends ask Peter to visit her. In an upper room of her house, he prays over her body and she is restored to life. Rembrandt depicts Peter in the act of praying; the body of Tabitha can be seen on a bed in another room.

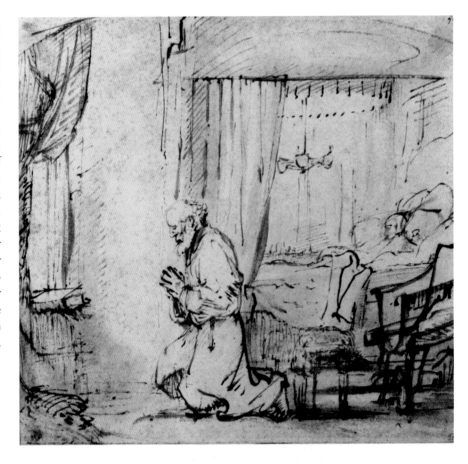

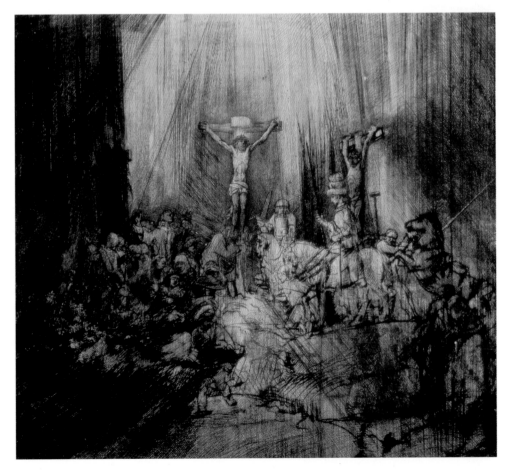

The Three Crosses, 1653, (V states) etching, drypoint and burin, The State Hermitage Museum, St. Petersburg, Russia 38.2 x 44.6cm (15 x 17½in)

Rembrandt captures the chaos of 'The Skull', the place where the crosses of two criminals, and the cross of Christ were erected. An unidentified figure on horseback holding a spear, rides toward the cross. Luke XXIII: 32 narrates that the crowd drew lots for the clothes; Luke XXIII: 44 states that darkness spread over the Earth, after the death of Christ. This later state of the etching is much darker, in order to illustrate that moment.

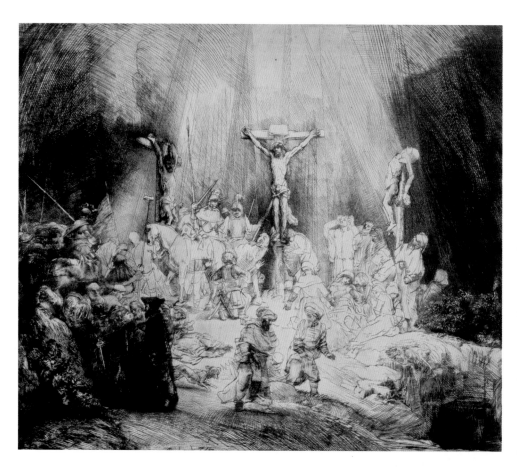

The Three Crosses, 1653, etching, drypoint and burin, (B.78.III) Fitzwilliam Museum, University of Cambridge, UK, 38.5 x 45cm (15 x 18in) The third state signed and dated *Rembrandt f 1653*

From Luke XXIII: 44-8, Rembrandt depicts a large disparate crowd gathered around the crosses where two thieves, and Christ, 'King of the Jews' hang. Two male figures in the foreground, deep in conversation, seem to be oblivious to the scene behind them. Rembrandt bathes the crosses in beams of heavenly light, depicting the biblical narrative of the moment of Christ's death. Close to the cross of Christ, Mary is seated on the ground, distraught with grief.

Christ Presented to the People, 1655, drypoint printed on paper, (VIII states), Fitzwilliam Museum, University of Cambridge, UK, 38.3 x 45.5 cm (15.1 x 17.9in). From the fourth state onwards, 35.8 x 45.5cm (14 x 18in)

Rembrandt depicts Christ presented to the people at the moment Pontius Pilate, standing near Christ, gestures toward him and says, 'Behold the man' (John XIX:5). Against an architectural backdrop, with references to Dutch building-types, Christ and Pontius are raised above the throng of people. A servant holds a jug of water and a bowl, for Pilate to wash his hands; a symbolical purification, distancing himself from the decision of the mob to crucify Christ.

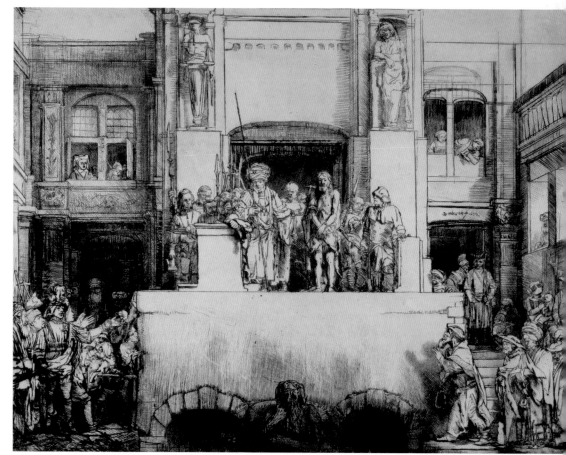

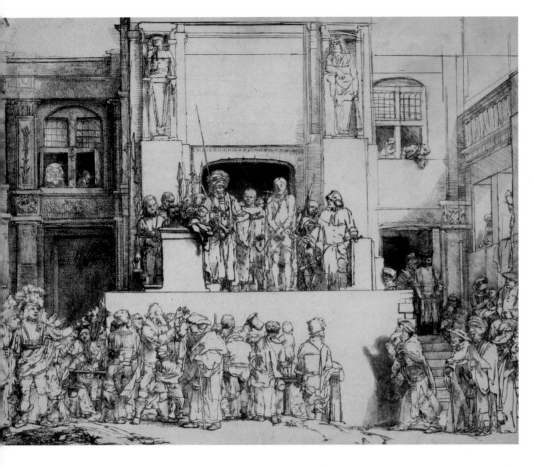

Christ Presented to the People, 1655, (VIII states), etching and drypoint, Art Gallery of New South Wales, Sydney, Australia, 35.5 x 45cm (14 x 18in)

This is the third state of eight, and printed on Japanese paper. Rembrandt depicts the moment that Christ is presented to the people with Pontius Pilate at his side. Beneath the figures of Pilate and Christ, a mob of people are gathered at the base of the building. The figures are removed in a later state to depict arches. Rembrandt copies the composition of an earlier etching of the subject by one of his favourite artists, Lucas van Leiden (1494–1533) *Christ Presented to the People*, c.1510.

Christ Returning from the Temple, 1654, etching with drypoint, Musée de la Ville de Paris, Musée du Petit-Palais, France, 14.4 x 9.5cm (6 x 4in) Signed *Rembrandt f. 1654*

A representation of the New Testament text, Luke II: 41-52, whereby the young Christ returns home with his parents, after visiting the Temple. It was custom to visit the temple at Passover; and according to tradition at the age of twelve, Christ's parents took him to Jerusalem to visit the temple. Rembrandt depicts the young Christ walking in a hilly landscape with his parents, holding their hands. His face is turned upward. At their feet is a small dog.

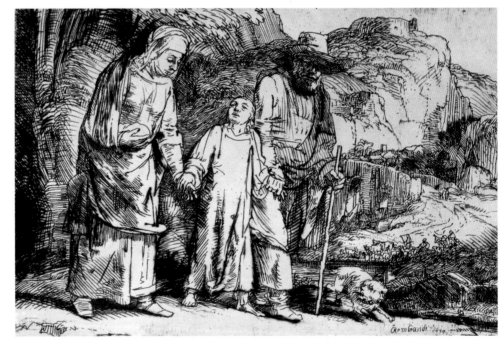

Portrait of Titus, Dressed as a Monk, 1660, oil on canvas, Rijksmuseum, Amsterdam, The Netherlands, 22.6 x 18.7cm (9 x 7½in) Signed *Rembrandt f. 1660*

The monk's clothing suggests an image of St Francis of Assisi. It is also suggested it may be the clothing of the Friars Minor Observant. On the Sint Antoniesbreestraat, close to Rembrandt's home, were two Franciscan establishments. The congregation of Catholics who attended services was large. Did Rembrandt create a portrait of an anonymous Franciscan monk, using Titus as the model, for an unknown patron?

The Anatomy Lesson of Dr Joan Deyman, 1656, oil on canvas, (fragment), Rijksmuseum, Amsterdam, The Netherlands, 100 x 134cm (39½ x 53in) Signed *Rembrandt f. 1656*

In 1653 Dr Joan Deyman succeeded Dr Nicolaes Tulp as the Praelector Anatomiae in Amsterdam. To the left in this fragment from the original (partly destroyed by fire), is Gysbrecht Matthisijsz. Calcoen, holding a skull. Dr Deyman is behind the corpse. On 29 January, Dr. Joan Deyman made his first demonstration in the anatomy theatre. Rembrandt recorded the dissection of the brain; a rare depiction in Dutch art of this period.

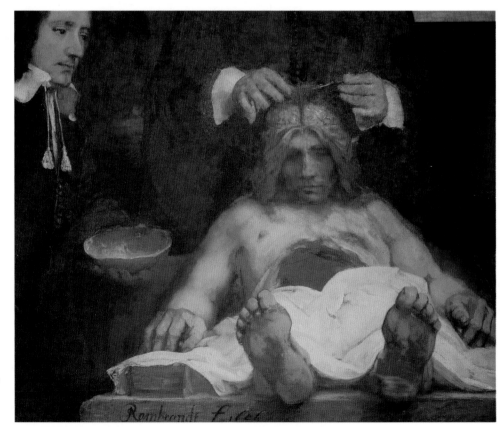

Abraham's Sacrifice, 1655,
etching & drypoint,
The Israel Museum,
Jerusalem, Israel,
15.6 x 13.1cm (6 x 5in)
Signed and dated lower
right: *Rembrandt f. 1655*

Rembrandt returned many
times to the subject of
Abraham's sacrifice of Isaac,
loosely basing his visual
interpretation on the bible
narrative, Genesis XXII:
1-18, in which God tests
Abraham's loyalty,
commanding him to sacrifice
his son Isaac. In this etching,
Rembrandt focuses on the
moment a winged angel,
sent from God, stays
Abraham's hand that holds
the knife with which he was
about to sacrifice his son
(Genesis XXII: 10-12).

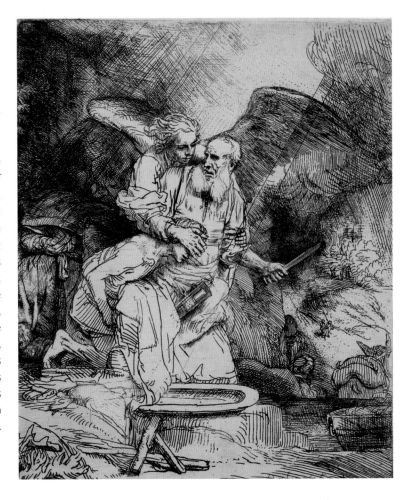

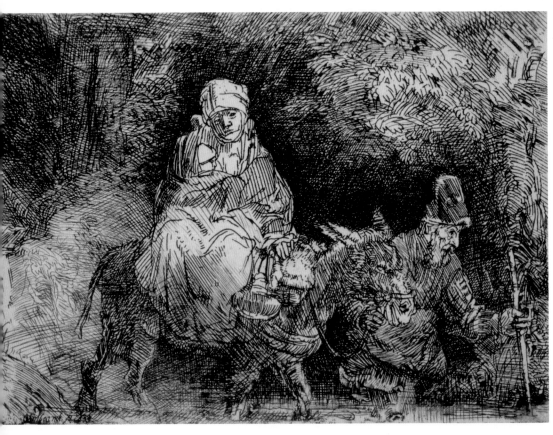

*The Flight into Egypt: Crossing
a Rill,* 1654, etching with
drypoint, Pallant House
Gallery, Chichester, UK,
9.7 x 14.4cm (4 x 6in)
Signed *Rembrandt f. 1654*

A visual reference to the
New Testament text,
Matthew II: 13-15.
Rembrandt made several
etchings of the 'Flight into
Egypt' from c.1626 onward,
each with a slight variation of
the bible narrative, in which
an angel sent by God tells
Joseph to take his child and
his wife Mary into Egypt, to
escape the massacre of
infant boys. Here, Mary is
depicted seated side-saddle
on a donkey, the infant close
to her breast, wrapped in a
shawl. Joseph leads the
donkey across a brook.

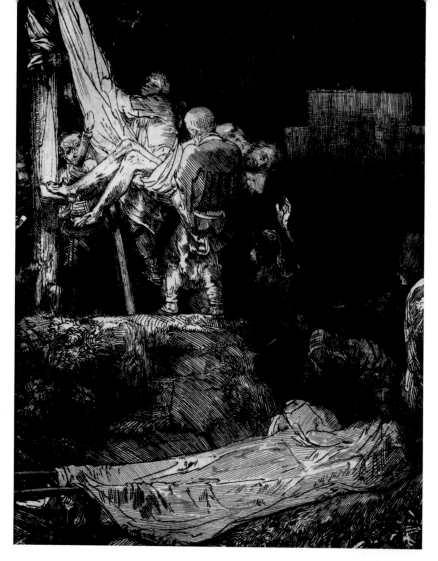

The Descent from the Cross by Torchlight, 1654, etching and drypoint, Musée de la Ville de Paris, Musée du Petit-Palais, France, 21 x 16.1cm (8 x 6in) Signed and dated *Rembrandt f. 1654*

Rembrandt creates a poignant visualization of the bible narrative, Matthew XXVII: 57-58, whereby Joseph of Arimathea is allowed to remove the body of Christ from the Cross, and bear it to a tomb. 'And Joseph took the body, and wrapped it in a clean linen shroud and laid in his own new tomb'. The nighttime scene is lit with torches. Rembrandt captures the moment that the dead body is lowered with the aid of disciples. At the forefront a stretcher is placed to carry the body to the tomb.

King David at Prayer, 1652, (III states), etching, Musée de la Ville de Paris, Musée du Petit-Palais, France, 14.3 x 9.5cm (5½ x 4in) Signed *Rembrandt f. 1652*

The Psalm of David, CXIX: 62, states 'At midnight I rise to praise thee…' King David, the second king of Israel, and author of the psalms, is depicted by his bedside, on his knees at prayer. His harp is shown by his side, the northerly wind through the strings would wake him at night to pray. David was known for his musical accomplishments (I Samuel XVI: XVII; II Samuel XXIII: 1), particularly harp playing. It was a popular subject in Jewish and Christian texts.

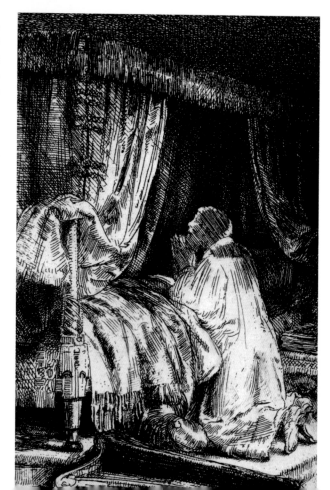

Nathan Admonishing David, c.1652, pen and ink on paper, Sterling & Francine Clark Art Institute, Williamstown, MA, USA, 12.6 x 14.9cm (5 x 6in)

One of two drawings on the subject by Rembrandt. The composition depicts the prophet Nathan, a messenger of God, admonishing David following his action of ordering the death of his General, Uriah, in order to marry Bathsheba, Uriah's wife. Nathan narrates a parable, which closely connects to David's villainous actions; David is angered by it but Nathan points out, 'You are that man!'

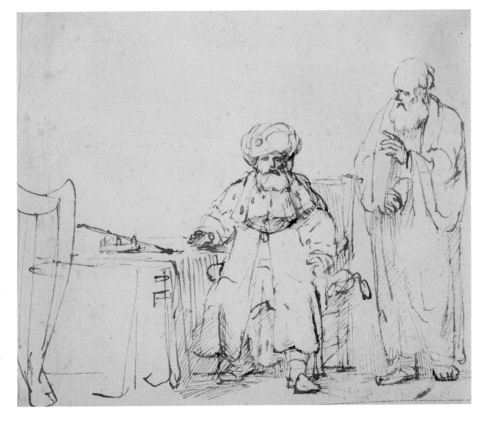

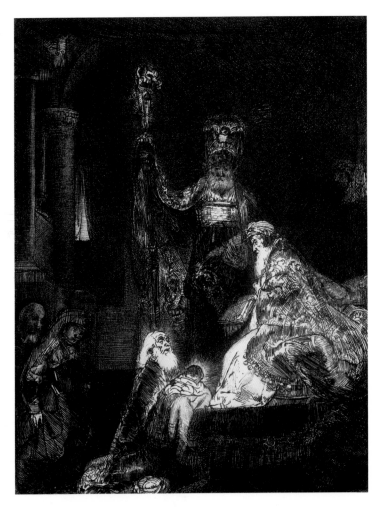

Presentation in the Temple, c.1654, etching with drypoint, Musée de la Ville de Paris, Musée du Petit-Palais, France, 20.7 x 16.2cm (8 x 6½in)

The etching is known as *Presentation in the Temple,* in the Dark Manner owing to the dark tonal shading surrounding the figures. The subject is taken from the New Testament, Luke II: 22-39. According to Judaic law, all firstborn male children were taken to the temple to be presented to God. Rembrandt created various etchings of the moment that the infant Christ was presented to the Elders of the temple.

The Blind Tobit, 1651,
(II states), etching with
drypoint, Musée de la Ville
de Paris, Musée du Petit-
Palais, France,
16 x 13cm (6 x 5in)
Signed twice *Rembrandt
f. 1651*

The etching illustrates a
moment from the
apocryphal Book of Tobit
XI:10. Tobit with arms
outstretched hurriedly feels
his way toward the sounds
of voices that emanate from
the open door of his home,
to welcome back his young
son Tobias, from a long
journey. Rembrandt portrays
the reality of blindness.
He etches Tobit, in his haste
to reach the door, knocking
over a spinning wheel and
unknowingly walking into
the path of Tobias's small
dog that runs to greet
the old man.

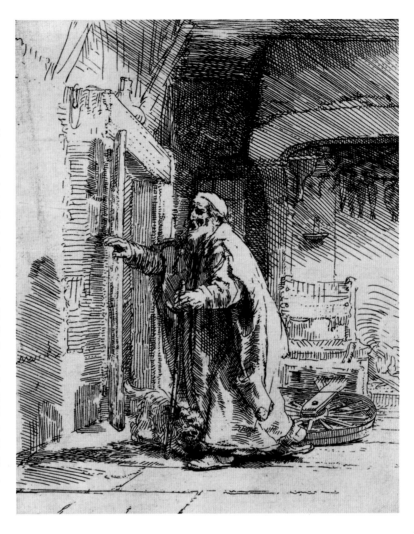

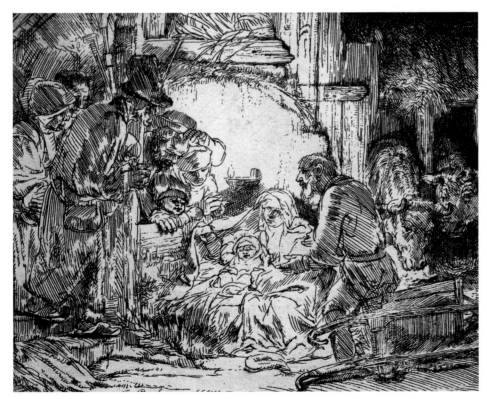

Nativity, 1654, etching,
Musée de la Ville de Paris,
Musée du Petit-Palais,
France,
10.6 x 12.9cm (4 x 5in)

In 1654 Rembrandt etched a
series of Christ's life, from
infancy to death, including,
*Flight into Egypt, The
Circumcision* and *Christ
amongst the Doctors.*
Rembrandt followed the
bible narrative closely, with a
compassionate interpretation,
which explored the life of
Christ in a deeply moving
understanding of his
humanity and vulnerability. In
this depiction of the Nativity
set in the stable of the inn,
the closeness of the Holy
Family is evident.

The Dream of St Joseph,
1650–5, oil on canvas,
Museum of Fine Arts,
Budapest, Hungary,
105 x 83cm (41 x 33in)

The artist cuts the picture space diagonally with three figures. The composition, informed by the biblical text Matthew 1:18, depicts an angel sent by God appearing to Joseph, the earthly father-to-be of Christ, to reassure him that the baby is a gift from God. The warm light and rich colour tones create an aura of intimacy. The angel at the top left is adorned with expansive wings. Joseph and Mary sit below him, asleep in a stable. He taps Joseph on the shoulder, to speak to him in Joseph's 'dream'.

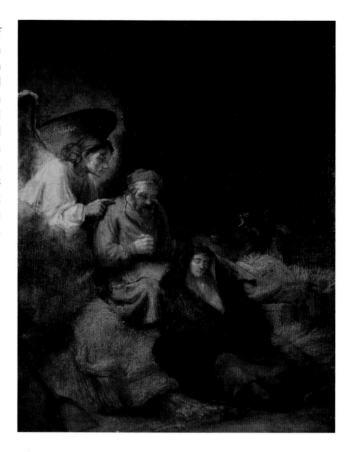

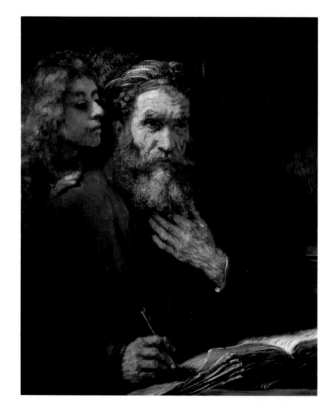

St Matthew and the Angel,
1661, oil on canvas, Musée
du Louvre, Paris, France,
66 x 52cm (26 x 20½in)
Signed *Rembrandt f. 1661*

A delicately produced portrait of the evangelist St Matthew. Rembrandt portrays Matthew in three-quarter profile seated and in the process of writing. His facial features express deep concentration. Standing at his right shoulder, an angel, without wings, appears to be whispering in Matthew's ear, giving him divine inspiration. The painting is stylistically close to *The Apostle Bartholomew* 1657, and *The Apostle Paul, c.1657.*

Peter and John at the Entrance to the Temple, 1659, (IV states), etching with drypoint and burin, Musée de la Ville de Paris, Musée du Petit-Palais, France, 18 x 21.5cm (7 x 8½in) Signed *Rembrandt f. 1659*

An illustration of New Testament, Acts III:1-10, in which St Peter and St John speak to a crippled beggar. Rembrandt created many etchings of this subject.

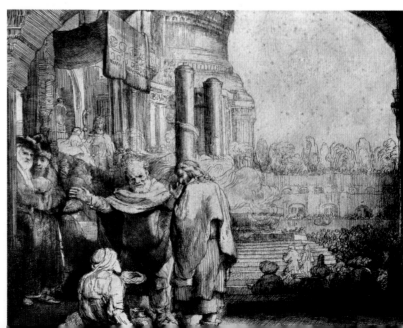

St Jerome Reading in a Landscape, c.1653, pen and wash heightened with white, on white paper, Hamburger Kunsthalle, Hamburg, Germany, 25.2 x 20.4cm (10 x 8in)

Rembrandt made several depictions of St Jerome (C.AD340–420), an ancient theologian renowned for exegetical studies, revision of the bible and translation of it into Latin. At least seven portrayals of St Jerome are etchings, the first was dated 1629. St Jerome is often depicted with a lion, owing to a story that he removed a thorn from its paw.

Moses Smashing the Tables of the Law, 1659, oil on canvas, Gemäldegalerie, Berlin, Germany 168.5 x 136.5cm (66 x 54in) Signed *Rembrandt f. 1659*

The painting is considered to be a section of a larger painting, commissioned for the new Town Hall in Amsterdam. The painting relates to the Old Testament, Exodus XXXII, when the prophet Moses returning from Mount Sinai with two stone tables of law 'written by the finger of God', finds the people of Israel worshipping a calf made of molten gold. In his anger he smashed the tables.

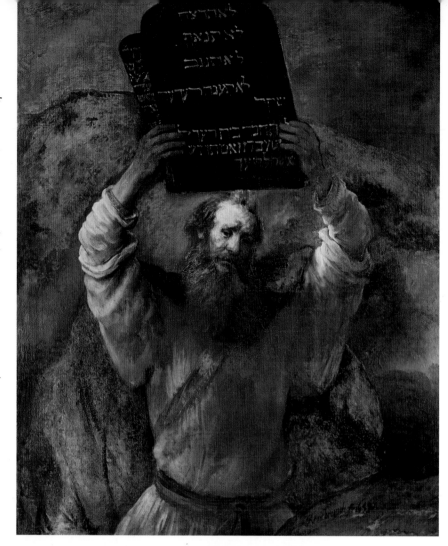

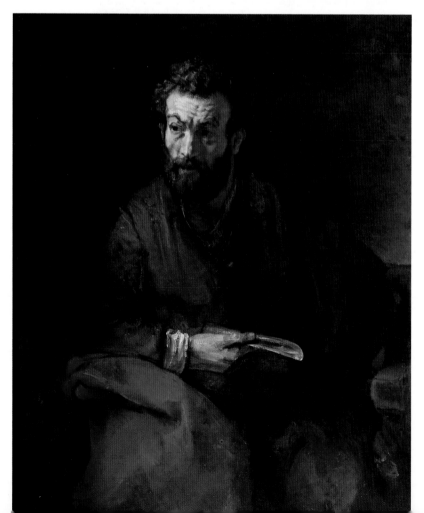

Jacob Blessing the Sons of Joseph, 1656, (detail), oil on canvas, Gemäldegalerie Alte Meister, Kassel, Germany, 173 x 209cm (68 x 82in)

The bible relates that the first blessing was a greater gift and reserved for the eldest child but Jacob wanted to first bless the second-born son of Joseph. As a young man Jacob had been duplicitous, receiving his blind father Isaac's gift of first blessing, by wearing a coat which belonged to his elder brother, Esau. Rembrandt portrays the moment that the near-blind Jacob has his hand stayed by his son, when Jacob's hand hovers not over the first-born but the second-born child, an error in Joseph's eyes but not for Jacob.

Jacob Blessing the Sons of Joseph 1656, oil on canvas, Gemäldegalerie Alte Meister, Kassel, Germany, 173 x 209cm (68 x 82in)

In his own style, Rembrandt illustrated Jacob, an old man near death, blessing the offspring of his youngest son. He includes Joseph's wife, Asenath, who is not present in the bible narrative, (Hebrews XI:21, Genesis XLVIII:1-22). She completes a loving family group. In the bible narrative. the near-blind Jacob, in a symbolic act of passing gifts to younger members of the family, stretches his hand to bless his grandsons, Manasseh and Ephraim. Rembrandt portrays the moment that the near-blind Jacob has his hand stayed by his son, when Jacob's hand hovers not over the first-born but the second-born child, an error in Joseph's eyes but not for Jacob.

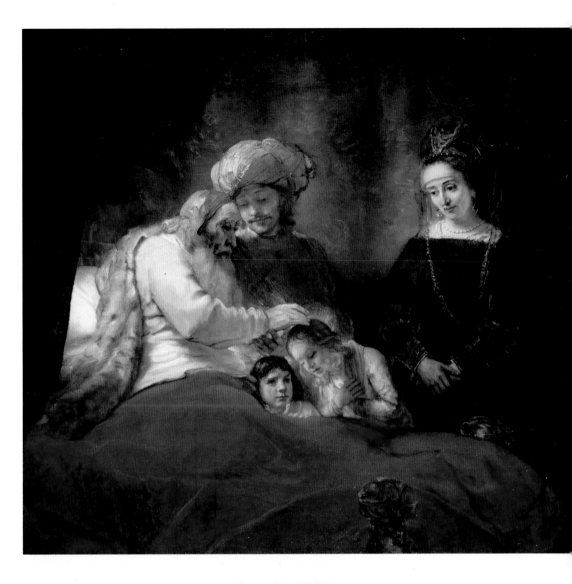

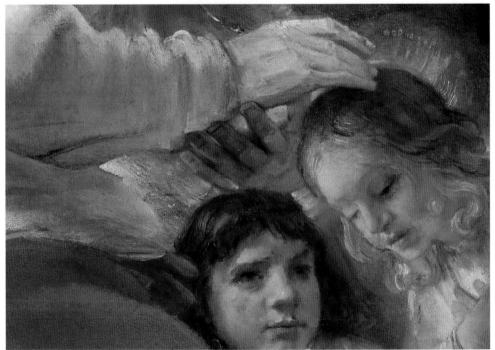

Jacob Blessing the Sons of Joseph, 1656, (detail), oil on canvas, Gemäldegalerie Alte Meister, Kassel, Germany, 173 x 209cm (68 x 82in)

The bible relates that the first blessing was a greater gift and reserved for the eldest child but Jacob wanted to first bless the second-born son of Joseph. As a young man Jacob had been duplicitous, receiving his blind father Isaac's gift of first blessing, by wearing a coat which belonged to his elder brother, Esau.

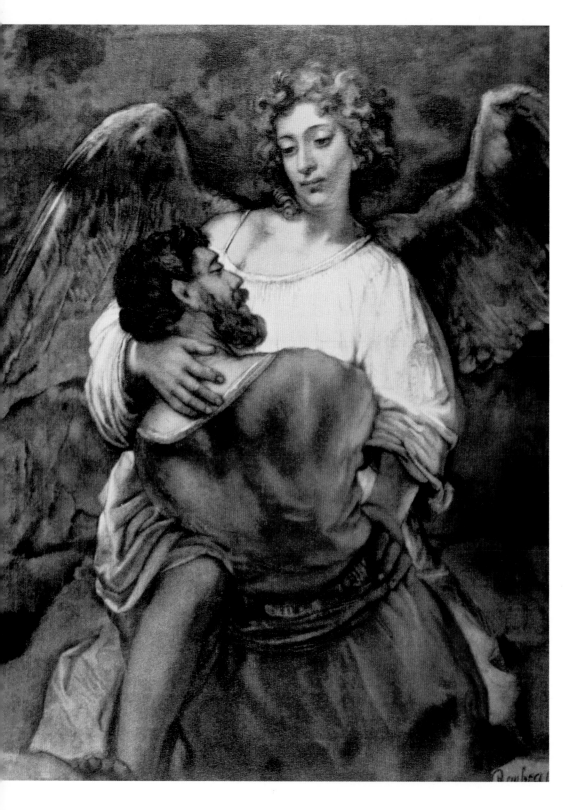

Jacob Wrestles with an Angel,
1659, oil on canvas,
Gemäldegalerie, Dahlem-
Berlin, Germany,
137 x 116cm (54 x 46in)
Signed *Rembrandt f.* (on an
attached small section of
canvas, lower right)

Attributed by scholars to
Rembrandt with some
reservations. Originally
the painting was larger,
which may explain the
re-attachment of
Rembrandt's signature
after it was cut down in size.
It is possible that it was part
of a series of paintings for
the Town Hall of
Amsterdam, alongside *Moses
Smashing the Tables of the
Law,* 1659. The work depicts
the bible narrative Genesis
XXXII:22-32.

The Agony in the Garden, c.1657, etching and drypoint with light surface tone, British Museum, London, UK, 10.9 x 8.3cm (4 x 3in) Signed 165. [last digit missing]

The etching depicts 'The Agony in the Garden' (Luke XXII:39-46), prior to Christ's betrayal by Judas. Christ visits the Mount of Olives to pray. Three disciples who have accompanied him fail to stay awake to pray with him or protect him. Rembrandt depicts Christ on the Mount of Olives at night. An angel holds Christ in a brotherly embrace.

Haman Recognises his Fate, 1665, oil on canvas, The State Hermitage Museum, St. Petersburg, Russia, 127 x 117cm (50 x 46in) Signed *Rembrandt f*

Rembrandt scholars debate the subject matter of this painting. The State Hermitage museum considers it a depiction of Haman (Old Testament, Book of Esther VI:1-10), the disgraced servant of King Ahasuerus, who planned to kill all Jews, from Ethiopia to India, which were the provinces of the king. Unmasked by Esther, the queen and her cousin Mordecai, Haman will be hanged. The alternative title is *David and Uriah*, following the Old Testament narrative (II Samuel: Ch.XI:1-13) of King David and his carnal desire for Bathsheba, wife of Uriah, one of his military personnel.

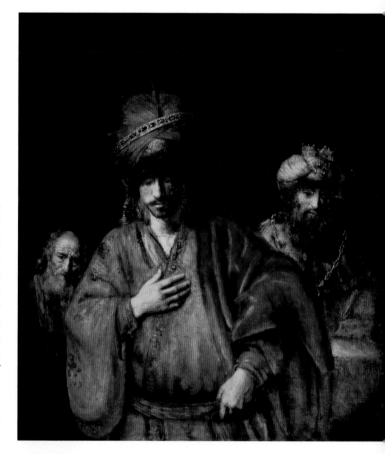

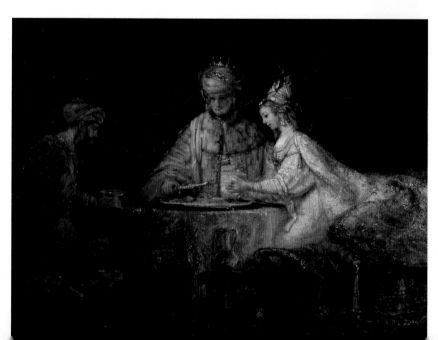

Ahasuerus (Xerxes), Haman and Esther, c.1660, oil on canvas, Pushkin Museum, Moscow, Russia 73 x 94cm (29 x 37in) Signed *Rembrandt f. 1660*

Rembrandt bases the three figures on the story of King Ahasuerus, Haman and Queen Esther, as told in the Old Testament Book of Esther. A plot, by Haman to kill all Jews in the king's provinces, is foiled by Esther.

St Martin and the Beggar,
c.1660, pen and ink on
paper, Musée des Beaux-
Arts, Besancon, France,
21.3 x 15.2cm (8.4 x 6in)
Signed *R*

Martin (St Martin of Tours,
AD316–97), a Roman soldier,
is depicted on horseback.
The drawing is informed by
the account of Martin cutting
his military cloak in two, to
give half to a beggar.
Rembrandt captures the
immediacy of the moment,
as Martin uses his sword to
cut the garment. The
Christian message related to
a dream, in which Christ
wears the other half of the
cloak. The narrative was very
popular with artists.

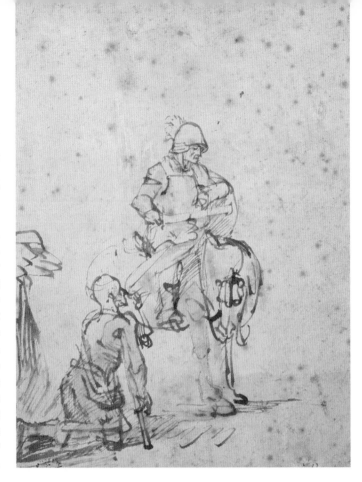

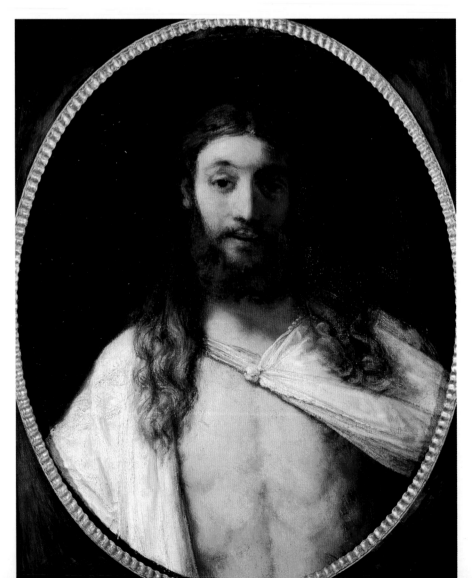

Ecce Homo (or *the Risen
Christ*), 1660, oil on
canvas, Alte Pinakothek,
Munich, Germany,
81 x 64cm (32 x 25in)
Signed *Rembrandt f. 1661*

An oval portrait of Christ,
possibly cut down in size.
The intention of the
depiction of Christ is unclear.
Historians range opinions
from 'Ecce Homo' (Here is
the Man), the words spoken
by Pontius Pilate (Gospel
of St John X: 5), to the
'Risen Christ' and his post-
crucifixion appearance during
a supper at Emmaus (Gospel
of St Luke XXIV:30-31). An
X-ray of the underpainting
revealed the figure holding
an object in his hands,
possibly a book.

Jesus Christ among the Doctors, 1652, etching with drypoint (III states), Musée de la Ville de Paris, Musée du Petit-Palais, France, 21.5 x 12.5 (8.5 x 4.9in) Signed *Rembrandt f. 1652*

According to the Gospel of Luke II: 41-48, Christ at the age of 12 accompanied his parents to the temple in Jerusalem to celebrate Passover. After three days he is found in the temple 'among the teachers, listening to them and asking them questions...' Rembrandt depicts an animated scene with the young boy centre stage.

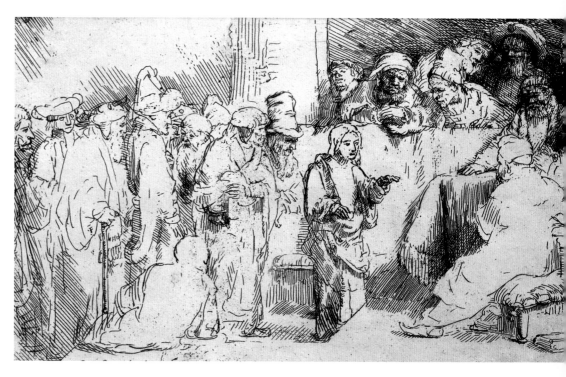

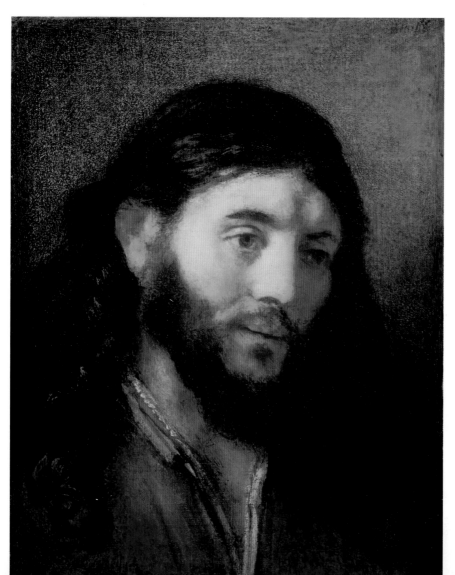

Head of Christ, 1650s, oil on canvas, Metropolitan Museum of Art, New York, NY, USA, 42.5 x 34.3cm (17 x 13½in)

Attributed to Rembrandt, this painting is one of 10 interpretations of the head of Christ, in bust length portraits, all dating to the 1650s. Some are attributed to Rembrandt's pupils. In Rembrandt's house inventory of 1656, three bust portraits, described as 'A head of Christ done from life' were noted. However, it remains uncertain if this painting is one of them.

Simeon and Jesus in the Temple, c.1639, drawing, Musée des Beaux-Arts, Besancon, France, 18 x 19cm (7 x 7½in)

Rembrandt returned many times to the biblical narrative of the elderly sage, Simeon and the presentation of the infant Jesus in the temple. It was a tradition for the first born males to be taken to the temple to be 'presented' to God. In this drawing the artist depicts Simeon holding the baby in his arms, with Mary and Joseph looking on; the female to the right is possibly the prophetess, Anna, who spread the word of the infant's holy identity.

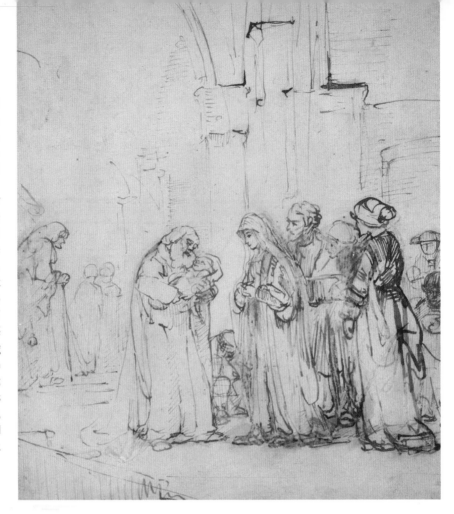

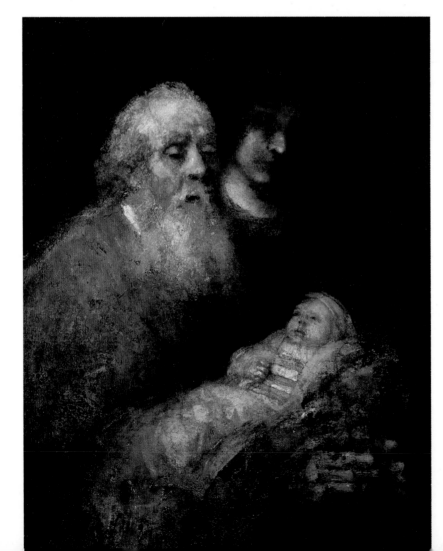

Simeon in the Temple, 1669, oil on canvas, Nationalmuseum, Stockholm, Sweden, 98.5 x 79.5cm (39 x 31in)

The depiction was based on the bible narrative, Luke II:22-35. Simeon, a holy man of Jerusalem, was told by the Holy Spirit that he would not see death until he had seen the Lord's Christ. When the infant Jesus is brought into the temple, Simeon took him in his arms with the words, 'Lord, now lettest thou servant depart in peace.' Rembrandt captures the emotional joy on the face of Simeon as he looks at the baby in his arms. The woman standing behind Simeon was painted by another hand, possibly because the painting remained unfinished at Rembrandt's death.

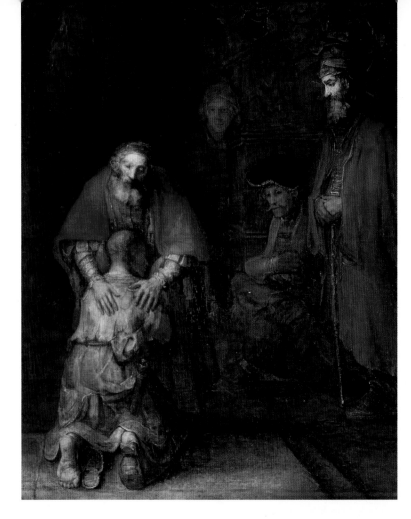

Return of the Prodigal Son, c.1668-69, oil on canvas, The State Hermitage Museum, St. Petersburg, Russia, 262 x 205 cm (103 x 81in) Signed *R.v. Rijn f.* The signature is unusual in that the artist did not sign his first name but used initials and surname.

One of the final paintings by Rembrandt, it is full of drama and compassion. He takes his subject from the Gospel according to Luke XV: 20-24. It depicts the end of Christ's parable of the wayward 'prodigal son'. Rembrandt depicts the reunion of the father and son, the father placing his hands in blessing on the shoulders of his son.

The Apostle Peter Denying Christ, 1660, oil on canvas, Rijksmuseum, Amsterdam, The Netherlands, 154 x 169cm (61 x 66½in) Signed *Rembrandt 1660*

A depiction of the biblical narrative: Mark XIV: 66-72. At the arrest of Jesus Christ, the apostle Peter is challenged by a maidservant of the high priest 'And thou also was with Jesus of Nazareth'. On three occasions, he denied it. The narrative tells that a cock crows, fulfilling Christ's prophesy that Peter would deny him three times before the cock had crowed twice. The figure of Peter stands, while the servant challenges him to admit that he was a follower of Christ. In the richly dark setting a bright beam of light illuminates her hand, highlighting her fingers.

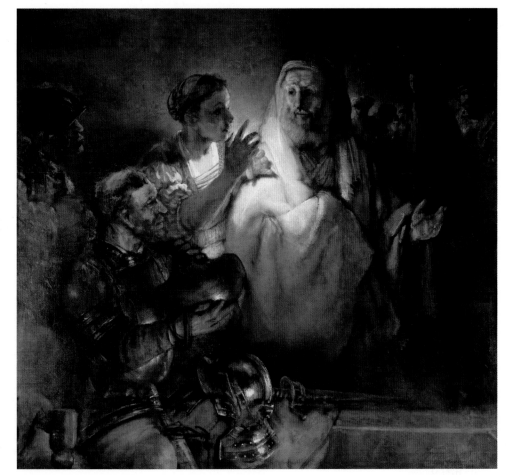

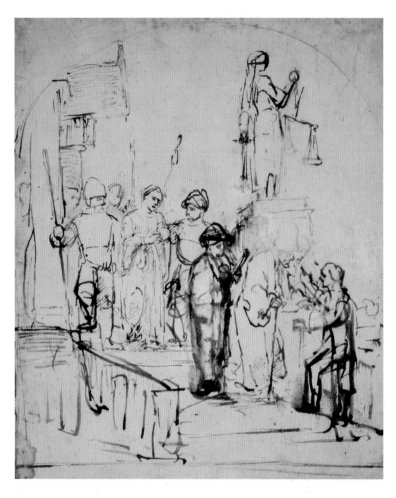

Susanna Brought to Judgement, c.1645–55, reed pen and brown ink with corrections in white, Ashmolean Museum, University of Oxford, UK, 23.8 x 19.6cm (9½ x 8in) Signed *Rembr…*

Informed by the Book of Daniel in the Apocrypha to the Old Testament, Susanna of Babylonia is falsely accused of adultery by two Elders and sentenced to death. She is saved by Daniel, a young prophet, who proves that the men are lying when their accounts of the adultery do not tally. Rembrandt depicts Susanna brought forward for judgement, passing a statue of the blind scales of justice.

St Jerome in an Italian Landscape, c.1653, pen and brown ink with brown wash, Fitzwilliam Museum, University of Cambridge, UK, 25.9 x 20.7cm (10 x 8in)

The first of Rembrandt's 'St Jerome' works dates to 1629, the last one is this drawing. Here St Jerome sits under a tree in an Italian landscape. Rembrandt did not journey to Italy but took his inspiration from Venetian art, particularly that of Titian. Jerome is absorbed in the book he is reading. To his left, on the far side of the tree, stands a lion; his protector. It looks out toward the distant landscape.

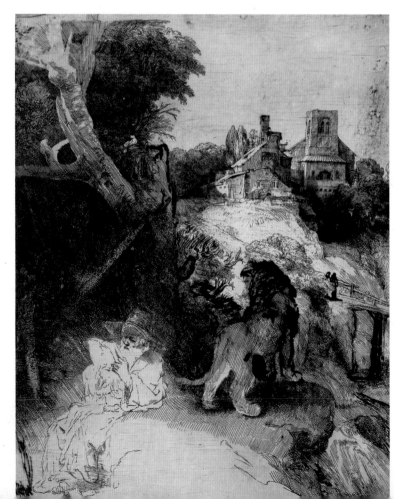

Christ and the Samarian Woman. 1659, Hermitage, St Petersburg, Russia, 60 x 75cm (24 x 29½in) Signed *Rembrandt f. 1659*

Attributed to Rembrandt with reservations that it may be the work of one of his followers. In an architectural setting the artist portrays two people at a water well. In the background a lush landscape is revealed. On the right a woman of Samaria draws water from a well. She holds the chain and the water pot. She is in conversation with Jesus Christ. (Gospel of St John IV: 1-42). Between them a small child looks into the well; his head and hands are visible.

The narrative states that Christ, a Jew, asks the woman to give him a drink of water, although Samarians would not normally speak to Jews.

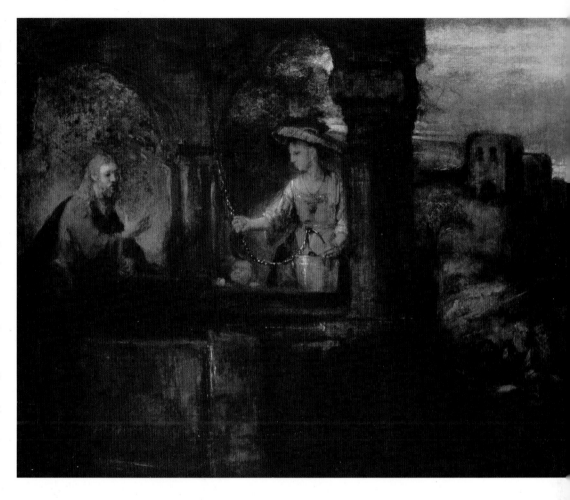

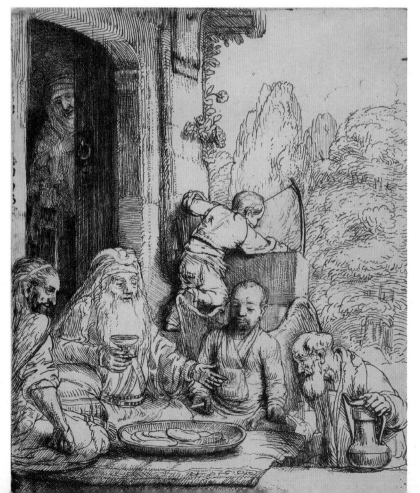

Abraham Entertaining the Angels, 1656, etching with drypoint, The Israel Museum, Jerusalem, Israel, 16 x 13.1cm (6 x 5in) Signed *Rembrandt f. 1656*

The Book of Genesis XVIII: 1-15, tells the story of the Hebrew patriarch Abraham, at the age of 99, sitting at the opening of his tent when God, as a mortal, appears to him with two angels. Abraham pleads for them to refresh themselves at his house and dine at his table. In return he is promised the birth of a son by his ageing wife, Sarah. Rembrandt sets the narrative in a house with Sarah listening at the open door while Abraham entertains the holy visitors.

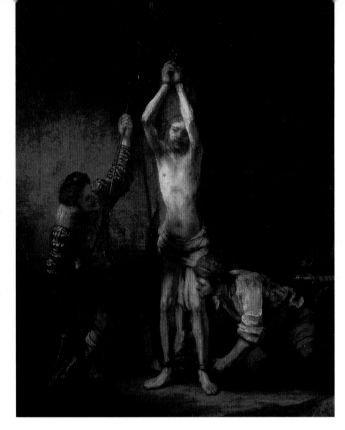

Christy at the Column, 1658, oil on canvas, Darmstadt Museum, Germany, 93 x 72cm (37 x 28in) Signed *Rembrandt f. 1658* (thought to be a faked signature)

The painting dates to 1658 but Rembrandt may have retouched the canvas around ten years later *c.*1668. There is a suggestion that some of the later painting work was carried out by an assistant of Rembrandt. The painting depicts the figure of Christ during his Passion. He is tied to a column to be scourged and beaten, and a crown of thorns is placed on his head.

*The Star of the Kings; a Night-piece, c.*1651, etching with touches of drypoint, British Museum, London, UK, 9.5 x 14.3cm (4 x 6in)

A Dutch custom named 'The Star of the Kings', held each year on 6 January, commemorated the Feast of Epiphany, the visit of the Three Kings to the newborn Christ in Bethlehem. In Rembrandt's era children went from door to door with a lantern shaped like a star; in return for a song, money was given to the children. Here, in a night scene, a group of children with a star-shaped lantern are watched by a couple who stand at the door.

The Circumcision in the Stable, 1654, etching (II states), Musée de la Ville de Paris, Musée du Petit-Palais, France, 9.7 x 14.4 cm (4 x 6 in) Signed and dated twice *Rembrandt f. 1654*

A stable is the scene for the circumcision of the infant Christ, taken from Luke II:21, 'and at the end of eight days, when he was circumcized, he was called Jesus, the name given by the angel before he was conceived in the womb.' Mary holds her hands clasped in prayer.

Christ and the Woman of Samaria, late 1640s, pen and brown ink on paper, The Barber Institute of Fine Arts, University of Birmingham, UK, 21 x 19cm (8 x 7½in)

Rembrandt's drawings were mainly for his personal use, kept in albums in his studio, and not created for sale. The subject matter of his drawings and sketches was often the narratives of the Old and New Testament. In this drawing, created with Rembrandt's reed pen and brown ink, he portrays a woman of Samaria standing at a well, in conversation with Jesus Christ. (Gospel of St John IV: 1-42). The significance of the story is that Samarians would not normally speak to Jews. The woman is taken by surprise when Christ, a Jew, asks her to give him a drink of water.

The Slaughtered Ox, 1655,
oil on canvas, Musée du
Louvre, Paris, France,
94 x 68cm (37 x 27in)
Signed: *Rembrandt f.1655*

The artist revisits an earlier
work of the same subject
that was painted in the
1630s. The carcass of the ox
hangs from the cross bar on
which it is tied, to drain away
blood before the butcher
dismembers it. In the
background, a maid peeps
out, adding real life to the
'still life' painting, an everyday
scene familiar in Dutch
villages and households.
Rembrandt infuses rich
dark blood-red colour in
thick impasto, to create
wedges of paint, cut and
scraped across the canvas.

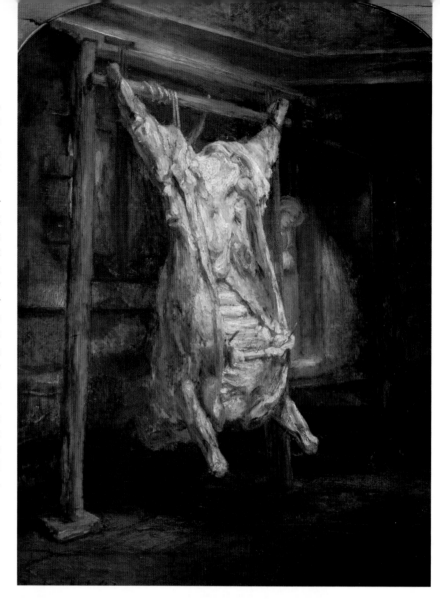

The Shell (Conus Marmoreus)
1650, etching with drypoint
and burin (III states),
Private Collection,
9.7 x 13.2cm (4 x 5in)
Signed *Rembrandt f. 1650*

A rare still life created by the
artist. The marbled cone –
Conus marmoreus – is the
shell of a venomous sea snail,
a popular object in Dutch
still life art. Samples would
have come from the Dutch
East Indies. Rembrandt, a
collector of shells, created
three states of the etching,
varying the intensity of
hatching and shading. He
overlooked the direction
that the snail exited the shell,
creating the whorl pattern in
the wrong direction.

Landscape with Trees, Farm Buildings and a Tower c.1650–1, (III states), etching with drypoint, Musée de la Ville de Paris, Musée du Petit-Palais, France, 12.3 x 31.9cm (5 x 12½in), photograph

The etching depicts a wide landscape with trees, a group of farm buildings and in the distance, to the right, a tower. Two states of the etching illustrate the tower with a clearly defined domed roof; a third state depicts the tower with the dome removed and burnished out. The scenic view may be one that is seen from a road leading toward Amstelveen. The buildings were on the estate of the tax collector Jan Uytenbogaert, an associate of Rembrandt.

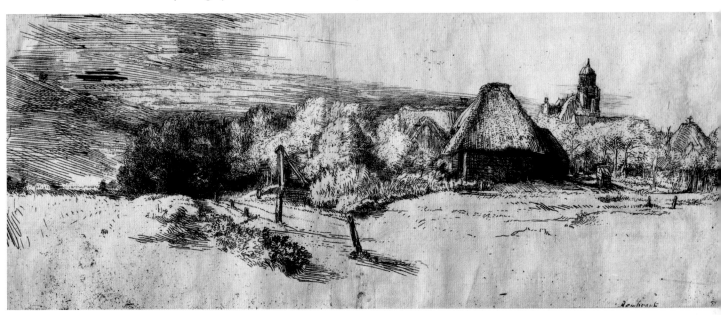

Kolf Game, 1654, etching (II states), Musée de la Ville de Paris, Musée du Petit-Palais, France, 10.3x 14.4cm (4 x 6in) Signed *Rembrandt f. 1654*

An interesting depiction of a man playing a game of golf (Dutch 'kolf') outside a building, possibly a tavern, where a man, seated in the interior scene, rests his leg on a bench. The game of 'kolf' was very popular in The Netherlands in Rembrandt's era and could also be played on frozen lakes. 'Kolf' was a forerunner of the modern game of golf. Through the window of the tavern can be seen two men interacting with the 'kolf' player.

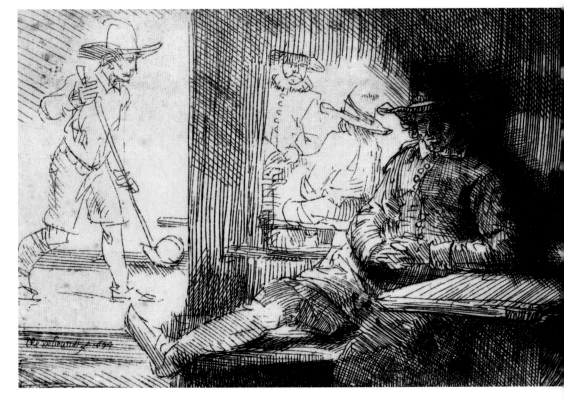

A River with a Sailing Boat on Nieuwe Meer, pen and brown ink, Private Collection, 8.9 x 15.2cm (3½ x 6in)

This river landscape depicts a sailing boat on Nieuwe Meer, which is about 8km (5 miles) southwest of Amsterdam. In this drawing, the artist captures the calm waters and marshlands of the location.

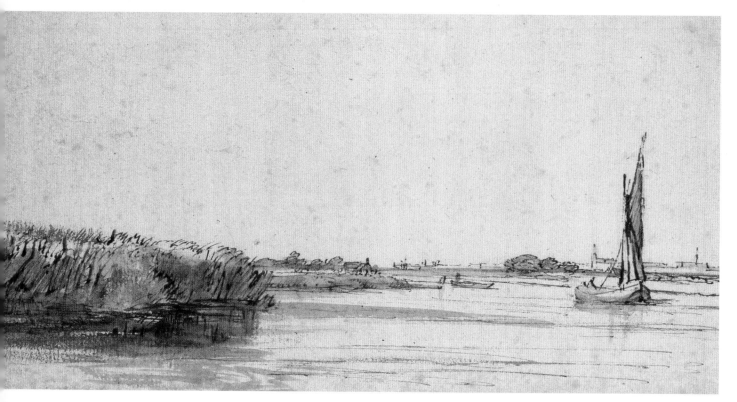

River Landscape with Ruins, c.1650s, oil on panel, Gemäldegalerie Alte Meister, Kassel, Germany, 67 x 87.5cm (26½ x 34½in) Signed *Rembrandt f*

This work is thought to have been created *c.*1637–40, and possibly left unfinished or reworked at a later date *c.*1656. The later additions may have been added by Rembrandt or possibly by an assistant. The work depicts a lush landscape with a vast expanse of sky. A traveller on a horse is in the left foreground riding alongside the river, where a barge is moored. He is approaching a stone bridge, which leads to ruins in the far distance.

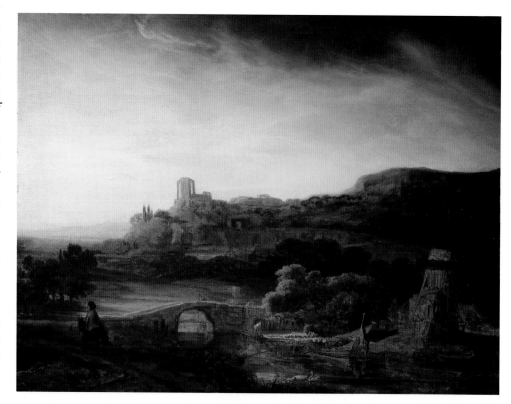

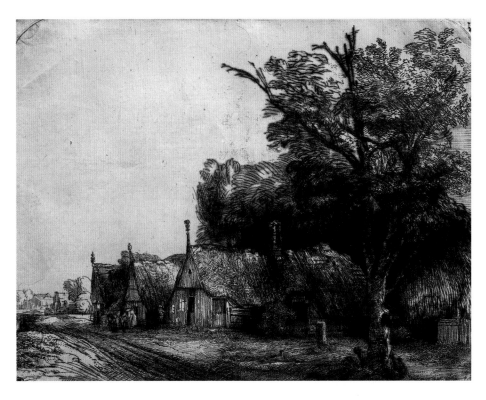

Landscape with Three Gabled Cottages, 1650, etching with drypoint (III states), Musée de la Ville de Paris, Musée du Petit-Palais, France, 16.1 x 20.2cm (6 x 8in) Signed *Rembrandt f. 1650*

The view of the cottages compares to a Rembrandt pen and ink drawing *Cottages on Schinkelweg, Looking Towards the Overtoom,* on the Schinkel canal, found a short distance outside Amsterdam in the direction of Sloten, an area that Rembrandt knew well. The use of light and shade, particularly in the second and third states adds to the character of the cottages and their surroundings.

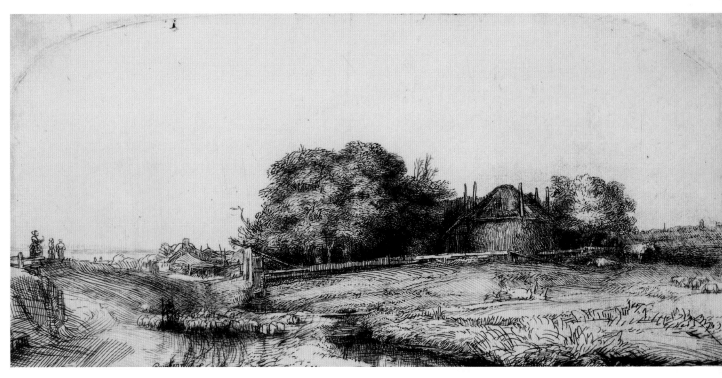

Landscape with Haybarn and a Flock of Sheep, c.1652, etching with drypoint (II states), UCL Art Collections, University College London, UK, 8.3 x 17.5cm (3 x 7in)

A landscape composition that depicts a flock of sheep, centre left, straddling a dirt road which runs near to a haybarn, centre right. In the distance to the left three figures are visible, drawn large in size in relation to the sheep. The location was used in other etchings, such as *Landscape with Trees, Farm Buildings and a Tower, c.1651,* depicting it from different directions and angles.

Winter Landscape with Cottages among Trees, c.1650, reed pen and brown ink, The State Hermitage Museum, St. Petersburg, Russia, 13.1 x 23.1 cm (5 x 9in)

One of many of Rembrandt's drawings, often quick sketches, of local lansdscapes which included small hamlets, a group of cottages or a pair of cottages on the outskirts of the city, in the lowlands.

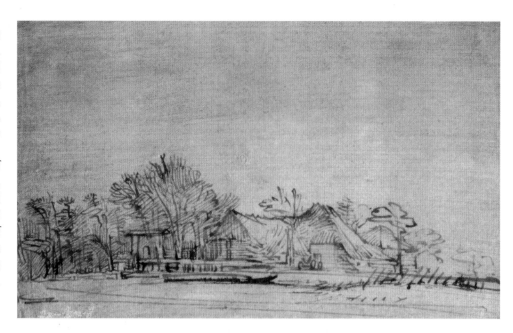

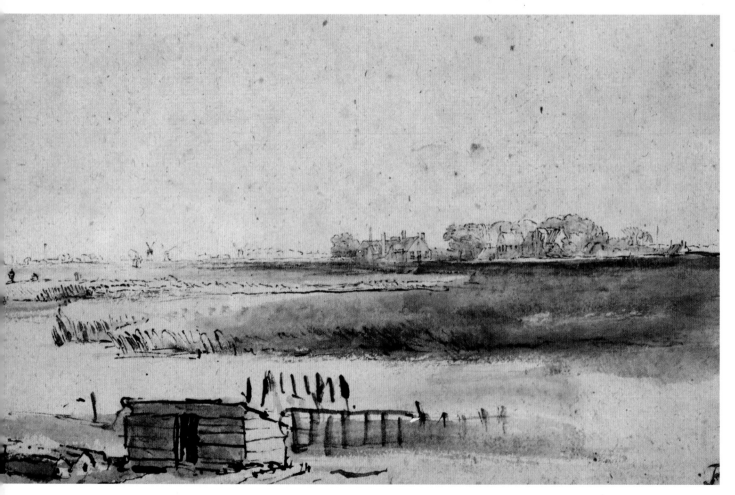

View of Houtewaal, c.1650, pen & brown ink, **Private Collection,** 12.5 x 18.2cm (5 x 75in)

A strong landscape depiction of a view well known to Rembrandt. During the difficult period of his insolvency and sale of his possessions, he took many walks to the outskirts of the city, to sketch and etch the local landscapes.

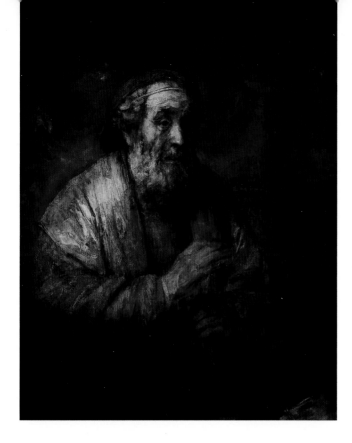

Homer, 1663, oil on canvas, Mauritshuis, The Hague, The Netherlands, 108 x 82cm (42½ x 32½in) Signed …*andt f. 1663*

A fragment of a lost painting, that originally depicted Homer dictating his verses to two scribes. Of those figures, only two fingers that hold a pen are visible at bottom right. The painting was one of three commissioned by the Sicilian art collector Antonio Ruffo. Ruffo's agent paid for the painting in July 1661; the work was only completed by 1663. The painting was damaged by fire, possibly in 1783 when an earthquake damaged Ruffo's palazzo at Messina, Sicily.

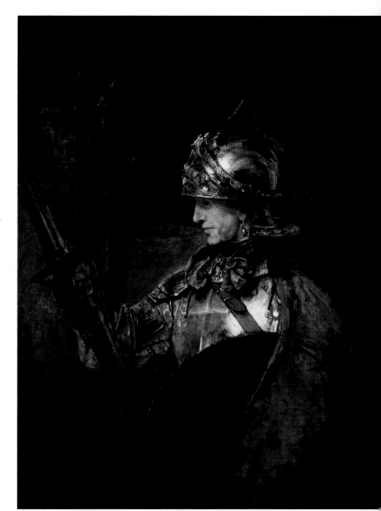

A Man in Armour (Alexander), 1655, oil on canvas, Art Gallery and Museum, Kelvingrove, Glasgow, Scotland, UK, 138 x 104.5cm (54 x 41in)

For the Sicilian art collector Antonio Ruffo, Rembrandt was commissioned to paint three portraits: of Aristotle, Alexander, and Homer. The painting of Alexander was originally a head only, later added to with four pieces of canvas, to create a half-length portrait to match the earlier *Aristotle with a Bust of Homer*, 1653. Archive correspondence shows Ruffo's displeasure with parts of the work. Historians have found it difficult to identify whether this portrait of *A Man in Armour* is one of the Ruffo paintings.

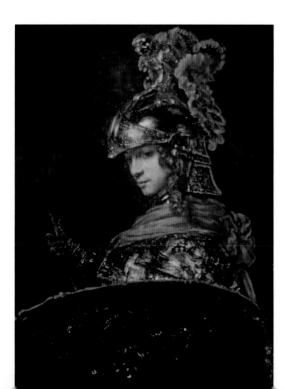

Alexander the Great, oil on canvas, Calouste Gulbenkian Foundation, Oeiras, Portugal, 118 x 91cm (46½ x 36in)

From historical accounts, it is possible that Rembrandt created two paintings of the Macedonian hero and honorary Greek, Alexander the Great (356–323BC), for Don Antonio Ruffo. This portrait depicts the young Greek warrior; he carries a shield and a tournament stick. His helmet is adorned with an owl emblem.

INDEX

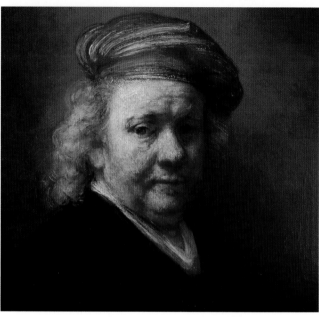

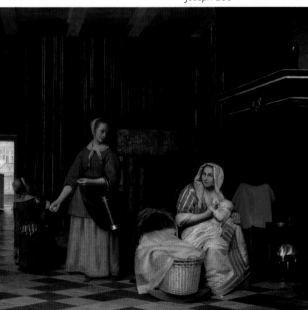

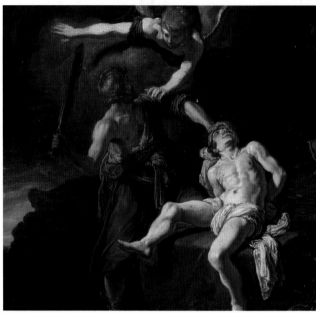

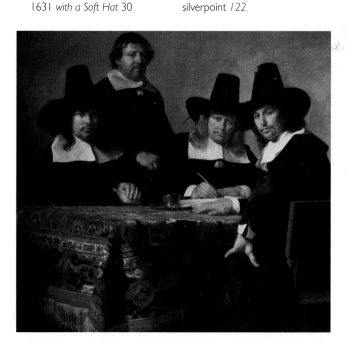

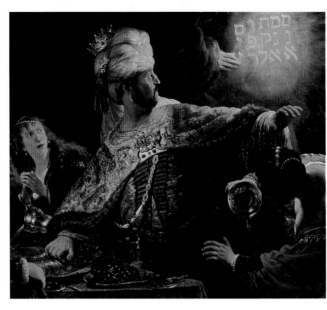

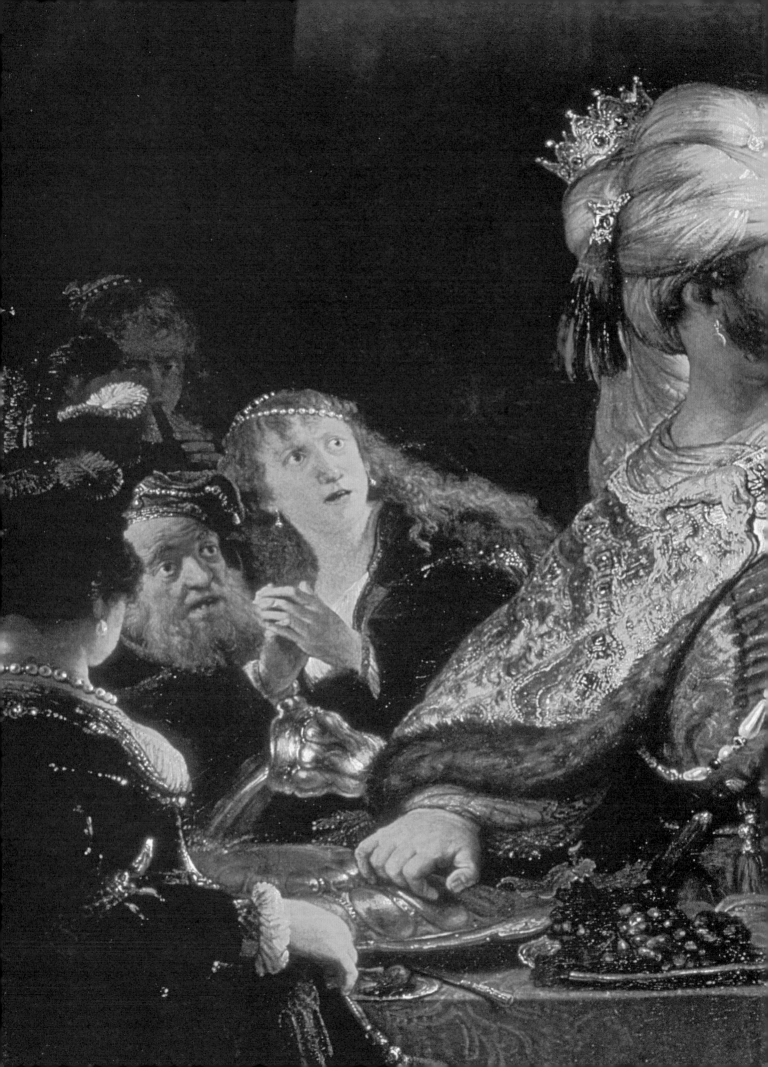

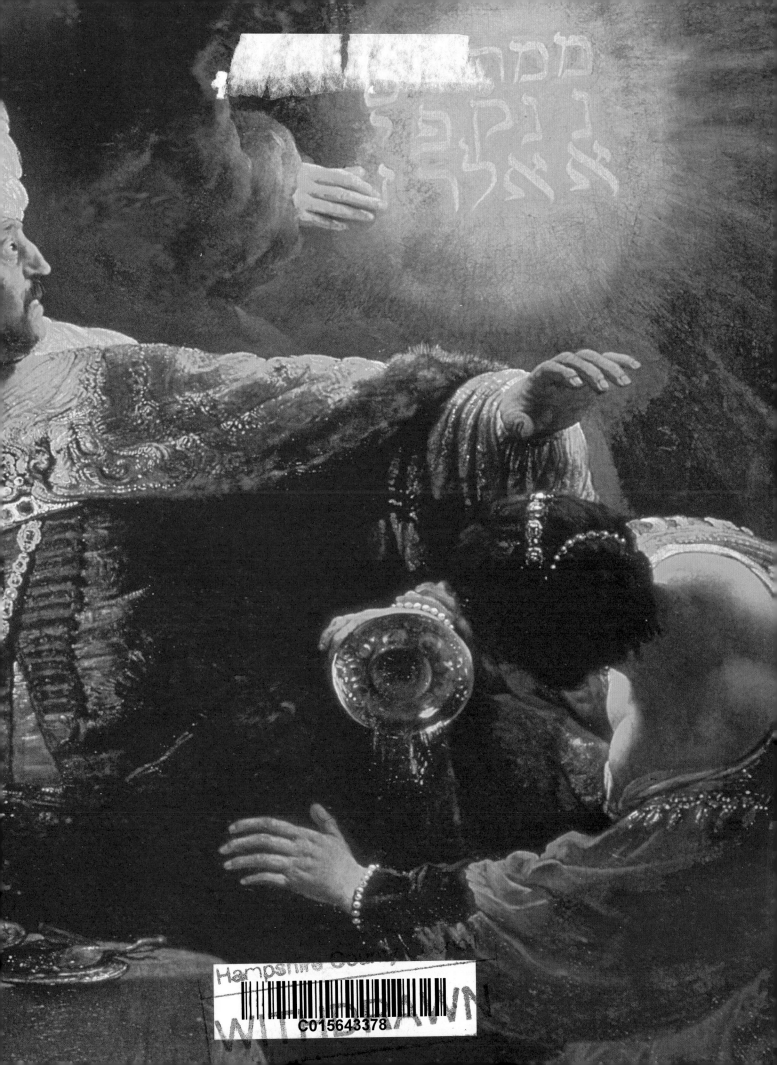